The Quest for Immortality

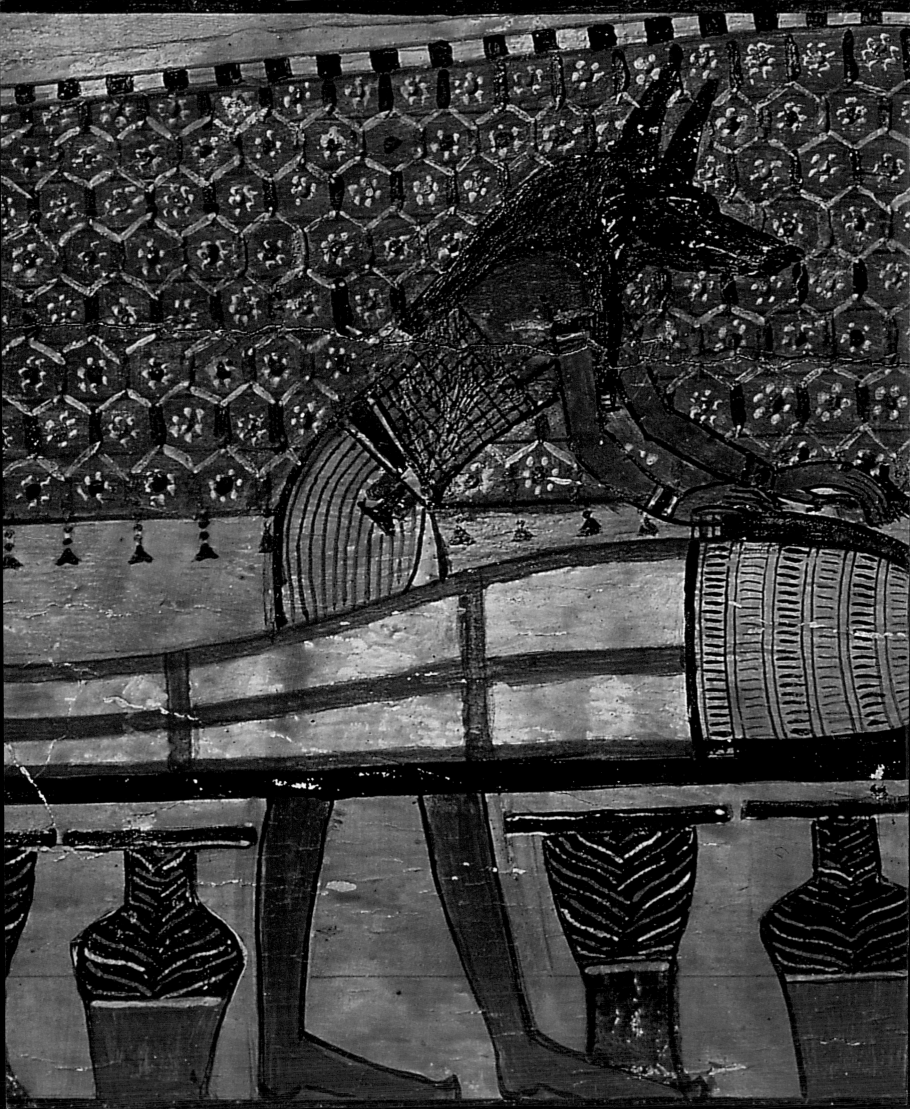

The Quest for Immortality
Treasures of Ancient Egypt

Erik Hornung and
Betsy M. Bryan, editors

Contributions by
Betsy M. Bryan, Terence
DuQuesne, Fayza Haikal,
and Erik Hornung

National Gallery of Art,
Washington, and
United Exhibits Group,
Copenhagen,
in association with
Prestel Publishers

The exhibition is organized by United Exhibits Group, Copenhagen, and the National Gallery of Art, Washington, in association with the Supreme Council of Antiquities, Cairo.

Exhibition dates
12 May – 2 September 2002 National Gallery of Art, Washington

The exhibition travels to museums throughout North America between 2002 and 2007

The book was produced by the Editors Office, National Gallery of Art.

Judy Metro, *Editor-in-Chief*

Karen Sagstetter, *Senior Editor*

Wendy Schleicher Smith, *Designer*

Chris Vogel, *Production Manager*

Production assistance by Nancy Van Meter. Typeset in Chaparral and Interstate by Duke & Company, Devon, PA, and printed on DacoStern, 150 gsm by Grafisches Zentrum Drucktechnik, Ditzingen-Heimerdingen, Germany

Library of Congress Cataloguing-in-Publication Data

Hornung, Erik.
The quest for immortality: treasures of ancient Egypt / Erik Hornung, Betsy M. Bryan.

p. cm.

Catalogue of an exhibition at the National Gallery of Art. Includes bibliographical references and index.

1. Art, Ancient — Egypt. 2. Art, Egyptian. I. Bryan, Betsy Morell. II. National Gallery of Art (U.S.) III. Title.

N5350 .H67 2002
709' .32'074753 — dc21 2002018847

ISBN 3-7913-2735-6 (alk. cloth)
ISBN 0-89468-303-9 (alk. paper)

The clothbound edition is published by the National Gallery of Art and United Exhibits Group in association with Prestel Publishers, Munich, London, and New York.

Prestel-Verlag
Mandlstrasse 26
D-80802 Munich
Tel: (89) 38.17.09.50
Fax: (89) 38.17.09.35
www.prestel.de

4 Bloomsbury Place
London, WCIA 2QA
Tel: (020) 7323.5004
Fax: (020) 7636.8004

175 Fifth Avenue, Suite 402
New York, NY 10010
Tel: (212) 995.2720
Fax: (212) 995.2733
www.prestel.com

Cover: (front) *Osiris resurrecting,* cat. 85; (back) *Canopic chest of Queen Nedjmet,* cat. 75

Interior details: (pp. ii – iii) *Sarcophagus of Khonsu,* cat. 68; (p. viii) *Sphinx of Thutmose III,* cat. 3; (p. xvi) *Statue of Isis,* cat. 79; (pp. 4, 6 – 7) *Offering table of Thutmose III,* cat. 6; (pp. 24, 26 – 27) *Gold pectoral with solar boat,* cat. 48; (pp. 52, 54 – 55) *Ushebti box of Djed-Maat-iuesankh* (cat. 104)

• Some twenty-five years ago the National Gallery of Art was pleased to introduce the exhibition of *The Treasures of Tutankhamun* to North America. Since then only one exhibition consisting entirely of objects coming from Egypt — *Ramesses the Great* — has visited our shores. At this time we are excited to welcome a new exhibition of Egyptian art, a perfect successor to the great *Tut*, and we are grateful to the Supreme Council of Antiquities, Cairo, and United Exhibits Group, Copenhagen, for crucial collaboration in preparing the exhibition. *The Quest for Immortality: Treasures of Ancient Egypt* combines aesthetically fine objects of Egyptian art with a fascinating glimpse into what the ancient Egyptians believed would occur in the world to which they journeyed after death. The remarkable tomb preparations undertaken by those ancient peoples begin to make sense as we comprehend their hope in the sun god and his victory each night over darkness and evil.

When we visit the pyramids or the tombs in the Valley of the Kings, we are impressed by the grandeur of these monuments, but as the story of ancient Egyptian funerary religion unfolds, we see the confident accomplishments of this great early civilization as the product of a culture like our own — full of faith and fear. The remarkable gifts of the Nile Valley, with its annual flood and unparalleled fertility, encouraged the Egyptians to believe that order could be created and maintained while intermittent famine, destruction, and disease reminded the population that order was neither automatic nor continuous. Only the action of the gods could ensure the harmony of the world; those who created it were also responsible for its continuation. In *The Quest for Immortality* we see sculpture, sarcophagi, and reliefs — objects that facilitated communication with deities, kings, and other intermediaries — made in the hope of guaranteeing an eternal and organized world. Religion and magic enabled people to partake of the gods' daily encounters with chaos and to attain for themselves a home in the afterworld. As we gaze with awe at the gold funerary masks of these kings and aristocrats who have not walked the earth for three thousand years, we see that the artifacts preserve not only the faith of these ancient peoples, but the hope we all have for the continuation of civilization.

The great tombs in the Valley of the Kings are carved in rock, sculpted, and painted with depictions of the Egyptian conception of the afterworld. Visitors pour into the monuments daily and experience firsthand the beauty of the sites, as they have for more than two thousand years. But these inspiring tombs are now threatened by the attention and by the changing natural environment in southern Egypt. We hope that all who visit *The Quest for Immortality* appreciate the generosity of the Egyptian government in lending these treasures to the United States and see in this gesture their belief that today's world must maintain the legacy of this great civilization.

Earl A. Powell III
Director, National Gallery of Art

• *The Quest for Immortality: Treasures of Ancient Egypt* presents the largest collection of objects ever to leave Egypt for a single North American exhibition. Highlighting masterpieces from the Egyptian Museum in Cairo, the Luxor Museum, and other collections in Egypt, the exhibition includes several works that have not been on display in public before and many that have never been shown outside Egypt.

At the core of the exhibition is a reconstruction of the sarcophagus chamber in the tomb of Thutmose III (1479–1425 BCE). On the original walls of this chamber appeared for the first time the complete text of the Amduat, the oldest Book of the Netherworld. The walls are replicated here, allowing visitors to track the sun god Re on his nocturnal journey and to gain insight into the burial of a pharaoh and the journey of the deceased through the twelve hours of the night. The exhibition affords visitors a truly unique opportunity to learn about the religion and burial customs of the ancient Eygptians through the treasures, tomb decorations, and artifacts they left behind.

The exhibition has been made possible by the wonderful cooperation and support of His Excellency Ambassador Nabil Fahmy; the Egyptian Minister of Culture, His Excellency Farouk Hosni; and the Supreme Council of Antiquities in Cairo, formerly headed by Gaballa A. Gaballa. The concept for the exhibition was inspired by years of preparatory work by the Swiss-based Society of the Friends of the Royal Tombs of Egypt, which together with its Egyptian sister society, is dedicated to preserving the endangered royal tombs of Egypt and to making the values of the pharaonic culture accessible to a wide public.

The successful merging of creative and planning skills brought to the project by the scientific committee of United Exhibits Group has also been vital to accomplishing the goals of this exhibition. We extend our gratitude to the members of that committee, headed by Erik Hornung, professor emeritus of Egyptology at the University of Basel; Dr. Theodor Abt of the Federal Institute of Technology in Zurich; Fayza Haikal, professor of Egyptology at the American University in Cairo; and Betsy M. Bryan, professor of Egyptian art and archaeology at Johns Hopkins University in Baltimore, Maryland.

The successful realization of the project in North America is due in large part to the expert and willing cooperation of the National Gallery of Art in Washington, under the leadership of its director, Earl A. Powell III. *The Quest for Immortality* travels to several museums in North America prior to an extended tour in Europe. It is our hope that visitors on both continents experience the enormous scope and power of this ancient but not lost civilization.

Teit Ritzau
President, United Exhibits Group

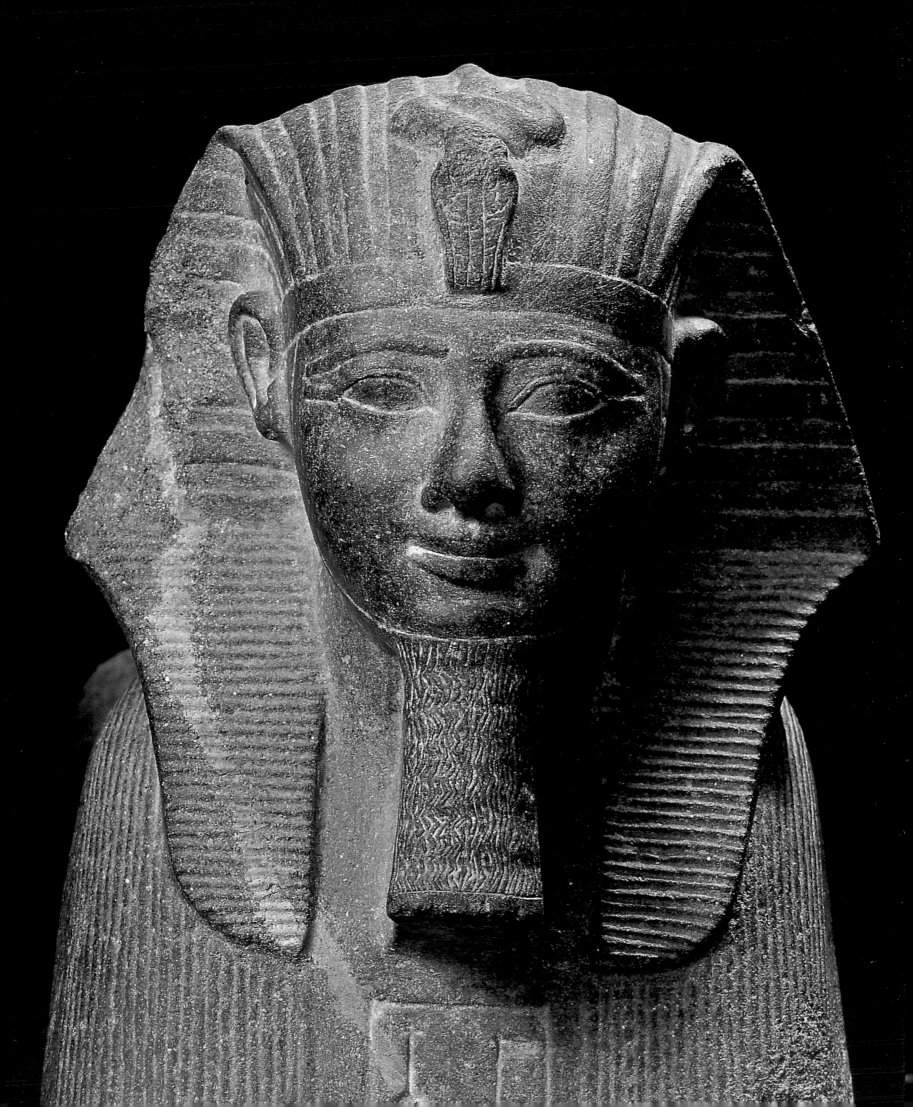

Acknowledgments

• We are grateful to so many people who have helped bring this exhibition and catalogue together in a very brief time. Foremost, our thanks go to those who have worked on the project from its beginnings, including Fayza Haikal of the American University in Cairo and Theodor Abt of the Federal Institute of Technology in Zurich, and of course Teit Ritzau, president of United Exhibits Group. Gaballa A. Gaballa, former secretary general of the Supreme Council of Antiquities in Cairo, has been supportive all along and took his valuable time to see that the exhibition was successfully completed. Dr. Sabry Abdel Aziz, general director of Upper Egyptian Monuments, was extremely supportive of the project, as was Dr. Mohamed el Bialy, general director for Luxor Monuments, West Bank, and Ibrahim Soliman, director of monuments for the Valley of the Kings. We thank also the entire staff of the Egyptian Museum in Cairo, especially Dr. Mamdouh El-Damaty, general director, and Adel Mahmoud, curator of New Kingdom art. Without their help and that of all the curators and conservators, this exhibition would not have been possible. Every time we needed something, they willingly took their time to help. In Washington, the exhibition would not have taken shape without the full energy and support of the National Gallery of Art and its director, Earl A. Powell III.

We also thank those who wrote entries for the book on a pressured timetable: James Allen, Metropolitan Museum of Art; Lawrence M. Berman, Museum of Fine Arts, Boston; Mamdouh El-Damaty, Egyptian Museum, Cairo; Terence DuQuesne, London; Richard Fazzini, Brooklyn Museum of Art; Rita E. Freed, Museum of Fine Arts, Boston; Richard Jasnow, Johns Hopkins University; Adel Mahmoud, Egyptian Museum, Cairo; Ibrahim El-Nawawy, Supreme Council of Antiquities, Cairo; Ann Macy Roth, Howard University; Edna R. Russman, Brooklyn Museum of Art; Emily Teeter, Oriental Institute Museum, University of Chicago. In addition we thank the members of Betsy Bryan's seminar who wrote entries for the volume: Fatma Ismail, Tammy Krygier, Yasmin El Shazly, Elaine Sullivan, and Elizabeth A. Waraksa.

A special thanks goes to David Roscoe, translator of Erik Hornung's essay, and to James VanRensselaer, photographer for Johns Hopkins University's Homewood Campus, who traveled to Egypt to reshoot nearly thirty objects on a tight deadline. Owing to his generosity and talent, and to the special courier skills of Daniel Shay at the National Gallery, we have a complete catalogue of fine photographs.

In Cairo the staff of the American Research Center in Egypt greatly assisted us with various arrangements and handled communications between the National Gallery of Art and the Supreme Council of Antiquities. We are particularly grateful to Robert Springborg and Amira Khattab. Our colleagues at other institutions have been highly supportive. They include Nancy Thomas at the Los Angeles County Museum of Art and Kenneth Bohač at the Cleveland Museum of Art. We thank Dorothea Arnold, director of the the department of Egyptian art at the Metropolitan Museum of Art, who kindly offered help in securing photographs from a vast archive. Kent Weeks provided assistance in accessing both plans and photographs of monuments from Thebes. Edwin Brock kindly replied to queries we had early on regarding royal sarcophagi.

ix

The staff at United Exhibits Group in Copenhagen has been especially helpful to us. Our thanks go to Factum arte, for design and implementation of the production of the tomb; Cortina Productions, for interactive touchscreen exhibits; J. D. Dallet for photography; Katrine Møllehave, for design of original concept; Claus Frimand, vice president, and Ditte Højriis, project coordinator, for project coordination and management; Troels Askerud and Claus Kongsted, for legal and financial advice; and Søren Løvenlund, chairman of United Exhibits Group. Part of this project was financed with the support of Eksport Kredit Fonden, Denmark.

At the National Gallery of Art we are grateful to Elizabeth A. Croog, secretary and general counsel; Nancy Breuer, associate general counsel; and James Duff, treasurer; for their wise deliberation on all agreements related to the exhibition. For their expert coordination and administration of all exhibition matters, we thank D. Dodge Thompson, chief of exhibitions; Jennifer Cipriano, exhibition officer; and their assistant Jennifer Bumba-Kongo. We are grateful to Susan M. Arensberg, head of exhibition programs, and Mark Leithauser, chief of design, for their early involvement and good advice on the selection and installation of the works; to Gordon Anson, head of exhibition production; Donna Kirk, exhibition designer; and Bill Bowser, production coordinator; for the installation design; and to Carroll Moore, film producer; Lynn Matheny, assistant curator; and Kelly Swain, research assistant; for creating a film for the exhibition. For knowledge and guidance in the delicate matter of packing and shipping the objects, we thank Sally Freitag, chief registrar; Michelle Fondas, registrar for exhibitions; Merv Richard, head of loans and exhibitions conservation; and Bethann Heinbaugh, conservation technician. Bob Grove, digital imaging coordinator, aided in the quick distribution of images for the exhibition. For her fundraising efforts, we thank Chris Myers, chief of corporate relations. Deborah Ziska, chief press and public information officer, and Domenic Morea, publicist, lent their enthusiasm and media skills to the promotion of this exhibition.

Many people on the Gallery's fine editorial staff led by Judy Metro worked with speed and grace to produce this book. Our thanks go especially to Karen Sagstetter, senior editor, for coordinating the editorial side and to designer Wendy Schleicher Smith for giving an elegant form and readability to the book. Other members of the team include Chris Vogel, Margaret Bauer, Sara Sanders-Buell, Mariah Shay, Amanda Mister, and freelancers Jane McAllister, Fran Kianka, and Michele Callaghan. Special thanks go to Kathlyn Cooney and Tammy Krygier, whose research, writing, and knowledge of many things Egyptian were invaluable to the entire team.

To all of those who have helped bring our project to its successful completion, we extend our deepest gratitude.

Erik Hornung and Betsy M. Bryan

• From earliest times the ancient Egyptians denied the physical impermanence of life. They formulated a remarkably complex set of religious beliefs and funneled vast material resources into the quest for immortality. While Egyptian civilization underwent many cultural changes over the course of its nearly three-thousand-year history, the pursuit of life after death endured. This volume focuses on the understanding of the afterlife in the period from the New Kingdom (1550–1069 BCE) through the Late Period (664–332 BCE). The New Kingdom marked the beginning of an era of great wealth, power, and stability for Egypt and was accompanied by a burst of cultural activity. Much of this activity was devoted to the quest for eternal life and was focused in the capital Thebes (modern-day Luxor), located along the banks of the Nile in Upper Egypt. The works of art illustrated in this book—statues, jewelry, painted coffins, and other furnishings for the tomb—are evidence of this pursuit. They come from the Egyptian Museum in Cairo, the Luxor Museum, and the sites of Tanis and Deir el-Bahari.

In ancient Egypt, religion and politics were inextricably linked. Egyptian kingship was associated with solar power, which may be understood as an attempt to immortalize the royal office. A sphinx representing the likeness of the pharaoh Thutmose III (1479–1425 BCE) visualizes this connection, for the sphinx was a symbolic manifestation of the sun god Re (cat. 3). The sphinx's links to the sun were owed, in part, to the fact that lions in ancient Egypt inhabited the desert margins and were believed to be guardians of the horizon, and therefore of the sun.

The bond between the sun and the pharaoh is an idea almost as old as Egypt itself. The Great Pyramids of Giza, built some forty-five hundred years ago, are themselves symbols of the sun, representative not only of its rays as they hit the earth but also of a sacred pyramidal stone in Re's sacred temple in Heliopolis. By the time of the New Kingdom, pharaohs were no longer buried in monumental pyramids, but rather in elaborate tombs beneath a pyramidal-shaped mountain at a site in western Thebes. Known today as the Valley of the Kings, this desert valley on the west bank of the Nile was the royal burial ground for more than six hundred years, until the Twenty-first Dynasty (1069–945 BCE), when the Tanis temple complex in the north of Egypt became the new site for royal tombs. Despite the relocation of the royal tombs to the north (a result of political upheaval in Egypt), the pharaoh's solar associations persisted. The royal tombs at Tanis, found intact in 1939, represent the most important archaeological find since the discovery of Tutankhamun's tomb in the Valley of the Kings in 1922–23. However, because the excavation occurred at the outset of World War II, it went largely ignored by the Western public. A resplendent gold mask and jewelry (cats. 43 and 47) are among objects found in the Tanis tombs.

Egyptian religion, as well as the authority of the king, rested on the concept of *maat*, translated as "truth," "justice," or "natural order." *Maat* was personified as a goddess with a feather on her head, or sometimes seen simply as the hieroglyphic "feather of truth" (cat. 88). The order instilled by *maat* governed the universe, causing the sun to rise and set every day, the Nile to flood its banks and deposit new layers of nourishing soil every year, and the dead to be reborn in the next world. Egyptian religion, in its essence, was an examination of these cycles of death and rebirth.

xi

For the Egyptians, the cycles were not merely guaranteed natural occurrences; the sun did not simply set and rise again twelve hours later undeterred. Rather, the setting sun signaled the death of the sun god Re and his descent into the nocturnal realm of the underworld. There, a host of protective deities helped him overcome a series of dangers that impeded his progress along the path toward rebirth as the rising sun at dawn. Descriptions of the sun god's nightly journey are inscribed on the walls of royal tombs and on the objects contained within. The inscriptions serve as a guidebook for the pharaoh's own journey toward rejuvenation, as ancient Egyptians believed that in the afterlife kings became one with the sun god, with whom they were reborn at sunrise. Without such assistance, the sun god's resurrection was impossible. The Egyptians, similarly, did not view their own rebirth in the next world as an absolute given; magic, force of will, morality, and obscure knowledge enabled human resurrection. Elaborate rituals and ceremonial objects were thus designed to provide the deceased with the essentials to reach the afterlife.

The dangers faced by the sun god Re during his nocturnal voyage were believed to be the same faced by all Egyptians upon death, regardless of class. But if the underworld journey was a perilous one for both the king and his subjects, it also was full of possibility, with the potential for resurrection and immortality at its end. Funerary rituals associated with mummification and burial may be understood as multiple layers of protection, aiding the deceased during the treacherous journey toward afterlife. The body was protected by physical coverings, amulets, and magical deities that together preserved the body and provided the deceased with the knowledge required to achieve resurrection. These protective layers also ensured safety for the *ba* — loosely translated as the soul and personality of the deceased.

The process of mummification, which prevented the body from fully decomposing, functioned as the first protective layer. The deceased's organs were removed from the body, dried in natron salts, wrapped in bandages, and placed in jars with lids depicting guardian deities. The body was similarly dessicated in natron, treated with oils, and then carefully swathed in linen. The wrapping of the body associated the deceased with Osiris, the ruler of the netherworld (cat. 78). The myth of Osiris told of his murder and the dismemberment of his body, which was subsequently collected in its parts, wrapped together, and reborn with divine assistance. To be resurrected, a dead Egyptian — commoner or king — needed to imitate the form of Osiris. Once mummified, the deceased was called "Osiris," and it was expected that he or she then would be reborn in the same magical fashion. An unusual image of the moment of re-awakening is depicted in a mummiform figure that simultaneously represents Osiris and the deceased in his form (cat. 85). The figure has just rolled over from its back and is becoming alert, lifting up his head, and awakening to new life.

The mummies of royalty and nobles were outfitted in elaborate attire that may have included beaded clothing, jewelry, finger and toe covers, and masks. The dressed body was then placed in its magically protective container, the coffin. Depending upon the deceased's status and wealth, the coffin may have then been placed into a series of nesting coffins (cat. 73), which, for the privileged, were set in a massive sarcophagus that rested in the tomb's burial chamber (cat. 100).

Within the tombs, Egyptians placed objects that would assist the deceased in their next life. Many royal tombs contained painted wooden boats such as the one buried with Amenhotep II (1427–1400 BCE; cat. 1). Modeled after royal barges that ferried kings along the Nile in life, such ship models were believed to be the kings' magical transport through the waters of the netherworld. Many of the items discovered in burial chambers were divine objects — statues of gods and goddesses, sacred

funerary texts, and beautiful jewelry with religious iconography, such as the pectoral of King Psusennes I. Placed over the chest of the deceased, the pectoral depicts goddesses protecting a winged scarab beetle, the symbol of the rising sun (cat. 47). The Egyptians believed that by representing deities in tomb chambers, their divine magic and knowledge would accompany the deceased in the journey toward rebirth.

The afterlife was understood as an actual physical existence requiring sustenance. Tomb furnishings, therefore, included a variety of basic provisions, such as clothing, furniture, toiletries, and offerings of food and drink. These everyday objects in Egyptian tombs inform us as much about ancient life as about the Egyptian understanding of death. The frequent decoration of these functional objects with gods and goddesses and sacred texts, for example, indicates that religion was not a distinct realm but instead permeated all aspects of Egyptian society. The chair of Sit-Amun, for example, made for the daughter of King Amenhotep III, is adorned with images of the leonine god Bes and the hippopotamus goddess Taweret— domestic deities who protected women and children (cat. 39).

If the afterlife was considered an actual physical place, it was also one where there was real work to be done. Recognizing this need but not wanting deceased pharaohs and nobles to be burdened with such labor, the Egyptians provided servants for the deceased in the form of small statues known as *ushebtis* (cats. 35, 59, 61). Often equipped with tiny hoes and other tools, *ushebtis* were prepared to perform the agricultural and building activities in the underworld. It was not uncommon to find hundreds of these figures in a single burial chamber — as many as one for every day of the year.

An important component of Egyptian religion is its tradition of funerary literature. The earliest known collection of religious spells, called the Pyramid Texts, dates to 2350 BCE at the time of the Old Kingdom. Over the course of the next centuries, a succession of new funerary texts slowly shaped the course of Egyptian religion. The New Kingdom, however, witnessed an explosion of such funerary texts, collectively referred to as the Books of the Netherworld. More coherent than their predecessors, these books offered the earliest systematic explanation of Egyptian religion. The most important of the texts are popularly known as the Book of the Dead and the Amduat (the latter meaning "that which is in the netherworld").

Those who could afford it commissioned personalized versions of the Book of the Dead to be inscribed on coffins, sarcophagi, *ushebtis*, and other objects for the tomb. The text contained nearly two hundred magical spells and cryptic knowledge that prepared the deceased for the challenges in the underworld. For example, the coffin of the nobleman Paduamen (cat. 73) includes many texts and vignettes from a spell designed to protect the body. The coffin lid depicts Nut, the sky goddess and mother of the sun god, her wings protectively outstretched on the abdomen of the deceased.

While the Book of the Dead was available to all Egyptians, the Amduat was reserved for the pharaoh and a few select nobles. The earliest known complete copy of the Amduat is found in the tomb of Thutmose III in the Valley of the Kings. The text describes in minute detail the geographical layout of the netherworld and the events that transpire in each of the twelve hours of the sun's nocturnal journey — believed to be the pharaoh's journey as well — from sunset and death to sunrise and rebirth. Painted onto the walls of Thutmose III's burial chamber in simple, cursive red and black lines that mimic writing on papyrus, the text guides the deceased through the netherworld.

Describing its various regions, depicting in images and hieroglyphic text all of the perils that must be faced, the Amduat provided the knowledge required to pass through unscathed. Hour by hour all deities, demons, and enemies are drawn and named, for to know the name of something is to harness its power.

The realm of the afterworld was inhabited by hundreds of gods and goddesses who assisted the deceased in the journey toward resurrection. While Osiris reigned as the ruler of the netherworld, all of the other deities worked together to protect the deceased and to aid in the quest for immortality. The deities were represented as humans, animals, and often both, with many gods taking the form of the inhabitants of the Nile Valley. For instance, the Egyptians worshiped the falcon god Horus, master of the sky and the embodiment of kingship; the crocodile god Sobek, connected with fertility and water; and the lioness goddess Sakhmet, who controlled the fortunes of war and pestilence. The goddess Hathor, believed to be the mother goddess, is represented as a cow or as a woman with cow horns. She is closely linked to another of the most powerful female deities, the goddess Isis, who in fact often wears Hathor's cow horns. Amidst this animal imagery, it is important to remember that what the Egyptians venerated was not the animals themselves but the powers associated with them.

The jackal Anubis, who oversaw embalming and guarded the body, was frequently depicted on funerary objects such as canopic chests — boxes that enclosed the four jars containing the mummy's extracted organs. A sculpted Anubis figure lies on top of a canopic chest, clearly marking his territory and domain (cat. 75). His image and power are reinforced by the painted Anubis (here depicted as a human body with a jackal head) rendered on the front of the chest.

Multiple manifestations of individual gods were common and indicative of the complex nature of Egyptian religion. In the case of Re, as many as seventy-five manifestations are known. A pectoral found in the tomb of Psusennes I (1039 – 991 BCE) in Tanis depicts several of these representations, including a winged sun disk, a motif repeated near the bottom of the pectoral, where a row of red carnelian disks signify the movement of the red solar disk (cat. 47). The sun god is also depicted in the central oval where a lapis-lazuli scarab, the morning manifestation of the sun god, is found. Further solar connections are seen in the use of gold, known generally as the "flesh of the gods," but with particular ties to the luminous sun. By including these many representations of Re in his tomb, the king associated himself with the sun's miraculous death and rebirth every day, thus providing himself with the same regenerative and protective powers for his own resurrection. As in many of the objects in this catalogue, the careful craftsmanship, detailed iconography, and rich materials of this pectoral remind us of the supreme importance of the quest for immortality in ancient Egypt.

GREECE

CYPRUS

• Kadesh

• Byblos

LEBANON

SYRIA

Mediterranean Sea

• Megiddo

NILE DELTA

Alexandria •

ISRAEL

JORDAN

Sais • • Busiris

Tanis •

LOWER EGYPT

• Heliopolis

★ Cairo

S I N A I

Giza •

Sakkara •

• Memphis

• Dahshur

FAYUM

• Medum

*Lake
Moeris*

S A H A R A

SAUDI
ARABIA

Nile

Hermopolis •

EGYPT

Asyut •

UPPER EGYPT

• Akhmim

R e d S e a

Abydos •

• Dendera

Valley of the Kings

Deir el-Bahari

Medinet Habu

Karnak

Deir el Medina

Tod • Thebes (Luxor)

Esna •

• Elkab

Edfu •

DAKHLA OASIS

Elephantine • • Aswan

*Lake
Nasser*

Abu Simbel • • Aniba

Faras •

Semna •

N U B I A

SUDAN

Nile

Sedeinga •

0 50 200

MILES

LIBYA

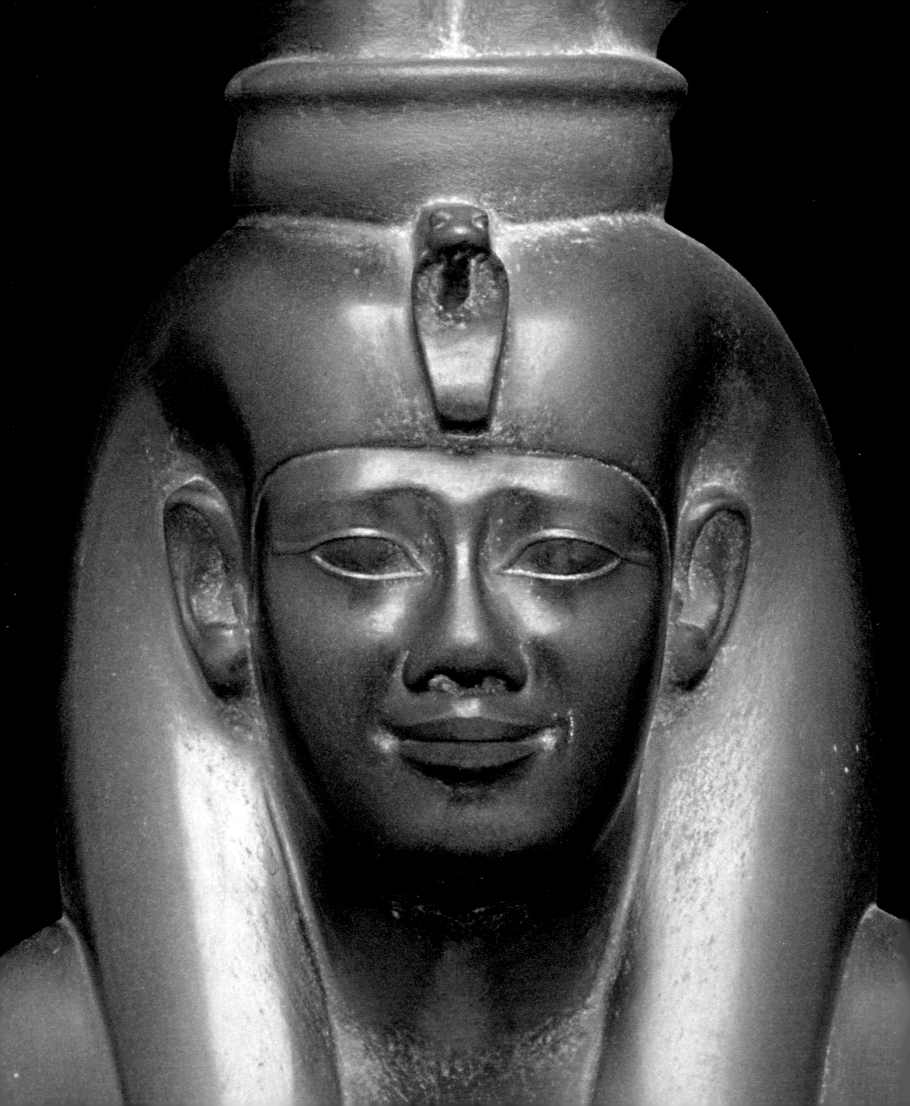

• The story of the quest for immortality that follows in this book details afterlife beliefs in the time of Thutmose III (1479–1425 BCE) and his successors in the New Kingdom. An understanding of funerary notions necessitates a look at two of the most important concepts from ancient Egypt—kingship and religion. In 1479 BCE, when Thutmose III ascended the throne in the Eighteenth Dynasty (1550–1069 BCE), Egypt had already seen fifteen hundred years of pharaonic rule. Writing, almost certainly the invention of a newly centralized monarchy, developed in the latter part of the fourth millennium BCE, and despite its primary use as an administrative tool, quickly was enlisted in the service of the state as the means of explicating the association of kingship with religious beliefs. Through writing the king's manifestation as the god Horus, the divine ruler on earth, could be linked to his role as "the favorite of the two ladies"—an allusion to Nekhbet and Wadjet, goddesses from the prehistoric cults of Upper and Lower Egypt, as well as his position as "he of the sedge plant and the bee," a reference to his ownership of the country, including the familiar sedge plant of Upper Egypt and the most significant product of Lower Egypt, bee's honey.

The ancient Egyptians were always concerned with explaining their world by the means of identifying it. Thus they were a nation of bureaucrats almost by definition. Titles and names and lists of both burgeoned in the documents of the First and Second Dynasties. By the Old Kingdom (c. 2686–2125) the tombs of officials carried long inscriptions made up almost entirely of titles and epithets of the tomb owners. In these early times, too, the tendency to make lists was manifest in the funerary context, where monuments carved with sculptured reliefs depicted deceased men and women accompanied by lengthy graphlike offering tables that detailed the names of breads, beer, ointments, clothes, et cetera, that they expected to be provided to them in perpetuity. The naming and illustration (for such were hieroglyphic writings) were tantamount to the presence of the offerings, just as were the actual food and objects placed in the tomb.

In addition to enabling the categorization of the world, writing also allowed for manipulation of concepts, such as the kingship. For example, as early as the middle of the First Dynasty (c. 2900 BCE), a list of kings is known, beginning with Narmer and ending with Den. The intent to memorialize the dynastic line of kings is evident here and constitutes an early use of writing to aid ideology. Interestingly enough, this first list added a name to those of the kings—the king's mother Merneith—for that queen, early forerunner to Hatshepsut, ruled Egypt and left a tomb and burial outfit consistent with those of her kingly ancestors. In later centuries the rule of Queen Merneith was reduced to a simple regency for Den by the compilers of king lists, as the potential of writing for reconciling history with political ideology and religion further evolved.

Religious literature developed within the context of the monarchy, where it served in the Old Kingdom to assure the king's journey to the heavens after death. The Pyramid Texts are first inscribed on tomb walls in the reign of Unas (2375–2345 BCE) at the end of the Fifth Dynasty and are entirely dedicated to the king's successful afterlife transformation. There were no parallel texts for private persons, although clearly there was a belief that a Field of Reeds awaited the blessed dead. Stress was rather placed on one's usefulness to the sovereign as a means to ensure travel to the next world. The Coffin Texts, which appeared by the First Intermediate Period (2160–2055 BCE), provided spells for all people hoping to gain the next world through their association with the sun god's daily rejuvenation. During the Middle Kingdom (2055–1650 BCE), Coffin Texts continued to be used for burials throughout the country, but kings made efforts to revive the central role of the monarchy in religion as well as in politics. The Middle Kingdom rulers attempted to recall the greatness of the Old Kingdom in their pyramid building and art styles, but they strengthened the kingship more by stressing other roles of the ruler. Rulers, such as Senusret I (1956–1911 BCE), built great national temples at the major cult centers in Egypt, some of which had been neglected

1

since the Sixth Dynasty (2345–2181 BCE). At Heliopolis, city of the sun god Re and the creator Atum, new constructions were carried out, and the temple of Karnak to Amun-Re was built in Thebes on the model of the Heliopolitan shrine. The temple of Ptah at Memphis was certainly expanded, as were the Theban temples to Montu. The rulers portrayed themselves as pious sons of the gods, while also fostering the notion that the king was the guarantor of life on earth. By encouraging the composition of literature that extolled the kingship, the personal connection between ruler and ruled was enhanced, as was the connection between the ruler and the powerful elites whose support was vital. Hymns were composed in honor of Senusret I and Senusret III, while other texts advised people to be loyal to the king who was Egypt's protection.

The roles of the ruler that developed during the Old and Middle Kingdoms continued to be prominent in the early Eighteenth Dynasty (1550–1295 BCE) but were enriched to form the New Kingdom kingship. The role of ruler as the guarantor of earthly order was greatly expanded, due to the wars to expel the Hyksos in the late Seventeenth and early Eighteenth Dynasties, followed by the conquests of Nubia, the Levant, and Syria. To emphasize the relationship between the new dynastic line and the major gods, kings sought to identify themselves as offspring of the deities. Ahmose called himself "son of Iah," the moon god honored in the royal name, while Thutmose III termed himself "son of Amun" and also "son of Mut," implying his association with the moon god Khonsu, the divine son of the Karnak gods. Hatshepsut even illustrated her bodily creation from Amun-Re on the walls of her temple at Deir el-Bahari, and Amenhotep III did likewise at Luxor Temple a hundred years later. Most commonly, however, kings spoke of themselves as the sons of the sun god, "the son of Re, of his body," the message repeated in numerous royal inscriptions. Even as the wealth and power of Amun-Re of Thebes was growing through the reigns of Hatshepsut to Amenhotep III, the connection of the kingship with the Heliopolitan gods Re-Horakhty and Atum also grew, in some ways overlaying the Amun cult itself. For example, within the great temple of Karnak, Thutmose III built an eastern temple dedicated to the sun god, while Osiride statues left by several kings wore the double crown of Atum and the white crown of Osiris. (The Middle Kingdom rulers also erected Osiride statues in Karnak, as well as in funerary temples.)

Indeed, the kings of the Eighteenth Dynasty did fuse the funerary with the national cults, pursuing a role for Amun-Re within the mortuary temples, while alluding to Re and Osiris in the temples on both banks of the river. In newly stressing the *sed*, or rejuvenation, festival, kings after Thutmose III particularly expanded the king's identification with the sun. Thutmose III ruled for fifty-four years, and after thirty years of reigning, kings were entitled to celebrate a *sed* festival. During this ritual the king demonstrated his physical worthiness to continue rule and showed his piety to the gods by visiting their numerous shrines, built to bring them together in a single complex. In response the gods bestowed the crowns of Upper and Lower Egypt on the king, renewing his kingship and granting him "millions of years like Re." Even as early as the Third Dynasty, the *sed* festival was an occasion for kings to adorn themselves with solar imagery, a custom elaborated during the time of Thutmose III. The king wears crowns hung with solar disks and uraei, making him the image of the sun. Thutmose III celebrated numerous *sed* jubilees, having been entitled to a renewal every three years following the first one. The solar connections were more evident late in his reign, particularly in the reliefs from his Deir el-Bahari temple, Djeser-Akhet.

During the reigns (1427–1352 BCE) of Amenhotep II, Thutmose IV, and most especially Amenhotep III, the last of whom called himself Re in inscriptions, this connection with the *sed* and the sun god was continued.

Here the quest for immortality joins the kingship to the religious beliefs of the Egyptians. While the Middle Kingdom rulers may have lacked a clear identification with the sun god, the New Kingdom kings recaptured that aspect of the Old Kingdom rulers. Without excluding the populace from its right to the afterlife, the kings kept the journey of the sun god through the twelve hours of the night to themselves (with the single exception granted to Thutmose III's vizier Useramun). The Book of the Secret Chamber, more often called simply the Amduat, was formulated by the beginning of the Eighteenth Dynasty and portrayed the king as the ram-headed *ba* of the sun descending into the netherworld to face the terrors of the night and to rise triumphantly at the eastern horizon. Although all people might hope to ride in the "barque of millions" together with Re, only the kings of the New Kingdom were to have the Amduat that ensured their identification with the sun, in body and soul.

The reign of Thutmose III (and Hatshepsut, his co-regent) was pivotal, for it brought together all the strands that characterize religion and kingship in the New Kingdom. The military king Thutmose III, who dominated the Levant and eventually Syria, effectively maintained the world order, while the builder Thutmose III humbly offered what the king possessed to the gods and showed the ruler offering to them as their priest. Having celebrated the *sed* festival, the king was imbued with solar connections that promised eternity for his rule. Even the form of the Amduat was innovative, since it was the first of its kind, an illustrated narrative. Although the ancient aim of identifying and categorizing the cosmos remained the prime aspect of the Amduat, the secret knowledge contained within the text was presented in a new way. Religious spells before the Eighteenth Dynasty had vignettes associated with them, and the Book of Going Forth by Day, often called the Book of

the Dead, was so conceived. The Amduat, however, was designed with interdependent scenes and sequential texts. The scenes are labeled, with the expansion texts placed in relation to the figures to maintain connection between texts and representations. It is no coincidence that the earliest non-funerary example of this type of book is in Hatshepsut's Deir el-Bahari Temple, where, with the Punt reliefs and the divine birth sequence, complete narratives are presented in the same fashion. Although the invention of this book form appears to have occurred with the writing of the Amduat, with literature as with all of Egyptian culture, the realm of eternity was never distant from the realm of life on earth. That indeed is the meaning of the quest for immortality.

Betsy M. Bryan

3

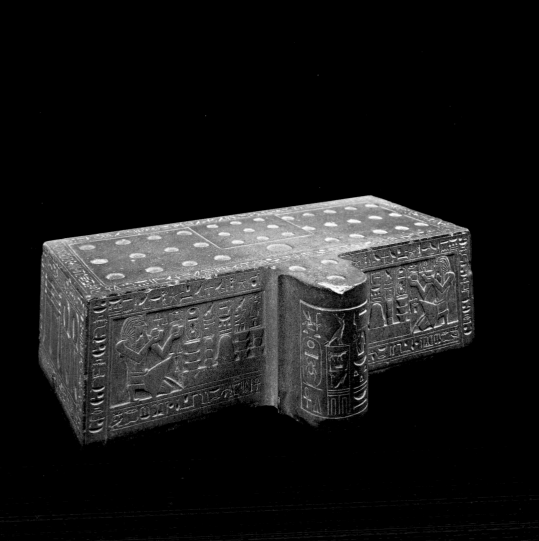

Thutmose III and the Glory of the New Kingdom

Fayza Haikal

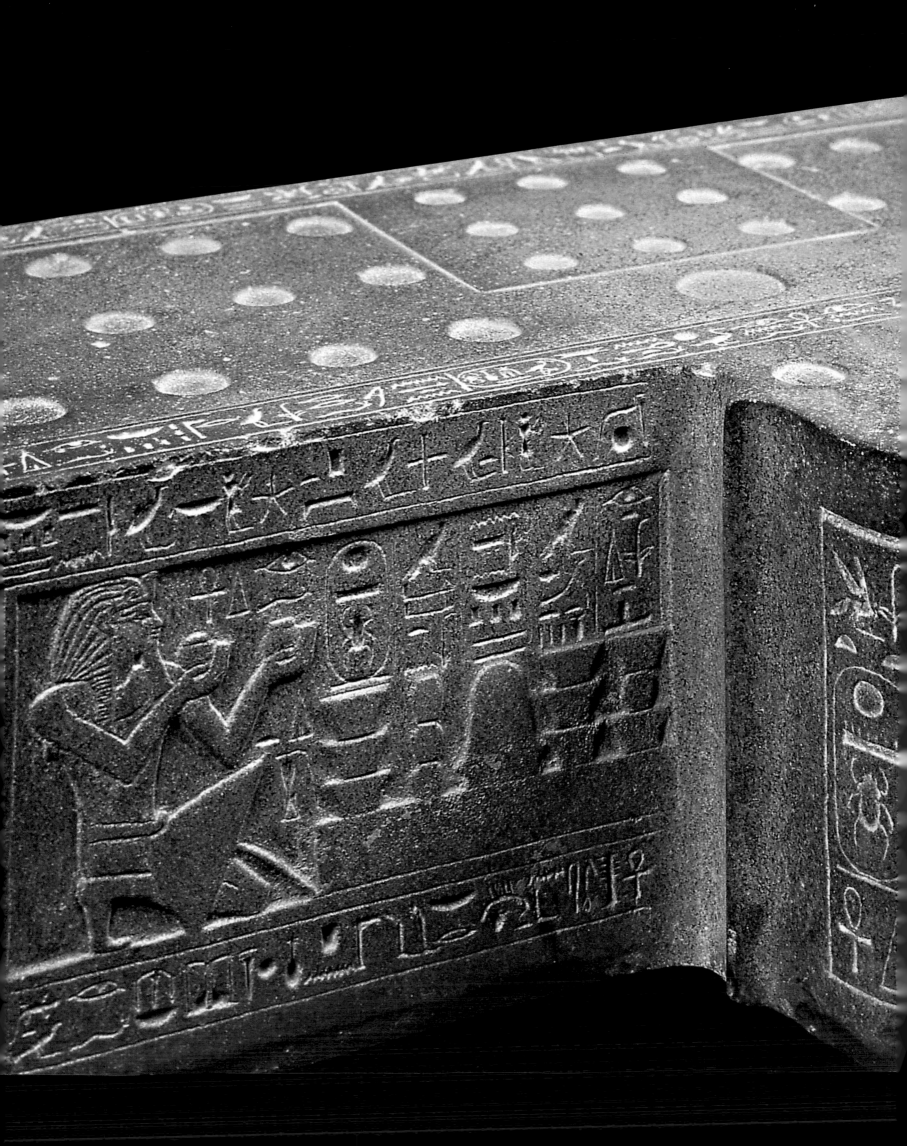

· Thutmose III is not only one of the greatest pharaohs of Egypt's ancient history, but he also belongs to its most glorious eras. Under this king many of the enduring concepts of Egypt's royal ideology as well as political and administrative systems came to be expressed on its monuments, thus giving us a better understanding of Egypt's daily life and beliefs and a better comprehension of the complexity and wealth of this ancient civilization.

Thutmose III was the fifth pharaoh of the Eighteenth Dynasty (fig. 1), the first dynasty of the New Kingdom (1550–1069 BCE), also known as the Empire. During more than fifteen centuries of recorded history, the Egyptian state had witnessed immense glory during the Old and Middle Kingdoms (2686–1650 BCE), economic depression during the First Intermediate Period (2160–2055 BCE), and despair and humiliation during the Hyksos occupation in the Second Intermediate Period (1650–1550 BCE). Now Egypt had finally recovered its spirit and hegemony. Recent experiences induced it to expand natural boundaries to protect itself and face the changing conditions and ascension to power of a number of neighbors on northeastern borders. This dramatic growth after the wars of liberation fought by the last kings of the Seventeenth Dynasty (c. 1580–1550 BCE) and the first kings of the Eighteenth (1550–1295 BCE), and resulting essentially from the exploits of Thutmose I, brought wealth home, opened new horizons, and prompted a renewed curiosity toward life in all its manifestations. It also demanded new developments in the administration of the country. Moreover, Thebes under Thutmose III was not only the religious center of the new empire but also the home of Amun-Re, king of the gods, under whose banner the wars were fought, and the city witnessed during the middle of

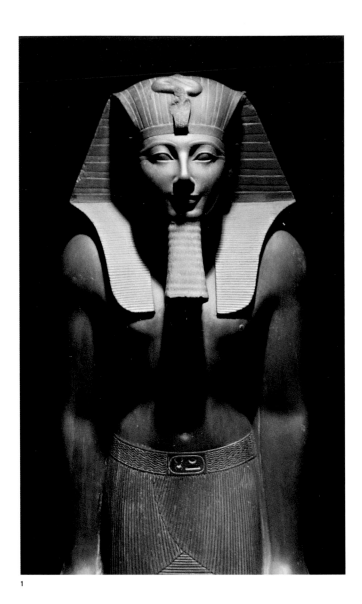

1

Having ascended to heaven, [Thutmose II] became united with the gods, and his son, being arisen in his place as king of the Two Lands, ruled upon the throne of his begetter, while his sister, the god's wife Hatshepsut, governed the land and the Two Lands were under her control; people worked for her, and Egypt bowed head.[1]

But somewhere before the seventh year of the king's rule, Hatshepsut assumed the full titulary of "King of Upper and Lower Egypt," and a co-regency was established, which lasted until near the twenty-second year of Thutmose III's rule, when Hatshepsut disappeared from the records and the scene was left entirely to the king. These two periods were extremely different, and it seems clear that Hatshepsut predominated during the co-regency, although there are references to Thutmose III on most of the official monuments. It also seems that the period of the co-regency affected the policies of the king during his autonomous rule.

Hatshepsut, King of Egypt

Already, as Thutmose II's wife and queen of Egypt, Hatshepsut must have had an important role as in ruling the country. Indeed, the female element in the ideology of kingship is prominent, since the royal couple is a reflection on earth of the primeval creative divinities. Their power of procreation is represented by their heir and the perpetration of kingship. The eminent political role of queens in periods of crisis is well documented in the history of Egypt after the end of the Middle Kingdom. During the wars of liberation at the end of the Seventeenth Dynasty, when kings were fighting on battlefields, the actual governing of the country was left to their wives. Tetisheri and Ahhotep, grandmother and mother of Ahmose I, the first king of the Eighteenth Dynasty, probably assumed important political roles, for their place on Ahmose's monuments is considerable.

Thus when Hatshepsut decided to become king of Egypt, the move was not without precedents. It only required some preparations. In her inscriptions in the temples of Karnak and Deir el-Bahari, she repeatedly

the second millennium BCE an unprecedented boom. Together with Thebes, the whole country was flourishing. This chapter endeavors to present the effervescence in all walks of life that informed this fascinating period.

Thutmose III ruled from about 1479 to 1425 BCE. He was the grandson of Thutmose I and son of Thutmose II and a lesser queen called Isis. He was still a young child when his father died, and his aunt and stepmother, Hatshepsut, daughter of Thutmose I and half-sister and wife of Thutmose II, ruled in his stead for a few years. The aged Ineni, the chief architect of Thutmose I and one of the most important officials under Thutmose II, described Thutmose III's accession to the throne:

8

mentions that her divine father Amun had indeed desired her to succeed her father. The god had designated her as his daughter and heiress to the throne through an oracle in the days of her father, Thutmose I, while they traveled to visit the gods in their sanctuaries and receive their blessings and the gift of life and power. According to an inscription concerning Hatshepsut's divine birth, Amun had even replaced Thutmose I in his union with Queen Ahmose to beget Hatshepsut. The images of this union of the god and the queen, her pregnancy, the birth of the princess, and her presentation to the god so he will recognize her, so exquisitely represented on the wall of one of the porticos of her temple at Deir el-Bahari, are the earliest scenes of theogamy that we have. They would be copied later in the temple of Luxor under Amenhotep III to symbolize his own divine birth and that of all the kings after him and to commemorate this essential characteristic of Egyptian kingship.

It is possible, therefore, that if Hatshepsut did not rule immediately after her father, it was because of the presence of a male successor whose sex better befitted the ideology of kingship (even though he was only the son of a secondary wife). Thus Hatshepsut, instead of ruling alone, was married to her half-brother, Thutmose II, who reigned briefly. But during his brief reign she is a prominent figure on his monuments and appears with him on official scenes. They begot Princess Nefrure, best known for her presence as a child on the beautiful statues of her tutor Senenmut (also her mother's chief steward and architect).

When Hatshepsut began to rule Egypt (c. 1473), the country was at the peak of its glory. Thutmose I's campaigns in Nubia and Syria had ensured the security and supremacy of Egypt, and wealth was flowing into the country from everywhere. There was no need for more campaigns in Asia because, as Hatshepsut says in her inscriptions, "The chiefs of Retenu were still under the fear of her father's time."[2] In the south, there are indications of expeditions to repress Kush, at the Third Cataract of the Nile in northern Sudan, which at some point had relations with the hated Hyksos themselves. To reach Punt, one of Hatshepsut's claims to glory, the expeditions must have crossed many regions that Dedwen, a Nubian

9

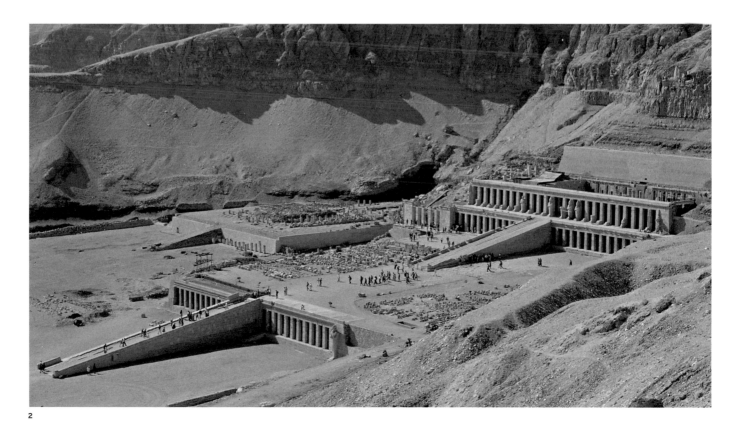

2

god, ceded to her under the name of "southern countries." Hatshepsut could therefore concentrate on her internal policies and building program in addition to the restoration of the sacred monuments of Egypt destroyed during the Hyksos domination and the liberation wars.

Hatshepsut's own building activities were many, particularly in Upper Egypt and Nubia. It is clear that she tried to link the New Kingdom with the Middle Kingdom as if to underline the continuity of the tradition and erase the Second Intermediate Period from the history of Egypt. Her temple at Deir el-Bahari is located near the Middle Kingdom Temple of Mentuhotep II and is certainly influenced by its architecture (fig. 2). Built in terraces against the mountain, with its sanctuary hewn into the rock, the temple, dedicated to Amun with additional chapels for Hathor and Anubis and an open court for Re-Horakhty, was also constructed for the celebration of Hatshepsut's own cult and that of her father, Thutmose I. In it, she also honors her Middle Kingdom ancestor Nebhetepre (Men-

tuhotep) and reinstates the ceremonies of "the Beautiful Festival of the Valley" established in the Middle Kingdom and apparently neglected in the Second Intermediate Period. During the festival, the god Amun of Karnak, accompanied by the reigning king, crossed the river to pay homage to the royal ancestors and visit them in their sanctuaries. This festival, to which the valley of Deir el-Bahari gave its name, continued to be celebrated until the Greco-Roman period in Egypt. In it, the link with the deified ancestors was established and annually renewed, thus legitimizing the reigning king's right to the throne. The festival developed through the ages and gradually became a commemoration of all the dead, private as well as royal (fig. 3), and after the onset of Christianity and even Islam some of its aspects remained part of the folklore of the country. Its echoes are still present in the traditional celebration of the dead performed today.

While Hatshepsut's temple architecture is inspired by its Middle Kingdom neighbor, the program of its decoration is newer to us, for in addition to the representation of "the festival of the valley" and "the divine conception and birth of the queen," the temple decoration also includes, next to traditional scenes, others typical of the reign of Hatshepsut. Her famous expedition to Punt, for example, is depicted in great detail. We see the Puntites in their habitat, with their houses built on pillars and their flora and fauna. The Egyptian expedition is welcomed by the chief of that land and by his enormous wife, too heavy to be carried by any donkey. The loading of the Egyptian fleet with gold and exotic products, including incense trees to be planted in the gardens of the god Amun in front of the terraces of Deir el-Bahari, is depicted on the wall of one of the porticos of the temple, while another shows the transportation of two obelisks by boat, all in a beautiful style reminiscent of the most splendid reliefs of the Middle Kingdom.

In addition to her memorial temple at Deir el-Bahari, Hatshepsut built extensively on the west of Thebes. Two tombs were made for her at different moments of her life, but it seems she essentially prepared one of those, tomb 20 in the Valley of the Kings, for her father, Thutmose I.

3

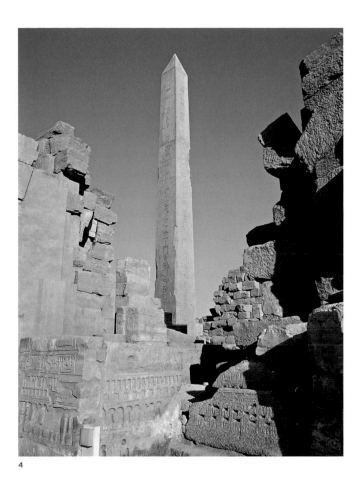

4

Indeed, the tomb contained two burials, and Hatshepsut had a stone sarcophagus, originally made for herself, enlarged to fit the taller body of her father. It is probable that the reappearance of stone sarcophagi for royal burials was another of the renewals and links with the Middle Kingdom that occurred under the queen. Certain scholars believe that she was the first pharaoh to have a tomb hewn in the Valley of the Kings.

Hatshepsut also began an exquisite little temple at Medinet Habu for the god Amun and the primeval ancestors of Amun. The temple played an important role in the rituals of the festival of the valley. Thutmose III completed it after the year when Hatshepsut disappeared from the records (regnal year 22). Later, other kings kept adding to it until the end of the Greco-Roman period.

In Karnak, Hatshepsut's program was just as ambitious and innovative. There she had a palace and erected several chapels in addition to two pairs of obelisks, one

of which, the one presumably east of the temple, has now disappeared. Of the other pair, erected between the Fourth and Fifth Pylons — in a columned court behind the temple entrance, one is still standing (fig. 4), dominating the temple from its height, while the other, now broken and lying in the vicinity of the sacred lake, presents to us a beautiful scene of the queen's coronation as pharaoh! Hatshepsut also built the Eighth Pylon to better mark the processional way to the temple of Luxor, south of Karnak. The Theban triad (Amun, Mut, and Khonsu) visited Luxor Temple on the festival of Opet, the other essential festival for kingship, celebrating the divine birth of the pharaoh and his link with the gods. A series of repository chapels for the barques of the gods to rest in on their way to Luxor was also established. One of these was reused by Ramesses II and is now standing inside the temple of Luxor.

But among the most beautiful and most important monuments for the history of the co-regency is the Red Chapel in Karnak on which she appears, together with Thutmose III, in many official ceremonies of their common reign. Hatshepsut disappears from the records around year 22 of Thutmose III. We do not know how her reign ended or when she actually died. The transition from the co-regency to Thutmose's autonomous rule seems to have happened without major signal events. Monuments begun by Hatshepsut under the co-regency were completed in Thutmose's name alone, and sometimes with architectural alterations. But Hatshepsut's "damnatio memoriae" does not seem to have started then. Many historians now believe that it instead happened in the second part of Thutmose's autonomous reign, and there is evidence that it continued until the middle of the reign of his son and successor, Amenhotep II. Hatshepsut's image was erased from all monuments and her name replaced by that of either Thutmose I, Thutmose II, or Thutmose III as if to make sure that the lineage was totally undisturbed. It has been argued, therefore, that the main reason for the annihilation of her memory was to ensure the legitimacy of the succession to Amenhotep II against any other branch of the family related to Hatshepsut, people who could have had some aspiration to the throne.

6 Scene of the vizier receiving the produce of Egypt for the king. Eighteenth Dynasty, reigns of Thutmose III and Amenhotep II, 1479–1400 BCE; painted plaster on limestone. Theban tomb no. 100 of the Vizier Rekhmire.

7 Thutmose III Festival Hall. Eighteenth Dynasty, 1479–1425 BCE; sandstone. Karnak Temple, Luxor. Built after the king returned from his first campaign into Asia.

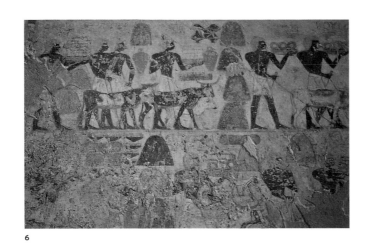

6

In the army itself, by then composed of professional permanent soldiers in all its arms, we begin to hear of "scribes of the army." Tjanen, for example, whose career began under Thutmose III whom he accompanied in his campaigns in the Levant, was overseer of the scribes of the army of the lord of the Two Lands (Upper and Lower Egypt). Hence he claims in his tomb that he was responsible for recording all the campaigns of the king.

Under Thutmose III we have for the first time, so far, a text that informs us fully on the duties of the most important official in Egypt, namely the vizier. The text is a welcome addition to studies based essentially on titles and prosopographies and gives us important clues on the administrative system of the country. The vizier reported directly to the king and coordinated with him both the administration of royal domains and the civil administration of the country. We know that more than one vizier could exercise the function at the same time, in different parts of Egypt. Under Thutmose III, there was a vizier in Thebes and another in Memphis, the northern administrative capital of Egypt since the beginning of history. In his magnificent tomb in the west of Thebes, the vizier Rekhmire recorded pharaoh's speech to him on the occasion of his appointment to the position and the king's constant stress on the importance of integrity and justice in all the vizier's dealings since he not only represents *maat* (justice, balance, right) but he also reflects the nature of his king and protects his reputation: "He is the copper that shields the gold of his master's house,"[10] and as the proverb says, "The king is mercy, but the vizier is control."

Rekhmire's tomb inscriptions and scenes combine elements of his private and professional life. As vizier and chief justice he gives audience to petitioners, imposes the laws and royal decrees, nominates and judges higher officials in case of misbehavior, supervises the cadastre and mining, receives foreign tribute from all over the empire, supervises building activities in the name of the king, and secures the pharaoh's security (fig. 6). His charges are indeed very heavy, but an army of officials and scribes, keeping the best archives possible in the ancient world, assists him. Other scenes necessary for his afterlife show, in addition to the sequences of the "opening of the mouth-ceremony," all the traditional scenes of funerals, offering bearers and banqueting on different religious occasions that we find in most tombs of western Thebes, though in various degrees of elaboration. Images of daily life are also recorded there, so that the study of this tomb alone could give us an almost complete account of Egyptian culture and society under Thutmose III.

It is not possible to enumerate here all the important officials of the reign whose tombs honeycomb the necropolis of western Thebes, in addition to those whose tombs were recently discovered in Memphis or elsewhere. But to give a better view of the complexity of Egyptian administration in the days of Thutmose III we cannot omit Menkheperre-seneb, the high priest of Amun-Re, whose duties toward the temple of Karnak necessitated the accumulation of treasures from various parts of the world, including costly Hittite and Syrian vessels and gold from the Egyptian eastern desert or from the land of Kush. Nor can we forget Amenemhab, Thutmose's companion in arms, in whose lively autobiography we read the most fascinating and amusing accounts concerning the pharaoh's battles as well as the mention of the exact date of the king's death.

At least two viziers of this reign, Ptahmose and Neferweben, have been recorded so far in the Memphite necropolis, in addition to a number of other high officials.

14

Menkheperre-seneb, for example, was overseer of foreign countries and chief of the Medjay (police) while Benermerut, the overseer of the two houses of silver and gold was also overseer of all works of the kings among other duties.

Building Program of Thutmose III

Thutmose's building activities probably surpassed most of the pharaohs. His monuments were everywhere in Egypt and Nubia, and there is evidence of Egyptian cult installations even in Asia, where in some places his name was fondly remembered many generations after his conquest. But unfortunately, of his building activities in the Nile Delta, little remains. Some structures were reused under later pharaohs or destroyed by humidity. We know about the existence of these monuments from contemporaneous accounts, such as Minmose, one of his overseers of works, or from titles of officials buried in Memphis. In addition to Benermerut who was "overseer of all works of the king," a certain Ameneminet, who was "chief of Memphis" and "general of the army" at the end of the Eighteenth Dynasty, was also "steward in the Temple of Thutmose III," a title that clearly indicates this king's presence in Memphis. This city, as already mentioned, was too important to be overlooked. It was not only the historical administrative center of Egypt but also a huge agglomeration not too far from the northeastern border, thus allowing proximity to events in Asia. Memphis was also the main center of worship of

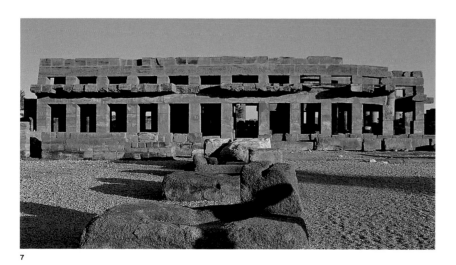

7

the god Ptah, one of the most important divinities of Egypt, and his temple was generously endowed with the pharaoh's bounty. The city's nearby harbor, Perunefer, was well known from the beginning of the Eighteenth Dynasty. In and around it many foreigners, coming to trade in Egypt, established themselves. It is well known that big cities in Egypt became quite cosmopolitan after the Eighteenth Dynasty expansion in Asia, as triumphant kings used to bring back prisoners as booty together with goods. A number were given as royal presents to the valiant generals who had captured them, but most went to crown properties or temple estates to express the king's piety and gratitude to his "fathers," the god protectors of Egypt under whose banners the battles were fought. Heliopolis, another great religious center of Egypt and perhaps the oldest, since it was the city of the sun god Re, was endowed by Thutmose III with a pylon and a temenos wall for its temple, in addition to the usual donation in grain, cattle, serfs and other riches to maintain life and production on the temple estates and better serve the god and provide for his offerings. Moreover, Thutmose erected at least two obelisks there. One is now on the Thames embankment in London; the other decorates Central Park in New York.

In Upper Egypt and Nubia, monuments have actually been found in many places, some in the form of additions to existing temples, some as distinct buildings. Akhmim, Atfih, Asyut, Medamud, Tod, Elkab, Edfu, and Elephantine are examples of such places. In Esna and Dendera, Thutmose's memory was still honored in the Greco-Roman period. In Nubia monuments in his name are already recorded from his regnal year 23, and between year 25 and 27 a fortress was built in his name farther south. From the later part of his reign monuments were erected everywhere down to the fourth cataract of the Nile. Amada, Ellesiya, Faras, Dakke, Argos, Doschai, Kubban, Semna, and Gebel Barkal are Nubian sites in Egypt and Sudan marked by his presence. But it is essentially through his monuments in Thebes that Thutmose III is best known (fig. 7).

15

The Akhmenu Monument and Temple of Karnak

Immediately after his return from his first campaign in
Asia, Thutmose III ordained the building of his famous
Akhmenu in the temple of Karnak. Situated behind
the sanctuaries of the east-west axis of the temple, the
Akhmenu is a complex monument, in architecture and
decoration. It seems to have gathered within its walls most
of the monarchical rites confirming both the legitimacy
of the kingship and its perpetuation. The temple was also
designated by the king himself as a "great temple of mil-
lions of years,"[11] built for his fathers, the kings of Upper
and Lower Egypt, in which their names would be estab-
lished with new statues and offerings in unprecedented
quantities. Indeed, in the Ancestors' Room, the king is rep-
resented making offerings to the statues of sixty-one kings
distributed in four registers. The most ancient one among
them is Snefru, father of Khufu and first king of the
Fourth Dynasty (2613–2589). There are names of kings of
the Old and Middle Kingdoms and of the Seventeenth
Dynasty — kings who ruled the whole of Egypt before the
New Kingdom and whose memory was respected and whose
legitimacy never disputed. Thus the link with the ancestors
was established and perpetrated through the ritual.

Related to that ritual was a series of chambers dedi-
cated to the god Sokar, a Memphite deity associated with
funerary rituals and festivals connecting with the ancestors
and ensuring resurrection ever since the Old Kingdom.
Because of his tie to monarchical rites of regeneration, this
god is also present in the "great temples of millions of
years" commonly known as "memorial/funeral temples"
on the west of Thebes. His presence in the Akhmenu thus
underscores the main purpose of that temple — to link
the reigning king with his royal and divine ancestors and
perpetrate and guarantee the regeneration of the royal
function. It is also because of this potential for life and
resurrection (dormant under his aspect of funerary god)
that Sokar has such an important place in the book of
Amduat, which ensures the resurrection of the deceased
king after his merging with the sun god in the afterlife.

Another important royal ritual depicted in this
temple is that of the Sed festival, commonly known as the
jubilee, during which the king's physical power and ability
to rule were reconfirmed. The ceremonies ended with the
gods renewing their mandate to the king and giving him
"eternity on the throne of Horus of the Living."

In addition to these rituals directly related to the
monarchy, the god Re was also present in the Akhmenu
in a solar chapel on the roof of the temple. Amun's secret
sanctuary could be reached via the famous botanical gar-
den on the walls of which Thutmose, for scientific or reli-
gious reasons, had represented all sorts of exotic flora and
fauna he had encountered during his campaigns abroad.

In the period between the erection of the Akhmenu
at the beginning of his autonomous rule and his annals
established in year 42, Thutmose III added many monu-
ments to the great temple of Karnak. These included a
new enclosure wall for the sacred area, a pair of obelisks,
one of which now decorates the city of Istanbul, two pylons
(the Sixth and Seventh), a kiosk between pylons seven
and eight, and ancestor shrines.

By the end of his fifty-four year reign, Thutmose
had also built a new central barque shrine for the temple
and had constructed an Eastern Temple, a contra-temple
to his Akhmenou, where a cult of the sun god Re-Horakhty
was enacted. He had built but never erected a single
obelisk meant to stand before this Eastern Temple. Thirty-
five years after his death, the king's grandson, Thutmose
IV, had this obelisk set up, after adding an inscription
telling how he had found it lying in the artisan's workshop.

In the west of Thebes, Thutmose completed what
was started during the co-regency, but sometimes replaced
the name of Hatshepsut with those of his father or grand-
father. His own memorial temple, Henket-Ankh (who
offers life), already in existence during the co-regency and
functioning from at least year 23, was much enlarged. Iron-
ically, it is almost totally destroyed today, and it seems
that it was already out of use by the end of the New King-
dom. Thutmose also erected a high temple to the glory
of Amun at Deir el-Bahari, next to but much smaller than
that of Hatshepsut and raised over it in height (fig. 8).
This one too is now mostly destroyed. The king had at least
three tombs dug in the Valley of the Kings: one for himself,

high up in the hill, apparently unfinished at the time of his death; one for his wife Merytre-Hatshepsut, mother of his son Amenhotep II, and one for his grandfather Thutmose I. He also completed his father's tomb and his memorial temple both situated north of Medinet Habu, at the other end of the Theban necropolis.

Art and Science under Thutmose III

Thutmose III's piety and concern with the afterlife manifested itself not only through his monuments to his ancestors and to the gods and their endowment with the spoils of his conquests, but also through his interest in religious texts. The Litany of Re, for example, well known from later royal tombs, is written on his very shroud, while the complete Amduat, already known from Thutmose I's tomb, fully unfolds on the walls of his burial chamber and of those of his vizier, Useramun.

Together with religious compositions ensuring his merging with Amun-Re, other literary forms developed under Thutmose III. Poetry is best illustrated by the text of the famous "Poetical Stele" with the rhetorical address of the god to the king. The alternation of narrative passages with inventories that we find in his Annals, or his damaged Youth Text, where the oracle of Amun selects him as king, are also new developments, although Hatshepsut's

oracle may have been slightly earlier. An ostracon of the same period develops a theme unknown to us before, with a text expressing "longing for Thebes" on one side, while the other carries a passage from an invocation to "Amun as Inundation." Written in a late form of classical Egyptian, this longing for a place could be a more timid precursor of the love poetry famous among Egyptian creations of the Ramesside period. It is still part of Egyptian culture to inquire discreetly about the beloved by asking about the place where he or she lives.

Thutmose's interest in the sciences was made clear by the importance he gave to the flora and fauna of the countries he visited and also by his concern for medicine and public welfare as evidenced by prescriptions of his time, preserved and followed throughout ancient Egypt's history.

Thutmose's royal wives are represented on a pillar of his tomb. Sitiah and Merytre-Hatshepsut were each "great royal wife" while Nebetta does not seem to have borne this title. Besides his heir Amenhotep II, we know of a certain eldest son of the king, Amenemhat, who may have died before his father, as he never ruled; a Thutmose and a Menkheperre are also attested. Merytre-Hatshepsut, the mother of Amenhotep II, gave Thutmose III a daughter as well. The king had many secondary wives, some probably from Asia. They are best known today for the wonderful jewelry they left behind.

Thutmose's reverence for his ancestors and care for his country were gratefully paid back. In addition to the celebration of his cult in his own memorial temples, we find him worshiped on scenes of private stelae either as himself or as a form of Amun, Min, or Thoth, both in Egypt and in Nubia. Menkheperre' the throne name of Thutmose III as king of Upper and Lower Egypt, became a sort of spell or amulet and was inscribed on scarabs not only in Egypt but also in the egyptianized Levant long after his death. His life and deeds became an important part of the Egyptian Senruset saga famous in the Greco-Roman period, woven around and combining in one, the great pharaohs of ancient Egypt.

Amenhotep II

Amenhotep II ruled Egypt (1427–1400 BCE) for about thirty years after his father and followed the same firm policy in the Levant. Even as a youth he had been famous for his physical strength and love of martial arts. His great stele erected near the sphinx in Giza describes him as one "who had no equal on the battlefield"; "who knew horses and cavalry so that he didn't have his equal in his numerous army"; "there was no one who could draw his arc or surpass him at running"; "his arms were vigorous and indefatigable when he held the rudder to direct his barge."[12] And indeed, one of his most famous reliefs depicts him shooting arrows through a series of copper targets while driving his chariot full speed with the reins attached around his waist (fig. 9). This image of the king was so popular and so descriptive of his personality that we find it again on scarabs in the Levant. Some art historians even think might have been, together with similar representations of war divinities, a model for certain scenes in Greek mythology. No wonder then if, when in year 7 he had to face a coalition of unaligned chiefs in the region

of Takhsy, he defeated them and brought seven of them bound, head-down, on the royal barge back to Egypt. The hanging of six of them in Thebes is depicted on the walls of his temple; the seventh was taken all the way down to Napata in Upper Nubia to display the might of Egypt and her young king. A second campaign in year 9 seems to have been sufficient to establish a lasting peace under the supremacy of Egypt so that the king could benefit from its economic rewards and concentrate on his building program inside the country. Among his many great and perhaps one of his most innovative monuments is the temple he built for the Sphinx at Giza, who had been identified in the New Kingdom with the god Horus in his form of Horemakhet, or "Horus in the Horizon," the whole site of the pyramids having become a place of pilgrimage for the worship of royal ancestors.

Thutmose IV

Thutmose IV's rule was short and peaceful (1400–1390 BCE). He is remembered mainly for the "dream stele," which he set between the paws of the Sphinx; for the beautiful art of this period, which we can admire in the private tombs of his high officials and courtiers; those of his father, and for gradually demilitarizing his court and the civil administration of the country. Thus we rarely find the title of general among his courtiers. The dream stele tells us how the Sphinx selected him, presumably among other royal princes, as his own son, to become his heir upon the throne of Egypt (fig. 10):

One of these days it happened that prince Thutmose came traveling at the time of midday. He rested in the shadow of this great god. [Sleep and] dream [took possession of him] at the moment the sun was at zenith. Then he found the majesty of this great god speaking to him from his own mouth like a father speaks to his son and saying: "Look at me, observe me my son Thutmose:

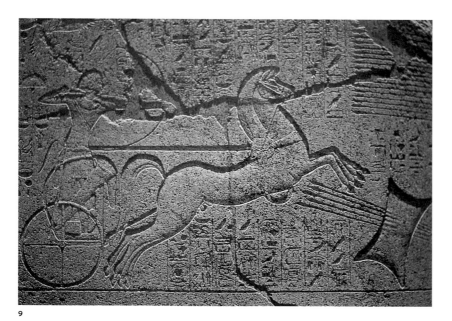

9

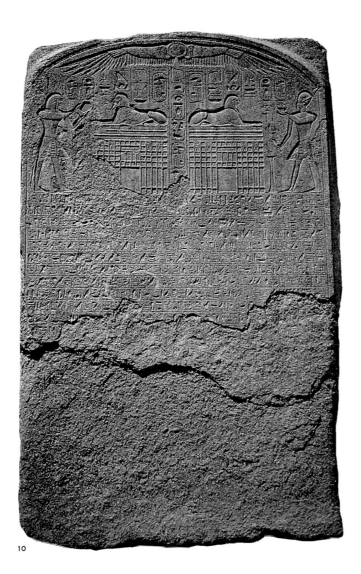

10

I am your father Horemakhet-Khepri-Re-Atum. I shall give to you the kingship [upon the land before the living]...The sand of the desert upon which I used to be, [now] confronts me; it is in order to cause that you do what is in my heart that I have waited, for you are my son, my protector. Look, I am with you. It is I who guide you.[13]

Thus this stele not only gives us an account of Thutmose's designation as king by the god, but also informs us about, presumably, the Sphinx's first clearance from the sands of the desert.

Amenhotep III

After Thutmose III the towering figure of the dynasty must be seen in his great grandson Amenhotep III (1390 – 1352). During nearly thirty-nine years under his rule, Egypt enjoyed peace and affluence, and the peak of prestige both in Nubia and in the Levant. Amenhotep III and his era were dazzling. Internationally, it was sufficient to conduct relations through diplomatic missions, not only with Asia Minor, but also with Greece and the Aegean islands. His prestige manifested itself in royal monuments unprecedented thus far, and in the number of private tombs and in the wealth and refinement of their decoration and funerary accoutrements. The reliefs in the tombs of Ramose, Khaemhat, or Kheruef would alone suffice to illustrate the sophistication of social life and the arts. Amenhotep, son of Hapu one of the king's most famous courtiers, was in charge of the completion of some of his most glorious monuments. He was allowed to have his own memorial temple overlooking that of his king. Because of Amenhotep, son of Hapu's great knowledge and wisdom, his people later deified him. Tombs of other great officials of this period were found in many places in Egypt.

The Colossi of Memnon that now dominate the plain in western Thebes were cult statues of the king protecting Amenhotep III's First Pylon at his memorial temple. Literary texts abound that describe the beauty of this temple, now totally destroyed, as well as the splendor of "the gleaming Aten," his palace in Malkata south of his temple. His monuments in Karnak and Luxor are equally magnificent and particularly innovative. In Luxor he reshaped the temple to underline its specific purpose — regenerate the royal *ka* through the rites performed during the Opet festival, when Amun of Karnak came to Luxor in his form of Kamutef, the fecundity god, accompanied by his consort Mut and their child Khonsu and the king himself, to reenact the latter's divine birth to regenerate his divinity and reassert his right to kingship as the legitimate heir to the god.

19

The monuments of Amenhotep III are too numerous to discuss here, but we should mention that in Memphis, the first known Apis-bull burial in the Serapeum dates to his reign. His building activities in Nubia indicate that his own deification is beyond doubt, as is that of his great wife, Queen Tiye, who not only appears with him in scenes of his jubilee on the wall of his temple in Soleb but who is also deified in her own temple nearby, at Sedeinga, as the sun god's counterpart. The deification of Amenhotep III and Queen Tiye became a model to be emulated later by the next outstanding pharaoh, Ramesses the Great, but it also paved the way to his own son Amenhotep IV's religious reform, which brought about the collapse of his dynasty.

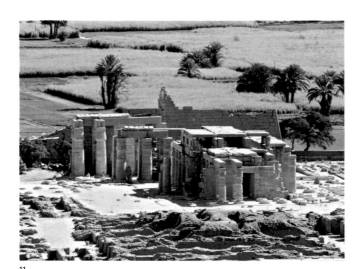

11

12

Ramesses II

Ramesses II's figure dominated the Nineteenth Dynasty (1295–1186), not only because he ruled for about sixty-seven years (1279–1213 BCE) but also because of the number and magnificence of his monuments and his policy inside Egypt and abroad. On the international scene he had to deal with a changing world and face the Hittites who, newly risen to power in Anatolia, were challenging Egypt's supremacy in the Levant. Ramesses waged a series of wars against them, the most important being that of regnal year 5, which ended in stalemate after the famous battle of Kadesh. The battle, however, was publicized as a feat of the king's personal valor and recounted on the walls of no less than five of his temples (fig. 11). The international political scene nevertheless remained highly unstable, and conflicts between the Hittites and their Assyrian neighbors induced the Hittites into peace negotiations with Egypt. A formal treaty was signed in year 21.

With peace on the eastern front, Ramesses II could concentrate on his western borders and build a whole series of fortifications to ward off Libyan invaders. In the south, generals of his army who kept peace and ensured prosperity occupied the position of King's Son of Kush. They also supervised his vast building program in lower Nubia, where rock-cut temples bear witness to his grandeur and the genius of his architects (fig. 12). His deification and that of his great wife, Nefertari, are particularly evident at Abu Simbel, where Ramesses is offering to his own deified self on the façade of the great temple, while Nefertari is clearly identified with Hathor in the small one.

Ramesses' monuments appear everywhere in Egypt. In addition to his own memorial temples, where his colossal statues received a special cult, both official and popular, he enlarged those of the gods under whose banners he fought. His presence is particularly strong in Luxor, where his pylon, courtyard, and colonnade are now essential features of the temple. In Karnak he completed the magnificent hypostyle hall that his father, Seti I, had started as a "temple of millions of years," like the Akhmenu of Thutmose III or the memorial temples of the west of Thebes.

Although many of his monuments in the north of Egypt have been dismantled and reused, Memphis still holds a number of his great colossi, one of which was moved to Cairo to decorate the central station square soon after the 1952 revolution.

Ramesses II's building program included the appropriation of many monuments, presumably as a sort of reconsecration, after restoring them. Thus we find his cartouches on statues originally belonging to Amenhotep III or to the great kings of the Middle Kingdom, whom Ramesses admired and wanted to emulate.

Among Ramesses' most extraordinary building activities is Pi-Ramessu, his residential capital in the western delta where his family originated. This city, which was started by his father Seti I as an extension of Avaris, the old Hyksos' headquarters, is, in fact, the Ramesses of biblical tradition, where the people of Moses were said to have worked and out of which their Exodus started. Its beauty and wealth are described in many literary texts of the period. It is said, among other things, that Pi-Ramesses was so vast that the sun rose and set within its boundaries.

During his long life the king had numerous wives and many children; his sons were often represented on his monuments, as young generals of his army. Because of his longevity, many of them predeceased him, and it seems that they were buried in a monumental tomb in the Valley of the Kings, opposite that of their father. Among his sons, two are to be noted: Khaemwaset, the high priest of Ptah in Memphis who enjoyed restoring the monuments of his ancestors and who became a hero of later tales, and Merenptah, his thirteenth son and successor to the throne of Egypt who, like his father, had to face the changing balance of power on the international scene and fight the Libyans and Sea Peoples who had recently appeared and gradually controlled most of the eastern Mediterranean countries.

After Merenptah the dynasty ended in relative chaos due to further foreign pressures in the north, east, and west, and it took some time for the country to reorganize itself under Setnakht, the first king of the Twentieth Dynasty. But it is really his son, Ramesses III (1184–1153 BCE), who protected Egypt from the Libyans' intrusions in the western Delta and from the Sea Peoples, whom he destroyed in year 8 in a major land and sea battle represented in great detail on the walls of his memorial temple at Medinet Habu (fig. 13).

In spite of these military successes, the situation in Egypt was clearly declining. The state treasury, affected by huge donations to the temples and by all the military expenses, had problems paying workmen. Demonstrations against authority and organized strikes were reported for the first time in the history of Egypt. In the palace harem a conspiracy on the king's life was fomented. Although the criminals were discovered and mostly forced to commit suicide, it is not clear whether the king survived the plot. But we do know that his crown prince Ramesses IV eventually succeeded Ramesses III.

After Ramesses III, Egypt lost her provinces in the Levant and turmoil continued on the international scene. Internally, his successors could not stop the degradation. It continued until it brought about the collapse of the once-glorious New Kingdom.

If royal monuments and officials' private tombs give us a fairly good view of ancient Egypt's ruling class, we still have very little material data on the working classes, and ethno-archaeological research can be useful in

this respect. The only group of people whose history is fairly well documented is the one directly connected with the royal building projects. In western Thebes, a village was built for them in a desert valley between the Valley of the Kings and that of the queens. From there, they could also easily access the royal memorial temples on which they would be working. The village housed families of architects, draftsmen, sculptors, painters, and highly specialized craftsmen entrusted with the digging and decoration of the royal tomb. They were organized in two gangs, and each one with its foreman lived on one side of the main road of the village. The sizes of the houses varied according to the status of their owner, but on average they had four rooms—two main ones in the front, followed by a kitchen and a storeroom—on a surface of about seventy-five square meters. A stairway ran to the multipurposed roof, where the family could enjoy open air and socialize with neighbors. Because the village was away from the cultivated valley and water sources, the state provided the villagers with most of their needs, even domestic help. Wealthy residents who had their own plots of land outside the village could be provided with more luxurious commodities.

A small group of temples was built to the north of the village, and the villagers' tombs were hewn in the hills surrounding it. The funerary equipment of the tombs, their decoration, and the texts that the deceased wished to have with them in the afterlife give us a fairly complete view of their standards of life and beliefs. Although we know of no collective worship in a temple, personal piety is expressed in hymns to the gods written in their tombs or in more personalized ones inscribed on stelae and deposited in temples as votive monuments. These, often written in response to a particular experience or in moments of great need, are particularly moving. A passage of one of them reads as follows:

You are Amun, the Lord of the silent,
Who comes at the voice of the poor;
When I call to you in my distress,
You come to rescue me,
To give breath to him who is wretched,
To rescue me from bondage.[14]

Personal piety is also expressed through ancestor worship, which, so typically in ancient Egyptian culture, linked the world of the living with the other life and, somehow, ensured resurrection. A little shrine with a dedication or an ancestor's bust was fixed for this purpose on the wall, in the main hall of the house. The dead were also honored in their tombs and remembered on the many official religious festivals throughout the year.

If we know little about ordinary craftsmen, we know even less about peasantry in general. Houses and graves have completely disappeared. Satirical texts in literature mention them with disrespect rather than pity and consider that they are the most miserable, overtaxed, and overworked class of the population. Yet, officials always boast in their autobiographies of their kindness and fairness to their dependents, in accordance with the principles of ethics that will ensure the survival of their souls. Moreover, the New Kingdom version of the Loyalist Teaching insists on the dependence of the upper classes on their subordinates and on the importance of their labor. Thus we read:

Provide for men, gather people together, that you may secure [?] servants who are active. It is men who create that which exists; one lives on what comes from their hands. They are lacking, and poverty prevails.

One longs for the Inundation—one profits by it; [but] there is no ploughed field which exists by itself....Do not make the laborer wretched with taxes; enrich him and he will be there for you the next year....He who appoints the taxes in proportion to the corn, he is a [just] man in the eyes of God[15]

Such statements, written in the fifteenth century BCE, are also manifestations of the glory of the New Kingdom.

22

Translations are by Fayza Haikal, but see also sources referenced.

1. James Henry Breasted, *Ancient Records of Egypt.* Vol. 2, *The Eighteenth Dynasty* (London, 1988), 142, §341.

2. Ibid., 91, §225.

3. Ibid., 180, §420, and Miriam Lichtheim, *Ancient Egyptian Literature.* Vol. 2, *The New Kingdom* (Berkeley/Los Angeles, 1976), 30.

4. Lichtheim, *New Kingdom,* 30.

5. Ibid., 32.

6. Ibid., 33.

7. Breasted, *Eighteenth Dynasty,* 202.

8. Henri Stierlin, *The Gold of the Pharaohs.* English ed. (Verona, 1997), 121–22.

9. Papyrus Harris 500, Papyrus British Museum 10060.

10. Breasted, *Eighteenth Dynasty,* 268–69, §666.

11. Ibid., 240, §604.

12. Lichtheim, *New Kingdom,* 41.

13. Betsy M. Bryan, *The Reign of Thutmose IV* (Baltimore, 1991), 146.

14. Lichtheim, *New Kingdom,* 105.

15. Richard B. Parkinson, *Voices from Ancient Egypt: An Anthology of Middle Kingdom Writings* (Norman, Oklahoma, 1991), 71.

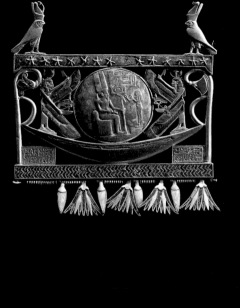

Exploring the Beyond

Erik Hornung

Translated by David Roscoe

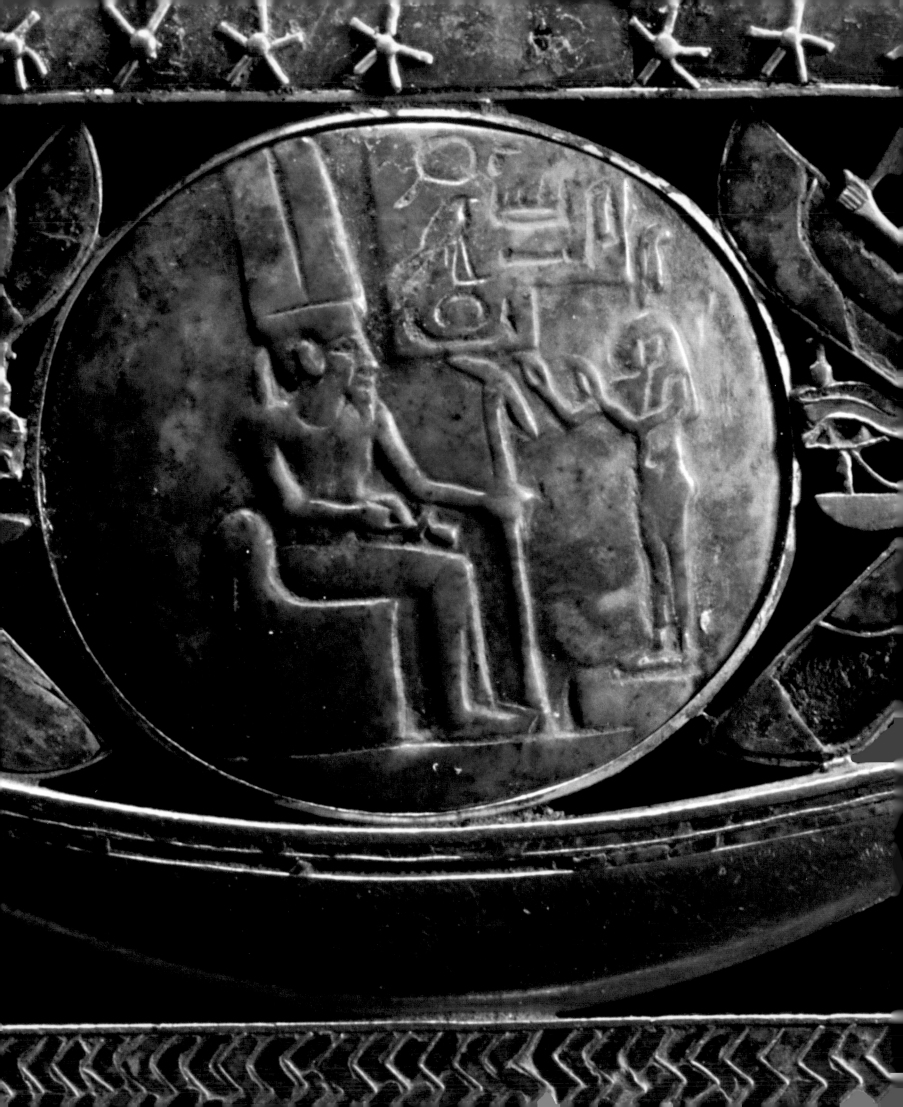

• Early on, the Egyptian turned his gaze to where the sun sinks every evening and tried to follow the celestial bodies in their nocturnal—to us invisible—path, in order to fathom the secret of their constant renewal: for every morning the sun appears, rejuvenated and refreshed on the eastern horizon, and repeats the creation of the world. In so doing, it conveys some sense of the forces of renewal beyond the grave.

Even in the Pyramid Texts, the oldest collection of religious spells that we know (around 2350 BCE), there are early descriptions of the Beyond, at the time still thought to be in heaven (fig. 1). The deceased pharaoh resorted to a number of aids to attain the desired goal among the stars that never set; his ascent to heaven, for which he used every means at his disposal, is a central theme of these spells. A particular destination in the Beyond is the Field of Reeds, a place of paradise where all the wishes of the deceased would be fulfilled. But there are also dangers in the forms of serpents, scorpions, and threatening sentries at the gate. This is why these texts contain not just hymns and rituals but also magic spells to ward off dangers. Osiris appears as the ruler of the dark netherworld, but the deceased would rather accompany the sun god in his barque to enter into the cycle of perpetual renewal.

After 2000 BCE the Pyramid Texts were replaced by the Coffin Texts, in which the world beyond death is depicted even more extensively. The ascent to heaven still played a role but now the gaze was turned more toward the depths of the netherworld, and the west definitely became the kingdom of the dead. A series of spells known as the Book of the Two Ways provided the deceased with information on how to bypass sentries and

sun is drawn through the netherworld in its own barque and turned to confront the observer, which is very rare in Egyptian art. This is intended to illustrate the fact that only now, beyond death, is it possible for there to be a "face-to-face" meeting with the gods, as expressed in the Harper's Songs (religious songs). Even more, the deceased is "indistinguishable" from a god, and in many scenes in the netherworld it remains unclear whether the figures are meant to be gods or the dead.

This godlike existence is only reserved for the blessed dead who have abided by the principles of *maat* and have proved their honesty in the Judgment of the Dead. On the orders of the sun god their every wish is granted; it states explicitly that they live on what the gods live on. This is symbolized most impressively in the scene with the Tree Goddess, first seen on one of the pillars in the burial chamber of Thutmose III, and later in many other tombs and in Book of the Dead papyri. A personified tree offers the deceased her breast or provides him with food and refreshing water (fig. 2). In addition to food, the blessed dead also receive air to breathe and clothing, and the sun's rays dispel the darkness around them.

Their reaction is rejoicing, which greets the god wherever he appears. All the inhabitants of the Beyond are united in this rejoicing, which gives way to general lamentation as the god moves on. Solar baboons have a special place among those rejoicing. They beat their breasts with their fists and call out in a secret language comprehensible only to the sun god; since Akhenaten (Amenhotep IV), the pharaoh has himself been represented in the company of these baboons as evidence that he belongs to the solar sphere.

In contrast to the rejoicing and to the care and attention bestowed on the blessed dead is the sad fate befalling the "fiends," condemned by the Judgment of the Dead because their evil deeds outweigh their good ones. They are punished in many different ways and this, too, like the provision for the blessed dead, is carried out on the "orders" of the sun god. In some places it is Horus, who blames the fiends for the murder of his father Osiris and punishes them. With their arms bound, they await

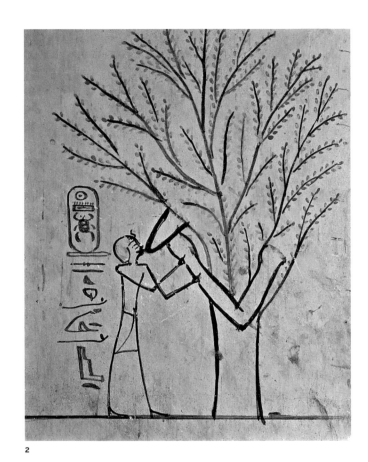

2

their extermination, which often comes about through the fiery breath of serpents. The individual components of their personality are also destroyed, in order to prevent them from being united, thus permitting a return to life.

This takes place in the ominous Place of Destruction (Hetemyt), situated in the very depths of the netherworld and representing the Egyptian hell "from which there is no escape." It is a place remote from the gods and a place of privation and also one of active punishment by painful torture. In the midst of the darkness there burns a purifying fire, consuming and transforming everything, and relighting the Light of the World every day. All the guilt that has accumulated is devoured by the purifying flame. This is where being transforms into non-being but gives rise to a new being. Time is also brought into this general recycling, whose hours are annihilated but return transformed.

Only in the royal Books of the Netherworld is this abyss of the world, this punishment and destruction of the

fiends, so graphically described, because only the pharaoh is equal to the view of this horror and can stand up to it. The spells of the popular Book of the Dead love to depict the joys of paradise and also set out to protect against dangers, but they avoid looking into the depths of hell and describing the process of destruction.

The worst "fiend" of all is Apophis, who often appears as a gigantic coiled serpent. He constantly attempts to bring the course of the sun to a standstill and with it the process of renewal and rejuvenation. The Book of Gates reinforces the impression of his omnipresence when describing its conquest in several nocturnal hours, whereas the struggle in the Amduat is concentrated on the seventh hour; this is immediately after the incipient renewal of light and life by the union of the sun-*ba* with its corpse, a particularly risky moment. By sucking noisily on the netherworld Nile, Apophis has created a sandbank on which the sun barque is supposed to run aground. But he is rendered lame by magic force, and in the Book of the Dead (Chapter 108) Seth thrusts his spear into the snake's body and forces him to regurgitate all he has swallowed, so that the barque can continue on its way.

The Book of Gates

Following the guidelines set down in the Amduat is a more recent composition known under the modern name of "Book of Gates." Here, the nocturnal journey is still divided into twelve hours, but each hour is separated from the next one by a large and well-guarded gate. Between the fifth and the sixth hour and at the end of the book, two special picture motifs have been inserted that show the Judgment of the Dead and the daily course of the sun. As in the Amduat, the sun's mode of transport is a barque, but there are only two escorts for the sun god, the creative forces Heka (Magic) and Sia (Mind). There are many other things that are simplified compared with the Amduat: the large number of divine beings are reduced to groups that can easily be counted; the individual names are not so important, and even the names of the nocturnal hours have been omitted. Nevertheless, the intent here is also to

convey knowledge about the Beyond and thus, above all, to ensure material welfare beyond death.

Alongside motifs familiar from the Amduat, one encounters a series of new motifs, such as the differentiation between the inhabitants of the Beyond into the four races of Egyptians, Nubians, Asians, and Libyans. Of particular interest in this book is the coming and going of time; time appears as a multicoiled serpent, out of whose body the individual hours are "born" and "devoured" again, or as an endless double-coiled rope that is unwound from the gorge of a divine being. The life span also allocated to the dead from this supply of time is made relative in the Beyond. One hour of the nocturnal journey corresponds to a full life span on earth.

In several scenes, the conquest of the sun's enemy Apophis is treated, and the two final hours depict in great detail the preparations for the daily sunrise, which is heralded by the baboons. The complex final scene offers a glimpse of all three dimensions of the world beyond: the depths of the primeval water Nun, on whose arms the sun barque reposes; and the depths of the earth and the depths of heaven, embodied by the goddess Nut.

The Book of Caverns

In the Book of Caverns, which came into being later and has been documented since Merenptah (c. 1213 BCE), the division into nocturnal hours is abandoned, and the sun god is only shown in the final scene in his barque. In the other scenes, his presence is indicated by a red sun disk, and it is significant that wherever fiends are being punished, the sun disk and hence the presence of the god is absent. The destruction of the fiends is depicted in greater detail and on each occasion is carried out in the lowest register, in other words, in the uttermost depths, where the rays of the nocturnal sun can never penetrate. Indeed, even the cauldrons are shown in which are cast the damned, their souls, shadows, and hearts. A picture from Egypt's Roman Period (30 BCE – 395 CE) links this cauldron directly with the Judgment of the Dead.

In the first two sections, the sun god addresses the gods of the realm of the dead in lengthy monologues,

31

and in the third section, the corpse of Osiris in his "chest." The inexhaustible care and attention of the sun god is dedicated to him, the "Greatest of the Non-Beings" and his retinue of blessed dead. The numerous caverns or vaults where the dead stay have led to the modern name of the book, and in the pictures the many ovals can be seen which are to be understood as sarcophagi. Inside them lie the deceased in their sleep of death, from which they are aroused to new life by the call of the god. Here, too, at the end, a final picture traces the whole course of the sun.

3

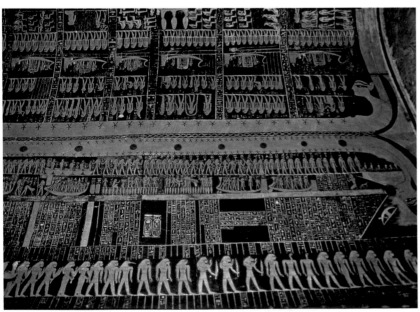

4

The Book of the Earth

The last great composition, recorded above all in the burial chamber of Ramesses VI, is the Book of the Earth (fig. 3), in which the deities of the depths of the earth play an outstanding role, and yet the nightly rebirth of the sun is also depicted in these depths of the earth. It is raised up by numerous pairs of arms, out of the depths in which the fiends are punished and destroyed, and thus it is saved from falling.

The daily and nightly course of the sun above the sky is illustrated on the ceiling of the royal tombs in the Twentieth Dynasty (1186–1069 BCE), from Ramesses IV on in a series of pictures that can be called the Books of Heaven. There, under a different aspect, the Beyond is placed in the womb of Nut, the goddess of heaven, who devours the sun every evening and gives birth to it again every morning (fig. 4). Between the two, the sun wanders through the womb of the goddess and comes across the same regions of the Beyond as in the Books of the Netherworld. Even the primeval ocean Nun flows around the womb of the goddess, whose long, naked body forms the framework for these compositions. The hope of rebirth that she embodies is also established in the decoration of the coffins and the sarcophagi. On the inside of the sarcophagus lid of Thutmose III can be seen a picture of the goddess protecting the dead; thus pictorial form is given to the ancient wish of the dead, documented as far back as the Pyramid Texts, to be taken up among the stars into the womb of Nut.

The Book of the Celestial Cow

Another of the Books of Heaven is the Book of the Celestial Cow, which makes its first appearance on one of the gilded shrines of Tutankhamun. In the center is a picture of the sky as a cow, supported by Shu and other gods; on the stomach of this celestial cow the sun, moon, and stars pass along. The relevant text, which sets out to explain the present imperfect state of the world, contains at the beginning the well-known myth of the "Destruction of Humanity," the Egyptian version of the story of the Flood. What is significant is the fact that the punishment is not inflicted by flood but by fire, because the annual flooding

32

of the Nile is regarded as a blessing, guaranteeing recurring fertility.

After paradisiacal primeval times, in which the gods and people lived side by side on earth and when it was always daytime because of the permanent presence of the sun, the people became incensed about the sun god Re, who had grown old. Re holds discussions with the other gods and then sends the goddess Hathor as his "eye" (uraeus serpent) to punish the rebels. Some are destroyed by fire, but the rest are saved, since Re himself takes pity on them and has the goddess deceived by giving her beer dyed red with ocher. Hathor is so enraged that she drinks the blood, becomes drunk, and loses her desire to destroy humanity. After this episode, Re refurbishes heaven and the netherworld and leaves earth on the back of the celestial cow. From now on, the gods dwell in heaven and in the netherworld; human beings remain on earth and can only have a sense of the presence of the gods in the cult images of the temples.

The Book of the Dead
Still the most famous text of afterlife, the Egyptian Book of the Dead (with the original title "Book of the Going Forth by Day") replaces the older corpus of Coffin Texts and has usually come down to us on papyrus; it does not boast the exclusiveness of the Books of the Netherworld but was available to both kings and government officials. The main concern here is practical assistance for the deceased, his burial, his protection, and his welfare, rather than a description of the Beyond, and yet the right knowledge also plays a decisive role. In several spells, the deceased is interrogated by divine beings from the Beyond, to whom he has to provide evidence of his knowledge. These are above all the guardians of the gates, but also the ferryman who is to take the deceased across; part of the examination tests the deceased about parts of the ferry or of the Judgment Hall.

A very special part of the examination is the notion of the Judgment of the Dead, in which the heart of the deceased is weighed against a symbol of the *maat*, the right and proper world order, to provide evidence of his good behavior on earth; Thoth, the god of wisdom, notes the

result and the monster Devourer of the Dead embodies the jaws of hell, which devour the condemned who do not live up to *maat*. By means of the "negative confession," which the deceased recites before Osiris and the 42 Judges of the Dead, he purges himself of all his transgressions; knowledge and purity enable him to enter the world of the gods. We have already mentioned the scene in the Book of the Gates in which the dead are allowed to look on the face of the sun, and the promise that he who gazes on Osiris cannot die. In the Book of the Dead, the deceased, in the face of the Gods, calls out again and again: "I am one of you."

The Tomb of a Pharaoh

The tomb of a pharaoh has always had a special place among tombs, both in size and in the abundance of the funeral equipment, as well as its favored location and the wealth of decoration. The oldest known royal tombs are in Abydos and date back to the end of the fourth millennium BCE. They consist of excavated chambers over which a flat tumulus curves; their monumental form ultimately led to the pyramid. The place for the funerary cult is marked by a stele with the name of the king; the discovery of writing made it possible to lift the deceased from the anonymity of prehistory and preserve his name beyond death.

In addition to their tombs in Abydos, the kings of the First Dynasty (c. 3000 BCE) had a secondary tomb in Sakkara, the necropolis of the new residence in Memphis. This duplication of the tomb now became another royal privilege, manifested in different ways; with the pyramids there was a second small pyramid, and later, in the New Kingdom there were two largely symmetrical halves to the one tomb.

The beginning of the Old Kingdom also signifies the beginning of the "Age of Pyramids," in which the royal tomb takes on this form — in the Third Dynasty as step pyramids and after the Fourth Dynasty as "genuine" pyramids. The oldest pyramids are also the first monumental stone buildings in history. The Egyptians regarded stone

5 Detail, the second hour of the Book of Gates from the tomb of Horemheb. Eighteenth Dynasty, 1323–1295 BCE; painted limestone. Valley of the Kings tomb no. KV 57.

6 The goddess Maat; detail from the tomb of Siptah, Nineteenth Dynasty, 1295–1186 BCE; painted limestone. Valley of the Kings. KV 47.

7 Detail, scene of the Opening of the Mouth ritual for statues of the king from the tomb of Seti I. Nineteenth Dynasty, 1294–1279 BCE; painted limestone. Valley of the Kings tomb no. KV 17.

36

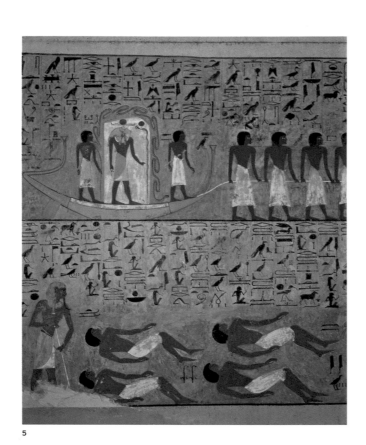

5

7

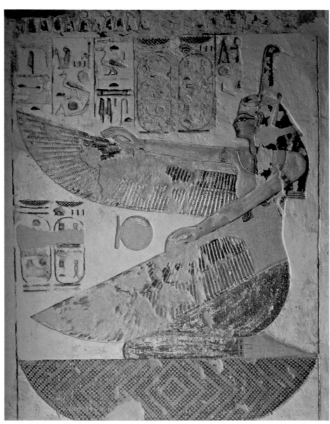

6

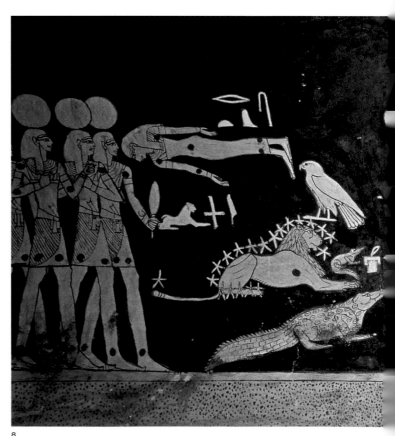

8

it enables us to study closely the working methods of the artists, from the first dividing up of the wall and the outlines of the figures right up to the finished product of the painted relief, which is of outstanding quality in this tomb.

Horemheb included some additional deities in his decoration, such as Horus "son of Isis"; his mother Isis; and the Memphite gods Ptah and Nefertem. The goddess Maat (fig. 6) receives him at the entrance of the burial chamber; in later tombs she appears in the passages between the rooms, and after Ramesses II appears already at the entrance of the tomb. Thus she provides the comforting certainty that the correct and harmonious order of things—known as *maat* in Egyptian—will also be preserved in the Beyond.

Initially Seti I continued the practice of decorating only the most important rooms in the tomb, but later he decided to extend the painted reliefs to the whole tomb, from the entrance to the rear wall of the burial chamber, a length of more than 100 meters (328 feet); in just two unfinished rooms he contented himself with the outlines

of figures and texts. The tomb consists of two halves, both ending with a pillared hall and their side rooms, and connected also in other ways; here the old idea of the duplicated royal tomb has been taken up again but in a different form. The axis of the two halves is shifted slightly but still runs straight, as was the case with Horemheb. The background colors used only in this tomb so differentiated, are white, blue, and yellow, with yellow being reserved for the burial chamber and intended to represent gold.

The larger area thus created allows for a much more lavish use of images. The fourteen decorated pillars alone provide space for fifty-six divine scenes (in contrast to the one scene with the Tree Goddess with Thutmose III), and the walls are now covered with a number of religious books, including ritual texts such as the so-called Opening of the Mouth (fig. 7). Even in the painting of the ceilings there are differentiations: in the first corridor there are protective winged creatures (vultures and serpents), as is common above the axis of temples; in other rooms there are star-studded skies; and above the sarcophagus itself, an astronomical ceiling with planets and constellations (fig. 8).

With Ramesses II (1279–1213 BCE) the sarcophagus hall was given a new layout, and this remained the norm until Ramesses III (1184–1153 BCE). There were now eight pillars and they stood at an angle to the axis, dividing the room up into three naves; the sarcophagus now stood in the central nave, which was made deeper. At the end of the Nineteenth Dynasty the royal tombs became less steep and were given imposing entrances, with wooden doors. The constant extending of the sites reached its limits and, with Ramesses IV (c. 1153–1147 BCE), led to a simpler layout, dispensing with pillars, steps, side rooms, and parts of the decoration. There was, however, an extension of the dimensions, specifically the width and height of the corridors, so that the tomb created an impression of space, and in fact served as a rather comfortable "hotel" for many of the expeditions in the nineteenth century.

A final extension was made by Ramesses VI (1143–1136 BCE), who covered the walls and ceilings of his tomb with almost the whole of the funeral literature of the New Kingdom, from Amduat to the Books of Heaven

10 Detail, the first hour of the Amduat in the tomb of Thutmose III. Eighteenth Dynasty, 1479–1425 BCE; painted plaster. Valley of the Kings tomb no. KV 34.

11 The second hour of the Amduat in the tomb of Amenhotep II, 1427–1400 BCE; painted plaster. Valley of the Kings tomb no. KV 35.

12 Detail, the middle register of the third hour of the Amduat in the sarcophagus chamber of Seti I. Nineteenth Dynasty, 1294–1279 BCE; painted limestone. Valley of the Kings tomb no. KV 17.

Its twelve sections correspond to the twelve hours that the sun god pursues on his nocturnal course through the "Hidden Space." Each section is divided into three registers, which correspond to the river of the netherworld with its two banks. A lengthy title emphasizes that this is the conveying of knowledge about the Beyond of the netherworld; hence the abundance of names given in the texts and in the writings accompanying the pictures. For some regions of the Beyond, they even give precise dimensions. There are frequent remarks to the effect that such knowledge is also very useful in this world.

The first hour of the night is depicted as a sort of intermediary realm and ends with the gate "which swallows all," which is where the netherworld actually begins (fig. 10). This hour presents itself in the form of a list of certain particularly important and typical beings to be found in the Beyond, who greet the sun god Re as he appears. Here, we meet the goddesses of the nocturnal

hours, the solar baboons, who cheer the sun as it rises and sets, the uraeus serpents, who bring light into the darkness as they breathe fire and drive away enemy forces and many others.

An even lengthier list is the catalogue of gods, found only in the tomb of Thutmose III, which lists and depicts 741 deities of the Amduat, without the "enemies." Ancient Egyptian science often employs such lists to arrange material in a manageable way and make it easier to grasp. In the Amduat, the Beyond is explored and opened up in this way, making it more familiar and less alien. Following the course of the sun enables the Egyptian to penetrate deep into these spaces.

The middle register is reserved for the sun ship and its escort. The name of the ship is "Barque of the Millions" because the vast numbers of all the blessed dead hope to sail in it and thus remain permanently in the vicinity of the god. In the center stands the god in his nocturnal form with a ram's head; the ram's head (*ba* in Egyptian) indicates that he is descending into the netherworld as *ba*-soul to be reunited with his body.

Right next to it, in a second barque, is his other main form, the scarab beetle, which represents the rejuvenated morning sun, already pointing out here, at the beginning of his nocturnal journey, the ultimate objective — the morning renewal of the sun. This is the great hope of everyone — to be renewed every day like the sun and thus vanquish death. This is why the scarab, which epitomizes this hope, was the Egyptians' favorite amulet even in the Middle Kingdom.

Immediately in front of the shrine of the god is the goddess Hathor, Mistress of the Barque, recognizable by the cow horns with the sun disk that she wears on her head. It is she who now, hour by hour, guides Re and his retinue through the nocturnal netherworld. As the goddess of regeneration she also guarantees the daily renewal of the world. The barque is occupied by a series of other deities, representing the "millions" who would like to sail in her. Horus has his place at the rudder, ensuring that the ship stays on course.

The deities in front of the barque are really to be seen in its accompaniment. At the head, in double form, is

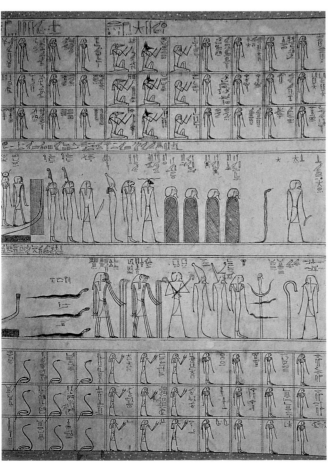

10

40

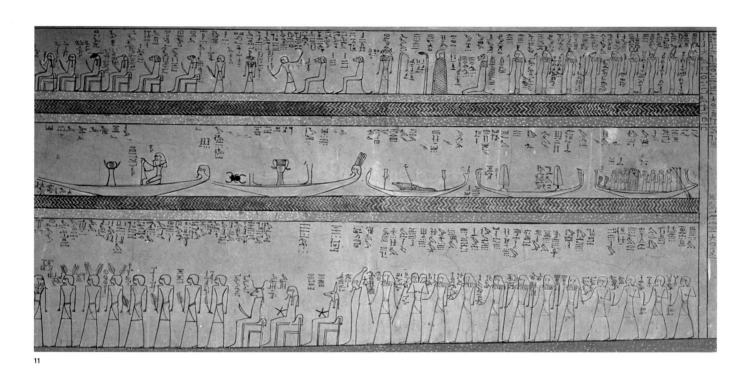

11

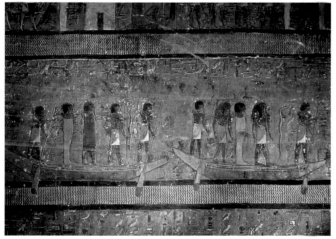

12

the goddess Maat; her presence creates the soothing certainty that the right and harmonious order of things, known to the Egyptians as *maat*, is preserved after death and accompanies the sun god on his nocturnal journey. This ensures that moderation, justice, truth, and order are guaranteed in the Beyond, despite all its terrors. In other representations, the goddess, regarded as the daughter of Re, is seen in the barque itself, and in the Amduat she appears again at the beginning of the second hour.

Osiris is also here, for the descent of the sun god leads into his kingdom, to the "being and non-being" ruled over by Osiris. Then comes the lion-headed Sakhmet, the goddess of healing, who is able to heal the injured eye of the sun and also fend off enemy forces. As in the Litany of Re, certain functions and aspects of the sun god appear as autonomous beings and accompany him in his entourage. In addition, there is a small selection from the many serpents with which the netherworld is populated; the god at the end of the register, the only one to turn toward the general direction of the sun's course, is the guardian of this region, who "seals up" the netherworld as soon as the sun and its entourage enter. This is intended to ward off anything that might disturb the process of regeneration and renewal that takes place every night in the netherworld.

The next two hours open up the actual netherworld, seen first as fertile fields dominated by the watery expanse Wernes in the second hour (fig. 11) and by the "Waters of Osiris" in the third (fig. 12). As with the Nile, his only river, source of all fertility, the Egyptian imagined there to be a broad river in the netherworld as well, whose banks are inhabited by the dead. The sun god sails along on this river in a boat, and in these hours is accompanied by other boats, whereas in the other hours his barque sails off alone. Traffic and transport for the Egyptian were via

waterways; the roads were continually broken up by canals and were of little significance, and the chariot was only used in war and for hunting.

The god attends to the welfare of the blessed dead, who, in the lower register, carry sheaves of wheat in their hands or wear them in their hair. They are the "Farmers of Wernes," whose material welfare is depicted here. In the kingdom of Osiris no one is expected to suffer shortage but should find everything necessary in abundance. People are provided with land that they can cultivate themselves. In the third hour, the presence of Osiris is documented on several occasions, and in the final text of the hour, Re turns directly to Osiris, to whom he allocates his creative force. But in the Amduat, Osiris remains oddly passive, neither acting nor speaking himself even though he is repeatedly present; this is a way of stressing his helplessness, into which he has been plunged by his violent death at the hands of his brother Seth.

There are also numerous reproachful beings with knives in their hands so as to render all fiends harmless, as well as their *ba*-souls and their shadows. For the threatening strangeness of the Beyond is embodied in dangerous

beings, which the deceased has to know to be able to pass them.

The texts describe the function of the beings represented and the orders from the sun god, with which he allocates to the dead everything they need for their renewed life in the Beyond—light, air to breathe, freedom of movement, food, and clothing. The long texts at the end of the first three hours also give the dialogues of the god with the inhabitants of the netherworld, who greet him joyously. When the god enters the "Land of Silence," as the realm of the dead is commonly called, it is filled with light and the sound of his voice; both of these arouse the deceased from their sleep of death and as he moves on a cry of lamentation goes up from those who have to remain behind in the darkness.

With the fourth hour, the fertile, well-watered landscape stops abruptly, giving way to the desert of Ro-setau, the "Land of Sokar, who is upon his Sand," a barren kingdom of sand populated with serpents; their sinister mobility is emphasized with legs and wings on the serpents' bodies. A zigzag path through this hour region that is full of fire ("from the mouth of Isis") and is repeatedly blocked by doors (fig. 13). For the first time, the sun barque can only advance by being towed and, in so doing, turns into a serpent whose fiery breath pierces a way through the otherwise impenetrable darkness. The other boats, which accompanied them in the previous hours, have to turn around here.

The darkness is so deep that the sun god is unable to recognize the inhabitants of this region; only the fire-spitting heads of the many serpents glow in the darkness. But the light needs the darkness to be able to renew itself. In the very center of the hour the solar eye is kept and protected by Thoth and Sokar, and it is the preservation and renewal of this solar eye that is at stake here. Sokar is actually the God of the Dead of the northern residence of Memphis, but in the New Kingdom he becomes a figure of Osiris. Thoth is the god of all arts and wisdom who succeeds in separating the quarrelsome brothers Horus and Seth and in healing the injured eye. At the end of the hour, the sky suddenly opens up to reveal that the Beyond does not merely consist of such desolate sand

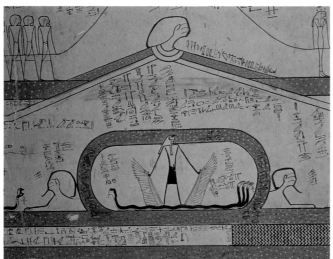

14

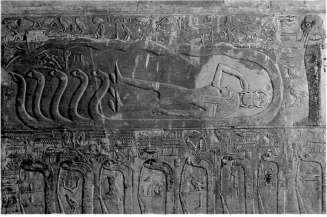

15

regions. In the tomb of Thutmose III, this section is located near the only exit, thus showing the *ba*-soul of the king its heavenly destination. A single line of text points out that the king "leaves the netherworld to light up Heaven, to accompany Re in heaven and in the earth."

In the fifth hour, the gloomy region of sand continues, but it differs somewhat from the usual structure, and places emphasis on the center by means of an intersection of the registers. This hour sphere embodies the west and contains all the essential elements of the realm of the dead. The hill with the two birds of lamentation (Nephthys and Isis) is the burial mound of Osiris from which emerges the rejuvenated sun as a scarab. The butchers on the other side of the hill and the numerous threatening serpents are besought to let the sun god pass in peace so that he can negotiate the narrow pass in the center of the hour.

Seven male and seven female figures seize the tug rope, as does the solar beetle from above. The journey takes them across an oval that represents the cavern of Sokar and is embedded in the double-head of the Aker sphinx (fig. 14). It is probably once again an image of the whole netherworld, in which the mysterious union of Osiris-Sokar with the sun god occurs every night. The multiheaded serpent, whose wings are seized by Sokar, is an aspect of the sun god. The burial mound above the oval is crowned with the head of Isis, who protects the land of Sokar with her fiery breath. Farther down, the "Lake of Fire" is indicated as a place of punishment, which is described at greater length in the Book of Gates. There it is, surrounded by blessed dead with ears of corn, showing that from it they can draw food and refreshing water as a "Lake of Life," whereas for the fiends, those damned in the Judgment of the Dead, its water is fire.

In the sixth hour, after the desert of the land of Sokar, the sun reaches the depths of the netherworld, the "water-hole," which is filled with the primeval water Nun, whose personification appears at the end of the hour. Here lies the sun's corpse, with which the god unites as *ba*-soul. The corpse is illustrated twice, at the end of the upper and middle register; it is not shown as a mummy but as a scarab, or sun beetle (fig. 15), already associated with the rejuvenated morning figure, so that it contains within itself the germ of new life. Coiled around it protectively is a multiheaded serpent. But the body is also to be seen as an image of Osiris, who is embodied in the upper register by the lion-shaped "bull with the thunderous voice." The mystery in which the corpse of the sun is shrouded is given even greater prominence later in the Book of Gates; there he remains invisible, and there is not even any mention of his name, thus guaranteeing this invisibility.

Like *ba* and body, Re and Osiris are joined in union at the lowest point of the nocturnal journey, and the incipient return to life is indicated in the semi-raised, not yet totally upright stance of the deities in the upper and lower register. It is only at this crucial point that the "Kings of Upper and Lower Egypt" are present with their symbols of power (scepter, crowns, and uraei) so that they can assist the dead pharaoh to return to life. The lower register

43

19 The tenth hour of the Amduat depicting the deified drowned in the lower register, in the tomb of Amenhotep II. Eighteenth Dynasty, 1427–1400 BCE; painted plaster. Valley of the Kings tomb no. KV 35.

20 Detail, the eleventh hour of the Amduat in the burial chamber of the tomb of Thutmose III. Eighteenth Dynasty, 1479–1425 BCE; painted plaster. Valley of the Kings tomb no. KV 34.

21 The twelfth hour of the Amduat in the burial chamber of the tomb of Amenhotep II. Eighteenth Dynasty, 1427–1400 BCE; painted plaster. Valley of the Kings tomb no. KV 35.

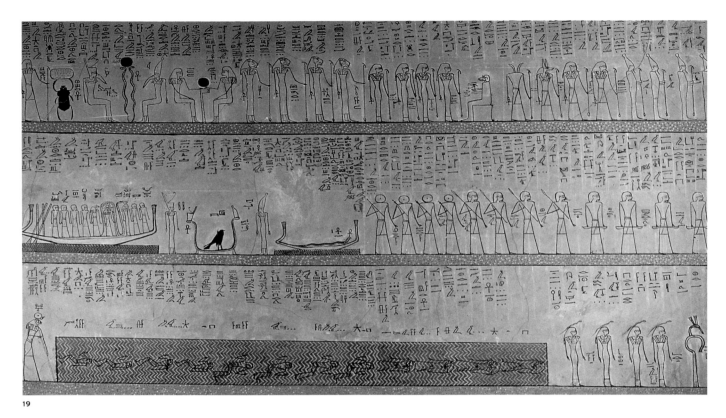

19

The upper register deals with the protecting and healing of the "eye," which appears as the eye of Horus and was already being protected in the fourth hour; also responsible here, in addition to Thoth (the enthroned monkey with the eye in his lap), is the lion-headed Sakhmet, the goddess of healing, who is present in many different forms. The scarab beetle at the beginning of the register once again anticipates the morning renewal. In the center, in front of the sun barque, are the *ba*-souls of Sokar (falcon on the serpent with legs) and Osiris (falcon-headed serpent in the boat), as well as the "bodyguard" of the sun god, who protect him against his enemies in the darkness and are armed with various weapons, most of them being archers. They escort him throughout his journey in the netherworld, preparing the way for him to the eastern horizon.

The eleventh hour is filled with intensive preparations for the imminent sunrise, the "emergence from the eastern mountain of Heaven." In front of the barque comes the "world-encircler"—a serpent inside which in the next hour the miracle of rejuvenation takes place. As uraeus serpents, Isis and Nephthys transport the two

crowns of Upper and Lower Egypt to the eastern "Gate of Sais," which is guarded by four forms of the goddess Neith, who is revered above all in Sais in the Nile Delta.

In the upper register, time and the birth of the hours are the central issue. What is important for the sun god as "Master of Time" is not to miss the right moment for the new sunrise. The double head of the god symbolizes the dual aspect that time had for the Egyptians; this can be seen clearly in the double names of Neheh and Djet for the meaning of "eternity" or even "time," with Neheh standing for the dynamic aspect of time and Djet for the static. Time itself is in the form of a serpent, which gives birth to the individual hours and then devours them again after they have run their course.

In addition to the entourage of the sun god, four goddesses appear on double serpents at the end of the upper register, each with a hand in front of her face. They give off their fiery breath, which burns the fiends in the lower register; these fiends have fallen into fire-filled pits (like hills in the representation; see fig. 20). Horus accuses them of having done harm to his father Osiris, for which they must be punished. The serpent "which

46

burns millions" and goddesses of punishment armed with knives execute judgment to ward off any danger that might threaten the sunrise. In the pits the bodies, the *ba*-souls, the shadows, and the heads of those punished are destroyed one by one. The final pit is "the desert valley of those upside down," where we find four goddesses with the sign for "desert" on their heads; thus judgment is passed in the desert, before the new rising of the sun, and the red morning sky reflects the bloody punishment.

In the twelfth nocturnal hour, the new birth of the sun finally takes place (fig. 21). As it is a repetition of the primeval creation, the primeval gods are in attendance,

with two pairs (including the primeval water Nun) being depicted at the beginning of the lower register. The process is shifted to the interior of the serpent "world-encircler," who was brought along in the previous hour, and the traction force of what is going on is indicated by the unusually large number of those towing—twelve males and thirteen females. All of them pull the barque, with its "millions" of blessed dead, through the body of the giant serpent. They go back to front, from the tail to the mouth, which points to the essential reversal of time that enables a rejuvenation to take place; according to the texts, all the beings enter the tail of the serpent as frail and infirm old people, and emerge from the mouth as little children; the transformation thus takes place inside the body of the serpent.

At the end of the hour, the solar beetle, already present at the prow of the boat, flies into the open arms of the god of the air Shu, who raises the sun up to the day sky. The goddess of Heaven, Nut, is not depicted, but the text mentions the rising of the sun from her thighs and hence the process of a real birth. The whole event takes place amid the general cheering of the gods in the upper and lower register. This cheering is meant not just for the

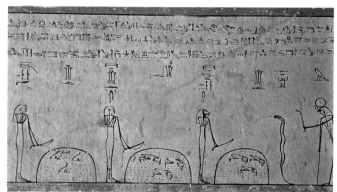

20

47

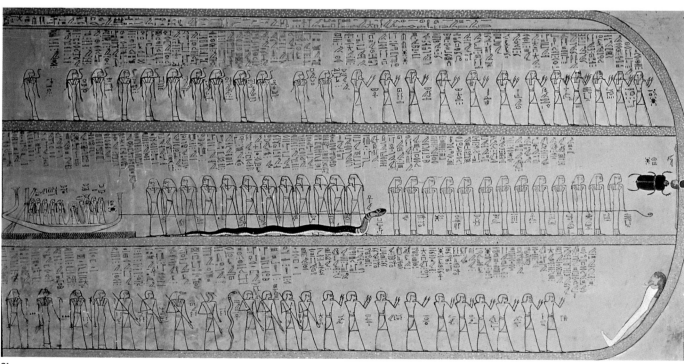

21

from the Cauldron"; in fact generally "The One Who
Destroys his Enemies," and "he has arranged the heat in
the Place of Destruction." He also has to vanquish his
adversary Apophis, who constantly threatens his progress.

The first "large" Litany is followed by eight others,
as well as various intermediary texts identifying the
deceased pharaoh with the sun god, as well as with the
primeval water Nun and hence the world before the creation,
from which the sun itself once emerged. There is a short
piece of text chosen by Thutmose III as the only one for
his tomb, alongside the figures and which, after Seti I, was
placed separately on the ceiling of the second corridor.
This text is addressed to the "United One," meaning the
night sun and Osiris.

Only toward the end does the deceased present
himself as Osiris but the most important thing is his wish
to be born again, like the sun, and to be protected from all
dangers, specifically the "Slaughterers" and the "Demons
with sharp knives." The pelican goddess greeting him is
probably an embodiment of Nut, the goddess of Heaven,
who is there to help the deceased and the sun to new life.
His complete deification graphically depicts the "Member
Apotheosis" — a litany in which every part of the body
is equated with a deity, so that at the end it can be said:
"No part of me is without God." In a final litany, the
deceased worships the "west," which stands for the whole
realm of the dead and at the same time is an aspect of
the goddess Hathor, our guide.

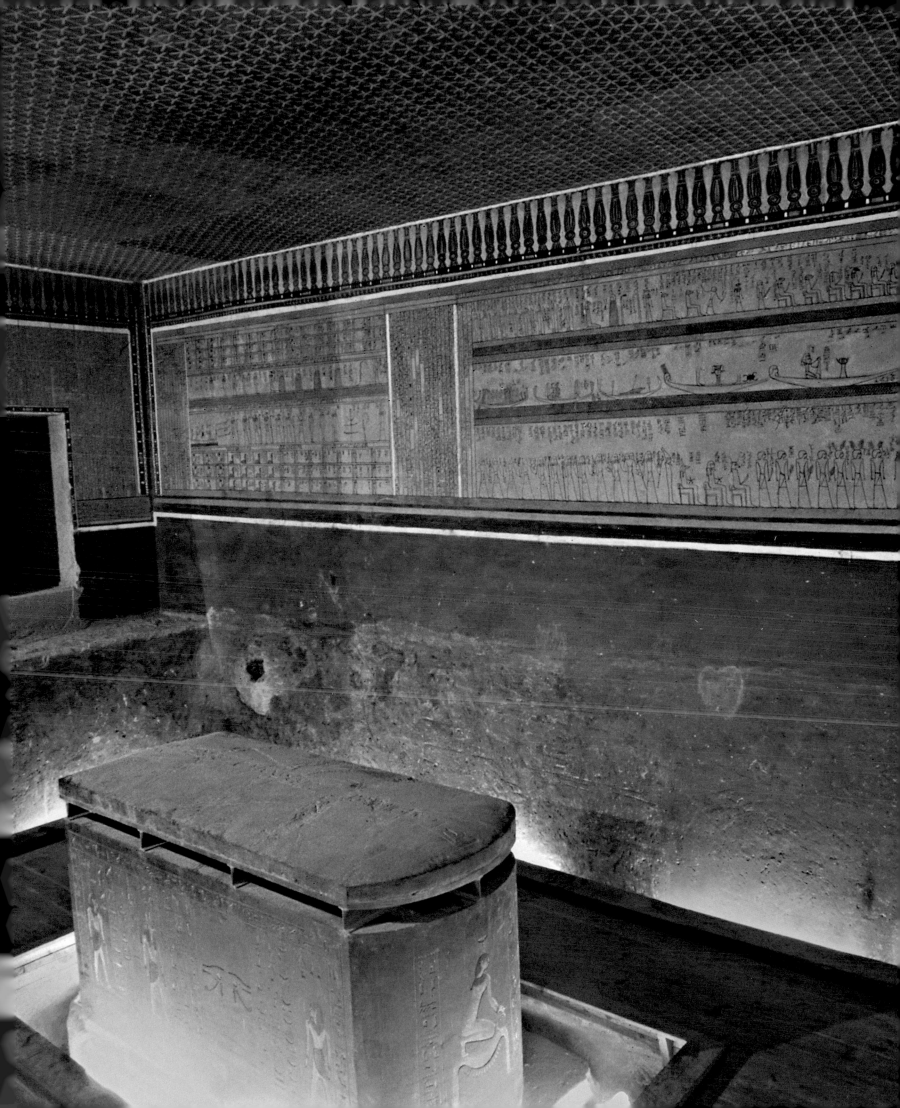

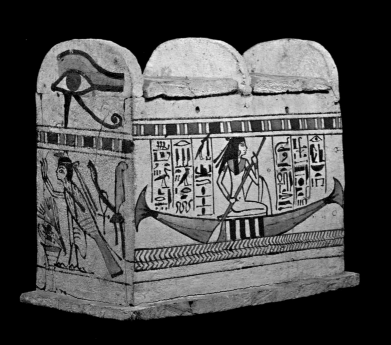

Art for the Afterlife

Betsy M. Bryan

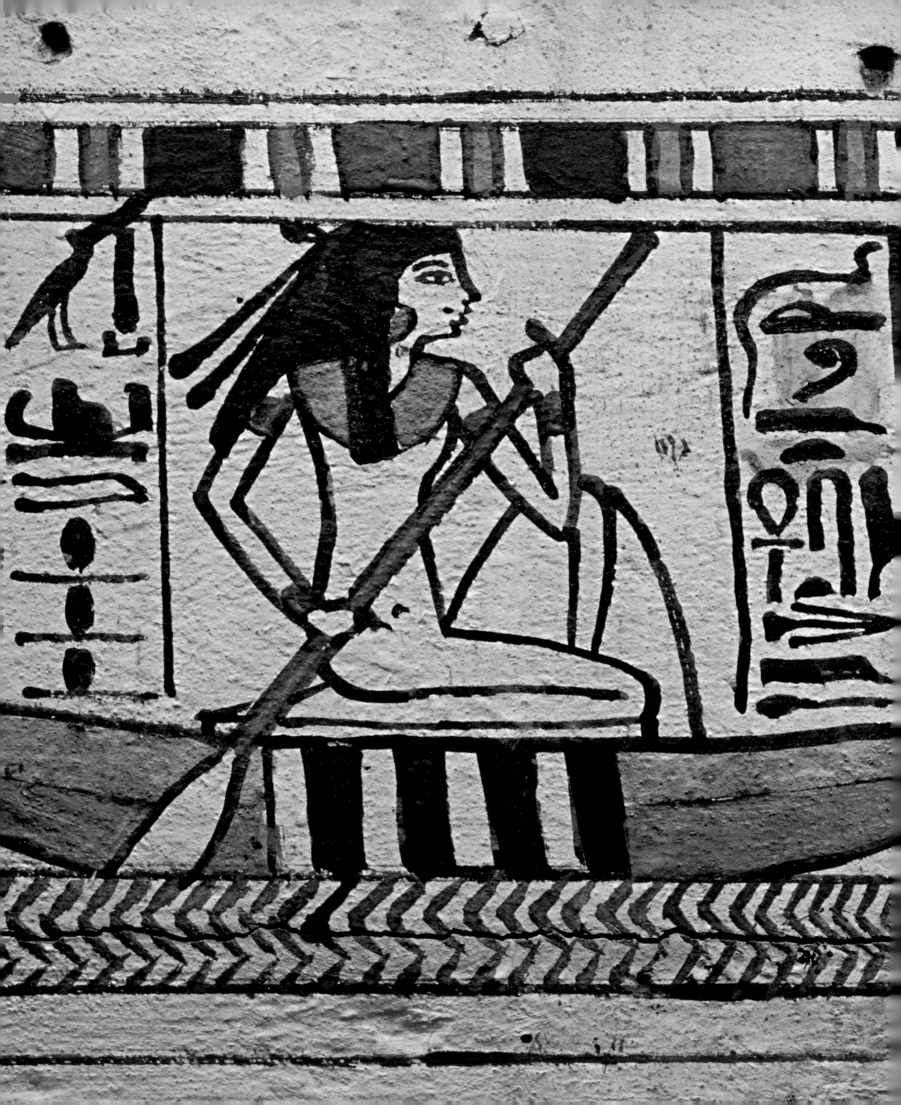

• As early as 4500 BCE, Egyptians adorned their deceased loved ones with jewelry, laid them upon textiles, and carefully placed prized belongings, such as combs, weapons, and magical figures, beside them. They set offerings of food and drink next to the bodies, which, even at that early time, exhibited attempts at preservation that presaged the practices of mummification. Neolithic remains have been found wearing wigs and padding for bodies and faces, to resemble better the skin of the living. Craftsmen fashioned handmade pots for the burials, which as early as the fifth millennium BCE were painted with scenes of hippopotamus hunts or crocodiles soaking in the Nile. Some pots had tiny sculptures of animals made separately out of clay and attached to the rims of the vessels, as if marching in a circle. Obviously the creative abilities of the early Egyptian culture were strongly directed to preparation for the afterlife. The hope of a continued existence fueled the production of funerary arts for more than five thousand years, as artisans worked together with priests to portray in images and texts an understanding of this world and the next.

The Egyptian artisan often is not granted the label "artist," however, in what may be an unwarranted modern view. "Beauty," or more accurately, "perfection" was commonly applied as an epithet to images commissioned by rulers for themselves or the gods. The great scribe and Overseer of Royal Works for Amenhotep III (1390–1352 BCE), Amenhotep, son of Hapu (cat. 15), spoke as follows of the Colossi of Memnon in western Thebes, which were made for the king: "I directed the works for his statues, great of breadth, higher than his pillar. Its *(sic)* beauty *(neferu)* eclipsed the pylon."[1] The matter-of-fact cultural view of

called the *wabet* (pure place), or the *per nefer* (the house of completion). For some seventy days the embalmers cleaned, dried with natron salts, anointed with oils and herbs, and finally wrapped the body of the deceased. Rituals were recited throughout this period and accompanied every step in the process, for the mummified body, together with the divine spirits — the *ka* and the *ba* — made up each blessed deceased person. The mummy, for the ancient Egyptians, was thus in some ways treated like a statue — as the work of artisans making a *tut,* or perfected likeness, which could likewise contain spirits. Upon completion the mummy, which was now a new form of the person "filled with magic" as a result of the ritual act performed,[5] was placed within coffins that served as further likenesses and protections for the journey through the next world.

At the time of burial, family members and friends may have accompanied a water procession that led from the shore of the Nile, where, one assumes, stood the embalming house, next to a harbor nearer the rock-cut tombs of western Thebes (fig. 3). From the landing place, sleds pulled by oxen carried the coffins, now hidden within large wooden shrines. The other funerary equipment was either dragged or carried by the long line of mourners as they moved across the desert to the cemeteries laid out

beneath the pyramidal shaped hill today called the Qurn, but referred to as Meretseger (she who loves silence) by the ancients. The burial goods ranged from objects used in everyday life — mirrors, headrests, jewelry, cosmetic vessels — to objects made specifically for the funerary rituals — canopic boxes and jars, *ushebtis* (funerary statues), and magical implements (fig. 4).

The building and furnishing of a tomb was considered the duty of any Egyptian who could afford it. The legendary advice of King Khufu's son, Hardedef, to his son states: "Make good your dwelling in the cemetery, make worthy your station in the west. Accept that death humbles us; accept that life exalts us. The house of death is for life."[6] For the Egyptians the final journey to the tomb was the important beginning of a new life in the afterworld, but it was also a very human display of wealth amassed during life. Many of the objects borne to a burial place had been acquired long before death, and the most important works, such as coffins or Books of the Dead, might be commissioned directly from the artists with individual specifications from the purchaser, just as with the scenes placed on the walls of tombs. The artisans who built and decorated the royal tombs in the Valley of the Kings (c. 1300–1050 BCE) also provided one another with tombs and burial objects. In a letter written around 1250 BCE, an artisan writes to his son: "Please make arrangements to procure the two faience heart amulets about which I told you, 'I will pay their owner whatever he may demand for the price of them,' and you shall make arrangements to procure this fresh incense, which I mentioned to you in order to varnish the coffin of your mother. I will pay its owner for it."[7] Here we see the family of the artisan compiling the burial outfit for that day whenever it might come.

As with the amulet and coffin mentioned, all Egyptian art was functional; the concept of pure decoration probably did not exist in ancient times. The vast majority of objects deposited in tombs was religious in meaning and purpose, but this did not mean that they were slavishly produced as exact replicas for hundreds of years. Rather, within the hieroglyphic artistic form, styles came and went, materials and colors changed, and details of decoration varied. A look at some of the most important

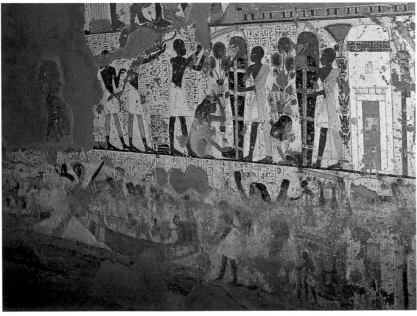

3

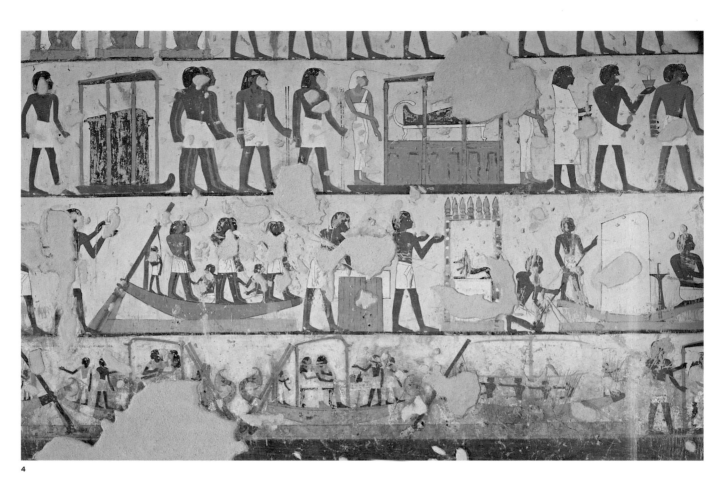

4

burial objects and their specific relationships to the journey of the deceased through the netherworld illustrates this point.

The Symbolism of Materials

Egypt is a country rich in minerals, and the ancient Egyptians quarried hundreds of different types of stones for building and statue making. Their choices were guided not only by the beauty of the materials but also by the symbolism they considered to be attached. For example, red granite *(mach)* came from the Aswan region, and because of its red color the Egyptians associated it with the sun. Kings are often carved from red granite (see cat. 4), while royal sarcophagi are nearly always made of a solar stone (see cat. 100), whether granite or quartzite. Red, yellow, orange, and gold materials were all associated with the sun, and the more common materials, limestone

(iner hedj) and sandstone *(iner hedj en rudjet)*, respectively, may have been included in this category. Black stones were used to indicate resurrection and rebirth. Black was the color of the fertile silt deposited by the Nile flood each year, and from that new silt came verdant crops that covered the countryside and nourished the population. Thus the Egyptians called their country the "Black Land," and likewise called granodiorite *iner kem* (black stone). The objects shown in catalogue numbers 3, 10, 11, 14, 15, 76, and 77 are all sculpted of this stone, while another dark gray material, graywacke, favored in the Late Period (664–332 BCE), was used to fashion images of Osiris and Isis (see cats. 78, 79). In all these cases the black stone was chosen either to allude to eternal life for kings and elites or to point to the rejuvenating powers of the gods. The same meaning is attached to objects painted black, as seen in catalogue numbers 8 (the god Amun with black skin), and 28 and 29 (statues from the tomb of Thutmose III meant to assist in his rebirth).

the king as the god Osiris. A series of these statues was placed in the temple of Karnak within the columned hall at that time just within the entrance pylon. These so-called Osiride statues are now all lacking their faces, but this head was found lying in the hall and is of the same scale as the colossi. In the fifty years that passed since the reign of Ahmose, the portrait type changed dramatically. Although the eyes are still large and wide open, they are not obliquely turned and are delicately outlined. They are shaped naturally, the lower lid being nearly horizontal and the upper highly arched. There is no visible bulge. Thutmose I has a long nose that in profile appears somewhat aquiline. This is a distinctive feature of the ruler's family, and the trait first appears in sculpture of this time and is characteristic of the rulers from Thutmose I through Thutmose III. The facial type is simplified with cheekbones prominent in the middle of the face. The idealized and refined look recalls the statuary of Senusret I of the Twelfth Dynasty (fig. 8), whose sculpture and monuments dominated Karnak until the Eighteenth Dynasty. An intentional archaism was frequently introduced by the

sculptors at Karnak who used the sweet and elegant images of Senusret I as a visual reference. Thutmose I has a wide mouth that is clearly smiling. A hard edge is visible surrounding the mouth but does not interfere with the swell of the lips. The upper lip is somewhat thinner than the lower and gives the impression of being slightly pulled over the teeth. The family of Thutmose I had a distinct overbite, the effect of which is seen in all statuary through the reign of Amenhotep III.

Thutmose III's statuary (1479–1425 BCE) is represented by two portraits in the catalogue (see figs. 9, 10). The first was found in the king's temple at Karnak, called the Akhmenu ([Thutmose III is] Effective of Monuments). This building was largely constructed and decorated in the first years after the king assumed sole rule of Egypt. His aunt and stepmother, Hatshepsut, had ruled as co-regent with him since his young boyhood, but once he ruled alone he began work on his temple in Karnak. The portrait type of Thutmose III changed little over the first twenty-five years of his sole rule. This statue's face does, however, show strong links to the image of Hatshepsut, whose many sculptures were left in her funerary temple at Deir el-Bahari. The facial shape here is triangular, tapering from broad cheekbones, heavy in the mid-face, to a narrow chin. Later statues of Thutmose III reveal less of a tapering face shape (see cat. 4). The nose here is quite large and curved in profile. The mouth, slightly smiling, is as wide as the base of the nose, and the eyes, wide open, are slightly smaller than those of Thutmose I but shaped naturally. The face of the king on the sphinx is similar but not identical. Made perhaps a decade later than the last, this statue shows a more idealized facial type. The nose is slightly smaller and little hooked when seen in profile. The eyes are smaller too, but are shaped similarly to those in catalogue 3. The overall appearance has eliminated the strong feminized elements of Hatshepsut's statuary and accented the robust and fleshy face of the king but with less individualization of features.

The statue of Sennefer and Sentnay (fig. 11) preserves the features of Amenhotep II (c. 1427–1400 BCE), son of Thutmose III. Similar to the portraits of his father in the last years of his reign, Amenhotep II has a full face,

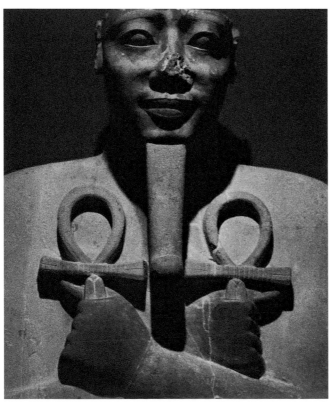

8

62

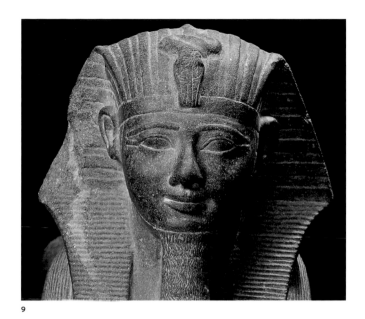

9

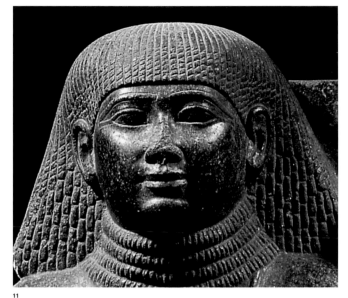

11

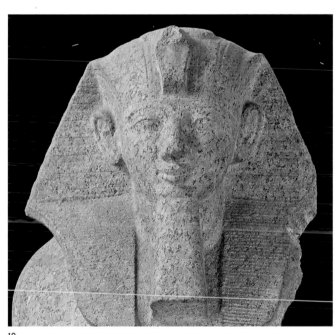

10

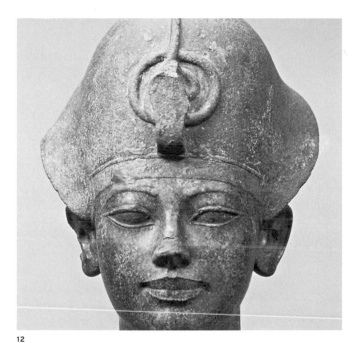

12

broad across the cheekbones, but slightly higher on the face than his father—at the middle of his nose. The king's eyes are somewhat wide open and are neither entirely naturally shaped nor ovoid. The upper lids are less arched than on Thutmose III's statuary, creating a more oval shape. The king's nose is long and thin at the top, then splayed at its base. His mouth is as wide as the base of the nose but shows no smile. The statuary of Amenhotep II often suggests idealization that forbids personality, and

Sennefer's face is representative. Without the elaborate wig and festive gold collars and heart amulets that he wears, Sennefer's face is fleshy (perhaps intended to suggest he is overweight) but not distinctive.

Amenhotep III's portrait is represented by two statues (see cats. 15, 76), one a god and the other a private person. In contrast to the image of Amenhotep II, that of his grandson Amenhotep III is highly individualized. The king (fig. 12) has a rather long and highly fleshy face, with

13 Detail, Ushebti of Hat. See cat. 59.

14 Head of Tutankhamun. Eighteenth Dynasty, 1336–1327 BCE; limestone. The Metropolitan Museum of Art, New York, Rogers Fund, 1950 50.6.

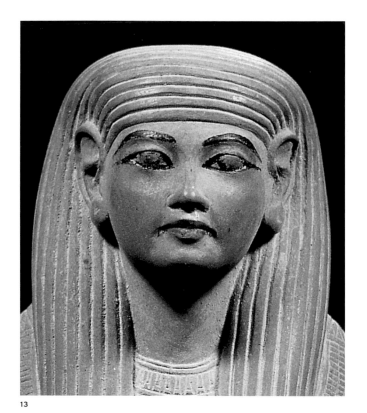

13

64

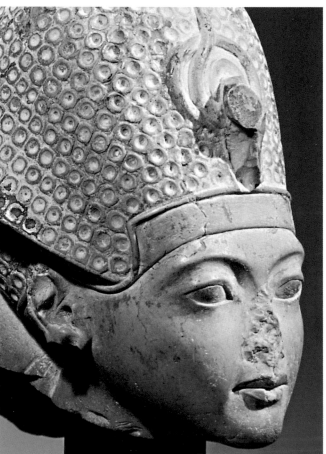

14

little or no suggestion of bone structure. The eyes of the ruler are entirely ovoid in shape, and they are narrow. In most cases the eyes are set at a slight angle, in a manner one might call Asian. The mouth is as distinctive as the eyes. It is a full mouth, as wide as the king's nose at its base, and the upper and lower lips are full. The upper lip has a deep "vee" in its center and a slight bulge where it meets the lower one. This represents that same Thutmoside overbite seen as early as the statuary of Thutmose I, but on a generous mouth such as here it purses the lip. The entire mouth is rimmed by a raised rim, a lip line, consistently found on the statuary and sculpture of this king. All in all this is a highly identifiable face.

The Ushebti of the Adjutant Hat (fig. 13) is a small masterpiece of Egyptian art, re-creating as it does the perfectly sculpted face of an Amarna ruler in a miniature scale. The face preserves the portrait style of the late Amarna Period—the end of the reign of Akhenaten (Amenhotep IV)—or early in the reign of Tutankhamun. The round and youthful face and the large almond-shaped eyes, characteristically outlined in black, are hallmarks of the late Amarna age. The mouth, with its full lower lip and slightly down-turning corners, is also a feature of the period, originating in the depictions of Amenhotep III's widow Tiy at the beginning of her son Amenhotep IV's reign (1352 BCE). The traits seen so often earlier in the Eighteenth Dynasty—aquiline nose, strong cheekbones, and evidence of an overbite have all disappeared. The portrait here betrays a break in the royal family succession (fig. 14).

The image in catalogue 13 preserves the features of Ramesses II of the Nineteenth Dynasty (c. 1279–1213 BCE), although it began its existence as a colossal statue of King Senusret I of the Twelfth Dynasty (c. 1956–1911 BCE). One of a series of granite statues of Senusret I made for the temple of Ptah at Memphis, this piece and the others were re-carved for Ramesses II when he rebuilt that cult center.[9] The face of Ramesses II was often round in shape, although it could be fleshy but long. This second model seems the guide here and conforms better to the original shape of Senusret's own face. Ramesses had oval-shaped eyes, but these were carved more wide open than seen in the reign of Amenhotep III or the Amarna era. His eyeballs are often, as here, made to bulge slightly. A highly distinctive feature

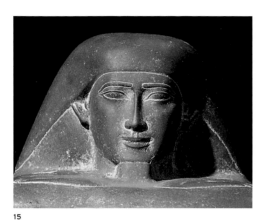

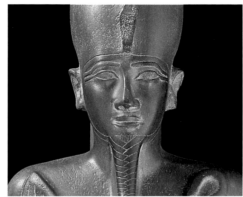

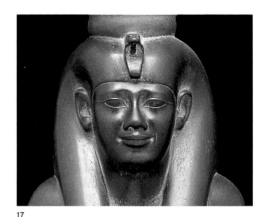

15

16

17

of his eyes is an upper lid area carved back from the surface of the eye, producing a convexity between the upper lid and the eyebrow. Here that has been "faked" by a wide lid line in higher relief than the lid above it. Ramesses' mouth often emulated that of Amenhotep III, and here that is particularly true. The nose is narrow and long, being mildly aquiline. The mouth is wider even than the base of the nose and is drilled at the corners and rimmed by a raised lip line. Even the pursed upper lip is copied here, although it is unlikely that Ramesses II's family had the same overbite prevalent in the family of the Thutmosides. This portrait type is meant to invoke the memory of important earlier rulers, whose identification with Ramesses might inject his image with more power, but it is still unmistakably Ramesses II.

Not again until the Twenty-fifth Dynasty can we talk decisively of royal portraits. The catalogue includes several pieces that date from the beginning of the Twenty-sixth Dynasty (c. 664 BCE), the so-called Saite period, and presumably preserve the features of Psamtik I, first king of the period (although actual statues of the king are lacking for the comparison). The block statue of Paakhref (fig. 15), inscribed with the name of Psamtik I on his shoulder, displays a long thin face set with extremely long and almond-shaped eyes. Bone structure is apparent in the upper face. The eyes are delicately rimmed on the upper lid by a narrow cosmetic line, and the brows above are quite nearly horizontal. The nose is long, thin, and quite narrow at its base. The mouth is the most characteristic feature of the face, since it is wide and bowed in a smile. This smile is common to the Saite period and is often claimed to be the inspiration for the "archaic smile"

seen on early Greek *kouroi*. The statue of Osiris (fig. 16), dedicated by Psamtik I's daughter Nitocris, depicts a very similar facial type and might be considered a true royal image, since Osiris appears wearing the royal crown of Upper Egypt. Finally, the sarcophagus of Nitocris herself displays the feminized portrait face of Psamtik I (see cat. 100).

The statue of Isis dedicated by one Psamtik dates from the end of the Twenty-sixth Dynasty and is the latest portrait type shown here. The face displays the Saite features of the ovoid and outlined eyes and horizontal brow types, but the facial shape is shorter and has lost its strong structure — it is now fleshy and almost cherubic. These are features similar to those seen on statues bearing the name of King Amasis or Psamtik III (c. 526 BCE; fig. 17).

The more generalized facial images, such as that of Hekaemsaef (cat. 53) or Isis-em-akhbit (cat. 51), cannot strictly be called portraits, but they are representative of the periods in which they were made. Isis-em-akhbit, for example, has a large fleshy face, almond-shaped eyes, and a thick mouth, reminiscent of the later New Kingdom (compare the face of Ramesses II). These features were still in fashion in the Twenty-first Dynasty (1069–945 BCE), when Isis-em-akhbit's coffin was made. The mummy mask made for Hekaemsaef is typical of later Saite faces. The almond-shaped eyes with narrow straight brows are quite evident, as is a fleshy face and the archaic Saite smile. Without our knowing that this piece dates from the time of Amasis, however, we might not be able to assign it to a specific reign. Nonetheless, the influence of Egyptian portraiture was such that even simplified forms, such as coffin faces or masks, reveal the general time in which they were fashioned.

65

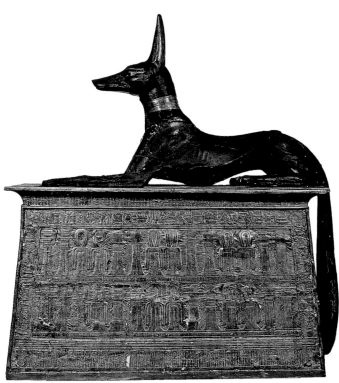

19

had a parallel function to that of the canopic box (fig. 19). Within that shrine were compartments that held amulets identified with mummified limbs, as well as embalming materials and jewels.

Shabtis, Shawabtis, Ushebtis, and Their Boxes

During the Middle Kingdom the Egyptians began producing small mummiform figures to be placed with other funerary objects in a tomb. These roughly carved wooden figures supplanted models of agricultural workers often placed in graves from the Old Kingdom on, and their purpose was to perform labor on behalf of the deceased. By the Second Intermediate Period the mummiform figures were often inscribed with an utterance from the Book of Going Forth by Day, Spell 6: "The spell for causing that the funerary servants do work in the other world." The word for these funerary figures varied, from *shabti* in the Eighteenth Dynasty, to *shabti* and *shawabti* in the later New Kingdom, and finally to *ushebti* in the first millennium BCE. The meaning of *shabti* and *shawabti* is uncertain, although deities called *shebty* from the Ptolemaic Edfu temple inscriptions and associated with the creation of the cult may be related. *Ushebti* may derive from the verb in Egyptian, *wesheb* (to answer), since the spell addresses the figure and tells it to respond when the deceased is called to perform conscripted labor in the next world.

At the beginning of the New Kingdom, tomb owners might acquire a group of ten to thirty *shabtis* for their burial, while kings had hundreds. In the Twenty-first Dynasty, *ushebtis*, as they were now known, appeared in more standardized numbers. Boxes made for the purpose contained 365 figurines plus 36 overseers. A worker for every day of the year was thus provided, but these were organized into groups of 10 overseen by the 36 directors. Since the Egyptians identified the length of the year and the hours of the night by observing 36 groups of stars that changed every 10 days (and to which they added 5 days) at the beginning of the year, the *ushebtis* were clearly thought to correspond to the same time periods. In the Egyptian netherworld each hour of the night was associated with a geographic region or

70

contain the viscera were considered to be the province of the Four Sons of Horus, who protected the body. Although these gods appear in anthropomorphic form through the Eighteenth Dynasty, later they appear differently. Imsety was human headed; Hapy, baboon headed; Duamutef, jackal headed; and Kebehsenuef, falcon headed (see cat. 41), one of two sets of canopic jars from the tomb of King Osorkon II at Tanis. The jars belonged to Prince Hornakht of the Twenty-second Dynasty, although the lids were certainly taken from a New Kingdom royal set. The gold plaque used to cover King Psusennes I's embalming incision (cat. 40) also shows the Four Sons.

Boxes to hold the canopic jars were also commonly provided in tombs and, since the early New Kingdom, had been shaped in the form of the shrine of Upper Egypt. The box shown in catalogue 75 belonged to Queen Nedjmet of the Twenty-first Dynasty, a sister of Ramesses XI. Atop the canopic box lies the jackal god Anubis whose watchful state betrays his role as guardian of the cemetery. A wooden shrine from the tomb of Tutankhamun shows Anubis atop a differently shaped chest. This box may have

town. Those regions were organized just as on earth and consisted of lands donated by the sun god to the blessed dead and the gods who dwelled there. These *ushebti*s worked this land instead of the deceased themselves.

This book illustrates several New Kingdom funerary figures. The earliest is from the reign of Amenhotep III and belonged to the king's father-in-law, Yuya. The image shown in catalogue 35 is a wooden mummiform figure with a gilded face and a striped headdress, the typical mummy head covering. The *shabti's* hands are shown as fists, but they are not holding anything. Since the reign of Thutmose IV, Amenhotep III's father, *shabti*s had appeared holding hoes in their hands and carrying bags on their backs. Yuya lacks these implements on this figure, but these figures are accompanied into the next world. Separately made model hoes, adzes, and even a mud-brick mold were included in Yuya and Tuya's burial, along with wooden yoke poles with bronze bags to hang across the servant's shoulders. These very well equipped *shabti*s also had shrine-shaped boxes for containers, such as that seen in catalogue 38. In the netherworld we see mummies standing in shrines like this as they waited for the sun god's arrival, when they would be awakened by his power (fig. 20).

Late in the reign of Amenhotep III or in that of his son Amenhotep IV (before he termed himself Akhenaten), the Royal Scribe Amenhotep, called Huy, acquired a *shawabti* and model coffin for his burial (cat. 60). The figure shows Huy with a long wig, rather than a headdress, and a divine beard. His hands hold the amulets for stability and protection, rather than agricultural implements, but the inscription on the *shawabti* is the standard Spell 6. A figure belonging to the adjutant Hat (cat. 59) dates from the Amarna Period (c. 1352–1327 BCE), during which the temples of the great gods were closed and the funerary deities were forbidden by King Akhenaten. The man Hat must nonetheless have hoped for a life in the next world and purchased a figurine holding the by-then traditional hoes and carrying a basket on his back. Instead of Spell 6 from the Book of the Dead, Hat's text is an offering addressed to the only god recognized by Akhenaten, the Aten, or sun disk.

From the tombs of Sennedjem and his son Khabekh-net come two last *shawabti* examples. Khabekhnet is represented in a mummy form (cat. 61) with a long wig, no beard, and holding hoes. The seed bag is on his back. The traditional *shawabti* spell is written in horizontal lines, as on Yuya's example. Here, the colors are different from earlier examples, however, for at Deir el-Medina particularly, *shabti*s are frequently painted with a white ground and then decorated in red, yellow, green, and black. Sometimes these *shawabti*s are varnished and thus appear more yellow, but they are more often painted as here. The figure in catalogue 62 represents Sennedjem himself, but here he is depicted as if in real life. He wears an elaborate wig made of plaits and echelons, and his garment consists of a shirt with pleated sleeves and an over kilt with an intricately pleated front apron. The figure was originally white on the garment areas and red on the body, but varnish has turned

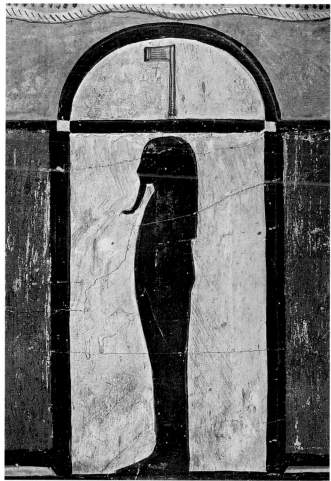

the body nearly entirely yellow. The inscription is not the standard *shawabti* spell, but rather, a dedication formula which guarantees offerings for Sennedjem's cult from the temple of Karnak. The form of the figure in the guise of real life is first seen in the tomb of Yuya and Tuya, and it has been suggested that figures such as these acted as overseer figures for the other *shawabtis* when they performed their labors.

Khabekhnet's box (cat. 63) was designed in the form of two shrines, to contain two *shawabtis*. One side of the box is decorated with images of the two figurines. From the Twenty-first Dynasty comes a *ushebti* box for the Singer of Amun and Lady of the House Djed-Maat-iuesankh (cat. 104). This box type was designed to hold some 401 small figurines, probably of faience. The form retains the shrine shape, but the interior is divided into several compartments each of which held many *ushebtis*. Figure 21 shows the deceased rowing herself across the sky in a boat, while the text states: "The Osiris, the Lady of the House,

Singer of Amun-Re King of the gods, Djed-Maat-iuesankh Ferrying across in peace to the Field of Reeds so that excellent spirits [*bas*] may be received."

From the survey of several types of objects given above, the reader may conclude that the burial outfit was intended to facilitate and support the rituals for the afterlife. The Books of the Dead, carried by so many who expected to travel the ways of the netherworld, were aided in their effectiveness by the many tomb objects that could be made to function through magic. *Ushebti* formulas from the Book of the Dead, Chapter 6, have already been mentioned, and heart scarabs were inscribed with Chapter 30, "Spell for not letting [name of the deceased] heart create opposition against him in the world of the dead." The rubric for Chapter 30 shows how important were the objects themselves: "To be inscribed on a scarab made from nephrite, mounted in fine gold, with a ring of silver, and placed at the throat of the deceased."[16] Spell 140 includes the instruction that it should:

72

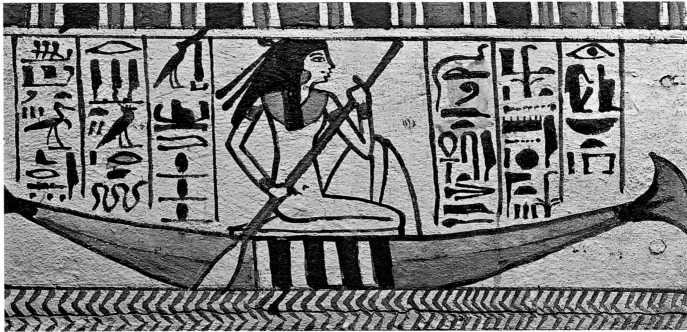

21

be spoken over a *wedjat* eye of real lapis lazuli or carnelian, decorated with gold. There should be offered to it everything good and pure before it when Re shows himself in the second month, last day; and there shall be made another Wedjat eye of red jasper which is to be placed for a man on every member which he desires. He who utters this spell will be in the Bark of Re when it is taken out with these gods, and he will be like one of them; he will be raised up in the world of the dead.[17]

In both of these instances objects are described which, because of the materials employed, only wealthy elites and royalty could have afforded to possess, and yet the description probably betrays, as said at the beginning of this essay, the ideal Egyptian aesthetic. Artistry and fine materials, combined with correct ritual form, produced the most desirable — artistic — objects, which were believed to have the greatest efficacy.

But lest we think the ancient Egyptians never questioned their own values and beliefs, let us end with a quote from a great literary work, composed around 1900 BCE, "The Dispute of a Man with His *Ba*."

My *ba* opened its mouth to me, to answer what I had said: If you think of burial, it is heartbreak. It is the gift of tears by aggrieving a man. It is taking a man from his house, casting [him] on high ground. You will not go up to see the sun. Those who built in granite, who erected halls in excellent tombs of skilled workmanship — when the builders have become gods [i.e., died], their offering-stones are desolate, as if they were the dead who died on the riverbank for lack of a survivor....Listen to me! It is good for people to listen. Follow the feast day, forget worry![18]

73

Translations not otherwise referenced are by Betsy Bryan.

1. Wolfgang Helck, *Urkunden der 18. Dynastie* (Berlin, 1957), 1822–23.

2. There are several entries for the term "knowledgeable artisanship" in Adolf Erman and Herman Grapow, *Belegstellen* for the *Wörterbuch der Ägyptischen Sprache*, vol. 2 (Leipzig, 1938), 445, 4, under the entry for *rh*. One is from the Papyrus d'Orbiney 18, 3: The king sends craftsmen to cut down a persea tree and make fine furniture from it. The men sent are referred to as "knowledgeable craftsmen." Another, from P. Salliers I 1, 6, mentions "knowledgeable scribes"; a third, similar to the Amenhotep, son of Hapu reference, is from the Stela of Piye and describes the building of a battlement as "an act of knowledgeable craftsmanship." Finally a citation refers to "an act of knowledgeable craftsmanship; I do not do incompetent craftsmanship."

3. In fact, the Great Sphinx was pictured on stelae of the New Kingdom, drawn with wings folded on the lion body. These are not visible on the monument today, but they may have existed in paint in antiquity. This naturally merely adds to the composite hieroglyph. See Christiane Zivie, *Giza au Deuxième Millénaire* (Cairo, 1976).

4. From the "Tale of Sinuhe," Miriam Lichtheim, *Ancient Egyptian Literature: A Book of Readings*. Vol. 1, *The Old and Middle Kingdoms* (Berkeley, 1975), 229.

5. For a fascinating discussion of the initiation rites in the funerary (and other) contexts, see Jan Assmann, "Death and Initiation in the Funerary Religion of Ancient Egypt," in William K. Simpson, ed., *Religion and Philosophy in Ancient Egypt* (New Haven, 1989), 135–59.

6. For a full translation in English, see Lichtheim, *Ancient Egyptian Literature*, vol. I, 58–59.

7. Edward Wente, *Letters from Ancient Egypt* (Atlanta, 1990), Letter 218, 153.

8. "The Memphis Theology" in Lichtheim, *Ancient Egyptian Literature*, vol. I, 55, with some minor translation changes.

9. It is only due to the extraordinary work of Hourig Sourouzian that we know exactly which Middle Kingdom ruler this image once represented. Remarks here are summarized from her study, "Standing Royal Colossi of the Middle Kingdom Reused by Ramesses II," *Mitteilungen des Deutschen Archäologischen Instituts, Abteilung Kairo* 44 (1988): 229–54, Tafeln pls. 62–75.

10. The final text of the Second Hour of the Amduat, cited in Alexandre Piankoff, *The Tomb of Ramesses VI*, vol. I (New York, 1954), 246.

11. Erman and Grapow, *Wörterbuch der Ägyptischen Sprache*, vol. 1, 378–79.

12. Jean-Louis de Cenival, *Le Livre pour Sortir le Jour* (Paris, 1992), 52.

13. Bernard Bruyère, *Rapport sur les foullles de Deir el Médineh (1924–1925)*, 27–28, fig. 18.

14. For the Book of the Dead of Paduamen, see Alexandre Piankoff, trans., and Nina Rambova, ed., *Mythological Papyri* (New York, 1957), 1090–116.

15. The final text of the Second Hour of the Amduat. See Piankoff, *Tomb of Ramesses VI*, vol. I, 246.

16. Raymond O. Faulkner, ed. and trans., *The Ancient Egyptian Book of the Dead* (London, 1972), 56.

17. Ibid., 132.

18. Lichtheim, *Ancient Egyptian Literature*, vol. I, 165.

The King and Society in the New Kingdom (catalogue nos. 1–16)

The king in ancient Egypt held a singular position as the ultimate authority on earth. During the New Kingdom (1550–1069 BCE), Egypt was once again unified under strong and ambitious kings. The king not only held a place at the top of a pyramid of governmental officials but he was also the chief officiant of the cults of the various deities. Images of the gods reflect the features of the king during whose reign they were created, further strengthening the connections between the king and the gods.

1 Boat from the tomb of Amenhotep II

Eighteenth Dynasty, reign of Amenhotep II, 1427–1400 BCE; painted wood. Height 50 cm (19¹¹/₁₆ in); length 234 cm (92⅛ in); depth 41 cm (16⅛ in). Thebes, Valley of the Kings, KV 35. The Egyptian Museum, Cairo JE 32219/CG 4944

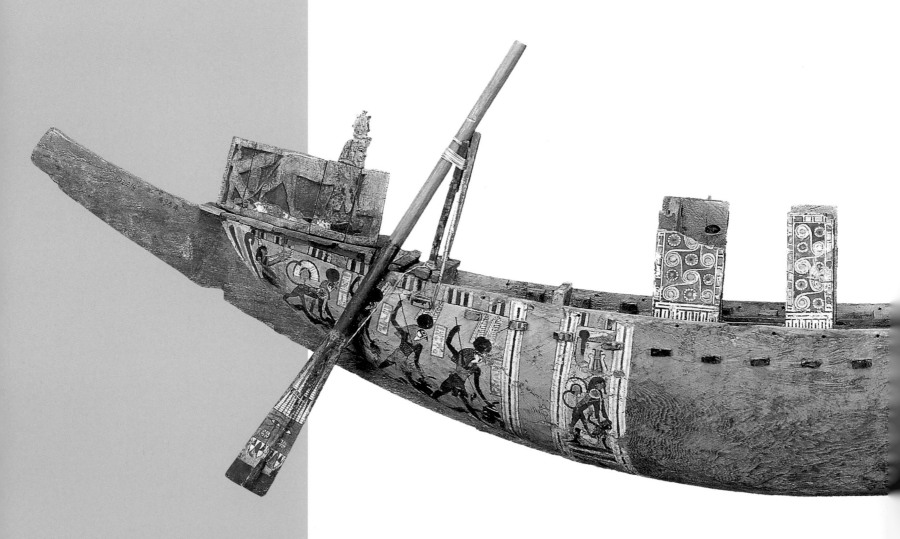

The tombs of kings contained boats, either life-sized or models, from as early as the First Dynasty. The ruler traveled by water, whether it was to inspect his land, visit the temples, or in the afterlife, journey through heavens. In the New Kingdom the ships placed in tombs were models of royal vessels whose primary function was travel. Examples of both rigged and unrigged vessels have been found, since the mast and sails were needed to go upstream, but the voyage downstream would be accomplished with rowers alone.

The long hull accommodated several deck fixtures.[1] At the prow and the stern of the ship are castles represented by wood plaques deco-rated with scenes of the king as sphinx. The two steering oars stood just before the stern castle and were supported by painted posts. The cabin was likely of two stories, though here the remains of the upper story are not indicated. The elabo-rate running spiral decoration is similar to that seen on house and palace walls of the Eighteenth Dynasty, such as at Malkata, the palace of Amen-hotep III. Openings in the walls of the partially preserved cabin were doorways for the structure, and the upper story was probably reached from within and served as a storage area.

It has been noted that Amenhotep II's ships are painted with scenes of the king tram-pling foes of the Levant and Nubia and that they may, therefore, be war ships. The likelihood is, however, that Egyptian vessels were not so finely distinguished by function and that the same ships carried troops headed to war with the ruler and led processions up and the down the river when the king visited the temples and towns of Egypt on inspections.

This ship was designed to sail upstream with a central mast and two yards to carry its sail. The mast ran through the center of the deck cabin, and the fixed yards ran the length of the

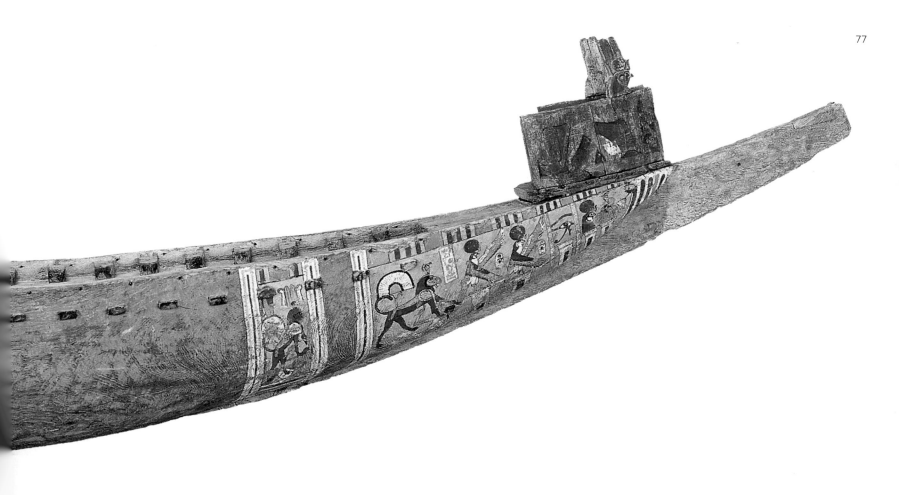

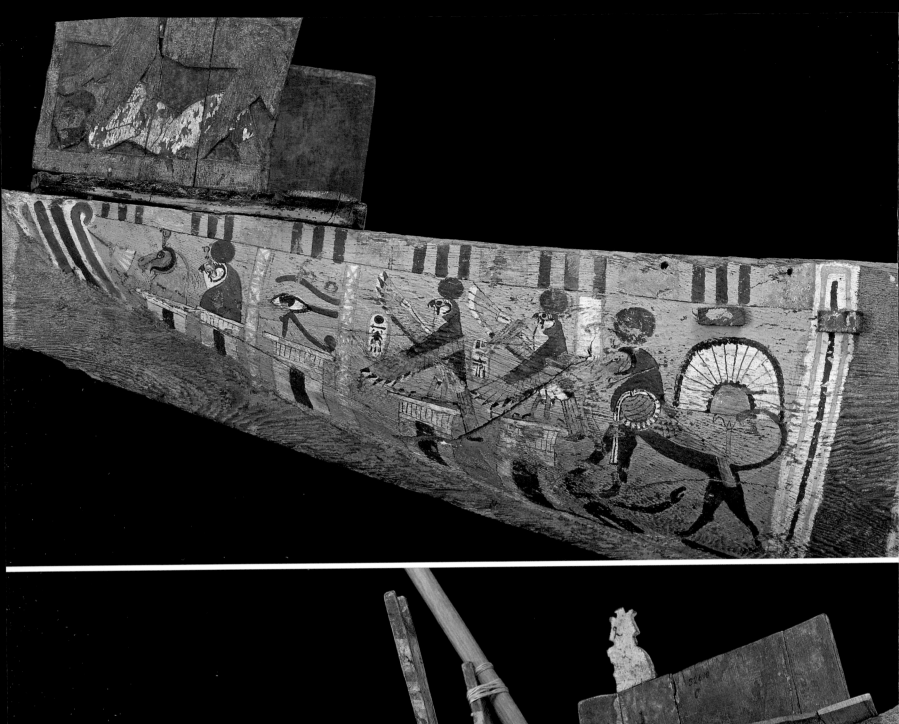

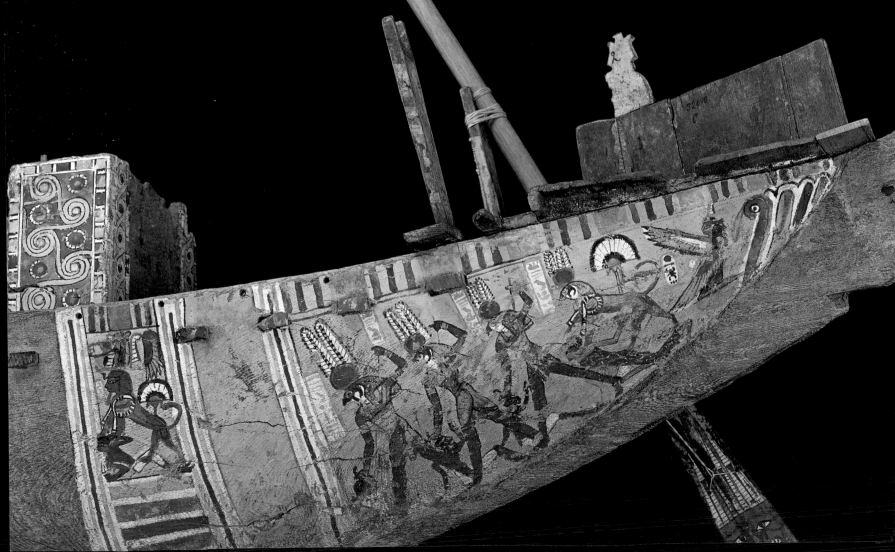

deck, such that raising and lowering sails was a lengthy process. The deck of the ship is fitted along both sides with bench seats for the rowers. The construction of the hull is also visible on the sides of the ships where thorough-going beams are visible and set in place between the planks, making the strength of the ship very great. The ends of the ship may once have had terminals in the shape of papyrus umbels, but these would have been removable in the event the ship was needed for less-ceremonial duties. A scene in the tomb of Rekhmire, the vizier of Thutmose III and Amenhotep II, shows a similar ship under sail, with the deck rowers pulling oars and the sail up. Like the scene on the block from Thutmose III's Deir el-Bahari temple (cat. 9), the rowers are standing as they approach the port of Thebes. When under sail and in mid-voyage, as in the scenes of Hatshepsut's expedition to Punt, the sails are up but the rowers are in a sitting position at the oars.

On the sides of the ship are painted scenes showing the god Montu smiting the enemies of Egypt and the gods. The painting at the stern is typical and shows, from right to left, the goddess Maat kneeling on a basket with her wings outspread in a protective gesture. Before her is a falcon-headed sphinx, with a sun disk on its head and a fan shown above its back. It is trampling a Libyan, identified by a feather on his head. To the right are three falcon-headed gods with sun disks and tall plumes on their heads. They are spearing a Syrian on the left, a Nubian in the center, and another Levantine on the right. In a separately defined area to the right is a sphinx of the king wearing the *atef* crown trampling a Nubian. The fan is again on the back of the sphinx, and above is a winged sun disk. The four depictions of Montu are labeled from left to right as follows: "Montu lord of Armant, Montu lord of Tod, Montu lord of Thebes, and Montu lord of Medamud."

The god Montu had predominated in the Theban region before Amun-Re's ascension to primary local deity, and Thebes was surrounded by a rectangle of temples of Montu in the First Intermediate Period (2160–2055 BCE) and Middle Kingdom (2055–1650 BCE). Armant and Tod represent the southwest and southeast temples of the god respectively, while Medamud is the northeast one. The temple of Montu, lord of Thebes, remains uncertain, although it is likely to be represented by a monument in the northern cemetery area on the west bank, perhaps at Mentuhotep's Deir el-Bahari or farther to the north. Montu, as here, was often shown wearing a corselet that formed a type of armor, and he was commonly invoked in battle inscriptions to fight alongside the ruler. The fan on the back of the two sphinxes indicates the royal *ka*'s presence in the scene, such that the king is present in the depiction of the gods. Amenhotep II may be understood to have been manifest as Montu and as a trampling sphinx. **Betsy M. Bryan**

1. Björn Landström, *Ships of the Pharaohs: Four Thousand Years of Egyptian Shipbuilding* (London, 1970), 108–10.

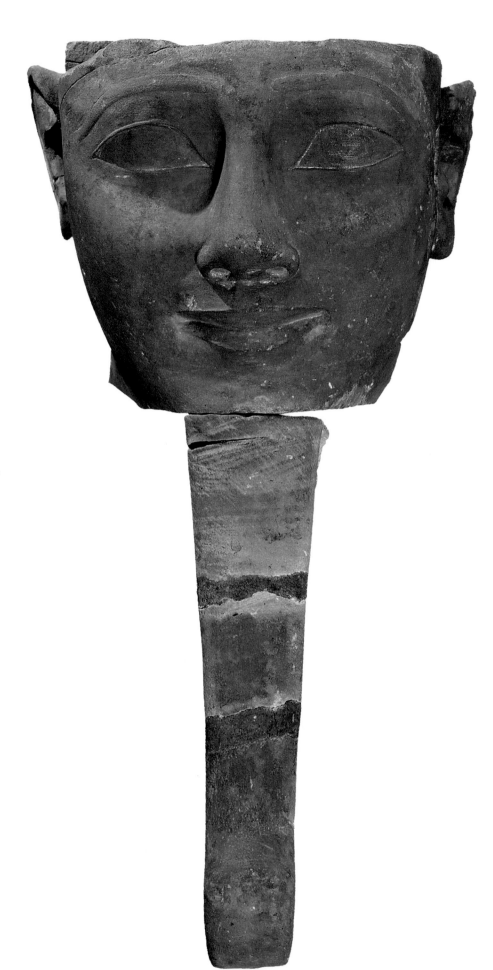

2 Head of Thutmose I

Eighteenth Dynasty, reign of Thutmose I,
c. 1504–1492 BCE; painted sandstone. Height
102.8 cm (40½ in). Karnak, Wadjyt Hall. The
Egyptian Museum, Cairo JE 38235/CG 42051

• This head of Thutmose I derived from one of
the standing colossal statues of the king in the
form of Osiris, shown as a mummy wearing
either the white or double crown. The statues on
the south side of the court wore the white crown
of Upper Egypt, associated with Osiris, while
those on the north wore the double crown seen
also on the great solar god of Heliopolis, Atum.
Thus, in the sculpture, as in the Amduat and all
New Kingdom religious literature, the union of
Osirian and solar theologies was presented. Since
this statue's crown is lacking, its original head-
dress and placement in the court are uncertain.

The head itself is sandstone painted red,
with the remains of blue on the beard and black
on cosmetic lines and eyebrows. The beard is long
(55 cm [21¼ in]) and curved at its end, it being
the traditional beard of a god. The face shows a
slightly smiling and youthful visage, character-
ized by prominent cheekbones that are nonethe-
less tempered by fleshy cheeks. The nose is long
and just slightly curved beginning from its very
high root above the level of the eyes. The mouth
is thicker in the lower lip than the upper, which
rather betrays the slight protrusion caused by
an overbite—a feature that distinguished the
Thutmoside family at least through the reign of
Amenhotep III (1390–1352 BCE). The eyes are
the dominant feature of the face, being very large
and wide open. They are rimmed above by a
thin lid line, and the eyelids are deep and convex.
The eyebrows are plastically rendered in low
raised relief.

The head of Thutmose I was found in
1903 near the southeast angle of the masonry
that surrounds the southern obelisk of Hatshep-
sut, lying against the north face of the column
there. Recent work in the Wadjyt Hall has eluci-
dated the architectural history of the hall in
the Eighteenth Dynasty (1550–1069 BCE). It is
now established that Thutmose I built both
the Fourth and Fifth Pylons, and the platform
between them was planned as a unit, thus
indicating that both gateways were built at a single
time, along with the court. The court began

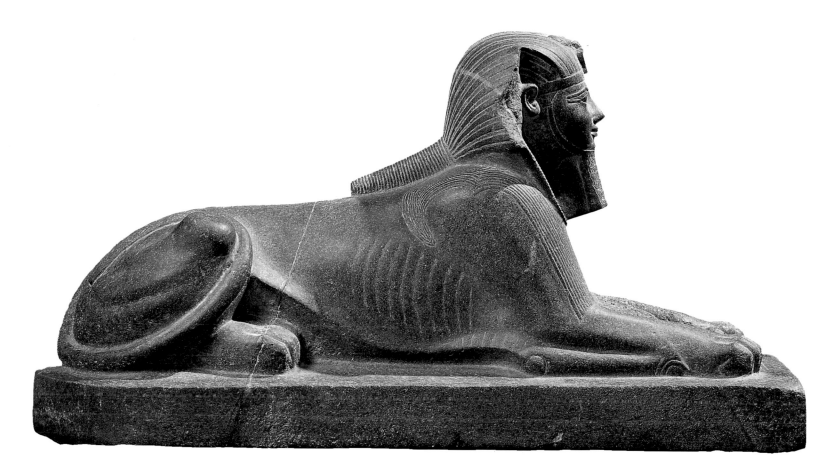

as one open to the sky, but later, in a second building phase, Thutmose I had the series of Osiride statues placed there and created a peristyle court, roofing over the columns he had erected. Sixteen statues stood in the northern half of the hall and twenty in the southern. Of the thirty-six sculptures, this one bears the only completely preserved face, although fragments of some remain in situ. All the statues bore the name of Thutmose I, and none shows any trace of name changes. In the period following Thutmose I's decoration of the hall, Hatshepsut altered it into a Wadjyt Hall, meaning she changed the columns to papyriform ones, of wood supporting a wooden roof. She had already erected her two great obelisks by that time. Both she and Thutmose III (1479–1425 BCE) avoided dismantling or obscuring the statues of her father, Thutmose I, but late in his reign and in that of his son, Amenhotep II (1427–1400 BCE). Hatshepsut's obelisks were hidden by stone masonry adorned with four Osiride figures of Thutmose III. **Betsy M. Bryan**

1. Luc Gabolde and Jean-François Carlotti, "Nouvelles Donnés sur la Ouadjyt. I. La chronologie relative des enceintes du temple et les murs de la Ouadjyt: es sondage à l'angle nord-est de la salle," *Cahiers de Karnak II* (forthcoming).

3 Sphinx of Thutmose III

Eighteenth Dynasty, reign of Thutmose III, 1479–1425 BCE; granodiorite. Height 33 cm (13 in); width 21.5 cm (8 7/16 in); depth 62.5 cm (24 5/8 in). Karnak, court of the cachette. The Egyptian Museum, Cairo JE 37981/CG 42069

• Carved for King Thutmose III, this imposing statue, once stood in the temple complex of Karnak. Its original position in the temple is unknown, but it probably lay near one of the main features constructed there by Thutmose III: the court between the Fifth and Sixth Pylons, in front of the sanctuary; the Seventh Pylon, south of the sanctuary; or the festival temple known as the Akhmenu, behind the sanctuary. From the Middle Kingdom onward, royal and private statues were continually erected within the temple complex. To make room for them, older statues were occasionally removed and ceremoniously

buried in the court in front of the Seventh Pylon. Eventually more than seventeen thousand statues were disposed of in this cachette, including Thutmose III's sphinx.

The sphinx form, combining the human head of a king with the body of a lion, is generally thought to have symbolized the pharaoh's might. Set within the temple of Karnak, it would have served both to perpetuate the king's presence there and to protect the image of the temple's god, Amun-Re. In this example the king's head wears the royal *nemes* headdress with a uraeus, and the royal beard; the beard was part of the king's ceremonial regalia and was tied on by means of straps, shown here on either side of the face. The king's face exhibits the typical features of Thutmose III's statuary, with its slightly arched nose and pleasant mouth. The lion's body masterfully evokes the animal's latent power, even though a number of its features, such as the ribs and mane, are stylized rather than realistic (see fig. 9, "Art in the Afterlife").

The sphinx was a favorite form of Thutmose III, who had at least fourteen such statues created for him. In his case the image was partic-

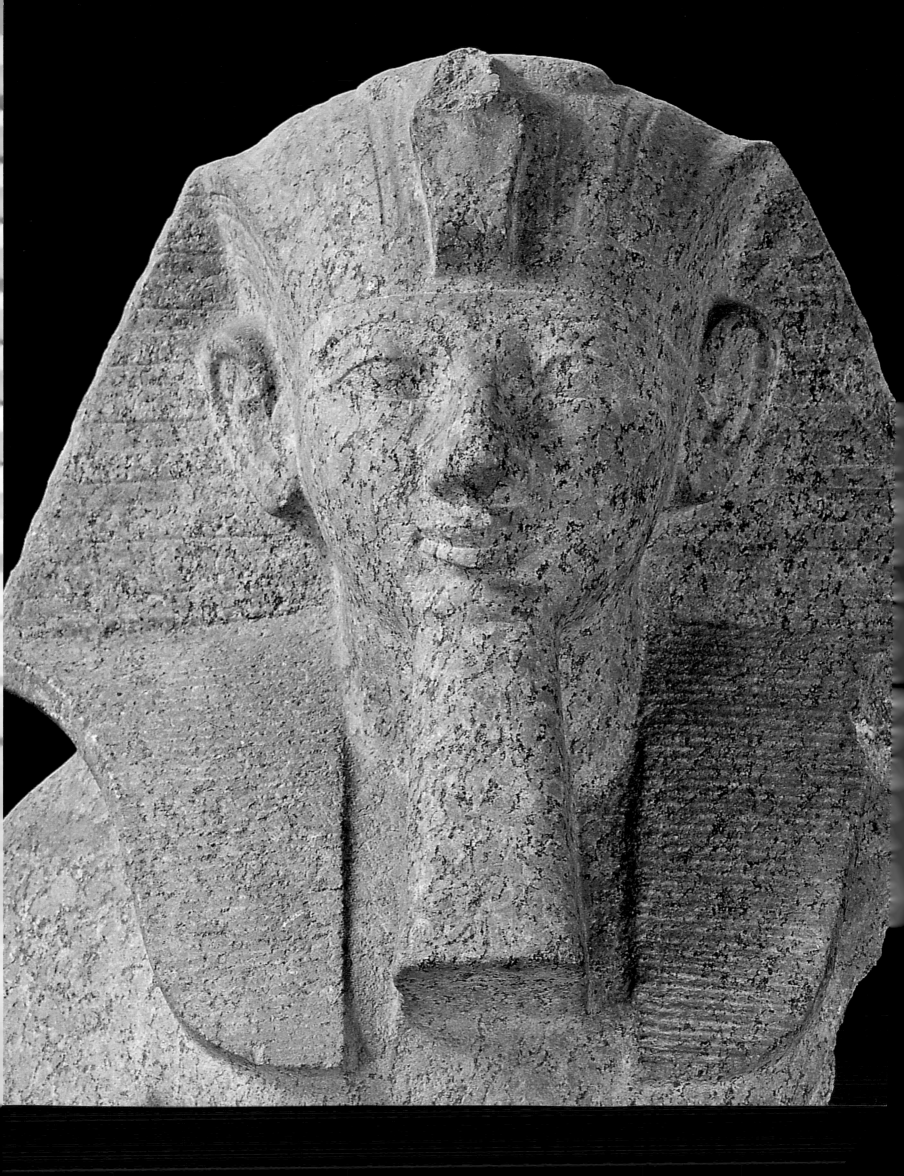

5 Fragment of an obelisk

Nineteenth Dynasty, reign of Ramesses II,
1279–1213 BCE; red granite. Height 335.6 cm
(140 in); width 101.6 cm (40 in); depth 139.7 cm
(55 in). Tanis (possibly taken from Pi-Ramesses);
Supreme Council of Antiquities, Tanis

• This fragment of an obelisk was most recently
at the site of Tanis (modern San el-Hagar),
located in the northeastern Delta. Tanis was the
residence and burial place of the Twenty-first
and Twenty-second Dynasty kings, but much of
the city was constructed using older materials
taken from nearby sites. This obelisk fragment is
one such example of re-used material. It is in-
scribed with names and images of Ramesses II,
who reigned during the Nineteenth Dynasty,
and may have originated at his own capital city,
Pi-Ramesses, located not far south of Tanis.

This is the top portion of an obelisk fash-
ioned out of red granite. Standing over 335.6 cm
(eleven feet), only two of its four sides are well
preserved, and portions of its pyramidion are
damaged. However, what remains is enough to
determine that its original owner was Ramesses II.
Carved in sunken relief, the uppermost deco-
ration consists of epithets of the king, as well as
his *nomen* and *prenomen*, both enclosed in car-
touches. Only one side of the pyramidion inscrip-
tion can be read in full, but what remains on
the damaged side suggests that the glyphs were
the same there. They read: "Lord of the two
lands, Usermaatre-Setepenre" and "Lord of
appearances, Ramesses, Meryamun, given life
like Re."

Below Ramesses' epithets and names are
two offering scenes, also carved in sunken relief.
They depict Ramesses kneeling and making offer-
ings to the god Atum. On one side of the obelisk,
Ramesses is shown wearing a cloth headdress
known as the *nemes;* on the other side, he wears a
wig topped by plumes, ram's horns, and a sun
disk. It is only possible, however, for us to observe
the god to whom Ramesses is offering on one
side of this obelisk. The god is shown seated on
a throne wearing the double crown of Upper
and Lower Egypt. This is the usual headdress of
Atum, and the *was*-scepter and ankh that he

holds in his hands are his customary insignia.
Above the heads of Atum and Ramesses is an
inscription bearing their names. Atum is called
"Lord of the two lands, the Heliopolitan" and
Ramesses, like the inscription on the pyramidion,
is both "Lord of the two lands" and "Lord of
appearances."

Below the offering scene on both sides of
the obelisk is a Horus falcon wearing the double
crown. Behind the falcon is a sun disk with a
uraeus hanging from it, and the uraeus holds

an ankh. All are carved in low relief. These royal
symbols are the markers of a king's Horus name,
which is usually written inside a rectangular
frame with a niched facade at the bottom, called
a *serekh*. On this obelisk fragment, only the upper
portion of the rectangular frame and the first
two words of Ramesses' Horus name remain. They
are *ka-nakht* or "strong bull." The rest is broken
off, but would have continued down the side
of the obelisk, most likely followed by Ramesses'
other names as well.

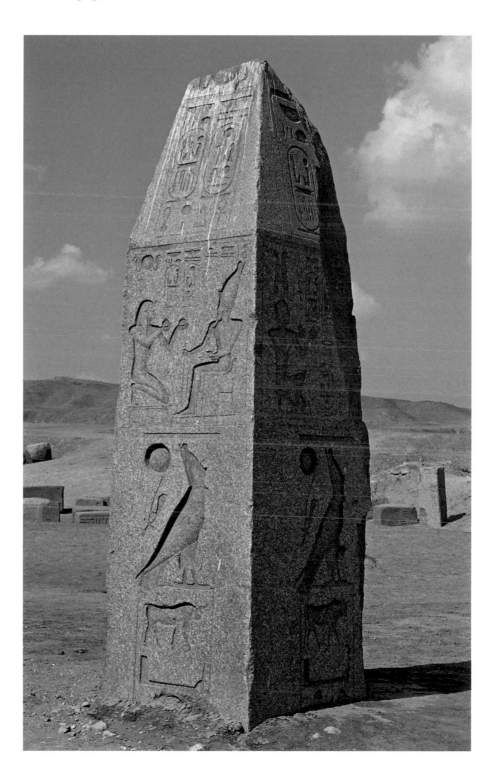

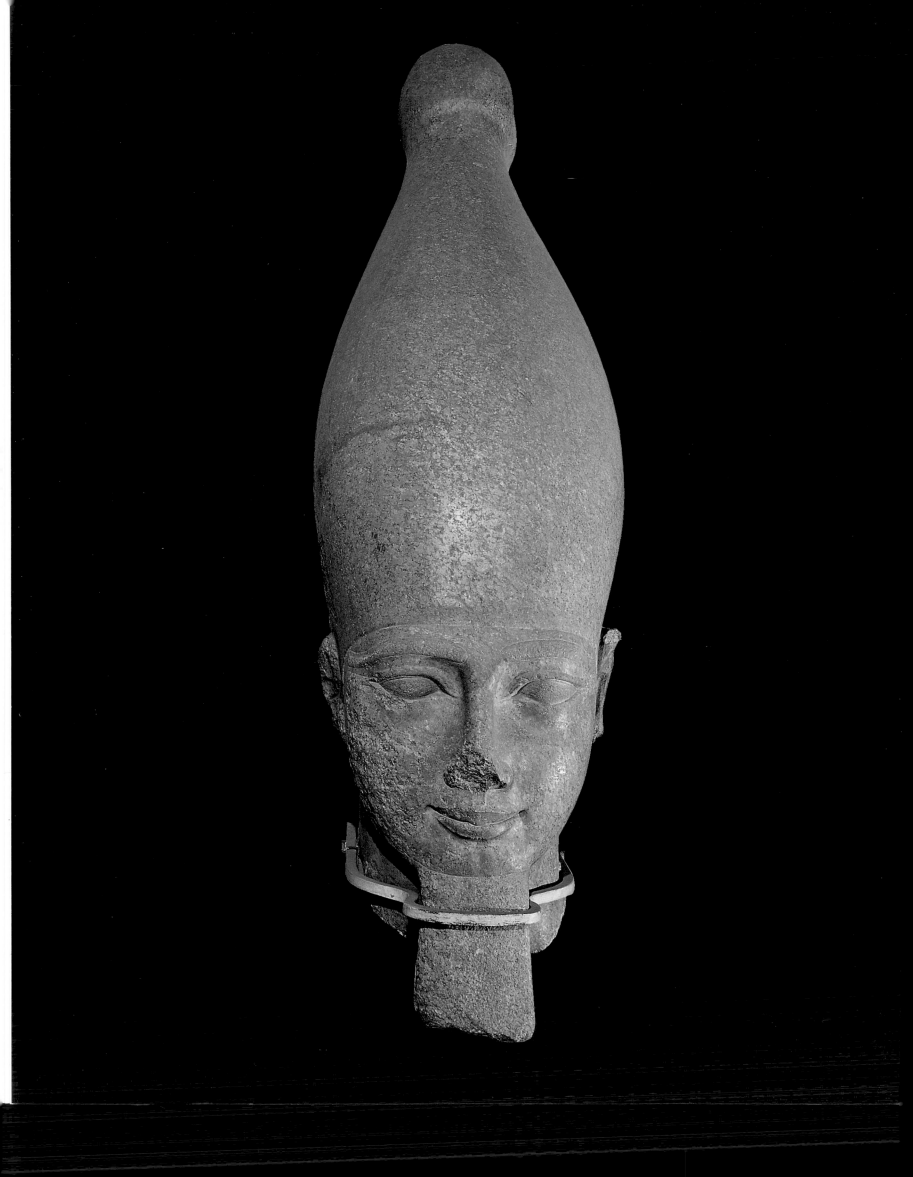

13 Colossal head of Ramesses II usurped from Senusret I

Nineteenth Dynasty, reign of Ramesses II, 1279–1213 BCE, and Twelfth Dynasty, reign of Senusret I, 1956–1911 BCE; red granite. Height 230 cm (90 9/16 in); width 71.5 cm (28 1/8 in); depth 106 cm (41 3/4 in). Memphis. The Egyptian Museum, Cairo CG 644

• Ramesses II has left more monuments bearing his name and/or face than has any ruler of Egypt. In many cases, however, the objects did not originally carry either his name or portrait. Ramesses took over the statues and buildings of other kings with frequency and industry. While we might consider this activity as usurpation, it may not have been perceived as such by Ramesses. Indeed, when a king with the affluence and power of Ramesses II chose to recarve a statue of an earlier pharaoh, he may have expected to partake of the greatness of that ancestor. In the case of this statue and several others from Memphis,[1] the Nineteenth Dynasty king placed his own face on a colossal, 6.7 meters (22-feet) striding image of Senusret I, second king of the Twelfth Dynasty. Senusret, like Ramesses II, ruled a long time and left his monuments prominently visible even seven hundred years later. He was responsible for the early complex at Karnak Temple, where his greatest official, Mentuhotep, left statues of himself near the central part and where he built for Senusret a temple to Amun-Re recalling the sun god Re's sanctuary in Heliopolis.[2] In the case of this statue and at least four others like it, Senusret apparently punctuated a temple entrance at Memphis with colossal images of himself.

The careful viewer of this statue will see the hallmarks of the artists whose task it was to turn Senusret I into Ramesses II. Look at the sides near the ears, where the chin strap has been narrowed and cut over the lower border of the crown. The crown meets the face at the brow with a higher surface, suggesting the entire face was cut down for reshaping. The face of Senusret I differed greatly from that of Ramesses II, but the later king's artists attempted to preserve links to the earlier work. Ramesses' eyes, for example, are normally more ovoid in shape than those of Senusret I, but despite this reshaping the sculptors added a heavy and wide lid line above the eyes and a deeply cut lower lid as well, features seen on the portraits of Senusret. In adapting the eyes, the artists widened the corners. According to Hourig Sourouzian, who recently commented: "With good light, one can still discern… traces of the original spring of the upper lid and the remnants of the deeply cut horizontal inner canthi."[3] Ramesses' mouth is far fuller than that of Senusret and is modeled on that of Amenhotep III. Profiles of statues of Senusret show that king's mouth protruding prominently beneath the nose. Ramesses' artists carved back the mouth surface to re-create the lips, and the profile now shows little or no protrusion. **Betsy M. Bryan**

1. David Jeffreys, Jaromír Malék, and H.S. Smith, "Memphis 1985," *Journal of Egyptian Archaeology* 73 (1987): 19, gives a list of Ramesside statuary from Memphis. G7 is CG 643.

2. For the Middle Kingdom form of Karnak, see Luc Gabolde, *Le "grand château d'Amon" de Sésostris I er à Karnak: La décoration du temple d'Amon-Ré au Moyen empire.* Paris, 1988.

3. Hourig Sourouzian, "Standing Royal Colossi of the Middle Kingdom Reused by Ramesses II," *Mitteilungen des Deutschen Archäologischen Instituts, Abteilung Kairo* 44 (1988): 231.

14 Sennefer and Sentnay

Eighteenth Dynasty, reigns of Amenhotep II and Thutmose IV, 1427–1390 BCE; granodiorite. Height 135 cm (53 1/8 in); width 76 cm (29 15/16 in); depth 67 cm (26 3/8 in). Karnak, Temple of Amun-Re, north of the Great Hypostyle Hall, discovered by George Legrain 1903. The Egyptian Museum, Cairo JE 36574/CG 42126

• This statue of Sennefer, the mayor of Thebes, and his wife, Sentnay, represents them seated on a high-backed chair. Their bodies are carved in high relief with arms interlaced. Sennefer wears a heavy wig that reaches to his shoulders but leaves his ears exposed. He has a slight smile and the features of a middle-aged man. Sentnay's face is narrower than that of her husband and does not have the extended eyeline that prolongs the corners of his eyes. Their faces, however, have almost identical features: well-defined almond-shaped eyes and eyebrows in relief, a straight nose with a rather wide base, and a small, fleshy mouth.

Around Sennefer's neck is the massive *shebyu* collar of four strands that would have been composed of gold rings. He is also wearing a double heart-shaped necklace and a long skirt with a knot at his waist. His right arm rests flat on his lap. Sentnay is seated to his left wearing a long tripartite hair wig with thin braids that cover her ears, a broad collar, and a long tight dress with two shoulder straps.

Between the couple is one of their daughters, Mutnofret, represented on a much smaller scale and standing on a small base. She is wearing a long dress and a long tripartite wig ending in braids. She is positioned once again on the right side of the chair sitting in front of an offering table sniffing a lotus flower (detail, p. 97). The scene is repeated on the left side of the chair but with her sister Nefertari.

New Kingdom elites were keen to put their statues in the temple of Karnak in order to receive the offerings and blessings of visitors. The owner of this statue was rewarded with this privilege. Sennefer was the mayor of Thebes during the reign of Amenhotep II, and his wife, Sentnay, was the royal wet nurse. His tomb at Thebes, famous for its beautiful scenes and grape

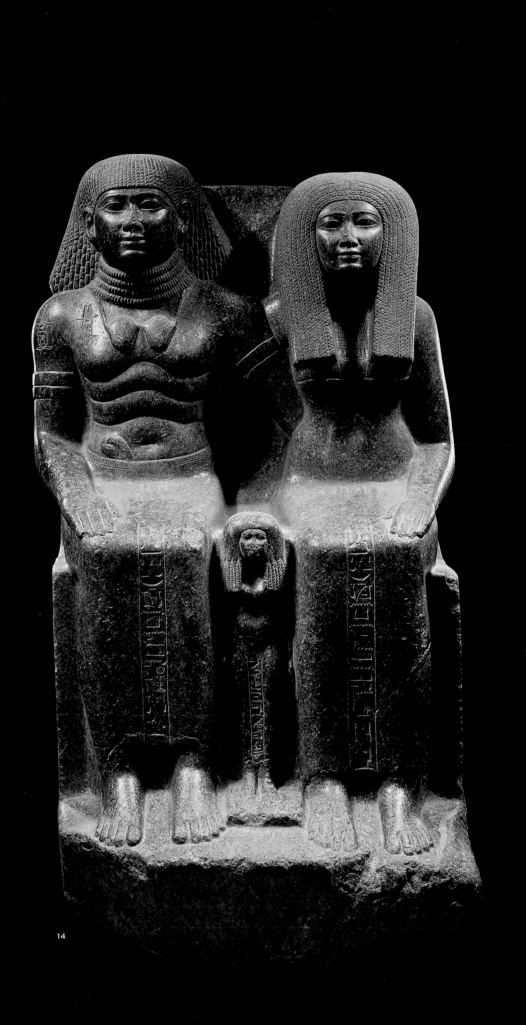

arbor ceiling, is another mark of the high prestige of this couple. The massive collar and the necklace, as well as the armlets, are part of an honorific award from the king for his distinguished duties. Sennefer proudly wears this "gold of favor," which began in the time of Thutmose III, both on his statue and in the painted scenes of his tomb.

The stylized folds of fat on Sennefer's torso are a sign of well-being and a prosperous life according to popular fashion in the Eighteenth Dynasty, originating in the Old Kingdom (2686–2125 BCE; compare the statue of Amenhotep, son of Hapu, cat. 15). The interlacing arms were also a fashion of the New Kingdom, as was the appearance of children between the legs of their seated parents, especially in the Eighteenth Dynasty, although this tradition goes back to the Old Kingdom as well.

Two cartouches of King Amenhotep II are incised on Sennefer's right shoulder. Cartouches on the shoulder first appeared on private statues in the reign of Thutmose III and became more common in the later New Kingdom.

On the left side of the seat, next to the scene of the daughter Nefertari, is an inscription identifying two draftsmen, or artisans, Amenmose and Djed-khonsu. This has been thought to be a signature for the statue, but could also be an addition intended as a votive offering to invoke Sennefer's intermediacy. The addition could date from the Eighteenth to the Twenty-first Dynasties.

Fatma Ismail

14

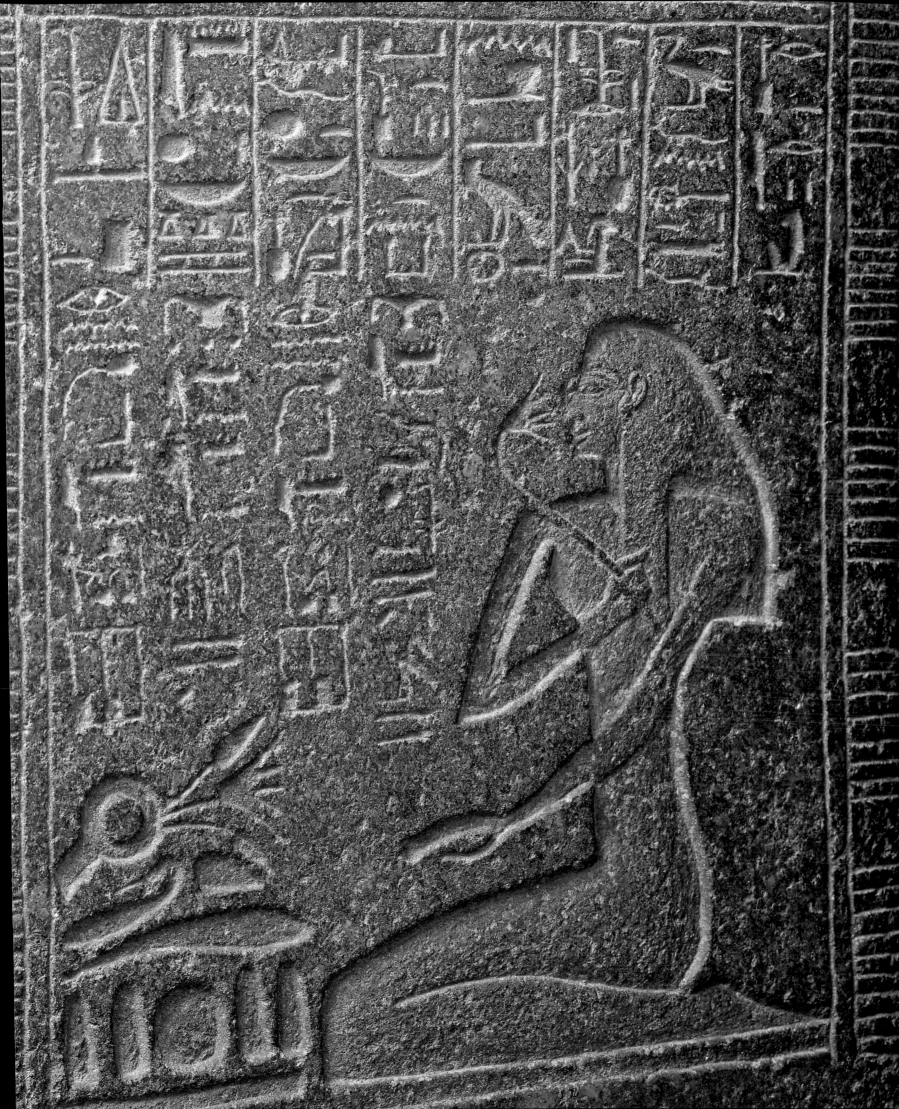

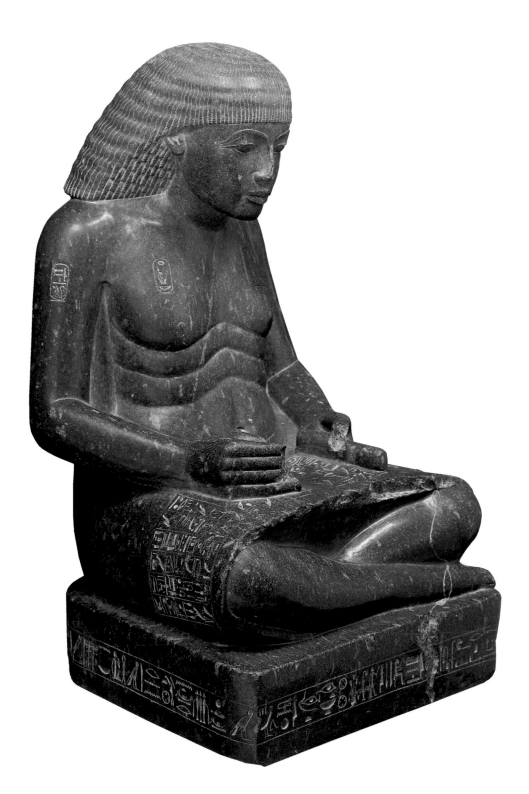

15 Amenhotep, son of Hapu, as a scribe

Eighteenth Dynasty, reign of Amenhotep III, 1390–1352 BCE; granodiorite. Height 125 cm (49 3/16 in); width 73.5 cm (28 15/16 in); depth 71 cm (27 15/16 in). Thebes, Karnak, Temple of Amun-Re, north face of Tenth Pylon, east side of doorway, excavations of Legrain, 1913. The Egyptian Museum, Cairo JE 44861

• The scribe statue, seated cross-legged, a papyrus roll stretched over his lap, has had a long and distinguished history in Egyptian art, and the highest officials were proud to display themselves in this deceptively humble attitude. This magnificent example is one of a pair showing Amenhotep, son of Hapu, Amenhotep III's greatest official and one of the most important individuals in Egyptian history, that were in a prominent position in Amun's temple at Karnak.[1] The inscription on the papyrus is oriented toward the sitter and reads:

Placed as a favor from the king to the hereditary prince, count, sealbearer of the king of Lower Egypt, royal scribe, scribe of recruits Amenhotep, vindicated, who says, "The king placed me as overseer of works in the mountain of quartzite to direct the monuments of his father, Amun of Karnak. I brought back numerous great monuments consisting of statues of his majesty of skilled work, brought from Lower Egyptian Heliopolis to Upper Egyptian Heliopolis, that they may rest in their place in western [Thebes]. My lord did something useful for me, placing my image in the house of Amun, knowing it would remain [there] for eternity.

Quartzite, with its ruddy hue, was considered the most solar of stones. As overseer of recruits, Amenhotep, son of Hapu, had all the country's manpower at his disposal to carry out the king's orders. Enormous quantities of quartzite quarried at Gebel Ahmar (Lower Egyptian Heliopolis), near present-day Cairo, were then shipped some seven hundred kilometers upstream to Thebes (Northern Egyptian Heliopolis) to adorn the courtyards and pylons of Amenhotep III's vast buildings at Karnak and on the west bank with monumental images of the king. Perhaps the most famous are the two seated figures known as the Colossi of Memnon, which

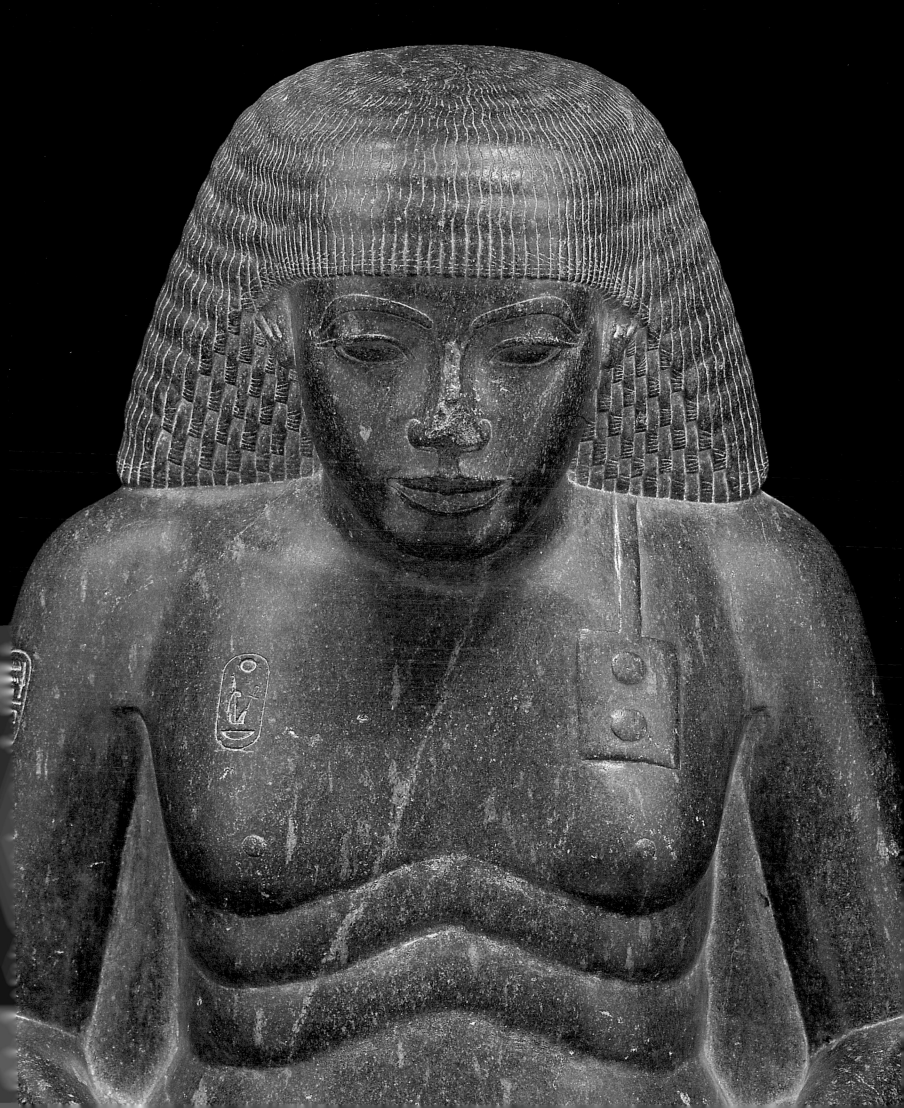

The ancient Egyptians strove to equip their dead with magical means by which to pass protected through the netherworld, the necessities of daily life, and as many luxuries as possible. The most important of the royal tomb furnishings were coffins, sarcophagi, and canopic equipment. Statues of the king preserved his image, and images of the gods and goddesses strengthened the connection between the king and the deities. Persons of royal stature were interred with stores of foods and beverages, amuletic jewelry, *ushebtis*, fans, mirrors, cosmetics, perfumed oils, items of furniture, and symbols of their office and status.

17 Girdle of Mereret

Twelfth Dynasty, reign of Senusret III, 1870–1831 BCE; gold. Extended length 40.8 cm (16 in). Dahshur, Pyramid precinct of Senusret III, tomb of Mereret. The Egyptian Museum, Cairo CG 53074

• On 8 March 1894, working in one of the galleries inside the enclosure wall of the pyramid of Senusret III, Jacques de Morgan uncovered a box inlaid with gold underneath the floor of a room that contained an empty coffin. Inside was a large hoard of jewels and cosmetic items belonging to Princess Mereret, daughter of Senusret III and sister of Amenemhat III (1831–1786 BCE). This splendid cowrie-shell girdle was part of her hoard.

Large and small shells have been strung together here, although originally they may have been part of two separate girdles, some parts of which are missing. One shell consists of two parts, one of which has a tongue and the other, a groove. Slotted together, they served as an invisible clasp. The shells are hollow inside, but contain tiny pellets that would have jingled seductively as the princess walked. The shells were made as identical halves, cast over a solid mold, soldered together, and then chased with parallel incised lines to represent the lip of the shell.

Because their shape recalls the vulva, cowries were associated with fertility. Marine shells were imported into the Nile Valley as early as the Badarian Period (c. 4400–4000 BCE), and included in tombs. Girdles of cowry shells are first depicted with some frequency from the early Middle Kingdom on (2055–1650 BCE), when they are worn by otherwise nude servant girls or concubine figures. Many of the royal princesses included them in their burial equipment. Sit-Hathor-Yunet, a daughter of Senusret II (1877–1870 BCE), had two splendid examples in her tomb at Lahun, one of which consisted of both cowrie shells and acacia seeds, and the other, of panther heads, which undoubtedly provided protection to the wearer.

Girdles continued to be popular in the New Kingdom (1550–1069 BCE), but the cowrie shape was reduced to a semicircle decorated with parallel incised lines around the curved edge.
Rita E. Freed

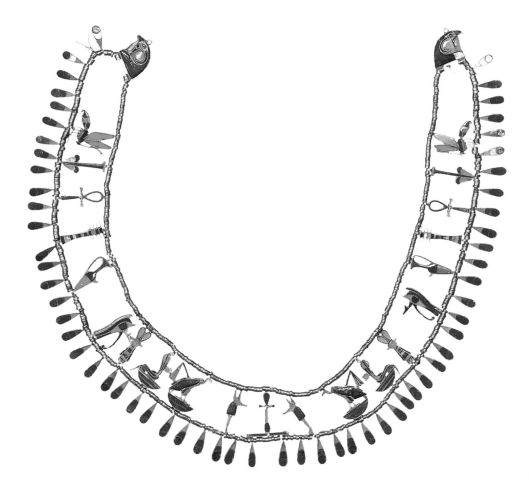

18 Necklace of

Princess Khnumet

Twelfth Dynasty, reign of Amenemhat II, 1911–1877
BCE; gold, carnelian, lapis lazuli, turquoise.
Total length 34.9 cm (13 3/4 in); width 2 cm (13/16 in).
Dahshur, funerary complex of Amenemhat II.
The Egyptian Museum, Cairo JE 31113, JE 31115

• Many would say the Middle Kingdom repre-
sented a high point of the jeweler's art, and this
is nowhere better reflected than in the delightful
collar of Khnumet, daughter of Amenemhat II
and wife of Senusret II (1877–1870 BCE). In 1894
Jacques de Morgan discovered her intact burial
at Dahshur within the enclosure wall of her
father's pyramid.[1] The jewels were found directly
on her mummy, but unfortunately their exact
order could not be recovered. Accordingly, the
individual elements were subsequently restrung
in an arbitrary way.[2]

Broad collars were important elements
in the funerary parure from the Old Kingdom
on (2686–2125 BCE), judging from the frequency
in which they were found on mummies, repre-
sented in sculpture, depicted on tomb or coffin
walls, and mentioned in the funerary literature.[3]
Traditionally, they were composed of rows of
tubular beads separated by tiny disk beads. Here,
the tubular beads were replaced by amuletic
hieroglyphs, which represent such good wishes
as long life, kingship, stability, and health. Each
element is composed of gold cloisons into which
semiprecious stones have been precisely fitted
and then polished. The gold most likely came
from the Eastern Desert or Nubia, the turquoise
from Sinai, and the lapis lazuli from Afghanistan.
Only carnelian would have been readily available
throughout the Egyptian desert. Although fal-
con-headed terminals are depicted as early as the
Sixth Dynasty (2345–2181 BCE),[4] Khnumet's are
among the first actual examples. The pleasing
juxtaposition of color gives this necklace a vitality
that is unsurpassed. Few jewels today can match
its delicacy.

In addition to other necklaces, Khnumet
went to her tomb wearing three bracelets on each
arm. An additional hoard of jewelry was found
under a cosmetic box on the floor of the offering
chamber. Altogether, there were more than two
thousand beads, pendants, bracelets, and diadems.
Some of the elements are thought to exhibit
Aegean influence.[5] Although three of Khnumet's
sisters were buried near her, none of them were
buried with the same quantity or variety of
jewelry. She must have been her father's favorite.

Rita E. Freed

1. Jacques de Morgan, *Fouilles à Dahchour en 1894–1895* (Vienna,
1895–1903), vol. 2, 40ff and pl. 2.

2. Ibid., 51.

3. For a detailed treatment, see Edward Brovarski, "Old Kingdom
Beaded Collars," in Jacke Phillips, ed., *Ancient Egypt, the Aegean,
and the Near East: Studies in Honor of Martha Rhoads Bell, vol. 1*
(San Antonio, 1997), 137–62.

4. Dwarf jewelers make them in a relief in the tomb of Mereruka,
as cited by Alix Wilkinson, *Ancient Egyptian Jewellery* (London,
1971), 32.

5. Ibid., 66.

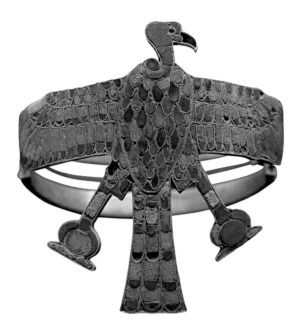

24 Vulture bracelet of
Queen Ahhotep

Eighteenth Dynasty, reign of Ahmose I, 1550–1525
BCE; gold, inlaid with lapis lazuli, carnelian, and
turquoise. Height 7 cm (2¾ in); width 7.5 cm
(2¹⁵⁄₁₆ in); depth 7 cm (2¾ in). Dira Abu el-Naga,
Mariette excavations 1859. The Egyptian Museum,
Cairo JE 4679/CG 52068

• The vulture bracelet said to have been found
on the body of Queen Ahhotep is a rigid ring
made in two pieces and connected by two hinges,
one of which opens with a removable pin. The
front part of the bracelet consists of a vulture
with feathers and other features detailed in red,
dark blue, and turquoise enamel cloisonné. The
head and talons are of lapis and the eye of red
carnelian. The wings of the vulture are spread,
stretching out in a curve that ends at the two
hinges; its head, body, and tail are thus perpen-
dicular to the bracelet. The head, tail, and talons,
which may have been visible when the bracelet
was worn, are also given some incised details
on the gold inner face of the bracelet. In its talons,
the vulture holds two *shen* hieroglyphs, loops
of rope that represent eternity.

The vulture is the animal that represents
Nekhbet, an Upper Egyptian goddess who is
often shown as a protector of the king. Queens
are especially associated with this vulture god-
dess, in that one of the most common form for
the queens' crowns is a vulture clasping the top
of the lady's head. However, in funerary context,
Nekhbet may have had special meaning as a pro-
tector of the dead. Like the mortuary god Anubis,
who is represented by a jackal, Nekhbet is associ-
ated with an animal that one would otherwise
assume might threaten the safety of the dead,
since cemeteries are often disturbed by vultures
and jackals. By assigning those forms to divinities,
the Egyptians turned these threats into a magical
protection for the bodies of the dead. Vultures
are often shown hovering protectively on the ceil-
ings of tombs and temples.

The back part of the bracelet also shows
an Upper Egyptian emblem—the blue lotus.
Two lotus buds of turquoise cloisonné touch the
hinges of the bracelet, with their stems curving
back to join at a red carnelian disk. The design is
framed by two rounded bands of gold striped
with lapis, above and below the gold wires that
represent the stems of the lotus buds. It would
be tempting to connect these two Upper Egyptian
motifs to the queen's political origins: her
dynasty originated in Upper Egypt, from which
they reunited the country, freeing the north from
the rule of a Syro-Palestinian people, the Hyksos,
by means of a war in which Ahhotep may have
played a part. However, the vulture and lotus are
far too common in jewelry designs to make such
a speculation certain. **Ann Macy Roth**

25 Coffin lid of
Queen Ahhotep

Eighteenth Dynasty, reign of Ahmose I, 1550–1525
BCE; wood; gilded colored wood. Height 216 cm
(85¹⁄₁₆ in); width 70 cm (27⁹⁄₁₆ in); depth 26 cm
(10¼ in). Dira Abu el-Naga, Mariette excavations
1859. The Egyptian Museum, Cairo CG 28501

• In February 1859 the excavations of Auguste
Mariette in Dira Abu el-Naga, near ancient
Thebes, turned up a large gilded coffin dating to
the early Eighteenth Dynasty. The coffin is often
said to have been loose in the fill, but both its
depth and the fact that it was accompanied by
four jars containing embalmed organic material
suggest that the workmen had discovered an
intact burial. The objects found there, made of
gold and other rare materials, and bearing the
names of two kings, Kamose and Ahmose, would
tend to support this idea. The circumstances are
obscure because the excavation was unsupervised,
and the finds were delivered to the local governor,
who discarded the body after unwrapping it.

The owner of the coffin was a queen named
Ahhotep. She was almost certainly not, as is
often stated, the famous Queen Ahhotep who was
the mother of Ahmose, the founder of the Eigh-
teenth Dynasty. The coffin of the more famous
queen was found in the Deir el-Bahari cache,
and was later, both in style and in the form of its
inscriptions. The Dira Abu el-Naga coffin does
not bear the all important title "king's mother,"
though the owner was a king's wife, probably
the wife of Tao II and the mother of a little
prince who died young and whose statue is in the

Louvre. Like the other monuments of this queen, her coffin and all of the burial equipment found with it use a form of the "Ah," or moon sign, that is not used after the twenty-second regnal year of Ahmose.

The coffin depicts the queen's face and neck, as well as a stylized wig with a royal uraeus at the brow. Her wig is of the Hathoric type popular in the preceding Middle Kingdom period (2055–1650 BCE), ending in two curls that wrap around a blue spool or ball. The queen's almond-shaped eyes are inlaid, the whites with Egyptian alabaster (calcite) and the irises with a black stone, possibly obsidian. Her eyebrows and cosmetic lines are indicated in blue paint. The shape of her body and feet are indicated only generally. With the exception of her face, the entire coffin is covered with a variety of different patterns of feathers and is known as a *rishi*, or feathered, coffin. This type was developed in the Seventeenth Dynasty (1580–1550 BCE), when it was common, but was restricted to royalty from the Eighteenth Dynasty. The feathers may represent the wings of a goddess wrapped around the body of the deceased for protection.

The pectoral represented on the chest of the coffin shows a vulture and a cobra, the two goddesses — Isis and Nephthys — who are associated with the protection of a king. The cobra and vulture pectoral is common on coffins of non-kings as well as kings, because these animals are also associated with the god Osiris, a dead king who was resurrected in the *duat*, the realm of the gods. A form of Osiris that combines him with two older mortuary gods, Ptah and Sokar, is mentioned in the offering formula that runs down the front of the coffin:

May the king give an offering to Ptah-Sokar-Osiris, the lord of Buto and the lord of Abydos, and Hathor, the chief lady of Aphroditopolis[?], that they may give invocation offerings of bread, beer, meat, poultry and every pure thing on which a god lives, all the good products of the Beloved Land [Egypt] and everything goes forth from the altar of Osiris to the *ka* of the great royal wife, she who is joined with the white crown, Ahhotep, may she live forever.

Ann Macy Roth

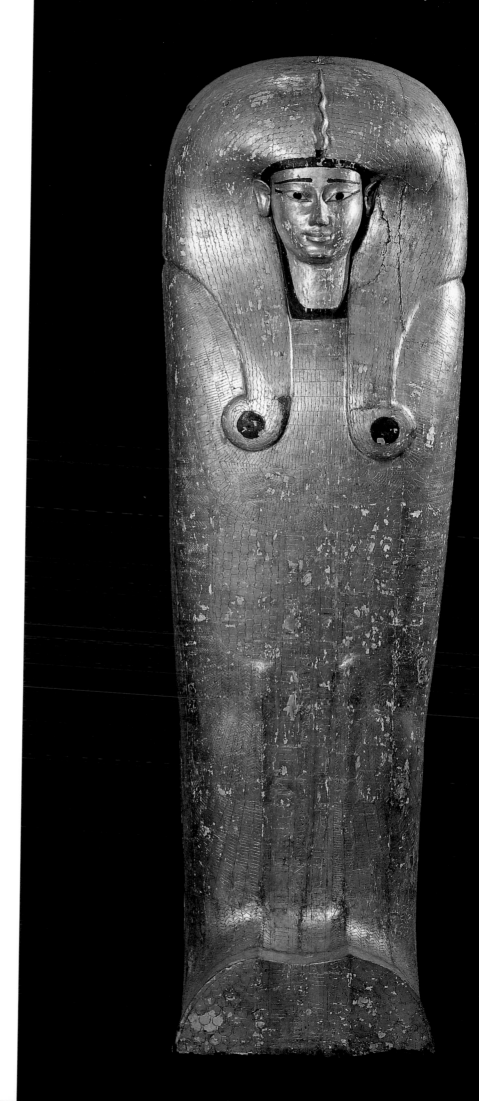

26 Ankh

Mid-Eighteenth Dynasty, reign of Amenhotep II, c. 1427–1400 BCE; painted wood. Height 53 cm (20⅞ in); width 26 cm (10¼ in) depth 3 cm (1³⁄₁₆ in); Tomb of Amenhotep II, Thebes. The Egyptian Museum, Cairo JE 32547

• This exquisitely crafted wooden figure of an ankh, the Egyptian symbol of life, was among the objects excavated by Victor Loret in 1898–99 at the tomb of King Amenhotep II in the Valley of the Kings. About forty objects of a similar kind were discovered there. Also found in the same tomb were numerous *djed* pillars of wood painted in various colors (see cat. 27). Much of the original blue pigment has been erased. This object, crafted in two sections, resembles the numerous smaller ankh-signs of faience and other materials that were among the most popular of Egyptian amulets. It is difficult to be sure precisely what function, if any, these figures had beyond their protective magical effect. They were probably custom-made for the king in his tomb to guarantee new life for him in the beyond.

The ankh is one of the most potent symbols represented in Egyptian art. It frequently forms part of decorative motifs. Ankh signs were commonly carried by deities in human or partly human form. Gods are seen placing them in front of the king's face to symbolize the breath of life. In the art of Akhenaten, the sun disk has arms that end in ankh signs. The significance of the ankh is often misunderstood as applying only to the mundane world, whereas words associated with ankh refer also to life in the netherworld. Hence the dead are called *ankhu,* and *neb-ankh* (possessor of life) is a common term for the sarcophagus. What the sign itself represents is disputed. Sir Alan Gardiner thought it showed a sandal strap, but if so, the symbolism is obscure, and the idea has found little favor. Wolfhart Westendorf felt it was associated with the *tyet* emblem or the "knot of Isis," both in his view being ties for ceremonial girdles. Winfried Barta connected the ankh with the royal cartouche in which the king's name was inscribed. It seems to be an evolved form of, or otherwise associated with, the Egyptian glyph for magical protection, *sa.* The presence of a design resembling a pubic triangle on one ankh of the New Kingdom (1550–1069 BCE) lends support to the idea that the sign may be a specifically sexual symbol. Perhaps, indeed, it combines female and male elements— a kind of abbreviated version of the Hindu lingam-yoni. It is significant that ankh was the word for "mirror" from at least the Middle Kingdom (2055–1650 BCE) onward. Mirrors shaped like ankh signs are not uncommon. Life and death mirror each other, and mirrors are employed in many cultures by shamans for purposes of divination. In any case, the symbolism is multi-layered. The ankh survived into the Christian era and was used by the Copts on their funerary stelae. **Terence DuQuesne**

27 *Djed* pillar

Mid-Eighteenth Dynasty, reign of Amenhotep II, 1427–1400 BCE; painted wood. Height 54 cm (21¼ in); width 24 cm (9⁷⁄₁₆ in); depth 2.5 cm (1 in). Tomb of Amenhotep II, Thebes. The Egyptian Museum, Cairo JE 32386.

· Like the blue-painted wooden ankh (cat. 26), this figure of a *djed* pillar forms part of the Loret excavations of the tomb of Amenhotep II. Many similar objects were excavated there. The wood is painted in various colors, the crosspieces rendered in yellow and the bands between them in (from top) blue, green, and red. The lower part of the *djed* consists of thick bands of blue, yellow, green, blue, red, green, and blue, between each of which is a narrower band of yellow. As in the case of the ankh from Amenhotep II's tomb, the workmanship of this object is very fine.

The *djed* pillar is one of the most important symbols of Osiris, lord of the netherworld, protector of the justified soul, and judge of the dead. Osiris is also a deity of plant fertility, and the pillar may be a schematic representation of a sacred tree, though the fact that early examples are made of ivory militates against this theory. Alternatively it could represent a pole to which sheaves of grain were attached. In any case, it is a very ancient sacred object. A ritual of erecting the *djed* pillar was carried out by the pharaoh himself, no doubt to ensure the continuing fertility of the fields and to guarantee that the god himself, as corn king, was periodically revived. A further purpose in raising the *djed* was to repel the god Seth, enemy of Osiris and incarnation of the chaos factor. The *djed* emblem was associated not only with Osiris but also with the Memphite god Ptah, and probably with Sokar. These connections would suggest an origin in Memphis, capital of Egypt during the Old Kingdom (2686–2125 BCE) and a perennial sacred center. Ptah, Sokar, and Osiris were merged into a single composite deity in the course of the New Kingdom (1550–1069 BCE). Perhaps because of the resemblance of the pillar to a spinal column, it was represented on the bottom of New Kingdom coffins in line with the actual location of the backbone. The symbolism of the *djed* is indicated by the meaning of the word in Egyptian: "firmness, capacity to endure."
Terence DuQuesne

28 Thutmose III

Eighteenth Dynasty, 1550–1069 BCE; wood. Height 79 cm (31⅛ in); width 23 cm (9¹⁄₁₆ in); depth 30 cm (11¹³⁄₁₆ in). Tomb of Thutmose III. The Egyptian Museum, Cairo CG 24901

· The plundered tomb of Thutmose III, one of Egypt's greatest military leaders, contained only a few objects when reopened in 1898. Among the pieces still remaining were an alabaster vase belonging to his wife, a model boat, faience plaques, and this statue of the king. Pharaohs placed their stone images, whose purpose was to receive offerings for eternity, at temple sites, as opposed to in their burials, where wooden statues functioned adequately. Here, Thutmose holds a typical stately pose. His left leg strides forward, hinting at the Egyptian king's capacity for action. The left arm is bent, grasping a cane or staff that is now missing, while the right arm remains at his side, the hand curled around what probably was a scepter. Both the arms are attached as separate pieces. His youthful, idealized body is wrapped in a kilt, the front of which juts out to form a flat triangular apron. The statue is crowned by a *nemes* headdress, originally with a uraeus at the brow, that falls over the king's chest in two lappets in front, and hangs as one tail down his back. Inlays would have formed pharaoh's eyes, but they, like the king's beard and feet, are now missing. The entire statue was coated with bitumen and would have stood on a base.

Thutmose III was the son of the pharaoh Thutmose II by Isis, a secondary wife, and inherited the throne as a young boy. His stepmother, Hatshepsut, served as his co-regent at first, but eventually took the title of king for herself. When she died in her twentieth or twenty-first year of rule, Thutmose III demonstrated his military prowess by focusing a series of highly successful campaigns in the Levant, Palestine, and southern Syria. On his eighth campaign, he and the Egyptian army crossed the Euphrates River, erecting a

111

stela to mark their unchecked advances through the region. Back in Egypt, a great pharaoh needed to be a great builder, and Thutmose promoted his name by constructions at sites including Nubia, Elephantine, Kom Ombo, Edfu, Thebes, Hermopolis, and Heliopolis. In the rare evidence relating to the personal side of the king, we discover that he held a great interest in botany—a room in his Festival Temple at the Karnak Temple precinct is covered with carved representations of exotic plants and animals that he brought back from his campaigns. Thutmose apparently possessed a wide range of talents, as his proficiency in writing led Rekhmire, who served as vizier under Thutmose III, to equate him with the divinities Seshat and Thoth.

After his fifty-four years of sole rulership, Thutmose was laid to rest in tomb 34, hewn high into a cliff in the Valley of the Kings. The tomb consists of a number of rooms and corridors, mostly undecorated, which lead to the king's burial chamber. The shape of this oval room, where the king's mummy was enclosed in a quartzite sarcophagus, mimics the circular form of the underworld as the Egyptians understood it. Painted on the walls were the twelve hours of the religious book of the Amduat, a text mapping out the pharaoh's journey through the next world. The cursive writings and almost sketchy figures, drawn in red and black ink, were imbued with the power and magic to assist the king in his quest for rebirth with the rising of the sun. **Elaine Sullivan**

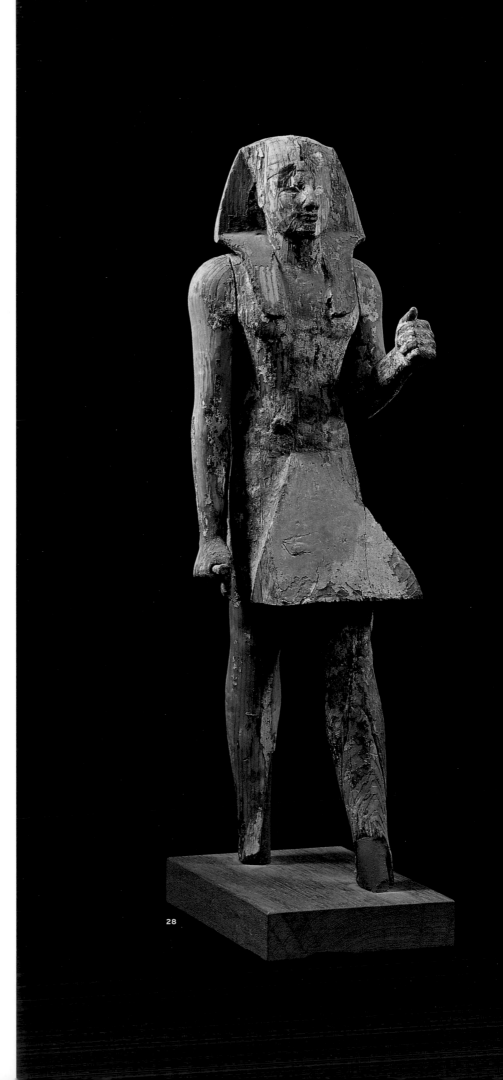

28

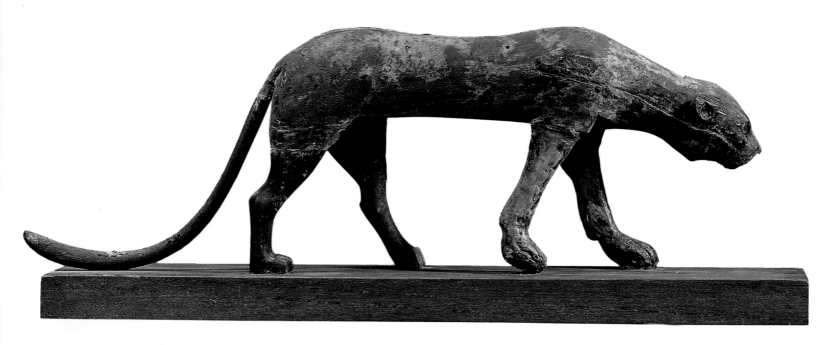

29 Leopard of Thutmose III

Eighteenth Dynasty, reign of Thutmose III, 1479–1425 BCE; wood covered with bitumen. Height 25 cm (9 13/16 in); length 75 cm (29½ in); depth 12 cm (4¾ in). Thebes, Valley of the Kings, tomb of Thutmose III KV 34, excavations of Loret, 1898. The Egyptian Museum, Cairo JE 32248/CG 24912

• The leopard strides stealthily forward, left paws advanced, neck craning ahead, head lowered; its long tail trails gracefully behind, curving up at the tip. The leopard's skin is not spotted, but black. Black was the color of the fertile Nile silt and thus held the promise of resurrection, and bitumen was liberally slathered over all sorts of funerary equipment from coffins to statuary both as a preservative and for its symbolic value. On the animal's back are two rectangular mortises for the insertion of tenons. The leopard, therefore, did not stand alone, but was part of a group composition.

This is one of two striding leopards from the tomb of Thutmose III. Similar animals were found in the tombs of Amenhotep II, Thutmose IV, Tutankhamen, and Horemheb. As usual the pair from Tutankhamen's tomb are the most instruc-

tive, being intact. Each leopard carried on its back a striding figure of the king of gilded wood. Other statuettes show the king in a papyrus skiff, in the acting of harpooning an unseen victim. Wrapped in linen shawls and stored in black wooden shrines, these groups appear to have been standard items of New Kingdom (1550–1069 BCE) royal funerary equipment. The same statuettes appear painted on the walls of a chamber in the tomb of Seti.

Egyptologist Hartwig Altenmüller relates the two groupings to two standard themes of tomb decoration: the hunt in the papyrus marshes and the hunt in the desert.[1] The statuettes of the king harpooning are conceptually located in the Delta marshes; his unseen but implicit enemy is the hippopotamus. The statuettes of the king on a leopard, a wild desert animal, refer to the hunt in the desert. This leopard is not the king's adversary, but rather his hunting leopard. Such a hunting leopard appears in the desert hunting scene in the Fourth Dynasty (2613–2494 BCE) tomb of Nefermaat at Maidum.

Looked at in this way, it is not a statuette of a king on a leopard, but of a king and a leopard, the two working as a pair, the leopard at the king's side (and on the king's side), in the battle between good and evil. For these scenes are not merely (or even mainly) the depiction of a noble pastime. Rather, they embody through ritual a cosmic struggle of order against chaos, Horus against Seth, the king against his enemies. Both marsh and desert were perceived as battle zones, each a no-man's land between the world of the

living and the world of the dead. The passage through these unknown regions is full of obstacles, manifested in the wild and dangerous animals that need to be overcome. The leopard lived on the desert fringe, between two worlds; a liminal being, it was a fitting escort for the deceased.

The leopard was also an ancient sky goddess, straddling the nocturnal horizon, her pelt studded with stars. A leopard or cheetah skin was part of the costume of the *sem*-priest, who performed the opening of the mouth ceremony, revivifying the deceased and his images. The leopard's spots are sometimes rendered as stars, as on the statue of Anen, chief of sightings (high priest of Ra), *sem*-priest, and second prophet of Amun in Thebes under Amenhotep III (1390–1352 BCE).

Yet another interpretation, bound up with the concept of the leopard as the sky goddess, ties it in with the solar circuit, the king's vehicle across the heavens (like the solar boat), protecting him along the way and insuring his safe journey. All these interpretations are interrelated. There will probably always remain more to this statuette than meets the eye. **Lawrence M. Berman**

1. Hartwig Altenmüller, "Papyrusdickicht und Wüste: Uberlegungen zu zwei Statuenensembles des Tutanchamun," *Mitteilungen des Deutschen Archäologischen Instituts, Abteilung Kairo* 47 (1991): 11–19.

30 Amuletic plaque of Maat

Twenty-first Dynasty, 1000 BCE; gold. Height
10.5 cm (4⅛ in); width 26 cm (10¼ in); depth
5 cm (1¹⁵⁄₁₆ in). Sakkara. The Egyptian Museum,
Cairo JE 34526

• This finely detailed amulet represents a kneeling figure on a small base, with face and body turning toward the viewer's right. This graceful figure of a goddess is shown wearing a tight-fitting dress, armlets, bracelets, and a collar. She has a long wig of straight hair, and a solar disk surmounts her head. Her arms are wide open, and she holds the feather sign in each hand. Outstretched under her arms are two wings. This rather heavy plaque is skillfully executed, rendering every detail of the body, wings, and dress. There are many small holes pierced all around its fine edges.

When this plaque was found, it was covered by bitumen and accompanied by gold images of the Four Sons of Horus, indicating that it was stitched onto a mummy's bandages, or it may have been part of a beaded mummy net. The mummy net of Hekaemsaef (cat. 53) holds a nearly identical plaque. Each hole is incorporated into a thread of the beaded net. The mummy net still has the figurines of the Four Sons of Horus, who were responsible for protecting the internal organs of the body.

The identity of this goddess is slightly problematic, especially since many ancient Egyptian goddesses are represented with the sun disk, including Hathor, Isis, Bastet, Nut, and Maat. Fortunately the inscription on the mummy net clearly shows that the deity there is Nut, the sky goddess. Nut is usually represented on coffins, spreading her wings to protect the body of the deceased.

That gesture is also associated with Isis, the mother goddess and one of the four protectress deities for the mummy. However, the presence of the two feathers in this plaque indicates that the goddess here is Maat. Maat was one of the daughters of the sun god and represents the divine order, truth, justice, and the balance of the universe. Representations of Maat are attested as early as the Old Kingdom (2686–2125 BCE). She increasingly acquired distinctive funerary associations. Maat (or her dual form, Maaty) is usually pictured in the Amduat in the solar barque with her father, Re.

There is sometimes confusion between amulets used in daily life and amulets specially made for use in the afterlife and for helping the deceased in the difficult journey to the other world. Obviously this plaque is designed for funerary use. Maat is a visual reminder of the judgment scene, wherein the heart of the deceased is weighed against the small figure of Maat to evaluate his or her worthiness.

Funerary texts usually indicated the exact placement of an amulet on a mummy. Since the New Kingdom, the exact positioning was important. According to the archaeologist Sir Flinders Petrie, and in conjunction with the mummy net of Hekaemsaef, a plaque of this type was to be placed below the breast of the mummy.

Fatma Ismail

114

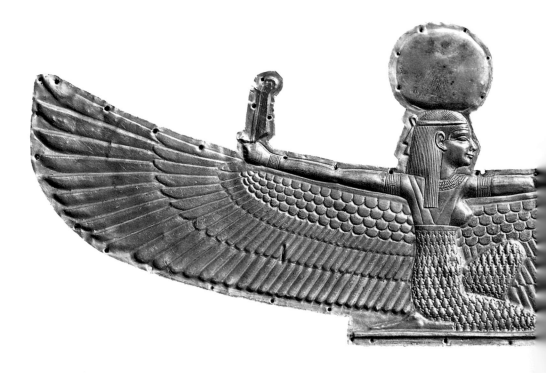

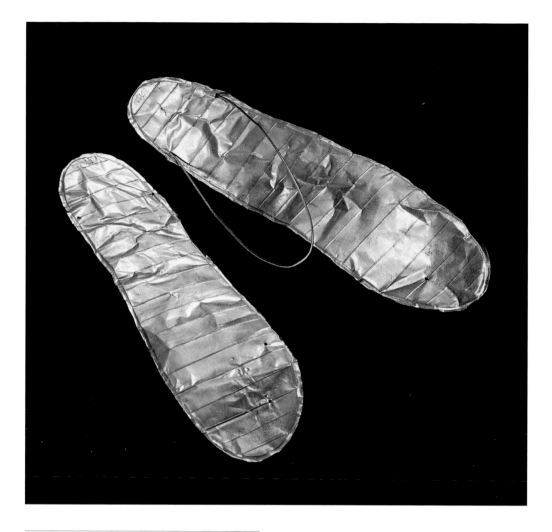

31 Funerary sandals

Late New Kingdom, 1200–1069 BCE; gold. Length
21 cm (8¼ in); 5 cm (1¹⁵⁄₁₆ in); width 7 cm (2¾ in);
other sandal: length 21 cm; width 7 cm (6½ in).
The Egyptian Museum, Cairo JE 35422 1 and 2

• When the royal mummies were prepared for
burial, they were fitted with gold protections for
their fingers, toes, and faces. In addition, they
were clothed and their feet were placed in gold
sandals. Funerary sandals were not intended to
be usable in real life, but rather, were made of
sheet gold that rapidly formed itself to the shape
of the deceased's feet. The mummy of Tutankh-
amun (1336–1327 BCE) wore thin sheet-gold
sandals similar to these but with preserved straps.
Betsy M. Bryan

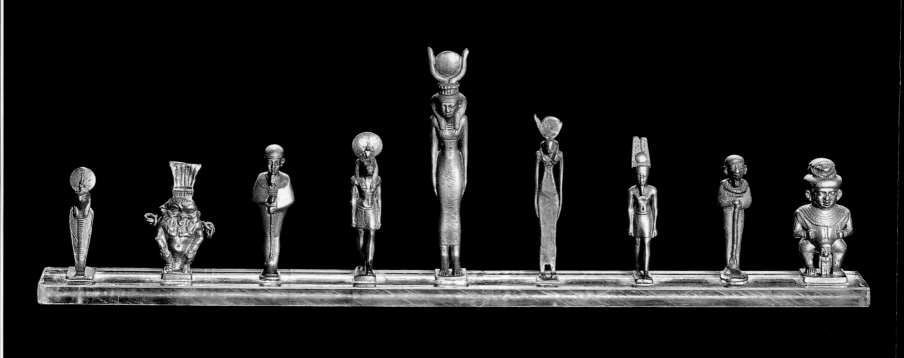

The goddess Isis appears frequently in myths and rites associated with death and rebirth. She is shown here as a woman with cow horns and a sun disk on her head, iconography she shares with the goddess Hathor. Isis was believed to aid in the purification and mummification of the dead and also functioned as a mourner and a protectress.

Hathor, a goddess of love, music, and dancing, is shown here looking remarkably similar to the goddess Isis, owing to the fact that the two were often shown as women with cow horn and sun-disk headdresses. in the Amduat, Hathor, a maternal figure, was regarded as the deceased's guide and appears frequently in illustrations of the underworld journey.

Amun, whose name means "the hidden one," was a primeval creator deity. Considered the father of the gods and of the pharaohs, he was called "king of the gods" in the New Kingdom. Here Amun is depicted as striding forward wearing his usual crown of double plumes.

Patek is a god in the form of a dwarf. This small god is a typical representation of Patek: a naked achondroplastic figure with short, bent limbs, clenched fists, a long trunk, and a large, flat-topped head. The sun disk on the god's head elucidates the connection between dwarfs and the solar notions of regeneration, rebirth, and fertility. Most images of Patek are small figurines or amulets and were used by both the living and the dead as protective magical objects.

Gold was as precious a material in ancient Egypt as it is now. However, it was valued not as much for its rarity, for it was readily mined in Egypt and Nubia, as for its significance. Its color and brilliance were reminiscent of the sun, and because it does not rust or tarnish, gold came to represent the purity and everlasting nature of the

gods themselves. Gold was even called "the flesh of the gods," thus making it a perfect material for the fashioning of amulets and figurines like the nine shown here.

Both the extraction and the working of gold were enterprises controlled by the state. This enabled pharaohs to equip their tombs with gold masks, jewelry, statuary, and other objects for eternity, all symbolic of their wealth, power, and quest for immortality. It is likely that these nine gold gods were once part of royal burial assemblages, since their quality is high and their workmanship excellent. Despite their small size, the many individual traits that help us to identify them have been rendered in careful detail, a testament to the skill of Egyptian craftsmen and their familiarity with this highly valued metal.

Elizabeth A. Waraksa

35 *Ushebti* of Yuya

Eighteenth Dynasty, reign of Amenhotep III,
1390–1352 BCE; painted wood. Height 25 cm
(9 13/16 in); width 8.5 cm (3 3/8 in); depth 6 cm
(2 3/8 in). Tomb of Yuya and Tuya KV 46, Valley of
the Kings. The Egyptian Museum, Cairo JE 95371

• This *ushebti* (funerary figure) of Yuya, the father
of Queen Tiye and father-in-law of King Amen-
hotep III, was found in the tomb he shared with
wife, Tuya. The tomb contained a total of twenty
ushebtis for the royal couple, of which seventeen
are in the Egyptian Museum, Cairo, and three
are in the Metropolitan Museum of Art.

 Ushebtis (also spelled "shabti" and
"shawabti") were placed in the tomb to perform
any labor that was assigned to the deceased in
the afterlife. They are magical figures meant
to be activated by the spell from the Book of the
Dead written on them.

 The images of Yuya and Tuya bear the
characteristic features of Amenhotep III: long,
narrow almond-shaped eyes, a somewhat broad
nose, and a generous mouth. The face is round
and fleshy, accentuating the youthful appearance.
This *ushebti* displays the classical mummy form
and wears a long headdress of alternating blue
and gold stripes, with bands at the ends. A broad
collar hangs in several rows around the neck,
and the crossed arms are suggested within the
mummy shroud. Only the hands are sculpted as
if protruding from the linens, and these, together
with the face, collar, and headdress, are gilded.

In the late Eighteenth Dynasty not all
ushebtis held agricultural equipment, as would
be the case slightly later. Yuya's figurines
had separately supplied hoes, adzes, and yokes
(cats. 36, 37).

 The text of the *ushebti* (here called *shabti*,
the most common writing during the Eighteenth
Dynasty[1]), consists of seven incised lines of
hieroglyphic inscription, written horizontally
around the body. The hieroglyphs are incised in
the wood and filled with blue pigment. A short-
ened form of the so-called Amenhotep III version
of chapter six of the Book of the Dead appears.

Illumination of Osiris, Yuya, he says: O *shabti*,
as to an assignment of Osiris Yuya, for any works
which are wont to be done in the god's land as
a man at his duty, indeed, or an obstacle implanted
for [me], in order to plant the field, in order to
irrigate the lands, to move the sand from the east
to west, if one assigns you work, at any time daily
[say] "Me, look at me."

Adel Mahmoud

1. For the *shabti* formulae, see Lawrence M. Berman, "Funerary
Equipment," in Arielle P. Kozloff and Betsy M. Bryan, *Egypt's
Dazzling Sun: Amenhotep III and His World* (Cleveland, 1992),
Chapt. 10.

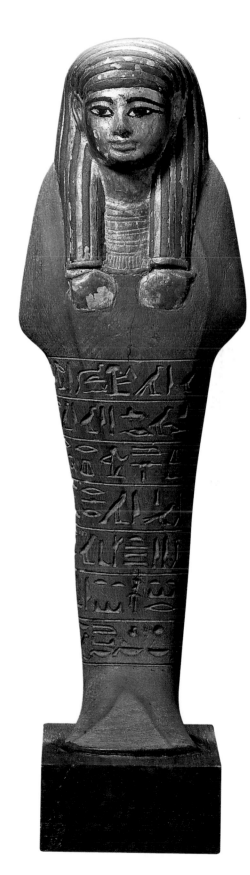

119

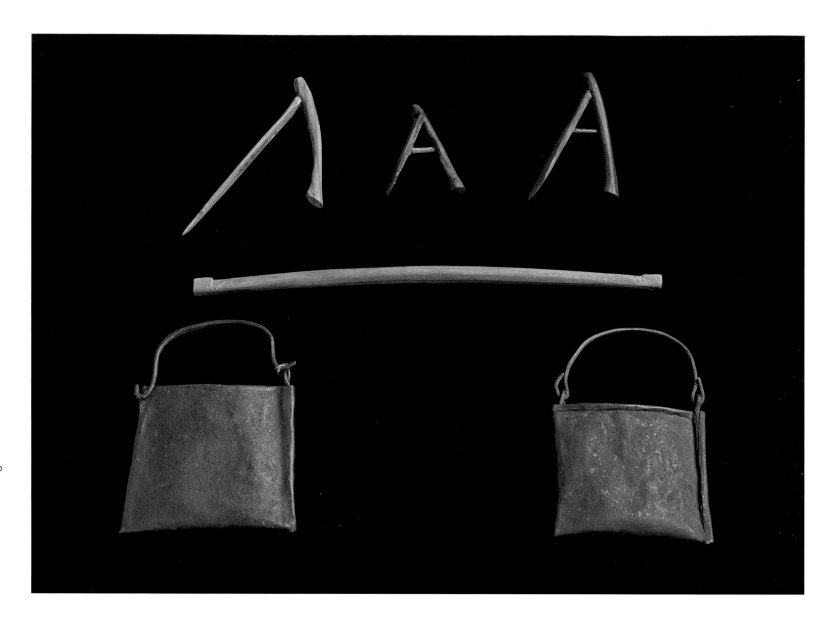

36 and 37 Model tools

for *ushebti*

36 Model hoes; wood. Hoe 1: length 7.5 cm (2¹⁵⁄₁₆ in); width 4 cm (1⁹⁄₁₆ in). Hoe 2: length 3.7cm (1⁷⁄₁₆ in); width 3 cm (1³⁄₁₆ in). Adze: length 5.5 cm (2³⁄₁₆ in); width 3.5 cm (1³⁄₈ in). Tomb of Yuya and Tuya KV 46; Valley of the Kings. The Egyptian Museum, Cairo CG 51145 / CG 51155 / CG 51156

37 Model bags and yoke; wood and copper. Yoke: length 16 cm (6⁵⁄₁₆ in); depth 0.6 cm (¼ in). Bag 1: height 6 cm (2³⁄₈ in); width 7.5 cm (2¹⁵⁄₁₆ in); depth 1.3 cm (½ in). Bag 2: height 5.5 cm (2³⁄₁₆ in); width 7 cm (2³⁄₄ in); depth 1.3 cm (½ in). Tomb of Yuya and Tuya (KV 46; Valley of the Kings. The Egyptian Museum, Cairo CG 51134

Eighteenth Dynasty, reign of Amenhotep III, 1390–1352 BCE; Tomb of Yuya and Tuya (KV 46); Valley of the Kings. The Egyptian Museum, Cairo

• Yuya was priest of Min, and his wife Tuya was the lady of the harem of the god Min. Their daughter, Tiye, became wife to Amenhotep III, and Yuya moved to the court to take a higher position. Yuya and Tuya's tomb contained a large number of objects made in the court workshops as well as extremely fine *ushebtis* and equipment for them, including twenty-five yokes, twelve adzes, and six bags. Chapter 6 of the Book of the Dead describes the duties of *ushebtis*: to move the sand from east to west, to irrigate the riparian lands, to fill the canals with water, and to take hoes, yokes, and baskets, as every child does for his master. Since the *ushebtis* of Yuya and Tuya were not depicted with tools in their hands, the tools here were separately fashioned and placed in the tomb for use by the funerary figures. This practice is known primarily from the reigns of Thutmose IV (1400–1390 BCE) and Amenhotep III (1390–1352 BCE). Thereafter, it became the norm to represent the tools in the hands of the *ushebtis*. **Adel Mahmoud**

38 *Ushebti* box of Yuya

Eighteenth Dynasty, reign of Amenhotep III,
1390–1352 BCE; painted wood. Height 37 cm
(14 9/16 in); width 14 cm (5 1/2 in); depth 14 cm (5 1/2 in).
Tomb of Yuya and Tuya (KV 46); Valley of the
Kings. The Egyptian Museum, Cairo CG 51043

· *Ushebti*s (funerary figures) were often stored
inside boxes that took the form, as they do
here, of a shrine facade, the decoration of which
imitates the appearance of the sanctuary of the
north, dating back to the archaic era of the kings
of Lower Egypt. The box, made of wood that
has been lightly plastered and then painted in
green, blue, red, and white, is distinguished by a
barrel-vaulted roof. The frames of false doors
were inspired by niching on early mud-brick temple
facades. The structure is mounted on a base,
which is likewise painted, here white. The knobs
(decorated with rosettes) on the lid and the front
enabled the box to be tied shut with a small cord,
which was stamped with a mud seal.

A vertical column of inscription on the
lid is in black. It identifies the owner of the box
as "the one revered by Osiris, the god's father
Yuya, justified." The *ushebti* box was found inside
the tomb of Yuya and Tuya, which held fifteen
ushebti boxes, thirteen of which are in the Egyp-
tian Museum, Cairo, with two in the Metropolitan
Museum of Art, New York.

The barrel-vaulted shrine shape was also
identified with the burial chest of Osiris, and
one word for a sarcophagus, *djebat*, took the form
of this Lower Egyptian shrine. In addition, the
dead in the afterworld wait in similar shrines for
their reawakening by the appearance of the sun
god in the dark nether regions. The form of the
shrine for *ushebti* boxes was traditional by this
time and continued in use for hundreds of years.
Adel Mahmoud

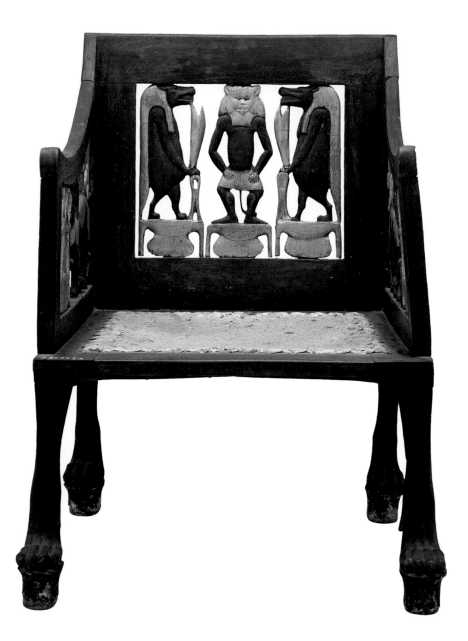

39 Chair from tomb of Yuya and Tuya

Eighteenth Dynasty, reign of Amenhotep III, 1390–1352 BCE; wood, gold. Height 60 cm (23 5⁄8 in); width 43 cm (16 15⁄16 in); depth 39 cm (15 3⁄8 in). Tomb of Yuya and Tuya (KV 46), Valley of the Kings. The Egyptian Museum, Cairo JE 95343A/CG 51111a

• Three chairs were found in the tomb of Yuya and Tuya, the parents of Queen Tiye, wife of Amenhotep III. Two are clearly associated with princess Sit-Amun, daughter of Amenhotep III and Tiye. This chair, although it does not bear an inscription, is likely another belonging to the princess. Given its small size, it was certainly made for her as a child. Its decoration is associated with the domestic sphere and particularly the realm of women.

The chair is made of various parts of pigmented dark wood (perhaps ebony or yew) with gilding, fixed together by tenon-and-mortise construction. A pillow stuffed with pigeon feathers was found with the chair. The seat is made of woven rushes. The legs, carved separately to imitate lion's legs, were added last. The paws rest on silvered bases. The back of the chair shows the god Bes flanked by two images of the goddess Taweret. Bes was a household deity who protected women and children from the perils of childbirth or illness. His representation is based on a lion shown frontally but over time gradually took on the characteristics of a dwarf as well. Bes, like Taweret, was a protector of Re, and in the Middle Kingdom (2055–1650 BCE) he often occurred on "magical wands" used to protect women and children at childbirth. The rebirth of the sun each day was identified with the birth of all children. Taweret also assisted with childbirth. Here, she holds two knives in one hand while resting her other hand on the hieroglyph for protection, *sa*. With her knives she will repel any threats to the family members, and in the funerary realm will challenge the enemies of the sun god.

The sides of the chair each show an antelope with legs folded beneath. The submissive attitude for the antelope suggests that the animal offers itself on behalf of the chair's owner. In some love poetry allusion is made to the gazelle, equating it to the man whose quest for a beautiful woman is frightening but rewarding. "O that you came to your sister swiftly, like a bounding gazelle in the wild; its feet reel, its limbs are weary, terror has entered its body, for a hunter pursues it with hounds.… As you pursue your sister's love, the Golden one (Hathor) gives her to you."[1] As is usual in artifacts from ancient Egypt, both understandings of the ibex are present here.

Adel Mahmoud

1. Miriam Lichtheim, *Ancient Egyptian Literature: A Book of Readings.* Vol. 2, *The New Kingdom* (Berkeley, 1976), 187.

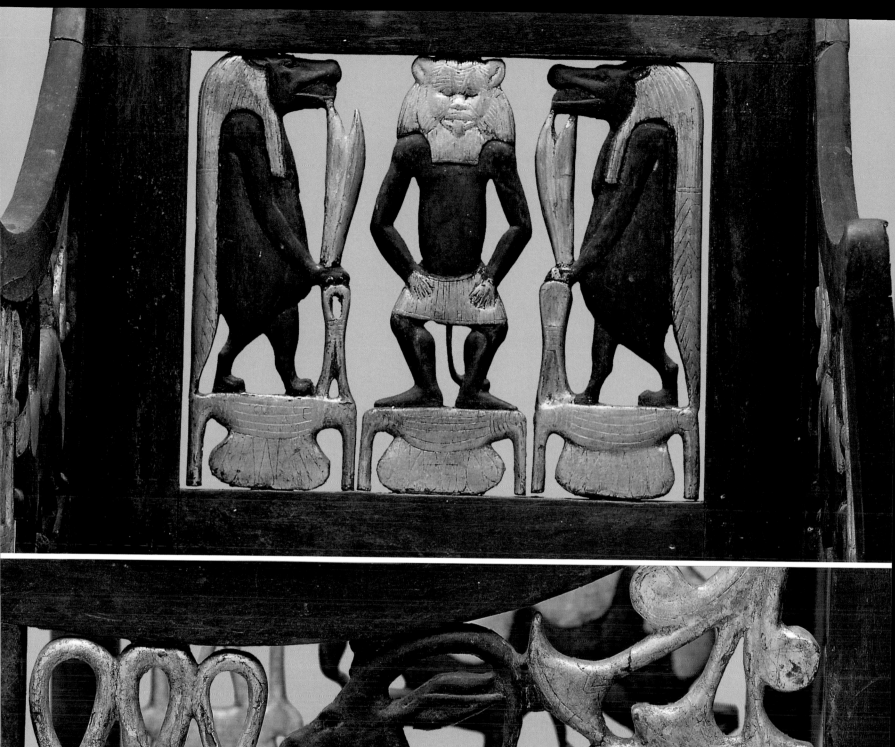

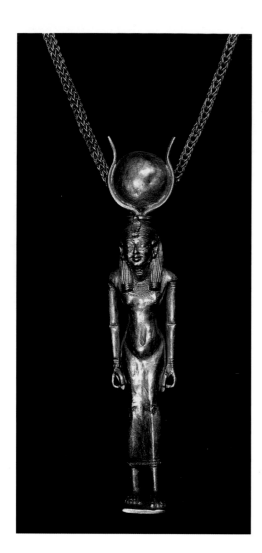

42 Necklace with pendant in the form of Isis

Twenty-first Dynasty, c. 1069–945 BCE; gold.
Height 50 cm (19¹¹⁄₁₆ in); width 2.3 cm (⁷⁄₈ in);
depth 2.2 cm (⁷⁄₈ in). Tanis, tomb of King
Psusennes I. The Egyptian Museum, Cairo
JE 87716

• The goddess Isis was the wife of Osiris—the primary deity of the afterlife—and the mother of Horus. She has strong associations with regeneration, for according to myths, she was impregnated by her husband after his death, creating the cycle of birth from death symbolized by the never-ending solar cycle and the Amduat.

Isis was also the archetypal symbol of a protective and caring mother, as attested by the thousands of bronze statues that have been found of Isis holding her son Horus in her lap. According to myth, she had the ability to protect, as indicated by texts that refer to her hiding her newborn son in the papyrus swamps of Khemmis to shield him from his evil uncle/brother Seth. From the Third Intermediate Period into the Roman Period (c. 1069 BCE – second century CE), Isis was associated with magical protection, and it was in that role that her cult flourished in the Ptolemaic and Roman Periods.

In a more strictly funerary context, Isis was one of the two chief mourners of Osiris, and hence she was one of the deities featured on coffins, canopic shrines, and other mortuary furnishings.

This figurine, with its wide hips, high waist, and breasts placed in the upper portion of her chest, is in the style of Third Intermediate Period statuary. She wears bracelets that are pushed up improbably on her arm. Her tightly fitting dress with a decorated hem is topped by a multilayer broad collar. A protective uraeus is on her brow.

It is often impossible to differentiate Isis from the anthropomorphic form of the goddess Hathor. Both wear headdresses composed of lyre-shaped cow horns and sun disks. However, the identity of this figure is assured by the inscription "Isis, Mother of the God," which is incised on the underside of its base. This was one of six gold amulets of deities found on the neck of the mummy of General Wenudjebauendjed who was buried in the tomb of King Psusennes I at Tanis. **Emily Teeter**

43 Funerary mask of Wenudjebauendjed

Twenty-first Dynasty, reign of Psusennes I,
1039–991 BCE; gold. Height 20.3 cm (8 in); width
17.8 cm (7 in); depth 15.2 cm (6 in). Tanis, Royal
tomb no. 3, chamber 4. The Egyptian Museum,
Cairo JE 87753

• The courtier Wenudjebauendjed held important military and priestly titles but was not definitely a member of the royal family.[1] Nevertheless, and perhaps a reflection of Libyan influence on Egyptian culture in what has been called the Libyan Period (Twenty-first or Twenty-second Dynasty through Twenty-fourth Dynasty), he was buried in the tomb of the king he served, Psusennes I.[2]

Wenudjebauendjed was buried with opulent furnishings, including his funerary mask. This was probably made in the same workshop as that of his king's, both sharing the taste of the other golden funerary masks of the Twenty-first – Twenty-second Dynasty from the royal cemetery at Tanis for slightly dull rather than highly polished surfaces. Unlike Psusennes' mask, Wenudjebauendjed's mask covered only the face, rather than the entire head, and does not have attributes of royalty such as a royal headdress and beard. Nevertheless, it is one of the few surviving examples of the gold masks made for kings and great nobles.

Gold's symbolism may have been more significant than its economic value. Not subject to corrosion, gold could represent the solar, the imperishable, and the flesh of the gods. Hence the funerary mask helped represent the deceased as a transfigured spirit eligible for eternal life and possessing divine qualities. Like some of the royal individuals buried at Tanis, Wenudjebauendjed, who had a gilded wood coffin, also had a silver coffin, which raises the question of whether or not these body and face coverings of gold and silver somehow symbolized solar and lunar regeneration.[3] **Richard Fazzini**

1. Despite a lack of royal titles, he has recently been described as a prince and member of King Psusennes' family by Henri Stierlin, *The Gold of Pharaohs*, trans. P. Snowdon (Paris, 1997), 170. Another Egyptologist has recently argued that he was royal in some way (G. Broekman, "Facts and Questions about Wen-Djeba-en-djed," *Göttinger Miszellen* 165 [1998]: 25–27). Equally unusual was the burial in this tomb of Psusennes' chief queen and of another man who was probably their son.

2. For an overview of the history and culture of the Third Intermediate Period, see John Taylor, "The Third Intermediate Period (1069–664 BC)," in Ian Shaw, ed., *The Oxford History of Ancient Egypt* (Oxford/New York, 2000), 330–68 and 466–68.

3. For the symbolism of silver, see Sydney Aufrère, *L'Univers minéral dans la pensée égyptienne. Vol. 2, L'intégration des minéraux, des métaux et des "Trésors" dans la marche de l'univers et dans la vie divine*, BdÉ CV/2 (Cairo, 1991), 409–28.

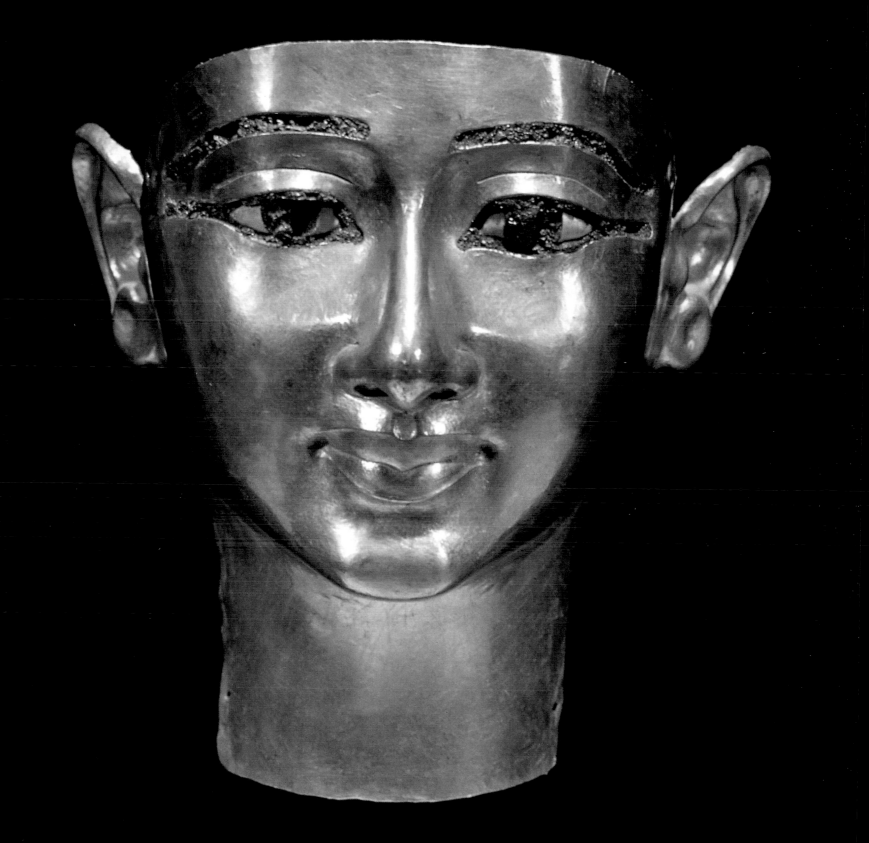

44 Pectoral of Sheshonk II

Twenty-second Dynasty, reign of Sheshonk II,
c. 890 BCE; gold and precious stones. Height
without band: 6.4 cm (2½ in); width 5.1 cm (2 in);
length of chain 31.5 cm (12¼ in). Tanis, tomb of
Sheshonk II. The Egyptian Museum, Cairo JE 72172

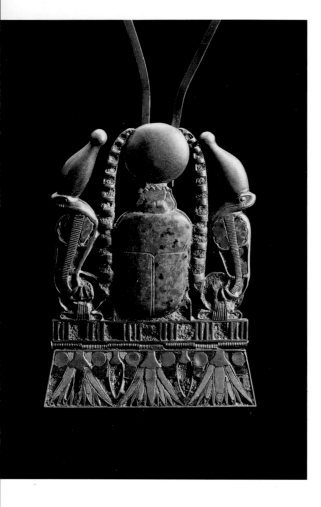

• One of the most enduring elements of the desire for eternal existence in the afterlife was the wish of the deceased to join the sun in its predictable cycle of rising and setting. This most prominent feature of the environment provided a comforting analogy for the idea of rejuvenation and formed the basis of New Kingdom funerary theology. As with so many aspects of ancient Egyptian religion, the basic precepts of beliefs were derived from the natural phenomena that they observed around them every day.

The complex iconography of this pectoral represents the cosmos and the rising of the sun at dawn from the darkness of the underworld. The lapis lazuli scarab, the representation of the newly born sun, as well as the hieroglyph for "to come into being," is shown emerging from the horizon that is represented by a double curved sign below it. The scarab pushes the round gold disk of the sun up into the sky to illuminate and revive the world.

The earthly realm is represented by the horizontal baseline, while the watery realm is shown as a row of aquatic plants that are hinged to the pectoral so that their movement mimicked that movement of water. The two uraei, wearing the white crown of Upper Egypt, symbolize the king. The king's successful association with the rising sun, and from it his rebirth, is symbolized by the attachment of the snakes' tails to the sun disk, for as the sun rises, the king would be carried with it to rejuvenation. The permanence of the cosmos and the king's association with the rising sun is symbolized by the circular hieroglyphs for "eternity" that are looped over each uraeus. The tails of the uraei and sections of the aquatic plants were originally filled with bright paste, which has now decayed.

The use of two white crowns on the heads of the snakes, rather than the expected red and white crowns, suggests that the composition is a rebus of the throne name of Sheshonk I: *hedj* (white crown) – *kheper* (scarab beetle) – *Re* (sun disk). Other pieces of jewelry, gold dishes, and even a stone sarcophagus were brought to Tanis from Thebes and elsewhere for reuse.

The decoration on the reverse side is chased rather than inlaid, the anatomy of the underside of the scarab being rendered naturalistically. This pectoral was part of a group of eight ornaments found suspended from the neck of the mummy of Sheshonk II. Most of the pectorals from the tomb were suspended on thin flat ribbons of gold rather than the more common chains. **Emily Teeter**

45 Bracelet with the eye of Horus

Twenty-second Dynasty, reign of Sheshonk I,
945 – 924 BCE; and Sheshonk II, c. 890 BCE; gold,
semiprecious stones. Height 4.5 cm (1¾ in);
diameter 7 cm (2¾ in). Tanis, tomb of Sheshonk II.
The Egyptian Museum, Cairo JE 72184A

• Sheshonk II (with the *prenomen* Hekakheperre) had two cylindrical bracelets showing the *wedjat* eye, but on inscriptions added inside these jewels we learn that they both had once belonged to the founder of the Twenty-second Dynasty, Sheshonk I (Hedjkheperre). That ruler is considered to have been the biblical Shishak who sacked Jerusalem in the tenth century BCE, and Sheshonk II must have believed that his heirlooms were powerful magic for his journey to the next world.

Although made of gold inlaid with stone and glass, the form of bracelet seen here imitates one that was already very ancient. Earlier the rigid cylindrical shape had been achieved in rows of beads of different colors separated by gold vertical bars. Here, vertical gold bars interrupt bands of carnelian and lapis lazuli inlays. The bracelets are made of two unequal sections of heavy sheet gold. They are hinged and closed with a pin that retracts. This rigid type of bracelet is first known from the burial of Queen Ahhotep, mother of King Ahmose, founder of the Eighteenth Dynasty (1550 – 1069 BCE; see cats. 21 – 25), which also

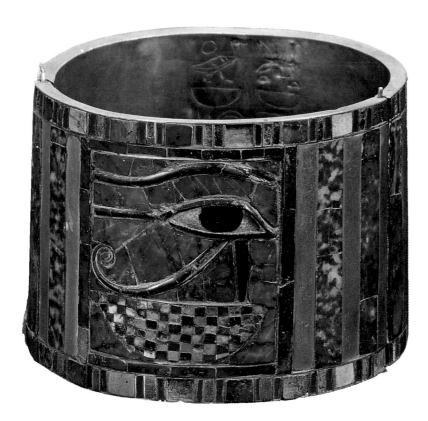

contained the older form made with beads and gold bars. Here, the bands of decoration are interrupted by a cloisonné field of lapis, carnelian, and black and white stone. The cloisonné method consisted of creating cloisons by soldering gold strips to the beaten gold base in the pattern desired. They were then layered with a cement to hold slivers of stone or glass cut in exactly the shape of the cloisons.

The cloisonné field contains the *wedjat* eye hovering over a basket, providing a hieroglyphic wish for "all health." The eye of Horus invokes the health of the mummy, particularly his bones, and these bracelets thus were meant to protect his wrist bones and keep his body intact. Since the *wedjat* is also a symbol for the sun god, the king's journey through the netherworld with Re is also alluded to. The *wedjat*, or right, eye adorns the bracelet for the right wrist, and the lunar, or left, eye adorns that of the left wrist. This bracelet and its companion were found on the mummy of Sheshonk II.

Betsy M. Bryan

46 Pendant of the god Ptah in his shrine

Twenty-first Dynasty, reign of Psusennes I, 1039 – 991 BCE; lapis lazuli and gold. Height 6 cm (2 ³⁄₈ in); width 3 cm (1 ³⁄₁₆ in); depth 1.7 cm (¹¹⁄₁₆ in). Tanis, tomb 3. The Egyptian Museum, Cairo JE 87712

• This pendant is composed of a reused lapis lazuli amulet representing the god Ptah, the feet of which had been accidentally broken. The mummiform god has a beard and holds a scepter surmounted by a *djed* pillar (primarily known to be a symbol of Osiris, but also a symbol of Ptah, who is called "the august *djed*"). The identity of the god may be confused by the solar disk, flanked by two ostrich feathers, which he wears on his head. However, the same headdress is worn by Ptah in a representation from a private tomb dating to the time of Ramesses VI (1143 – 1136 BCE) and suggests a syncretism with the primeval god Tatjenen. One may argue that this iconographic originality makes this damaged amulet valuable enough for it to have been later sheltered in a gold representation of the shrine of the god. The double cornice on the top of the shrine denotes

two chapels fit together. The god is flanked by two papyrus-shaped columns, each supporting a pair of falcons carrying a sun disk on their heads. On the exterior of the sides of the shrine are representations of twenty-four small gods, facing each other, split into two symmetrical sections.

The lapis lazuli from which this little Ptah amulet was carved is a metamorphosed form of limestone, rich in the mineral lazurite, which is dark blue in color. It was highly valued by the ancient Egyptians, for they believed that its appearance imitated that of the heavens. It was widely used in jewelry through the Late Period (664 – 332 BCE), when it was particularly popular for amulets.

Ptah was the creator god of Memphis. He was usually depicted as a mummy with his hands protruding from the wrappings, holding a staff combining the *djed* pillar (symbol of stability), the ankh sign (symbol of life), and the *was* scepter (symbol of dominion). He wears a tight-fitting skullcap on his head, leaving his ears exposed. From the Middle Kingdom (2055 – 1650 BCE) onward, he was represented with a straight beard. In Hellenistic times he was identified with the Greek god Hephaistos. Ptah was part of a Memphite triad consisting of his consort, Sakhmet (the lioness-headed goddess), and the lotus god Nefertem, whose relationship with Ptah is unclear. Although not a member of the triad,

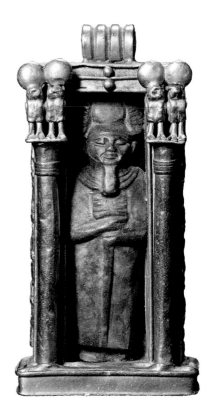

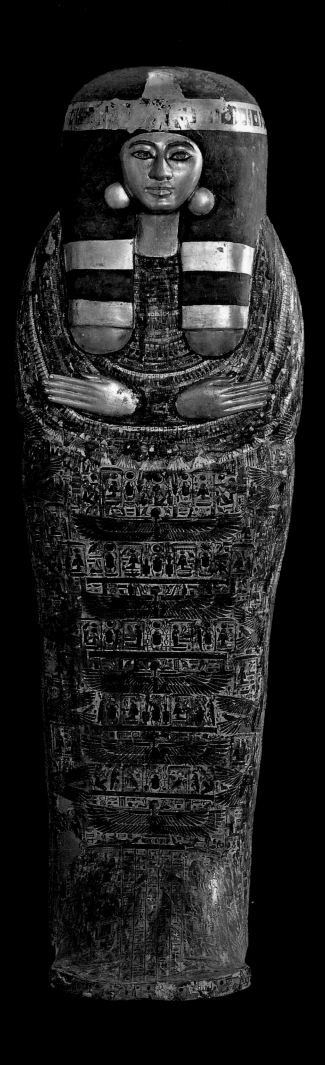

of Isheru" (Mut's temple at South Karnak). She was also known to have carried the title of "god's mother of Khonsu," an allusion to her role as the substitute for Mut in the rituals that brought Amun and Mut together to produce their offspring, Khonsu, the moon god. The importance of this role in the late Twentieth and Twenty-first Dynasties is underlined by its relief depiction on the walls of the Khonsu Temple at Karnak. The involvement of women in the birth aspects of the cult was probably expanded at this time. In the tomb of Hormose at Hierakonpolis, dated to the reign of Ramesses XI (1099–1069 BCE), the god's mother of Isis who performed a similar role to Isis-em-akhbit in the cult of Horus of Nekhen, participates in a procession and separate ritual apparently exclusively conducted by women. Isis-em-akhbit had at least two daughters, one of whom, Heryweben, was a chief of entertainers in the temple of Karnak and a second priest of Mut.

Isis-em-akhbit is also known to have possessed a Book of the Dead, which gives a fuller list of her titles. **Ibrahim El-Nawawy**

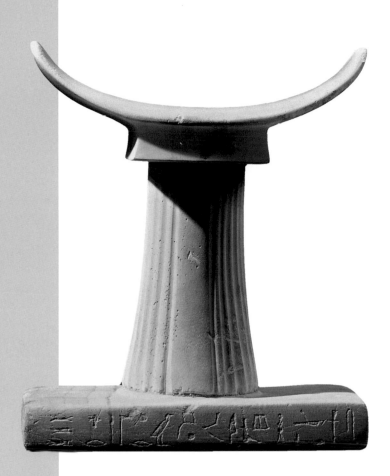

The Tomb of a Noble (catalogue nos. 52–75)

Constructing a proper tomb was a vitally important goal for the nobility in ancient Egypt. Commissioning coffins and canopic equipment was also a top priority. Tombs often included images of the deceased, many of which reflect the connection of the deceased to the gods. Tomb furnishings could include foods to sustain the dead person, amuletic jewelry, tools, furniture, and luxury goods. Because the world beyond death was agrarian, burials included statuettes known as *ushebtis*, which were designed to stand in whenever the deceased was called upon to perform tasks of manual labor.

52 Headrest

Late Old Kingdom – First Intermediate Period, c. 2345 – 2055 BCE; alabaster calcite or travertine. Height 20.7 cm (8⅛ in); width 18 cm (7 1/16 in); depth 9.5 cm (3¾ in). The Egyptian Museum, Cairo JE 88563

• This finely carved headrest is a type that can be dated Old to Middle Kingdom. The curved upper portion is characteristic of nearly every Egyptian headrest, while the fluted stem first appeared in the Old Kingdom. The base of the headrest is no wider than the curved upper portion, creating a symmetrical effect. While such a form may at first appear simple, this stone headrest shows expert skill in carving and proportion. In fact, the stem bears a resemblance to a building column, giving the headrest an architectural feel and making the object not just functional, but also attractive.

The headrest is inscribed for "the sole companion and lector priest, venerated one before the great god, Hery-adj-mer. (This last could also be an additional title, "chief irrigation canal supervisor.")

The Egyptian word for headrest is *weres*, and such objects were in use from the Third Dynasty (2686 – 2613 BCE) to the Late Period (664 – 332 BCE). Headrests were designed to support the space between a person's head and shoulder, and the upper portions were sometimes cushioned by linen. Headrests were made from a variety of materials, with stone being most popular in the Old Kingdom. In the Middle and New Kingdoms, wood became the preferred material, but stone, ivory, and faience were also used.

Headrests were used in everyday life as well as in burials. In some cases inscriptions were added to headrests to make them more appropriate for a burial, with the owner's name being inscribed together with the occasional funerary epithet like "justified" or "repeated life." This headrest, although it does not have any inscriptions, was probably part of a burial assemblage. Calcite, or Egyptian alabaster, was a stone regarded as appropriate for funerary equipment. Its whitish-yellow color and translucence was thought to evoke purity, a concept important for the deceased. Both the fine workmanship of this headrest, along with its material, make it exactly the type of headrest that a well-to-do Egyptian would want to lie on as he or she passed into the afterlife. **Elizabeth A. Waraksa**

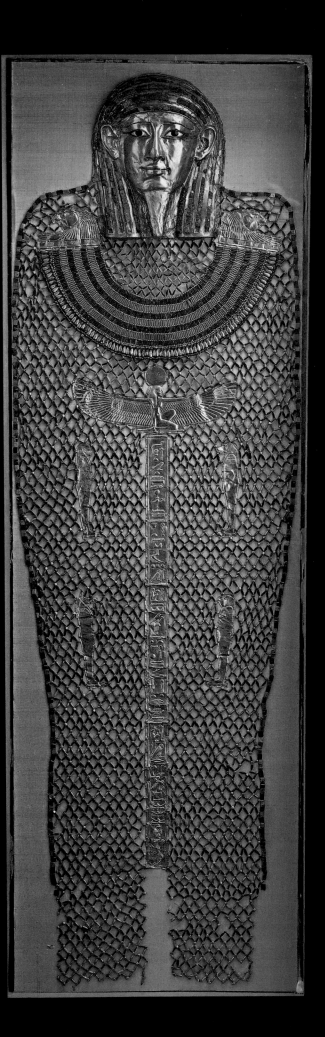

53 Bead net and gold mask of Hekaemsaef

Twenty-sixth Dynasty, 664–525 BCE; gold, semi-precious stones, faience. Height 145 cm (57 1/16 in); width 47 cm (18 1/2 in); depth .7 cm (1/4 in). Sakkara, tomb of Hekaemsaef. The Egyptian Museum, Cairo JE 35923 / CG 53668

• Although the Egyptians often placed reproductions of objects from daily life in their burials, some items, like this magnificent funerary set of Hekaemsaef, including a beaded mummy covering, mask, and collar, held a more ritualistic and protective meaning. The gilded mask, inlaid with eyes of feldspar and obsidian and brows and lids of lapis lazuli, preserves forever the idealized countenance of its owner. A divine beard hangs from the chin, and the face is surrounded by a headdress of black and green glass paste.

The net itself, which was reconstructed by scholar George Daressy, uses beads of gold, lapis lazuli, and amazonite to form a lozenge-patterned shroud. Hekaemsaef's *wesekh* collar, capped at each end with beaten-gold falcon heads, is strung with eighteen rows of these beads. The net is edged with rectangular beads of the same materials, all three of which the Egyptians considered extremely valuable and therefore appropriate for use in burials. Lapis lazuli, the most prized of all stones, is a lustrous dark blue mineral that was likely imported into Egypt from modern northeastern Afghanistan. Amazonite, also known as feldspar, is a green or blue-green mineral. Its origins are possibly the eastern desert of Egypt and the Libyan mountains. Both lapis and amazonite, called *khesbed* and *neshmet* in the ancient Egyptian language, were continually imitated by Egyptian craftsmen, using the domestically produced glasseous material faience. Gold, commonly mined in Nubia, was the most precious and favored material of the Egyptians. These costly beads are intersected with disks of gilded copper.

Woven into the net are five elements of beaten gold. The central figure depicts the sky goddess Nut, topped by a sun disk, stretching out

her protective winged arms over the body. A row of hieroglyphics runs beneath her, giving praise to the goddess and naming its owner as "Osiris, overseer of the royal boats, Hekaemsaef." The standing figures beside the inscription represent the Four Sons of Horus, commonly found on canopic jars, which held and protected the internal organs of the deceased.

By the end of the First Intermediate Period (2160–2055 BCE), the association of the deceased person with Osiris expanded from a strictly royal prerogative to an acceptable practice for private individuals, like Hekaemsaef. By merging with this chthonic deity—who had been murdered and then brought back to life—the dead could be regenerated into his eternal cult. Osiris was occasionally depicted wearing a shroud with a bluish-green diamond pattern, which looks similar to this type of beaded mummy net. The net appears in the funerary customs of the Twenty-fifth Dynasty (747–656 BCE) and remained popular through the Roman Period (30 BCE–395 CE). Those who could not afford the expensive net covering often replicated the lozenge pattern with paint on the outermost wrapping of their body, or even on their cartonnage coffin. Others used knotted string to form a more modest version of the beaded net.

Hekaemsaef's toes and fingers were covered with sheaths of gold, and his body was wrapped in a linen sheet. A large number of amuletic objects, including figurines of gods, animals, and scarabs in gold and stone were found with the mummy, all encased within a painted wooden coffin protected by a limestone sarcophagus. The intact tomb, discovered east of the pyramid of Unas in the Sakkara necropolis, safeguarded a variety of objects Hekaemsaef deemed necessary for his existence in the afterlife: canopic jars, faience *ushebti* figures, and models of boats, palettes, and pottery. **Elaine Sullivan**

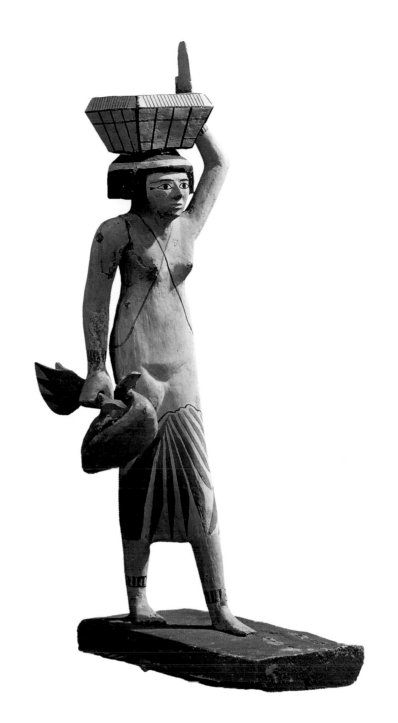

54 Offering bearer

Tenth Dynasty, c. 2100 BCE; painted wood.
Height 56.5 cm (22 ¼ in); width 15.5 cm (6 ⅛ in);
depth 34 cm (13 ⅜ in). Tomb of Nakht, Assiut.
The Egyptian Museum, Cairo JE 36291

• This wooden statuette is in the form of a woman wearing a form-fitting white garment held by a strap over the left shoulder, leaving the chest bare. The bottom of the skirt is decorated with a large feather pattern, and she wears two long, colored chains over her shoulders and wrist and ankle bands. Her round wig is short and black; a white headband runs around the back of a pigtail.

She has a full face, with eyebrows and eyes clearly defined in black, extending in fishtail-like cosmetic lines. The fact that she is depicted with her left leg striding forward in a broad step identifies her as a young, active woman. She stands on a rectangular base and carries an offering basket on her head, which she supports with a very peculiar, rigid gesture of her left hand. In her right hand she holds a duck by its wings. Some argue that the revealing garment, the jewelry, and the duck identify the woman as a concubine, for ducks and geese had sexual connotations and often appeared in love poetry.

The horizontal inscription on the top of the table reads, from right to left: "The venerated one before the great god, the lord of Abydos [Osiris], the beloved god's father, venerated one Khety, vindicated." Below the sculpted images of bread and wine, each of which is inscribed with Khety's name, is an offering formula: "A gift which the king gives: one thousand of bread, beef, fowl, and a good burial for the Treasurer and venerated one Khety."

Beneath the offering sit two images of the god Hapy, a personification of the Nile itself and the nourishment it brings. Each figure is labeled. Left: "Hapy, may he give all offerings." Right: "Hapy, may he give all foodstuffs."
Betsy M. Bryan

1. For the officials in the early Middle Kingdom, see James Allen, "Some Theban Officials of the Early Middle Kingdom," in *Studies in Honor of William Kelly Simpson* (Boston, 1996), 1–26. For other offering tables in Cairo, see Ahmed Kamal, "Tables d'offrandes" (Cairo, 1906–09), CG 23001–23256.

57, 58 Glass vessels

Eighteenth Dynasty, c. 1400–1300 BCE; polychrome glass. Height 9 cm (3 9/16 in); width 6 cm (2 3/8 in); depth 6 cm (2 3/8 in). Sakkara, grave 25, discovered 1923. The Egyptian Museum, Cairo JE 47778

Eighteenth Dynasty, c. 1400–1300 BCE; polychrome glass. Height 8 cm (3 1/8 in); width 5 cm (1 15/16 in); depth 5 cm (1 15/16 in). Sakkara, grave 25, discovered 1923. The Egyptian Museum, Cairo TR 12-3-26-2

• The two vases, in the shape of small kraters, are composed of bright blue glass with yellow, white and blue decoration. The prominent rims and wide necks of both vases are balanced by the swollen bodies and tall bases upon which they rest. The chevron pattern on the neck of the handleless vase ends after spreading a bit past its joint with the body. A similarly colored garland pattern resumes the ornamentation, continuing downward, leaving only the base unadorned. A large handle, extending from below the striped lip down to the shoulder, distinguishes the second vase. Garland patterns also trim this vase, with the colors peaking like waves on the neck and ballooning upward on the body. Two additional handles, placed on the shoulder, follow the decorative style. Vertical bands of color slide down the neck and foot of the object.

Ancient Egyptian artisans created objects from naturally occurring obsidian glass and a manufactured material called faience in prehistoric times, but it was not until the New Kingdom that the techniques for producing a true glass vessel appeared. As early styles of that period indicate, the technology and craftsmen likely arrived from western Asia. A proliferation in the use of glass for decorative objects such as beads, amulets, vessels, jewelry, and inlays began in the reign of Thutmose III, with the quality of glass objects reaching their zenith under Amenhotep III. These small vessels would have held unguents and perfumes destined for use by their owners in the afterworld. The Egyptians believed the world of the dead was similar to the world of the living, so they supplied their burials with the same objects needed in daily life. The costliness and resemblance to precious stones like lapis lazuli, amethyst, and turquoise made glass objects like these popular grave goods for kings, queens, and members of the royal court. Vessels were produced by melting a molten glass mixture of quartz sand, alkali and a mineral-based coloring agent around a clay core. Rods of heated colored glass were then wrapped around the vessel, pulled and draped to create a design. Once the vessel had been cooled in hot ash, the clay core was scraped out, leaving a hollow for the interior of the vessel. The lip could be formed from the reheated piece of glass itself by using tongs, and craftsmen attached the foot and handles separately. Archaeological excavations have uncovered crucibles, unworked glass, broken vessels and the by-products of glass production or glass reworking at various ancient sites in Egypt, including Malkata, Tell el-Amarna, and el-Lisht. These appear to have functioned as centers of glass manufacturing, and operated under the auspices of the pharaoh. **Elaine Sullivan**

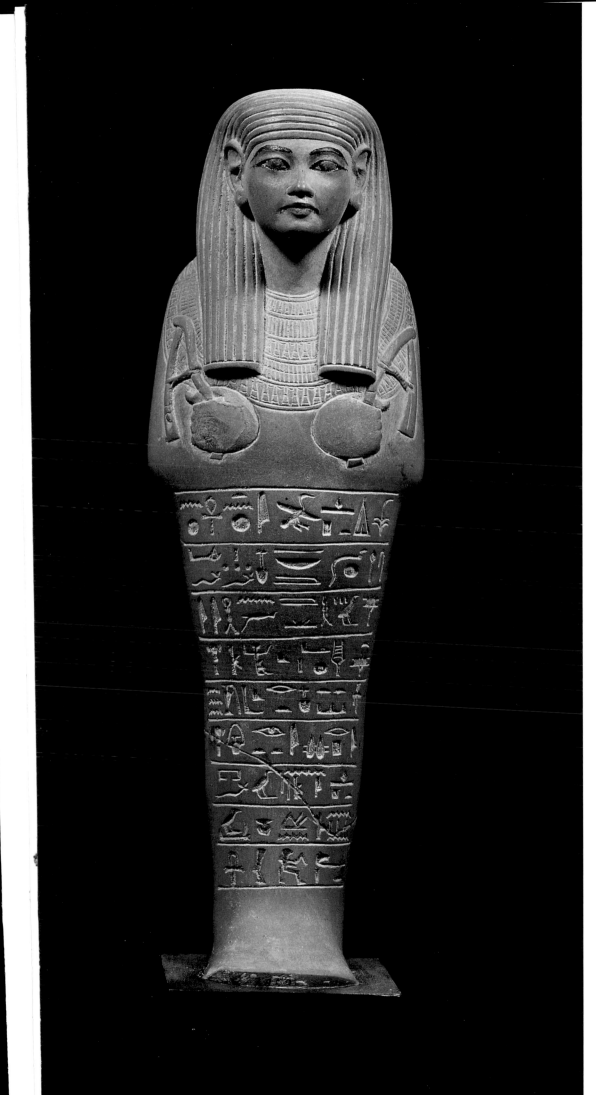

59 Funerary figure of the Adjutant Hat

Late Eighteenth Dynasty, reign of Akhenaten/
Tutankhamun, c. 1352–1327 BCE; limestone.
Height 20 cm (7 7/8 in); width 6.5 cm (2 9/16 in);
depth 4.5 cm (1 3/4 in). Purchased as "from Tuna el
Gebel." The Egyptian Museum, Cairo JE 39590

· This beautifully sculpted servant figure perhaps originated at the site of Tell el-Amarna, residence city of King Akhenaten of the late Eighteenth Dynasty. The king rejected the traditional gods of Egypt to embrace a single deity, the sun god Aten. Akhenaten condemned the representation and mention of other gods, and he particularly abhorred the great god of Thebes, Amun-Re, and his consort Mut. The inhabitants of Amarna continued to build tombs and have funerary goods made for their burials, but the prohibition of Osiris and other deities left the dwellers in Amarna without the customary guides to the underworld, including the Amduat. They nonetheless placed *ushebti*s in their burials, modified with inscriptions that omit Osiris and instead invoke Aten.

Instead of the standard *ushebti* text, Hat's inscription bears an offering formula normally found on stelae or on tomb walls. "A gift which the king gives and the living Aten who illuminates every land with his beauty, that he might give the sweet breath of the north, a long [literally high] lifetime in the beautiful west, cool water, wine, and milk for the offering for his tomb, on behalf of the *ka* [spirit] of the Adjutant Hat, repeating life." Typical of Amarna offerings, the list includes no meats and emphasizes libations.

The facial style of this figure is consistent with the end of the Amarna Period itself, including the thick mouth with downturned corners, ovoid eyes, heavily outlined in black (as compared to the hieroglyphic shaped *wedjat* eyes in cats. 40 and 101), and pierced ears.

The form of the funerary figure itself includes hoes in the hands of the mummy, as well as a seed bag hanging behind Hat's left shoulder. This latter feature became characteristic of *ushebti*s in the reign of Seti I, some fifty years later, and this is an early example.[1] **Betsy M. Bryan**

1. Jacques-F. Aubert and Liliane Aubert, *Statuettes égyptiennes: chaouabtis, ouchebtis* (Paris, 1974), 55.

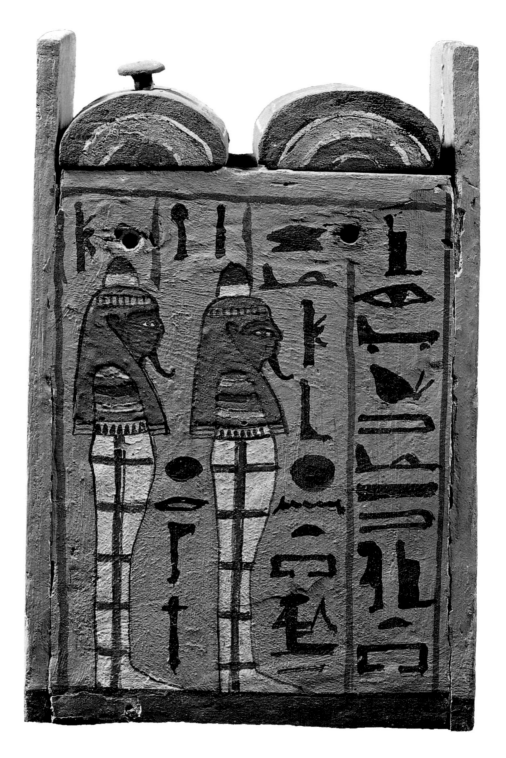

Four vertical columns of inscription read, "Osiris, the servant in the place of truth Khabekhnet, justified by the great god." On the front, two mummies are shown, carefully wrapped, covered with a funerary mask, and surmounted by an unguent cone.

Khabekhnet II, named for his paternal grandfather, was the eldest son of Sennedjem and Ii-neferti. He had the same title as his father, "servant in the place of truth." Khabekhnet was born during the reign of Seti I (1294–1279 BCE) or earlier, and functioned during that of Ramesses II (1279–1213 BCE). His own tomb lay next to that of his father. Khabekhnet married Sahte, the daughter of sculptor Piay and Neferkha. He had many children, all mentioned in the tombs of Sennedjem and Khabekhnet. Khabekhnet also married Isis, who was probably his niece, the daughter of his brother Khonsu.[1] On the lid of the sarcophagus of Khonsu, Khabekhnet appears with Isis in front of Khonsu and his wife Tamaket. The other sides of the box are painted with frames, suggesting the false doors in the ancient niched temples facades through which the *ushebti*s could enter and depart when needed. **Adel Mahmoud**

1. For the genealogy of Sahte, see M.L. Bierbrier, *The Late New Kingdom in Egypt (c. 1300–664 BC): A Genealogical and Chronological Investigation* (Warminster, England, 1975), 21, 24, 30–33, 125 no. 91. For the marriage of Khabekhnet to Isis, see Jaroslav Černý, Bernard Bruyère, and J.J. Clère, *Repertoire Onomastique de Deir el Medineh* (Cairo, 1949), 1.

64 Stool from Sennedjem's tomb

Nineteenth Dynasty, c. 1300 BCE; painted wood.
Height 36 cm (14 3/16 in); width 39 cm (15 3/8 in);
depth 32 cm (12 5/8 in). Tomb of Sennedjem, no. 1,
at Deir el-Medina. The Egyptian Museum, Cairo
JE 27290

• The ancient Egyptians used a number of different types of seats, from plain low stools to the folding stools and armchairs with backrests. The lattice stool seen here was probably the most common and is widely represented in Theban tomb scenes as a seat for people of all ranks.

The construction of this stool is simple and elegant, with four slender legs joined by tenon and mortise to a sloping seat. Crossbars between the legs provide stability, and the space below the seat on all four sides was strengthened with vertical struts and angled braces, which created a design for the sides. Indeed, tables were fashioned in nearly the same way but with flat tops in place of the curved seats. These lightweight tables were portable and are often seen in scenes with bearers carrying food for banquets. Likewise such tables and seats are shown being carried to the tomb during funeral processions.

The seat is formed of curved wooden slats and woven plant fibers, which pass through holes in the edge of the seat frame. It was sloped for comfort. It is noteworthy that this seat and several others from Sennedjem's tomb look worn on the top, indicating certain use in life, probably moved inside and out as needed.

Sennedjem's house would have been furnished with tables and chairs for receiving guests. The range of furniture discovered in his tomb show that Sennedjem played an important social role with his colleagues and neighbors in Deir el-Medina. **Adel Mahmoud**

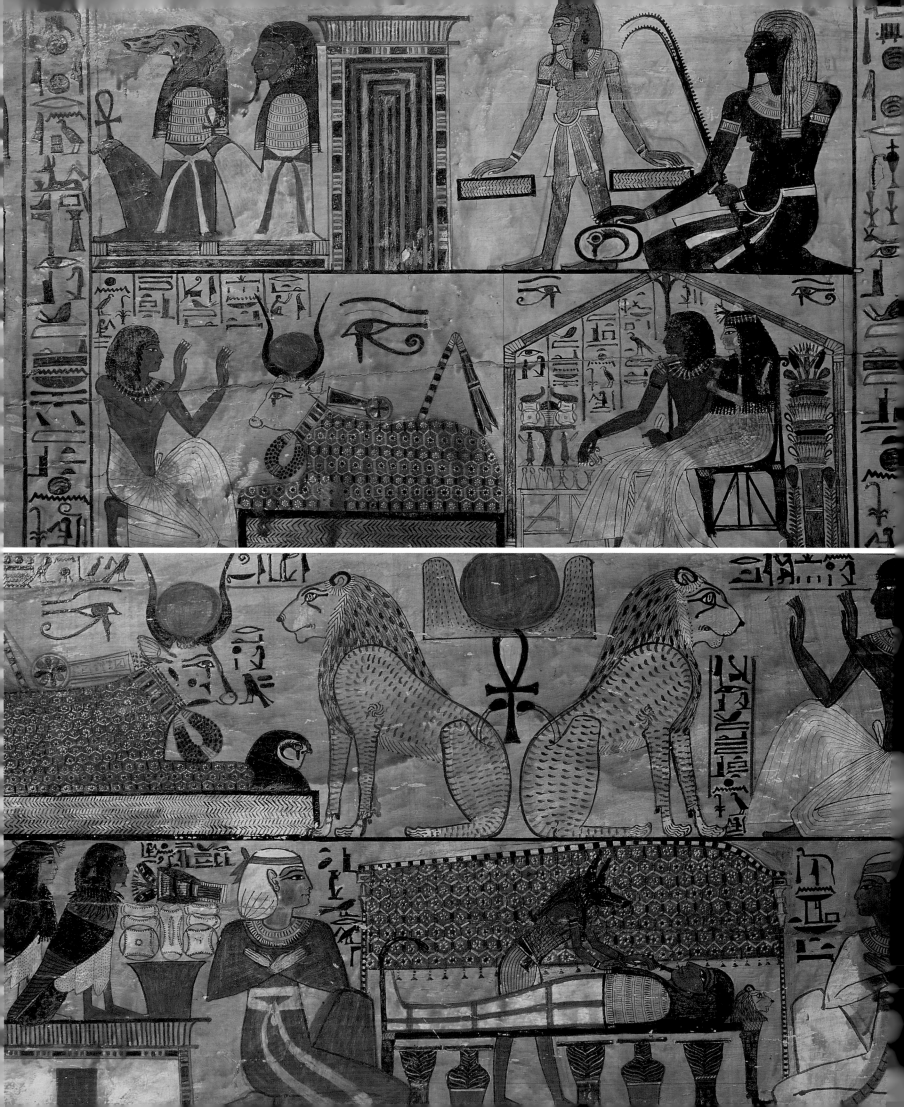

furnished and curved with sloping lid below the edge of the roof, a decorative cavetto cornice with a stylized frieze. Its roof shape is that of the shrine of the South, an archaic architectural form originally reflecting construction of wood posts and reeds. The sloped roof of the early shrine was used throughout Egyptian history for shrines and boxes that contained images of divine beings, including the deceased.

The sarcophagus was painted with beautiful scenes of the afterlife. On the two long sides, the text and the vignette are taken from the Book of the Dead. The short sides are decorated with the goddesses who defend the mummy; on the north side are Selket and Neith, who were responsible for protecting the deceased's head (p. 154). Before each goddess is her speech written in three vertical columns. On the south side are Nephthys and Isis, who were charged with protecting the deceased's feet.

The west side of the sarcophagus is divided into two registers, the upper one showing ibis-headed Thoth twice on each side. Two of the Four Sons of Horus are shown as well—human-headed Imsety on the right and jackal-headed Duamutef. In the middle of the upper register is a vignette of Chapter 17 of the Book of the Dead, an introduction to many of the important features of the next world. Khonsu is shown adoring double lions who represent "yesterday" and "tomorrow," with the horizon resting between them to suggest where the sun will rise. Behind the scene is the cow goddess Mehet-weret, "the great flood," associated with the goddess Hathor (p. 152, bottom).

In the lower scene the deceased's mummy, lying in a tent on a lion-headed bed, is attended by Anubis, who completes the embalming processes. The *bas* of Khonsu and his wife Tamaket appear in the scene to the left, watching the preparation of the corpses, with which they must join to complete the regeneration process. Bread and flowers, offerings for the mummies, also suggest that the necessities of life will be required for rejuvenation.

The lowest register contains forty vertical columns of text from Chapter 1 of the Book of the Dead, the subject matter of which is the funeral ceremony, consisting of several stages and dramatic scenes. The main purpose was to place the deceased in the tomb to be revitalized in the afterlife. The east side also shows Thoth twice in the upper register. Two sons of Horus—baboon-headed Hapy and falcon-headed Kebehsenuef—also appear.

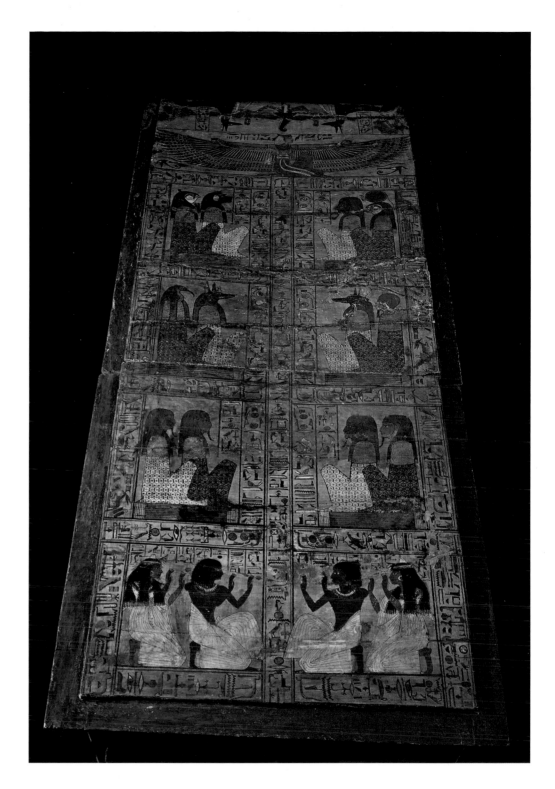

153

Another vignette of Chapter 17 of the Book of the Dead occurs here as well. Khonsu is shown adoring the celestial cow (p. 152, top). Nearby he and his wife are seated in a tent, where we see them holding a playing piece for the game *senet*. The game, which means "passing over," symbolized the preparations for entering the next world. It was played in real life but was equally appropriate for the funerary setting. The lower register has forty-three vertical columns of the Book of the Dead.[2]

The lid is decorated with panels showing the funerary deities, and Khonsu and Tamaket kneeling in adoration in the corners.

Adel Mahmoud

1. Khonsu's sarcophagus is similar to that of his father, Sennedjem, in the Egyptian Museum, Cairo, JE 27301.

2. For more details on the Book of the Dead, see Raymond O. Faulkner, Ogden Goelet Jr., and Carol Andrews, ed. and trans., *The Ancient Egyptian Book of the Dead* (San Francisco, 1994).

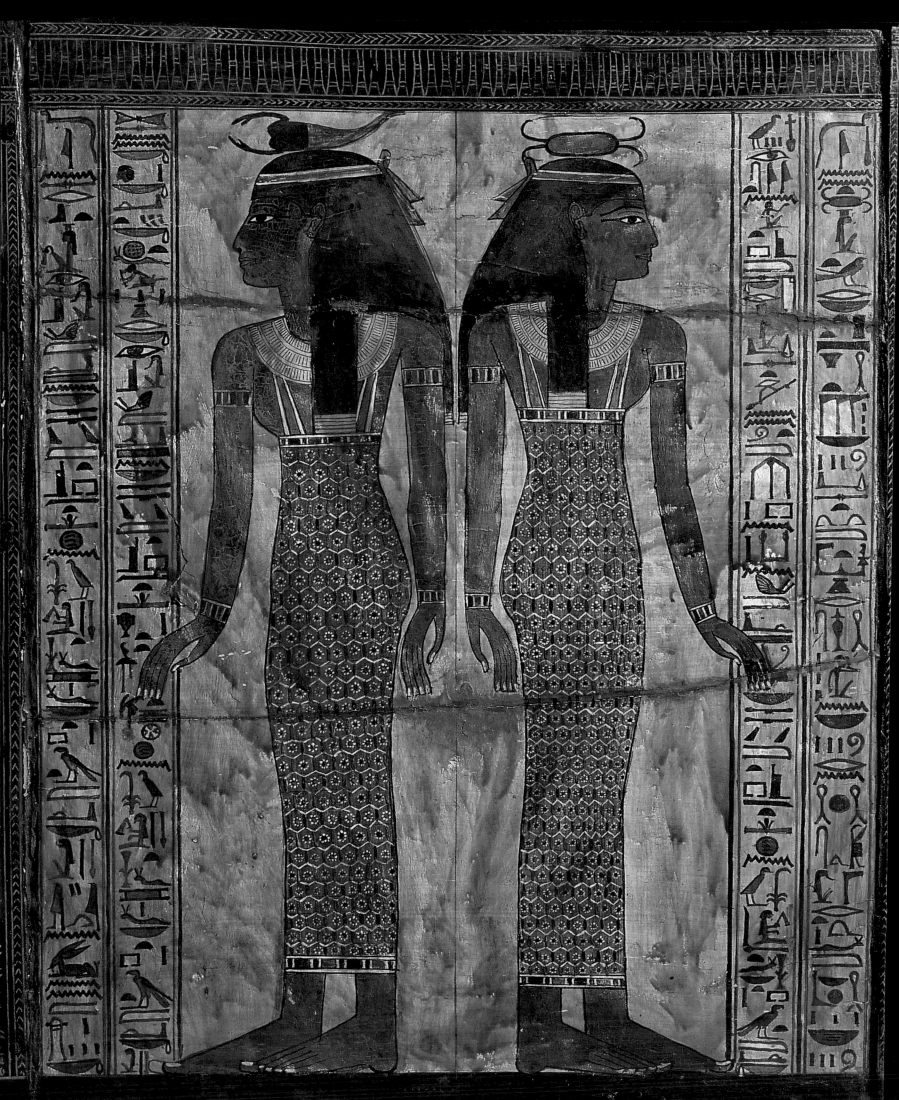

69 Clappers

Sixteenth Dynasty, c. 1600 BCE; Ivory. Length
20 cm (7 7/8 in); width 6.5 cm (2 9/16 in); depth 1 cm
(3/8 in). Provenance unknown. The Egyptian Museum,
Cairo CG 69224

New Kingdom, 1550 – 1069 BCE; ivory. Length
25.5 cm (10 1/16 in); width 10 cm (3 15/16 in); depth
1 cm (3/8 in). Deir el-Medina. The Egyptian Museum,
Cairo CG 69247

• These two clappers, carved from ivory hip-
popotamus incisors into the shape of the human
arm, belong to the genre of one of ancient Egypt's
most popular and enduring musical instruments.
Both culminate in the shape of a left hand with
long, thin digits. One of the clappers has an
inscription, which names its owner "Hereditary
Princess, King's Daughter Nensemekhtuef, may
she live" (or Life, Prosperity, Health!). This name
means "he shall not be forgotten," perhaps here
referring to a deity. The inscribed clapper retains
traces of carved fingernails, and a bracelet design
at the wrist. The other clapper also sports bracelet
ornamentation but no fingernail markings. It
has a small hole at its upper end, which would have
been used to tie it to another clapper or around
the musician's wrist. While the decorative sides
of the clappers maintain the rounded outer
surface of the original material, their interior
sides are flat.

Clappers appear in the archaeological
record of Egypt and Southern Palestine from the
fifth millennium BCE. The earliest examples dis-
play a boomerang shape, but later clappers can
also take a more vertical, pear shape. The top of
the instrument often was carved into the form
of a hand, but examples with lotus flowers or the
heads of gazelles, cows, ducks, humans, and
the goddess Hathor all exist. Designs covering
the rest of the instrument consist of incised dots
and circles, crisscrosses and bracelet designs
as seen on the examples here. Musicians played
the clappers by beating two against each other,
creating a snapping sound that could maintain
a rhythm. Unfortunately, no examples of musical
notation have yet been identified, so ancient
Egyptian music can not be reproduced. Some tomb
contexts have revealed exceptionally fine and
delicate clappers, suggesting that a number of
individuals had these objects produced specifically
for their use in the next world.

It is evident that music played a vital
role in Egyptian life, in both celebrations and
religious rituals. Temple and tomb reliefs depict
groups of professional musicians performing
and practicing. By the period of the Old Kingdom
(2686 – 2125 BCE), individuals held titles that
related to their musical functions — a tradition
that would remain important to both women and
men throughout later periods. A Middle Kingdom
(2055 – 1650 BCE) tomb shows its owner Senbi
receiving *menat* necklaces (a type of beaded neck-
lace that could be shaken to produce a rattling
sound) while clapper-wielding attendants stand
by. The corresponding inscriptions reveal a
ritualistic association with Hathor, whose strong
affiliation with music is clearly depicted at her
temple in Dendera. The god Bes also was linked
with music, and images of him dancing, playing
the harp or shaking a tambourine can be found.
Elaine Sullivan

72

My game pieces are made to endure in the
 embalming chamber
I have the full complement throughout the
 embalming chamber
My seven pieces are indeed winners
My fingers are like the jackals who tow the
 solar barque

158

I grasp his [my opponent's] pieces…
And pitch him into the water
So that he drowns together with his pieces.

The symbolism of this game is extremely rich
and is hard to elucidate fully. The jackals must be
connected with Anubis, the jackal deity who
weighs the heart in the other world and guides
the soul. One of the squares in the *senet* game
bears the image of a walking jackal. This and the
jackal-headed sticks are associated with the Spirits
of the West who tow the barque of the sun
through the night sky. Jackal-headed sticks call
to mind the Egyptian hieroglyph for "strong,"
weser, and the jackal-headed pole called *wesret*.
The turtle was an animal regarded as inimical
to the sun god and was perhaps seen as a mani-
festation of the chaos-spirit Apopis. The fact
that its image was bored with holes suggests an
apotropaic magical function. **Terence DuQuesne**

73 Anthropoid coffin of Paduamen, with inner board and lid

Twenty-first Dynasty, reign of the High Priest
Pinudjem II, 1069–945 BCE; painted and varnished
wood. Coffin: Height 198 cm (77 15/16 in); width 55 cm
(21 5/8 in); depth 30 cm (11 13/16 in). Inner board:
Height 180 cm (70 7/8 in); width 37 cm (14 9/16 in);
depth 12 cm (4 3/4 in). Lid of coffin: Height 198 cm
(77 15/16 in); width 55 cm (21 5/8 in); depth 35 cm
(13 3/4 in). From the tomb of Bab El-Gusus, found
in 1891 in Deir el-Bahari. The Egyptian Museum,
Cairo CG6233–6235

• Coffins to contain the mummy of the deceased
were an important element in the burial assem-
blage of ancient Egypt. They developed from a
simple rectangular form to very elaborate designs
of the New Kingdom (1550–1069 BCE) and the
Third Intermediate Period (1069–664 BCE).

 This beautiful coffin is rich in detail. The
coffin figure of Paduamen wears a long, straight
headdress that leaves his ears exposed. On the
outer lid of the coffin a beard is attached to Padu-
amen's chin; he holds an Isis knot, symbol of
protection, in his hand. Below his arms are repre-
sentations of the scarab beetle and three winged
deities, among which is the sky goddess, Nut,
spreading her wings over the body of the deceased.
Below the representation of Nut, the lid of the
coffin is divided into compartments, bordered by
four horizontal bands and one wide vertical band
of inscriptions, giving the names and titles of

Paduamen. His principal titles were "God's Father,
Master of Mysteries in Heaven, Earth, and the
Netherworld, He who opens the doors of Heaven
in the Temple of Karnak." These ranks indicate
that Paduamen accompanied the high priest
of Amun into the holy of holies in the temple of
Karnak and opened the doors of the shrine that
held the statue of the deity.

 At the foot, the deceased Paduamen and
his wife are shown making offerings to the gods
Osiris, Isis, and Horus. The interior of the coffin
lid is reminiscent of the style used at the end
of the Twentieth Dynasty, when the interior of
coffins was decorated with bright colors on a dark
red background. A large figure of Osiris occupies
almost all of the interior lid of Paduamen's coffin
(p. 161, left).

 The interior of the coffin box is dominated
by the figure of the winged goddess Isis standing
on the sign for gold; she has a frieze of uraei
adorning her head (p. 160, left). The two patron
goddesses of Upper and Lower Egypt, Nekhbet
and Wadjet, are shown as winged cobras holding
the ankh sign over the shoulders of Isis. Horus,
Anubis, the *ba* bird, and the Isis knot sign are used
alternately around the figure of Isis. The lower
half of the coffin's interior bears images of Isis
and Nephthys, each goddess standing on the
sign for gold. Between them are representations
of the god Wepwawet. The horizon sign is in
the lowest register.

 Among the most interesting scenes
on the exterior of the coffin box are the represen-
tation of the sun barque drawn by jackals, the
judgment scenes where Paduamen is led by Maat,
the goddess of truth, and by Thoth to Osiris who
is seated on his shrine (p. 160, right). Another
scene on the exterior right side of the box repre-
sents Paduamen in front of the tree goddess
providing him with life-giving water.

 The mummy board was placed directly
over the wrappings of the mummy (pp. 159 and
161, right). It is almost identical in shape, deco-
ration, and coloring to those of the lid. The
arms are clenched and may have had some sacred
emblems placed within them. Below the wide
collar is the goddess Nut spreading her wings.
Paduamen is represented with his wife making
offerings to several deities.

 The tomb of Bab El-Gusus, where this
coffin was found, is an old tomb that was extended
and reused, in the time of the high priest Menk-
heperre, to accommodate the coffins of members
of the high priest's family. **Fatma Ismail**

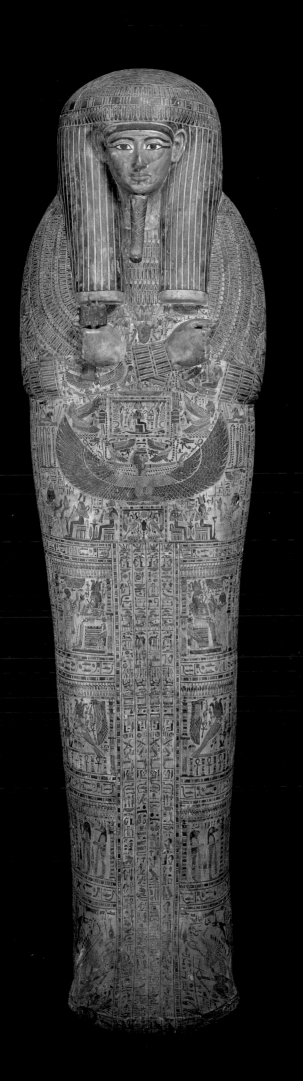
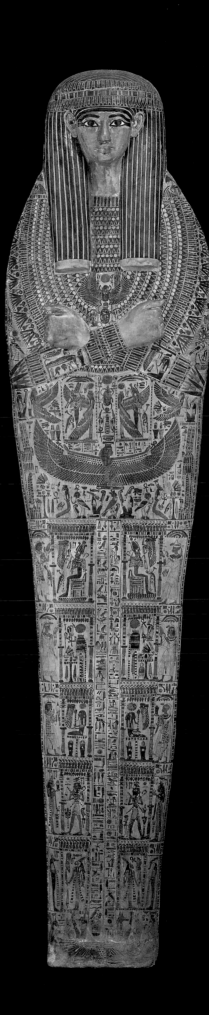

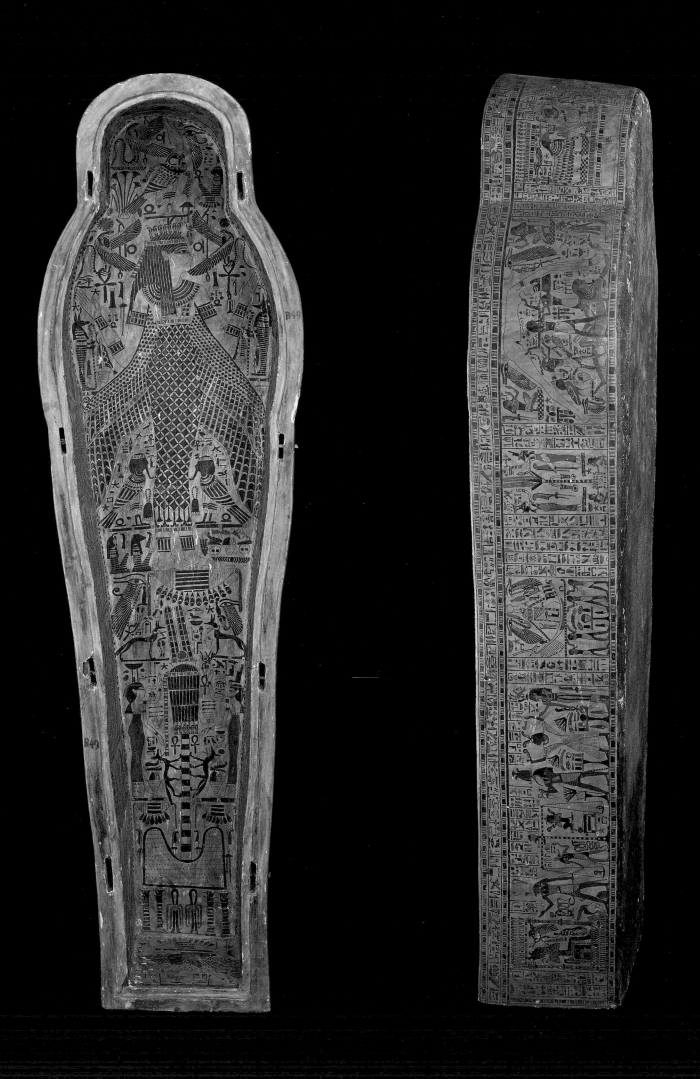

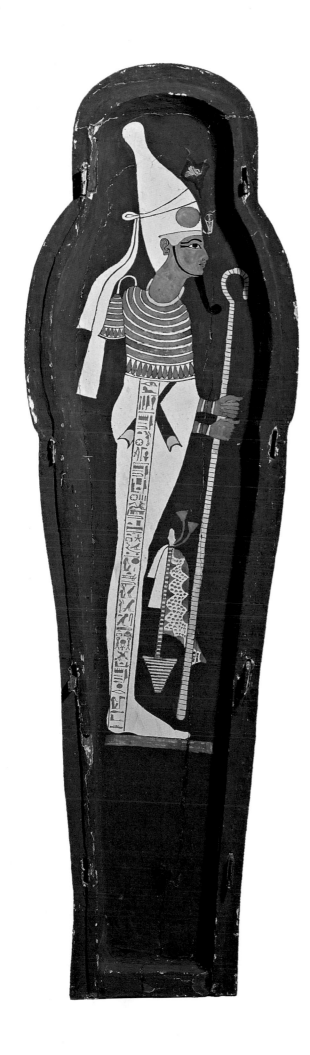

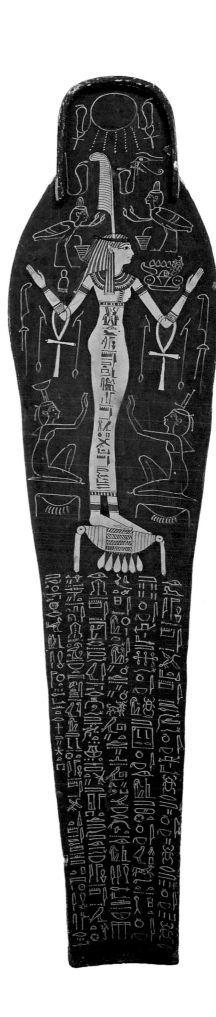

74 Jubilation relief

Nineteenth Dynasty, 1295–1186 BCE; limestone.
Height 60 cm (23 5/8 in); width 110 cm (43 5/16 in);
depth 15 cm (5 7/8 in). Found reused in the Serapeum;
likely from a tomb at Sakkara. The Egyptian
Museum, Cairo JE 4872/SR 11754

• This scene, capturing a celebratory moment in
a procession, embodies the vitality that the
skilled Ramesside artists infused into their reliefs
and paintings. Two rows of women attired in
elaborate wigs and diaphanous robes rattle
tambourines and stamp their feet, while a pair
of small girls, absorbed in their frenzied dance,
accompany the rhythm with the snap of their
hand-held clappers. Examples of these rhythmic
objects, usually formed out of bone, ivory, or
wood, are included in this catalogue (cat. 69).
Opposite them arrives a contingent of men, con-
ducted by one of its members wielding a baton.
Their contrasting dress suggests they hold differ-
ent occupations: simply attired soldiers in front,
three priests follow with clean-shaven heads,
and elaborately garbed nobles rejoice in the rear.
The raised heels of each man suggests a spirited
gait, emphasizing the forward motion of their
march. Arms held aloft, the retinue participates
in the acts of jubilation and praise. The Egyptian
artist chose to depict the straight lines of the
parade by deftly overlapping the bodies of each
man, carving just enough of the figures in the
background to delineate their physiques. The
exclusion of certain details, like the legs and feet of
the top row of musicians and the back arms of
the middle section of marchers, only adds to the
scene's feeling of motion and energy. The hiero-
glyphic inscriptions above and beside the second
row of men list the names of two of the partici-
pants, "Aanacht," and the scribe "Amenkhau."

In the Nineteenth Dynasty, decorative
themes for tomb reliefs stressed the journey of the
deceased to the next world, giving popularity
to scenes such as divine adoration, the weighing
of the tomb owner's heart, or mourners accom-
panying the sarcophagus to the tomb. This relief
has previously been labeled as part of a funerary
procession, but other interpretations are possible
—it may show a parade accompanying the divine
barque of the god on its movement at times of
festival. Sakkara, from whence this piece likely
derives, served as a necropolis for the Memphite
officials and members of court in the Eighteenth,
Nineteenth, and part of the Twentieth Dynasties.
Unlike the famous rock-cut tombs of the Theban
area, many of the burial places at Sakkara were
freestanding tombs built of mud-brick or stone
blocks. Even in ancient times the draw of ready-
made building material was too tempting to
resist, and the tombs were dismantled to be reused
in newer construction works. This block appeared
reused in the Serapeum, a cultic center nearby.
Elaine Sullivan

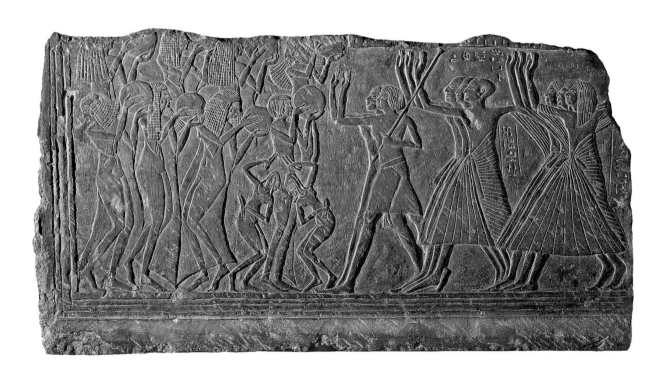

75 Canopic chest of
Queen Nedjmet

Late Twentieth Dynasty, c. 1087–1080 BCE;
gilded and painted wood. Height 83 cm (32 11/16 in);
width 50 cm (19 11/16 in); depth 66 cm (26 in).
Deir el-Bahari Cache, Thebes, discovered in 1881.
The Egyptian Museum, Cairo TR 20-12-25-11

• This canopic chest belonged to Queen Nedjmet, wife of the high priest Herihor. The term canopic is used to designate containers for the internal organs removed during mummification. The term is mistakenly associated with the Greek hero Kanopos who was worshiped in the form of a jar in the city of Canopus, modern Abu Kir.

This chest is represented in the form of a *naos* shrine: the upper part of the chest has a cavetto cornice, whereas its lid is rounded at the front and slopes down to the rear. It is mounted upon a portable sledge with four carrying poles. When this chest was found, it contained only *ushebtis* of Pinudjem II, the high priest of Amun in the Twenty-first Dynasty, and his wife Nesikhonsu.

A statue of Anubis is affixed to the lid of the chest. The statue is made of wood, stuccoed and coated with a black resin. The interior of the ears, the scarf, and the collar are gilded. Anubis was a funerary god, lord of the necropolis. He guided the dead in the next world and oversaw mummification.

The sides of the canopic chest represent friezes of cobras with the sun disk over their heads. There are also representations of the Isis knot and *djed* pillar of Osiris, symbols of protection and stability. On the front side of the chest, Queen Nedjmet is represented twice, standing before both Osiris and Anubis.

In the earliest canopic preparations the wrapped visceral bundles were placed directly into a chest or a specially built cavity in the tomb wall. Beginning in the Middle Kingdom (2055–1650 BCE), a chest, reflecting the design of the contemporary coffin or sarcophagus began to be used to house four canopic jars, each containing a human organ. By the New Kingdom (1550–1069 BCE) the canopic chest imitated the form of *naos* shrines, and was decorated with images of the recumbent figure of the jackal god Anubis or the four protector goddesses Isis,

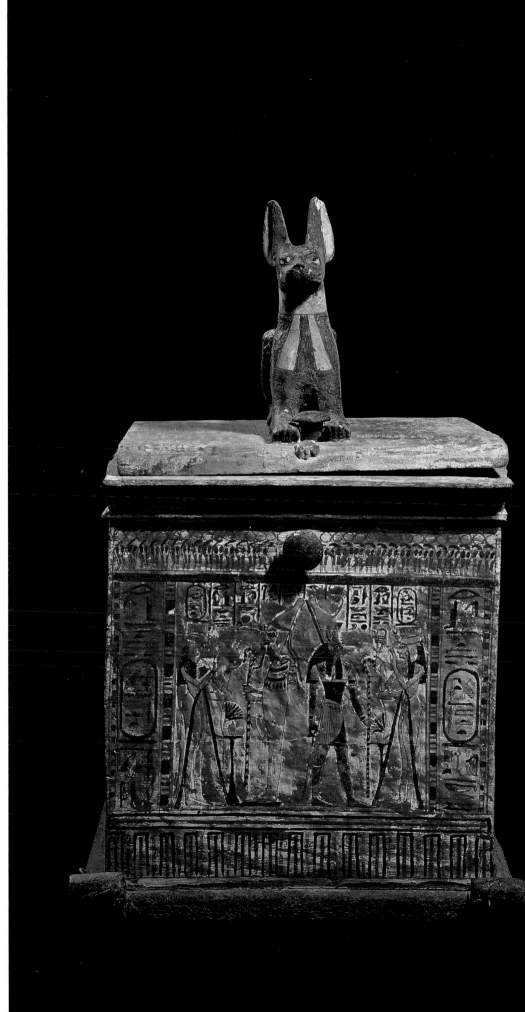

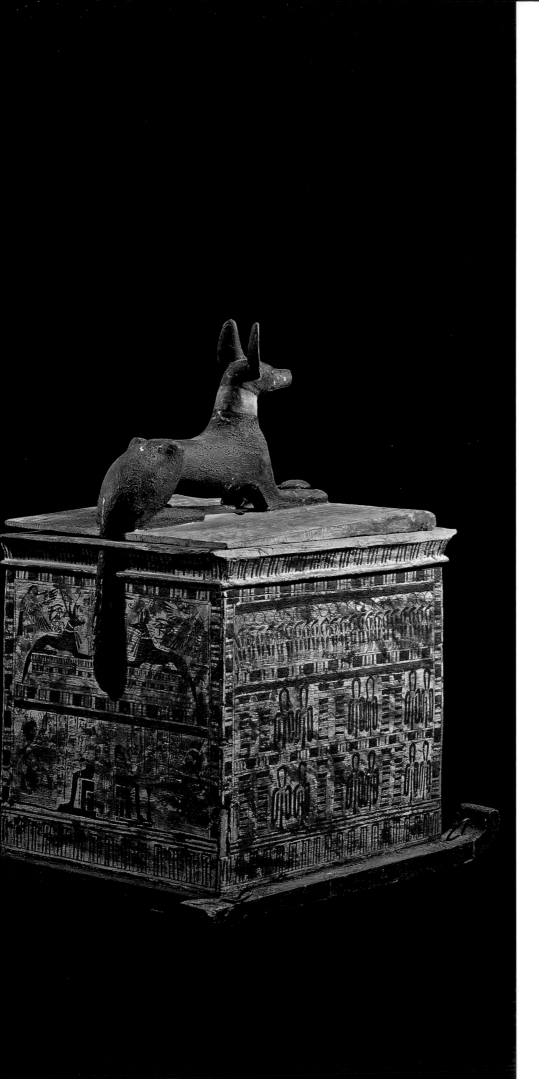

Nepthys, Neith, and Selket. By the end of the New Kingdom, a recumbent jackal of Anubis was normally attached to the lid of the chest and protective goddesses were no longer represented.

In the Twenty-first Dynasty, the viscera were returned to the body cavity of the mummies after embalming, each with an amuletic figure of the relevant deity attached. However, the symbolic function of the canopic equipment did not end. Many high-status individuals continued to place empty jars in their tombs. When the canopic packages came to be placed again inside jars, the amuletic set of the Four Sons of Horus continued to be incorporated into the mummy wrappings. Unlike contemporary mummies, the internal organs of Queen Nedjmet do not seem to have been returned to the body.

Nedjmet 's husband, Herihor, created a ruling class of the high priests of Amun at Thebes toward the end of the New Kingdom. Nothing is known about his burial equipment except a joint funerary papyrus with his wife. Based on indications in scratched graffiti, we believe that his tomb may still await discovery in Thebes. Queen Nedjmet may have been a sister of Ramesses XI. Her mummy was found in the Deir el-Bahari cache with wrappings referring to year 1 of Smendes (1069 BCE) of the Twenty-first Dynasty. **Fatma Ismail**

Realm of the Gods and the Amduat (catalogue nos. 76–107)

The ancient Egyptians were careful to equip their dead with detailed instructions for safe passage through the myriad perils of the netherworld. The texts and vignettes of the Amduat facilitated the safe journey of the deceased through the barriers and dangers of the twelve-hour nightly passage through the netherworld. Images of protective deities were dedicated in temples and included in tombs. Those of kings in particular could be filled with an abundance of statuettes of gods and goddesses. Deities connected to the netherworld, regeneration, and the solar cycle of rebirth took precedence.

76 Statue of mummiform deity

Eighteenth Dynasty, reign of Amenhotep III, 1390–1352 BCE; granodiorite. Height 180 cm (70 3/16 in); width 30 cm (11 13/16 in); depth 100 cm (39 3/8 in). Sheikh Abada. The Egyptian Museum, Cairo JE 89616

• The life-sized seated statue of a god is carved out of granodiorite, one of the hardest stones that Egyptian sculptors used. Despite the reticence of the material, the artisans achieved a highly smoothed and polished surface, marking the statue unmistakably as the creation of Amenhotep III's artists. Some one thousand statues in this stone were produced for the funerary temple of that king, the majority of them representing deities. This example was probably among that group, but, like many of these images, was later (perhaps already during the reign of Amenhotep III) moved to the site of Sheikh Abada in Middle Egypt. Even without the fine technical treatment of the stone, the statue would be assigned easily to the reign of Amenhotep III, given the characteristic ovoid and slightly slanting eyes with smooth convex eyelids (in contrast to the eyelids of Ramesses II, which are hollowed, or concave). The fleshy face of the god also bears the imprint of Amenhotep III's portrait, as do the thick lips, entirely encircled by an incised "lipline."[1] Although some of Ramesses II's portraits (see cat. 13) did emulate the facial shape and mouth of Amenhotep III, his artists nonetheless eliminated the lip lines and carved a mouth more like that from the late Eighteenth Dynasty than from the time of Amenhotep III. Here is the classic portrait face of that last named ruler.

This statue of a mummiform deity was not inscribed during the reign of Amenhotep III, but was later inscribed with the dedication, "The good god Usermaatre, beloved of Isis; the son of Re, Ramesses, beloved of Isis." A mate to this piece also came from Sheikh Abada (Cairo temp. no. 7/3/45/2). It is also mummiform in shape, but it has a beard, which this piece lacks. The inscription on its socle dedicates the statue to Ramesses II, beloved of Osiris. The site in Middle

Egypt also yielded an uninscribed life-sized striding statue of a falcon-headed god. Although it is unknown whom this deity represented, it is notable that a temple to the falcon god, Horus of Hebenu, was situated a few miles north of Sheikh Abada, where Amenhotep III carried out construction work late in his reign. Ramesses II reused the remains of those constructions for his own work at the site and perhaps took over these statues at that time.[2]

In its original conception, this statue may not have represented a female deity, but rather the chthonic god Tatjenen whose name, "the land is risen," alludes to creation on a primeval hill out of the water of chaos.

Deities in their mummy forms are not uncommon in the Egyptian underworld, where they are among the guardians of the hours of night who praise the sun god when he sails through on his boat. Scenes depicting the second hour of the night show a row of mummiform gods seated on thrones, just as they are here. The row is completed by a depiction of the goddess Isis as a bearded male. The statue's gender is nearly as ambiguous as this masculine form of Isis, since only slightly enlarged breasts appear through the mummy's shroud. Here, Isis has stepped out of her usual roles as wife of Osiris and protector of the mummy and is more to be understood as a member of the pantheon that guarantees the maintenance of the sun god's order, within both this world and the netherworld. **Betsy M. Bryan**

166

1. For a discussion of the portraits of Amenhotep III, see Betsy M. Bryan, "Royal and Divine Statuary" in Arielle P. Kozloff and Betsy M. Bryan. *Egypt's Dazzling Sun: Amenhotep III and His World* (Cleveland, 1992), 125–92.

2. Gomaà Farouk, "Hebenu (pp. 1075–76) in Wolfgang Helck and Wolfhart Westendorf, eds., *Lexikon der Ägyptologie*, vol. 2 (Wiesbaden, 1977).

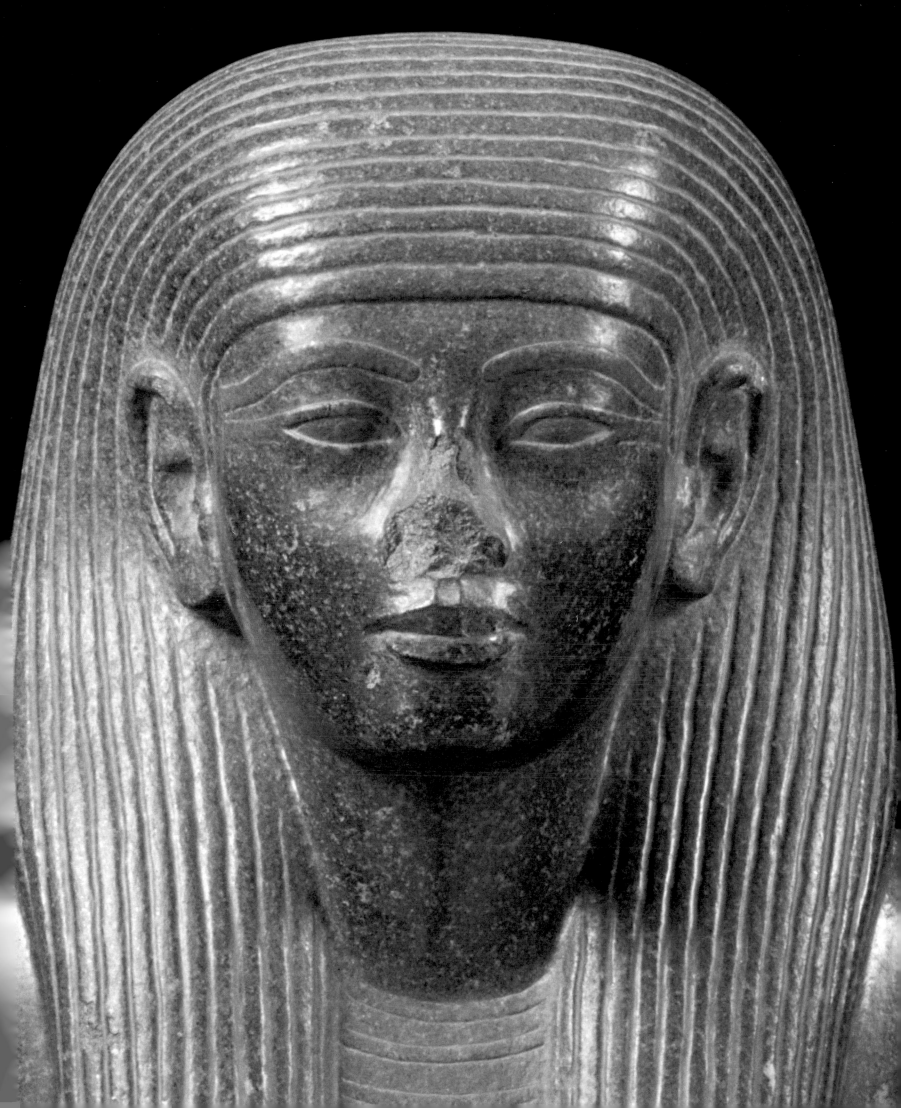

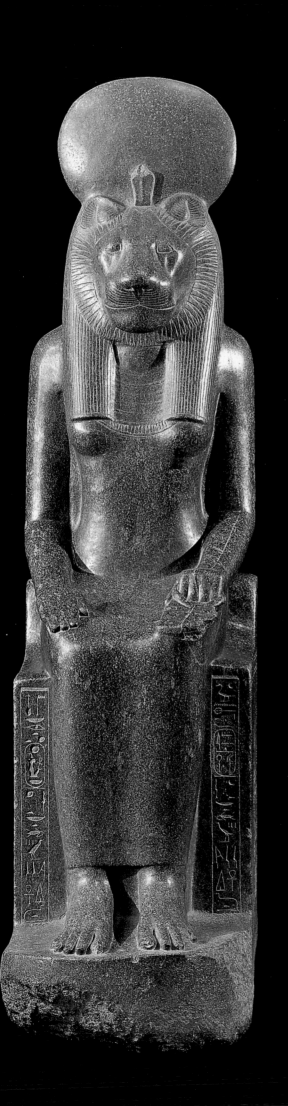

77 Seated statue of the goddess Sakhmet, "mistress of fear"

Eighteenth Dynasty, reign of Amenhotep III, 1390–1352 BCE; granodiorite. Height 207 cm (81½ in); width 56 cm (22 1/16 in); depth 98 cm (38 9/16 in). Temple of Mut, Karnak. The Egyptian Museum, Cairo CG 39063

• This is one of many similar statues of the lioness-headed goddess Sakhmet found in the first court of the temple of Mut in Karnak. The lioness head is joined to the human body in such a way that the lion's fringe of hair is extended into a wig. The figure is seated and bears on its head a sun disk with the uraeus. Its right hand rests flat on the right knee, and the left hand holds an ankh sign (the symbol of life). Around her neck, the goddess wears a broad collar of several rows of beads, known as a *wesekh* collar. The throne is of a standard form, with a backrest. A square at the side of the throne contains the plant of the north (the papyrus) and the plant of the south (the lily); between them is the *sema-tawi* sign, symbolizing the unity of Upper and Lower Egypt under the rule of one strong pharaoh. On the front of the throne is a vertical rectangle surmounted with the sign representing the sky. On the left is the following inscription: "The good god, lord of the cult act, of Nebmaatre, beloved of Sakhmet, mistress of fear, given life forever." The inscription on the right reads: "The son of Re of his body, Amenhotep, ruler of Thebes, beloved of Sakhmet, mistress of fear, given life forever."

Remains of paint indicate that the statue was probably painted. The eyes of some Sakhmet statues were tinted red. Most of the Sakhmet statues found at the temple of Mut were dedicated to the Eighteenth Dynasty king Amenhotep III, which is why Auguste Mariette ascribed to him the foundation of the entire temple. Some of the statues are inscribed with a dedication by Sheshonk I (945–924 BCE), the Shishak of the Bible (Twenty-second Dynasty). It was likely that Mariette regarded these inscriptions as usurped; although there is no trace of an earlier cartouche being chiseled out.

Sakhmet's name meant "she who is powerful." A member of the Memphite triad, the consort of the god Ptah, and the mother of Nefertem, Sakhmet personified the aggressive aspects of female deities. She was usually depicted as a woman with the head of a lioness but, as the daughter of the sun god, Re, she was also closely associated with the royal uraeus in her role as the fire-breathing "Eye of Re." It is mentioned twice in the Pyramid Texts that the king was conceived by Sakhmet.

As the Theban rulers of the New Kingdom (1550–1069 BCE) rose to power, the Theban triad (Amun, Mut and Khonsu) became increasingly important and began to acquire the attributes of other deities. As a result, Sakhmet began to be identified as an aggressive manifestation of the goddess Mut. Seven hundred thirty statues, two for each day of the year, were erected by Amenhotep III, in his mortuary temple in western Thebes. Most of these were later moved to the Temple of Mut at Karnak.

The aggressive nature of Sakhmet made her the perfect protector of the sun god as he journeyed through the netherworld. This is why she appears frequently in the Amduat. **Yasmin El Shazly**

78 Statue of Osiris

Twenty-sixth Dynasty, reign of Psamtik I, 664–610 BCE; graywacke. Height 150 cm (59 1/16 in); width 24.5 cm (9 5/8 in); depth 43 cm (16 15/16 in). Medinet Habu, discovered 1 January 1895. The Egyptian Museum, Cairo JE 30997 / CG 38231

• This large standing statue of the god Osiris shows him in mummified form, wrapped in an enveloping cloak, leaving the forearms free, with the crook and flail held in his crossed-over hands. His torso is slender and his legs are attenuated. A pyramidal-topped back pillar rises to the apex of the high crown of Upper Egypt.

The head of the deity is well carved. A long beard is attached to the chin with straps that descend from the ears and run along the lower jawline. The slight smile on the full-lipped mouth is accentuated by visible drill holes at its outer corners. The nose is straight and very thin. The wide eyes, almond shaped and delicately rimmed, surmounted by arched raised-relief eyebrows, are elegantly carved, with long plastically rounded

cosmetic lines emerging from their outer corners. This statue epitomizes the high Saite style. It is sculpted with great care and attention to detail in a comparatively soft stone, which makes its own elegant statement.

The inscriptions on the base of the statue and on the back pillar indicate that it was dedicated by the divine wife of Amun, Nitocris, to "Osiris, in front of west and the lord of life." Nitocris, daughter of Psamtik, was adopted as successor at Thebes to the divine wife of Amun Shepenwepet II, the daughter of King Piankhi.

Osiris was the god of the dead who presided over the court of justice in the hereafter. His usual representation was a form of mummified man wearing the *atef* crown, or the crown of Upper Egypt, as here, with his arms crossed over his chest and holding a crook and flail. The cult of Osiris dates back to at least the Fifth Dynasty (2494–2345 BCE), when his name occurs for the first time in the texts from the pyramid of King Unas. The cult center of Osiris is not easy to locate, because it was connected with all of the ancient nomes of Egypt, as mentioned in the texts of the Egyptian temples from the Ptolemaic Period (332–30 BCE), parts of the dismembered body of Osiris were dispersed to all of the forty-two Egyptian nomes. Each nome claimed to contain a grave of Osiris.

The god's main cult centers included the sites of the Abaton near Philae, Abydos, and Busiris. He was at the center of the festivals of the month of Khoiak between the end of the annual Nile flood and the sowing season. The main purpose of this festival was to re-create the scene of the death and resurrection of the god. Osiris was the absolute master of the afterlife — he who first defeated death to live once more in a new dimension beyond the grave. Osiris was one of the most important gods in the Egyptian pantheon, and his exploits were well known as a result of Plutarch's description that has survived. Osiris, the beloved lord of the earth, was killed and his body dismembered by his jealous brother Seth, but his sister-wife Isis and his sister Nephthys searched and found the scattered parts of his body and put them back together again, returning him to existence. **Mamdouh El-Damaty**

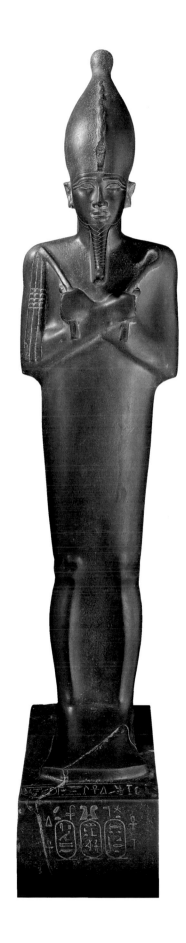

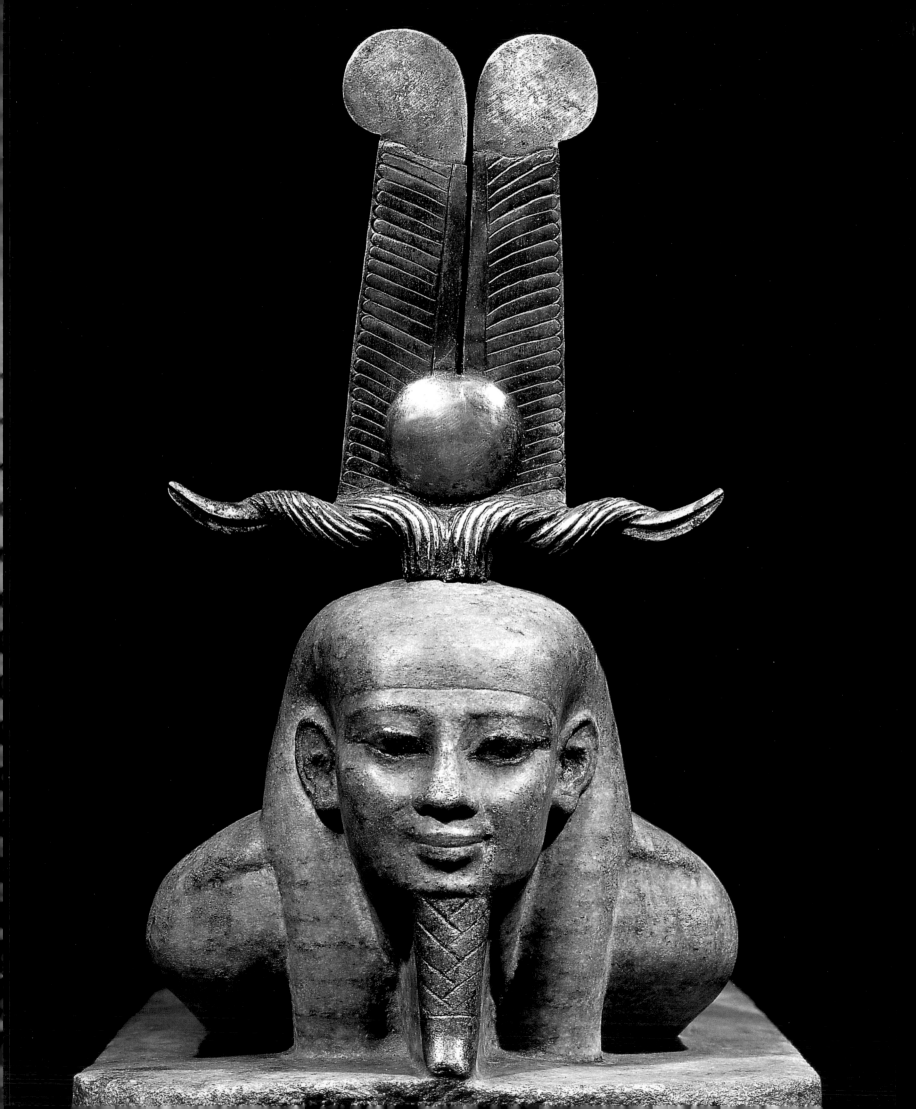

85 Osiris resurrecting

Twenty-sixth Dynasty, 664–525 BCE; gneiss, with a headdress in electrum and gold. Height 29.5 cm (11 5⁄8 in); width 18 cm (7 1⁄16 in); depth 55.5 cm (21 7⁄8 in). From Horbeit. The Egyptian Museum, Cairo CG 38424

• Close in length to the ancient Egyptian measurement of a cubit (average length 52.5 cm.), this prone figure wears a common divine headdress with lappets surmounted by two ostrich plumes. The plumes are a headdress called *shuty* worn by several gods, including Osiris. Here it is adorned with a pair of ram's horns and a sun disk that relate it further to the solar sphere. On the god's chin is a braided and curved beard of the type often worn by deities. The plinth on which the figure rests may have been intended for insertion into an inscribed base. Unfortunately, the lack of a text and a specific find-spot prevent a detailed interpretation of the statue's original function and its date of manufacture.

When studies were first published in 1872, the face of Osiris was likened to those of other images of King Apries (589–570 BCE); and although it does not closely resemble works recently attributed to that king, its idealizing style and hint of a smile are at home in that general era.[1]

Also since 1872, it has been identified as an image of the god Osiris in the process of resurrecting, on the basis of related reliefs and paintings in temples and tombs of the New Kingdom and later, some of which have the words "awake" or "awaken" above the figure.[2] That a god who died and was revived should be shown wrapped as a mummy is hardly surprising since this symbolized both the protection of the body and the potential for rebirth. Indeed, the daily solar cycle could be seen in terms of the sun god and Osiris, with sunset viewed as the solar deity's death as Osiris followed by his rebirth at sunrise. In addition to being a rare image in the round of Osiris in this pose, the sculpture is in the hard stone gneiss little used during the Late Period.[3]

Richard Fazzini

1. August Mariette, *Monuments divers recueillis en Égypte et en Nubie* (Paris, 1872), 11–12. For a recent attribution of statues to Apries, see Jack A. Josephson, "Royal Sculpture of the Later Twenty-sixth Dynasty," *Mitteilungen des Deutschen Archäologischen Instituts, Abteilung Kairo* 48 (1992): 93–95, pls. 16–19.

2. E.g., Jan Assmann, *Das Grab der Mutirdes,* AV 13 (Mainz, 1977), 90–92.

3. Dietrich Wildung, "Two Representations of Gods from the Early Old Kingdom," *Miscellanea Wilbouriana,* vol. 1 (Brooklyn, 1972), 151, and Thierry De Putter and Christina Karlshausen, *Les pierres utilisées dans la sculpture et l'architecture de l'Égypte pharaonique: Guide pratique illustré* (Brussels, 1992), 79–80.

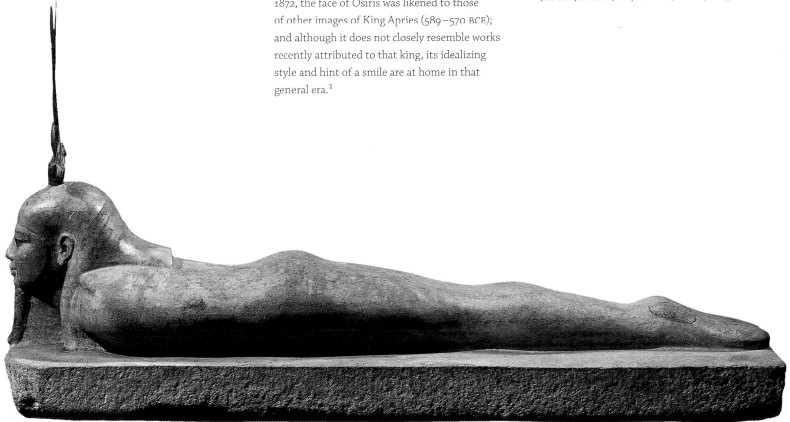

88 Goddess Maat

Third Intermediate Period, c. 800–700 BCE;
lapis lazuli and gold. Height 7 cm (2¾ in);
width 2.5 cm (1 in); depth 2.5 cm (1 in). Khartoum.
The Egyptian Museum, Cairo CG 38907

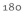

· This statuette depicts the goddess Maat as a seated woman. The uraeus on her forehead identifies her as a goddess, and the feather on her head is the hieroglyph with which her name was often written. The statue was apparently meant to be worn around the neck of its owner.

The ancient Egyptian word *maat* is an abstract term meaning essentially "things as they ought to be." The Egyptians viewed this concept as part of the order of the universe, somewhat akin to the concept of natural law. For that reason, *maat* was seen as a divine principle, female because the word is feminine in gender.

In theory, *maat* governed all aspects of ancient Egyptian life. On the broadest level it was the principle behind the regularity of nature, initiated at the first sunrise of creation: the daily cycle of sunrise and sunset, the yearly progression of the seasons, and the continual phenomenon of life, death, and new life. The uraeus on the forehead of this statue, which is unusual in depictions of *maat,* reflects the governing power of this principle.

Maat was also the moral and ethical principle that determined the proper mode of behavior in human society, from correct treatment of one's fellow human beings to just government. Its moral aspect is reflected in the funerary corpus known as the Book of the Dead, where the heart of the deceased is depicted in the final judgment being weighed against the feather that symbolizes *maat.* Temple scenes and statues also show the pharaoh presenting *maat* to the gods, commemorating his proper conduct of government. National and local officials were also supposed to exercise their offices in accordance with *maat.* For that reason the vizier, head of the national bureaucracy, sometimes wore an image of *maat* around his neck. The gilding on the feather and uraeus of this statue suggest that it may have belonged to one of these high officials., or perhaps from one of the Kushite royal family, since the figure comes from the Sudan, the home of the Twenty-fifth Dynasty conquering rulers of Egypt. **James Allen**

180

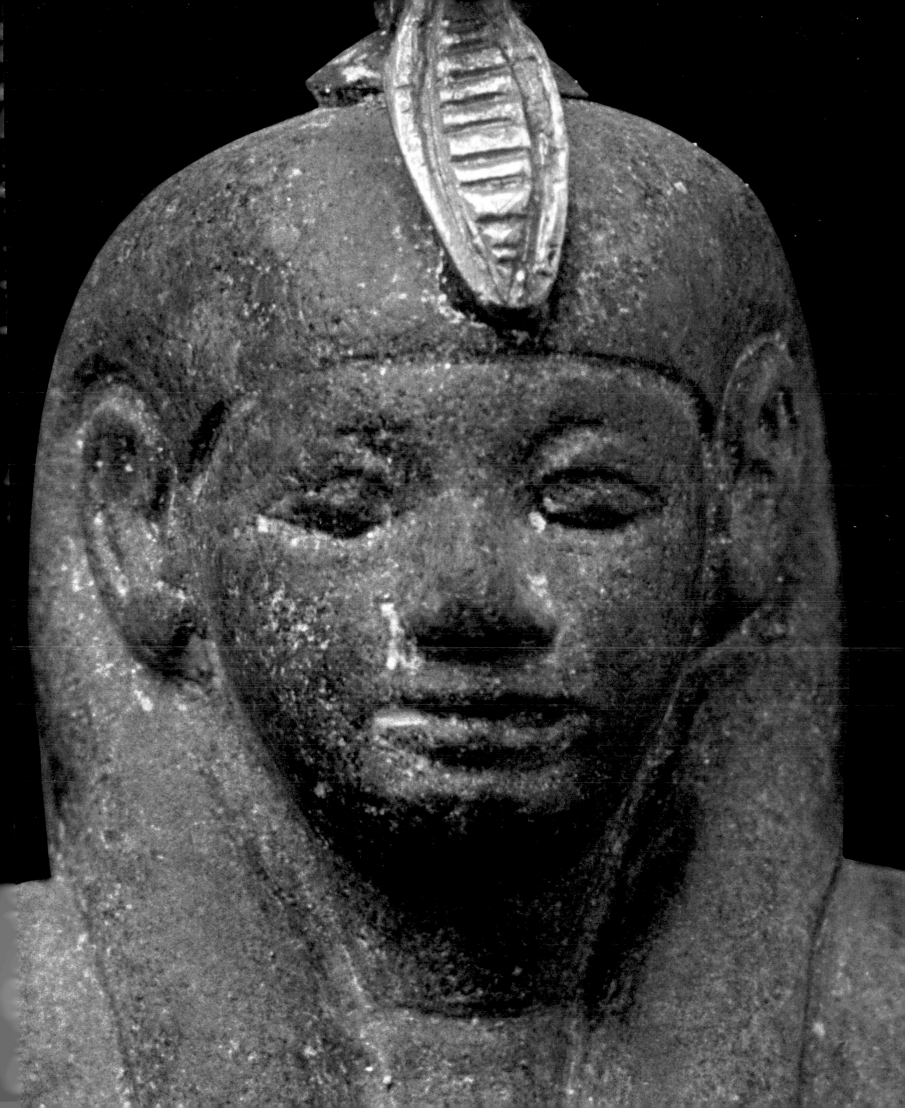

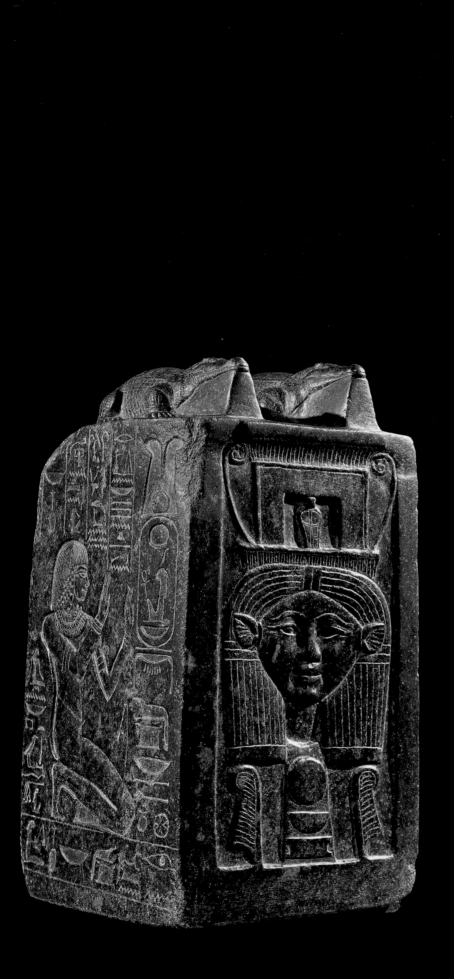

91 Block with relief
of Nebnefer

Eighteenth Dynasty, reign of Amenhotep III, 1390–1352 BCE; granodiorite. Height 55.5 cm (21⅞ in). Discovered in 1987 at the Sobek Temple of Dahamsha. Luxor Museum J 136

• This block is from the Sobek Temple in Sumenu (modern Dahamsha), a town southwest of Luxor. It shows on the right side in sunk relief an official, Nebnefer, adorned with an elaborate wig, worshiping the cartouche or royal name of Amenhotep III. On the left side the same man pays obeisance to the crocodile god Sobek and the goddess Hathor. Fittingly two crocodiles, the sacred animal and symbol of Sobek, crouch upon the block. This important deity is naturally most closely associated with water, streams, and swamps. He was particularly worshiped in the Fayum, but also had cult centers throughout the rest of Egypt, such as Sumenu.[1] In the front of the monument a Hathor *sistrum* is represented, this being a sacred rattle instrument used in temple cult. In the back the wife and mother of Nebnefer are shown playing the *sistra*, and holding the *menat*, a type of necklace also sacred to Hathor.

Crocodile deities appear, for example, in the Sixth Hour of the Amduat. In that section a male deity, perhaps Sobek, is merely called "crocodile," while a female deity is said to be associated with the primeval water of Nun.[2] Sobek is a god of fertility, feared for his power and mastery over the water. It is in this aspect that he appears in such underworld compositions as the Coffin Texts.[3] Generally Sobek has no wife among the goddesses, but he is often represented in company with Hathor, as in this monument.[4] Amenhotep III seems to have built installations at Semenu intended to house sacred crocodiles.[5] Such a votive monument as this one would have been displayed in the Sobek Temple, attesting to the piety of the donor, Nebnefer.

The vertical lines of inscription on the right side may be translated: "Giving praise to the Lord of the Two Lands; kissing the earth for the Ruler of Thebes by the priest, overseer of the treasury of Amun, Nebnefer." Behind Nebnefer: "Born to the mistress of the house, Djuf." Horizontal line at the bottom of the right side: "Made by the master of the secrets of Sobek, Nebnefer." The vertical lines on the left side may be rendered: "Giving praise to Sobek Sobek (sic). Kissing the earth for Hathor. I have given to you adoration to the height of heaven, while I cause your hearts to be satisfied every day, by the priest, royal scribe, and divine sealer of Amun, Nebnefer." Beneath this is a horizontal band of hieroglyphs: "Made by the priest of Amun, Nebnefer." In the back the vertical column in the middle runs: "Offerings and provisions which their *ka* gives to the *ka* of the priest, overseer of the Treasury of Amun, Nebnefer." Above the female figure with the *menat* and sistrum on the right: "His mother, the mistress of the house, Djuf." Above the female figure with the *menat* and *sistrum* to the left: "His sister, the chantress of Amun and mistress of the house, Huy." Beneath the two women in the back is a horizontal line: "Son of the overseer of the wine storeroom and scribe, Sobekhotep, justified of voice." Beneath the *sistrum* in the front may be read: "Beloved of Nebmaatre [i.e. Amenhotep III]."

Richard Jasnow

1. See Edward Brovarski, "Sobek" (pp. 995–1031) in Wolfgang Helck and Wolfhart Westendorf, eds., *Lexikon der Ägyptologie*, vol. 5 (Wiesbaden, 1984).

2. Erik Hornung, *Die Unterweltsbücher der Ägypter* (Zurich/Munich, 1992), 125. The male deity is said to be Sobek in Hornung, *The Ancient Egyptian Books of the Afterlife* (Ithaca, New York, 1999), 37.

3. Brovarski, "Sobek," 1000.

4. Ibid., 1008.

5. Ibid., 1004.

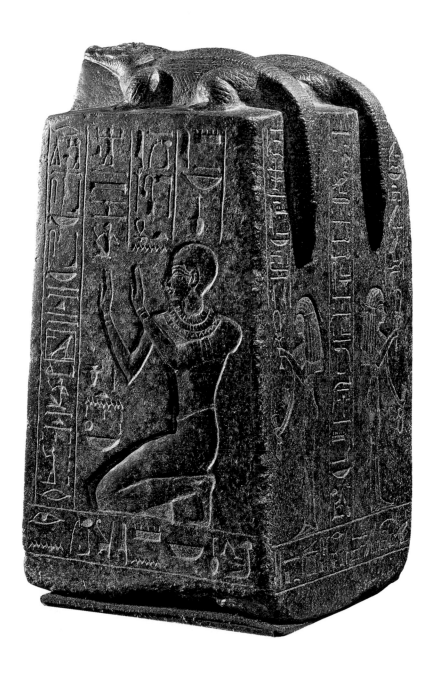

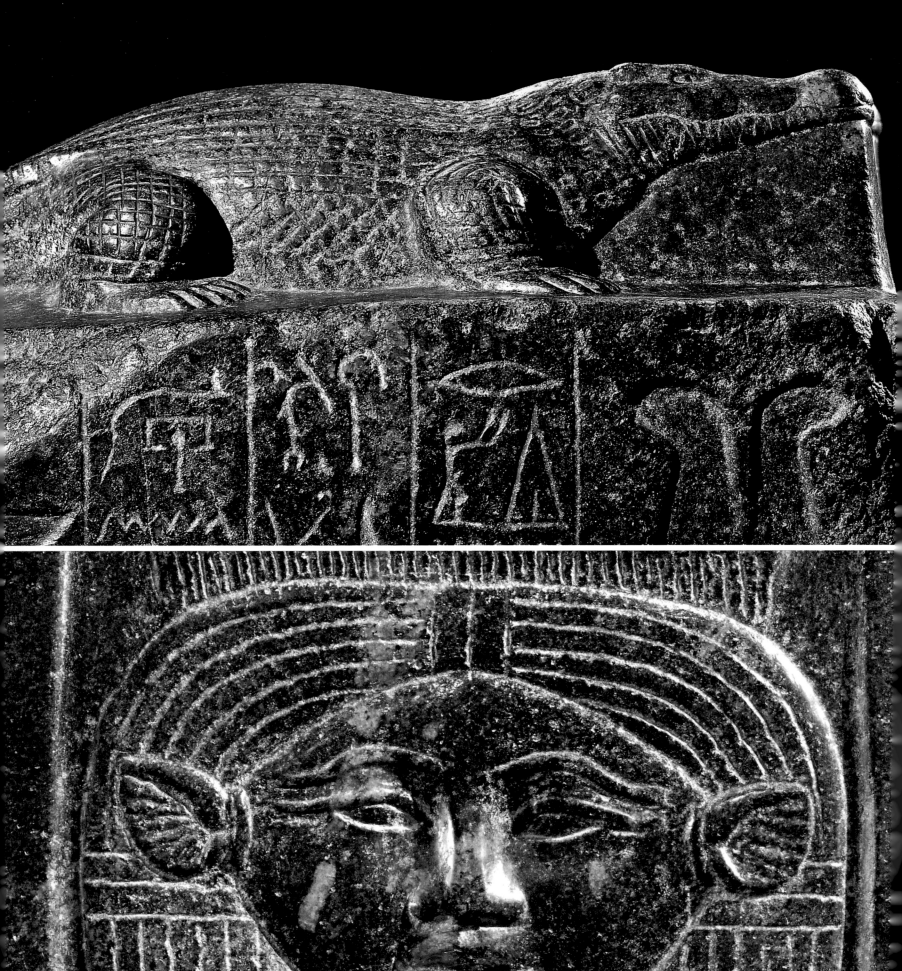

92 Falcon

Twenty-second Dynasty, c. 945–715 BCE;
bronze with gold inlay. Height 22.5 cm (8⅞ in);
width 7.5 cm (2¹⁵⁄₁₆ in); depth 17 cm (6¹¹⁄₁₆ in).
The Egyptian Museum, Cairo JE 30335

· The very beautiful and commanding Horus falcon was a votive offering to the god in the Twenty-second Dynasty. Bronze casting was greatly improved during the New Kingdom (1550–1069 BCE) and by the Third Intermediate Period (1069–664 BCE) it had become common to make gifts to the gods in the form of bronze statuettes inscribed with the donor's name and often a prayer as well. This piece is inscribed for "Horus the son, gives life [to] Imhotep, son of Padi-Neith." Unfortunately we do not know where the falcon was donated, and Horus the son of Isis was honored in a variety of locations, both in the north and the south. The inlay of gold was particularly characteristic of the Third Intermediate Period, when bronze working was at its apogee. Here it is used to outline the eyes, making them even more penetrating. It also forms the eye markings of the falcon, the leg bands of the bird, and, of course, the necklace, designed to imitate lotus garlands. Hanging down from the collar is a pendant with a heart and a sun disk. The falcon wears the crown of Lower Egypt, very brightly painted in red over the bronze. Whether the original crown also combined the Upper Egyptian crown or not is unknown, but it is possible.

Horus was the god embodied in the office of kingship, and through most periods of Egyptian history, images of the falcon also conjured up the presence of the ruler. In the temple of Seti I at Abydos several images show falcons on altars with shrines behind. The inscriptions make it clear that these are the great living falcons, but they are identified with Seti himself. In the Third Intermediate Period rulers at Tanis emphasized this association by fashioning coffins with falcon heads rather than human ones. The king as solar falcon could then enter the west quite prepared. The bronze falcon here also has solar connotations, as witness the sun disk around his neck. Whether it was associated in the minds of the Egyptians with the king is uncertain, but certainly the falcon Horus was a popular image for donation in the temples of the Third Intermediate Period. **Betsy M. Bryan**

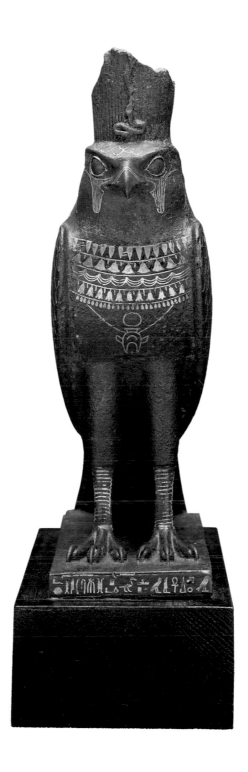

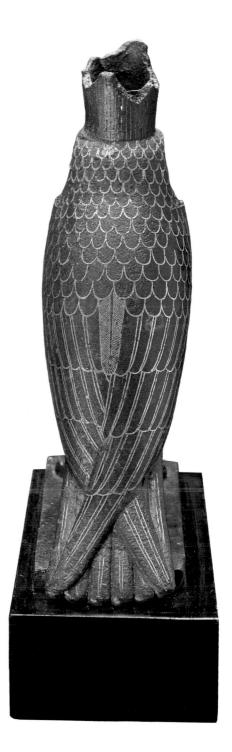

187

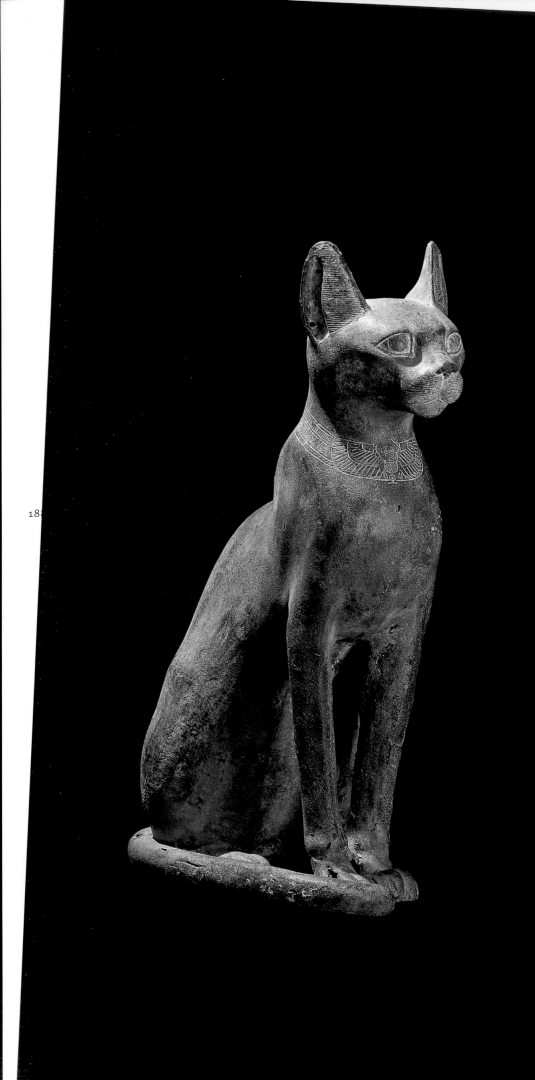

95 Bronze cat

Late Period – Ptolemaic Period c. 664 – 30 BCE; bronze. Height 38.5 cm (15³⁄₁₆ in); width 15.5 cm (6⅛ in), depth 29 cm (11⁷⁄₁₆ in). The Egyptian Museum, Cairo, JE 29147

· Bronze statues of cats were an important part of religious cult devotions from the Late Period into the Ptolemaic Period (c. 664 – 30 BCE). It was believed that buying, and then donating, a statuette to the temple could bring merit before the gods, and consequently ensure one's own life after death.

Thousands of bronze representations of cats are known, varying in size from small amulets to greater than life-size. The larger ones, like this example, had two functions. Those with a small interior cavity are thought to be votive statuettes that devotees would dedicate to one of the feline-form deities such as the goddesses Bastet, Pakhet, and Sakhmet. The statuettes would be left at a shrine or temple to bear witness of the individual's devotion. In some cases, the statue, or its base, would bear the name of the devotee, and more rarely, a short dedication text might be added.

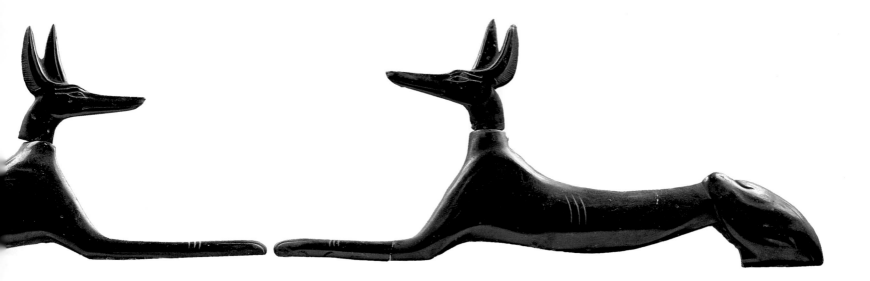

The figurines that have a larger interior cavity were, in some cases, used as coffins for mummified cats. In the beginning of the first millennium BCE, cult practices increasingly included animal mummies, which like the statues, were donated to the temple. The animals were considered to be the *ba*, or visible manifestation of the power of the deity, that they symbolized. Texts relate that priests bred the animals that were associated with the patron deity of the temple.[1] Maintaining a breeding stock, the priests culled the offspring and mummified them. Radiographic examination has shown that kittens were killed within a year of their birth, usually by having their neck broken. At times the mummy packets were very ornate and were decorated with false eyes, ears, and tails. Some mummies were inserted into the bronze cat coffins, while others had a bronze bust of a cat sewed to the mummy packet. In the second-century BCE Archive of Hor, which deals with sacred ibises, mummies and coffins were sold to pilgrims who then donated them to the temple where they were stored in the "hall of waiting" until they were transferred en masse to the temple catacomb each year. Thousands of bronze cat coffins and cat mummies have been recovered from sites throughout Egypt.

This statuette shows the cat proudly seated on its haunches, its tail curled around its front paws. The representation of a necklace is incised on its neck. Some examples of bronze cats were further decorated with small gold earrings. In a similar fashion, Herodotus related that sacred crocodiles were bedecked with glass or gold earrings and bracelets. **Emily Teeter**

96 Recumbent jackals

Late Period, 664–332 BCE; glass. Right and left, each: Height 8 cm (3⅛ in); width 19 cm (7½ in); depth 2 cm (¹³⁄₁₆ in). The Egyptian Museum, Cairo TR 21-12-26-19/1, 19/2

• Each of this exquisite pair of objects represents a couchant jackal, with the head cut separately from the torso and front legs. The back legs and tail are missing and would in all likelihood originally have formed a third piece. The material is black-colored glass. Since the figures are certainly intended to represent the god Anubis, black is an appropriate color, symbolizing the sanctity and mystery of night and the deity's chthonic aspects.

The objects would have been inlaid within a coffin or wooden shrine, more likely the former. The coffin of Petosiris of the Thirtieth Dynasty, (c. 350 BCE), was decorated entirely of polychrome glass inlays. Between the head and body of the jackals would have been placed a red glass band, normal shown on Anubis' neck.

Anubis is the guardian of the body, its divine embalmer and protector for the journey to the other world, where he has the further function of guide of souls. He is also closely involved in the judgment of the soul after death. In later Egyptian history, Anubis was associated with healing and with love magic. In view of his many important attributes both in this world and the next, it is not surprising that many jackal amulets have been found. The significance of this pair probably relates to the common practice of depicting, in the lunette of funerary stelae of the Middle Kingdom (2055–1650 BCE) and later, pairs of jackals seated en face to indicate not only the protection of Anubis but of the closely related twin deity Wepwawet, "Opener of the Ways." One of these jackals is often named as Wepwawet of Upper Egypt, and the other Wepwawet of Lower Egypt. The deity Wepwawet is invoked to open the ways to the netherworld, but he also has important functions in this life, as defender of the king and protector against enemies. **Terence DuQuesne**

97 Double snake coffin

Late Period, 664–332 BCE; bronze. Height 15.5 cm
(6⅛ in); width 44 cm (17 5/16 in); depth 6 cm (2⅜ in).
Provenance unknown; The Egyptian Museum, Cairo
JE 27254/CG 38704

• On top of this rectangular box, inscribed with
two horizontal lines of hieroglyphs at the front,
are two identical hybrid deities, in bronze, with
human heads and the bodies of upright cobras.
The bodies of the cobras are crosshatched and
have a ladderlike design down the front of the
hood. Each human head is adorned with a long
wig and false beard and topped with an *atef*
crown with plumes and horns; the two figures are
joined at the horns. The weathered inscription
on the front of the box may be rendered as "May
Atum give life to Teshnefer, son of Amenirdis."

The iconography of this very curious
object may be unique. Occasionally in the Late
Period the god Atum was represented as a cobra,
though without a human head, or as an eel. From
the same period a few examples of human-headed
eels, also sacred animals of Atum, have been
found. In three cases they have human heads
topped with the double crown and no doubt
represent Atum; they rest on rectangular boxes
that evidently served as coffins for individual eels
or snakes. Hybrid forms of Atum and other deities
are common in the Late Period. By this time the
god Atum had acquired the status of a near-uni-
versal deity. Such hybrid entities were generated
in order to maximize magical effectiveness; hence
the figures of Bes Pantheos with a large composite
crown, feet in the shape of jackal heads, and
attributes of various other deities. In the case of
the snake or eel coffins or boxes the object would
have been, in part, to obtain favor from the
deity in exchange for providing a casket for one
of his sacred animals. This object may have
been intended to thank the deity for rescue from
illness or, like the "healing statues" and Horus
stelae that are found from the Late Period onward,
to ward off some malady such as snakebite.
Terence DuQuesne

192

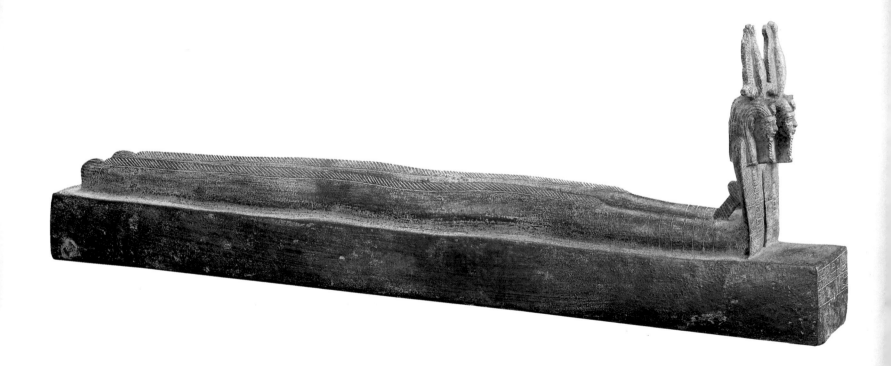

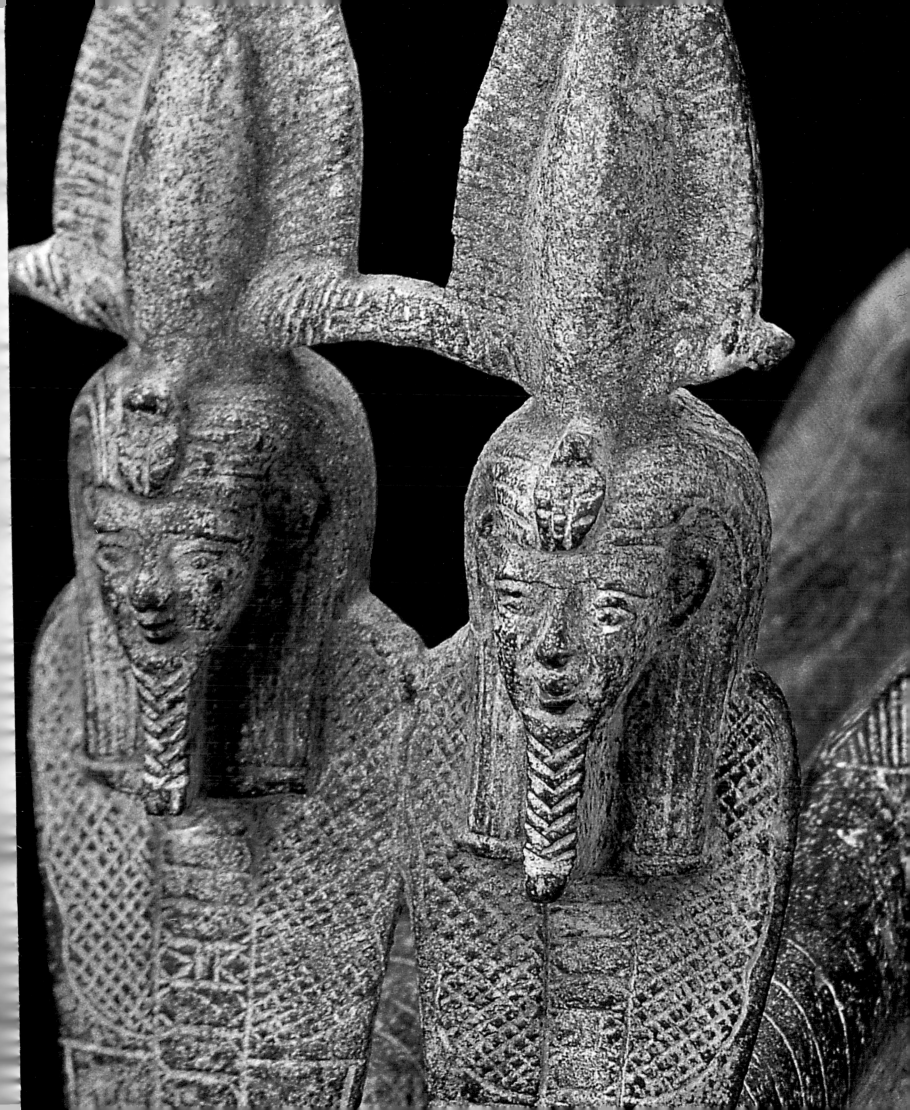

196

98 South

98 East

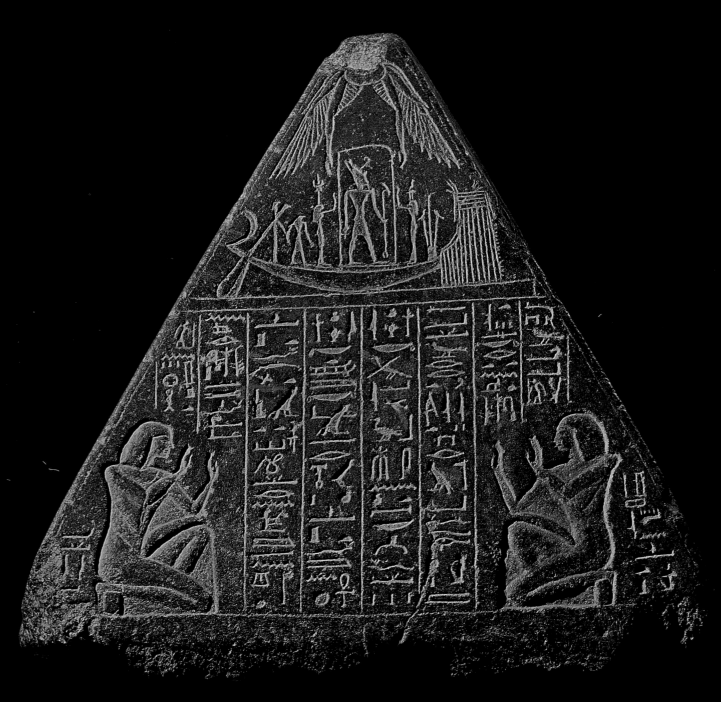

South face, lower register:
To left, a kneeling male figure with arms raised in adoration. Inscription (left):

Glorification to Re-Horakhty, to the divine image upon the horizon, by the Osiris, the true scribe of the king, by whom he is well loved, the great local count of Memphis, Huy, triumphant. He says: "Praise to you doubly, youth of the morning at Edfu, you who traverse the sky each day and who watch over the netherworld at night." Let him [the god] come to rest on the body of the Osiris Amenhotep, so that he may live as the southern stars live, the Osiris, the overseer of the temple, triumphant.

To right, a kneeling male figure with arms raised in adoration, balancing the figure to left. Inscription (right):

Glorification to Re when he sails up to the horizon, by the Osiris, the true scribe of the king, by whom he is well loved, the great overseer of the temple of Memphis Amenhotep, triumphant. He says: "Praise to you, youth, who renew the lovely sun disk of the morning." May he [the god] grant the sight of sunrays in the morning, and kissing the earth for him who is in the netherworld [Osiris], for the Osiris, the true scribe of the king, by whom he is well loved, [Amenhotep, triumphant].

East face, upper register:
Below a winged sun disk, two female figures with solar disks on their heads (probably Isis and Nephthys) kneel either side of a shrine within which stands a falcon-headed deity wearing the *atef* crown, bearing a crook and flail. He is named as "Sokar, lord of Ro-setau."

East face, lower register:
To left, a kneeling male figure with arms raised in adoration. Inscription (left):

Praise to you, Sokar-Osiris, king of everlasting, ruler of the Land of Silence, inspirer of great affection. May you visit the resting place of the great god, the setting of the sun in Ro-setau, the celestial company in the Shetayet, and the horizon in its visible appearance, for the inhabitants of the West, and for the Osiris, the true scribe of the king, by whom he is well loved, the great overseer of the temple of Memphis Huy, triumphant.

To right, a kneeling male figure with arms raised in adoration, balancing the figure to left. Inscription (right):

Praise to you, Osiris-Sokar, inspirer of affection, the one who comes into existence in the *henu*-barque. May you direct the celestial company to the Shetayet among the excellent transfigured spirits and (grant) rest for the body and (cause) it to be in the royal company of the great god, for the Osiris, the scribe of the king, by whom he is well loved, the king's mouthpiece in the temple of Memphis, the great overseer in his (Ptah's) temple, the principal count of Memphis, Amenhotep, triumphant.

North face, upper register:
Above, a winged sun disk with arms stretching down to touch a shrine in which Atum, the setting sun, anthropomorphic and wearing the double crown, stands holding a scepter. The shrine is set in the solar bark. To left and right of the shrine respectively, female figures stand with arms upraised. The female figure to the left wears the Abydos emblem on her head, and the one to the right has the symbol for the west on her head. At the stern of the boat, a standing falcon-headed deity, no doubt Horus, mans the rudder, just as on the south face.

North face, lower register:
To left, a kneeling male figure with arms raised in adoration. Inscription (left):

Praise to you, Atum in the evening, you who come to rest in life, you who set (as) a dead body in the western place. May my name be vigorous in the Land of Silence[?], for the Osiris, the scribe of the king, by whom he is well loved, the principal count of Memphis, city of Ptah, Huy, [triumphant].

To right, a kneeling male figure with arms raised in adoration, balancing the figure to left. Inscription (right):

Praise to you, you heir of Geb, born of Nut, possessor of glory, with great uraeus crown, inspirer of affection, who ascends as a god. May you grant the seeing of the sun in the Shetayet[?] of Sokar, for the Osiris, the scribe of the king, the principal overseer, the principal count of Memphis, Amenhotep [triumphant].

Terence DuQuesne

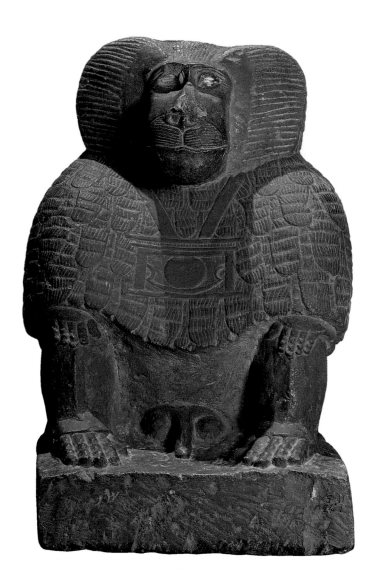

99 Baboon

**New Kingdom? 1550–1069 BCE; sandstone.
Height 60 cm (23 ⅝ in); width 43.5 cm (17 ⅛ in);
depth 44 cm (17 ⁵⁄₁₆ in). Provenance unknown.
The Egyptian Museum, Cairo TR 5-11-24-1**

• This statue depicts a cynocephalus (dog headed)
baboon, considered one of the main manifesta-
tions of the god Thoth. The baboon stands on
a square base with its hands resting on its knees.
The details are carefully incised. The eyes and
nose are hollow, suggesting that they may once
have been inlaid with a material that is now lost.
The hair is carved in such a way that it almost
looks like feathers. The genital area is left exposed,
probably emphasizing the sexual symbolism
of these creatures to the ancient Egyptians.
A pectoral with a representation of a sun barque
is carved around the neck.

The Egyptians had been familiar with
apes since the fourth millennium BCE. They were
linked with the rejuvenation rituals and festivals
of Upper Egyptian chieftains in Predynastic
times (c. 5300–3000 BCE), and later to those of
Early Dynastic Horus kings (c. 3000–2686 BCE).
Since then, they had a permanent place in ancient
Egyptian religion as one of the more important
animal forms into which the gods might be trans-
formed. As primeval animals, baboons and green
monkeys were prominent parts of the Egyptian
cosmogony. The earliest gods are sometimes
depicted with baboon heads. The baboon became
an aspect of the sun god, Re (probably the result
of the observation that baboons greet the rising
sun in the morning by barking), and of the moon
god, Thoth-Khonsu.

Thoth (Djehuty in ancient Egyptian)
was the god of writing and knowledge, who was
depicted in the form of two animals: the baboon
(*Papio cynocephalus*) and the sacred Ibis (*Thres-
kiornis aethiopicus*). In his baboon form Thoth
was closely associated with the baboon god,
Hedj-wer (the great white one) of the Early
Dynastic period. By the end of the Old Kingdom
(2686–2181 BCE) he was usually portrayed as
an ibis-headed man, holding a scribal palette and
pen or a notched palm leaf, performing some
kind of act of recording or calculation.

Thoth was worshiped together with his
lesser-known consort, Nehmetawy, at Hermopo-
lis Magna (the ancient city of Khmun), in Middle
Egypt. There was also a temple dedicated to him
at Dakhla Oasis and one at Tell Baqliya in the
Delta. Not much remains of the temple at Khmun
besides two colossal baboon statues erected by
Amenhotep III (1390–1352 BCE). In the vignettes
of the "judgment of the dead," usually included
in the Book of the Dead of the New Kingdom,
Thoth appears both in his anthropomorphic, ibis-
headed form, recording the results of the weigh-
ing of the heart of the deceased, and as a baboon
perched on top of the scales. Thoth played the role
of guardian of the deceased in the netherworld,
and as an intermediary between the various
deities, which is probably why he became associ-
ated with the Greek god Hermes in the Ptolemaic
Period (332–30 BCE). **Yasmin El Shazly**

100 Sarcophagus lid of Nitocris

Twenty-sixth Dynasty, 664–525 BCE; red granite. Height 82 cm (32 5/16 in); width 274 cm (107 7/8 in); depth 112 cm (44 1/8 in). Deir el-Medina. The Egyptian Museum, Cairo TR 6-2-21-1

• This lid is part of a massive granite sarcophagus made for Nitocris, who was a daughter of Psamtik I, the first king of the Twenty-sixth Dynasty. Like many monuments of this period, the sarcophagus is archaizing, based on royal sarcophagi of the later New Kingdom.[1] The princess, represented as a mummiform figure lying atop the lid, is carved almost in the round. Her pose is Osiride, with arms crossed over her chest, holding a crook and flail. She wears the lappet wig and vulture headdress of high female royalty; above her brow are the remains of a uraeus (or possibly a vulture head). In contrast to these traditional elements, Nitocris's facial features, especially the shapes of her eyes and brows and her upturned mouth, are early examples of the Twenty-sixth Dynasty "Saite" style.

When Psamtik I gained control of southern Egypt in 656 BCE, he installed Nitocris as the "God's Wife of Amun" at Thebes, thus continuing the Third Intermediate Period practice of appointing a royal daughter to this exalted, wealthy, and powerful priesthood. "Married" to the god Amun, these princesses functioned as royal surrogates for the kings. Since the office was celibate and succession was through adoption, Nitocris was adopted by her predecessor, the Kushite princess Shepenwepet II, in what was clearly a political arrangement. Psamtik further strengthened his daughter's position by also naming her high priest of Amun.

Like earlier god's wives, Nitocris had a mortuary chapel built within the precinct of the Small Temple at Medinet Habu.[2] This small structure also contains chapels for her adoptive mother, Shepenwepet II, and her birth mother, Queen Mehytenweskhet. Both women are also named in the inscriptions on the lid, along with her father.

The sarcophagus and its lid were found in 1885, at the bottom of a huge pit, in a cliff grotto above the temple of Isis at Deir el-Medina.[3] Whether Nitocris was actually buried there, or whether her sarcophagus was later removed from her original burial at Medinet Habu, is still unclear.[4] The sarcophagus of her successor, Ankhnesneferibre, the daughter of Psamtik II (595–589 BCE), which was found in another pit nearby,[5] had been reused during the Ptolemaic Period. Nitocris's sarcophagus, however, shows no obvious signs of reuse.

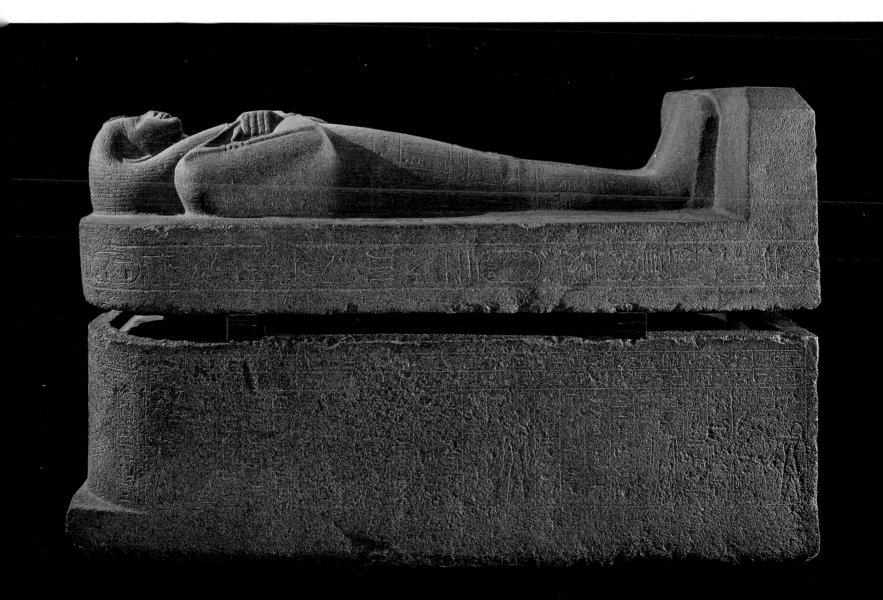

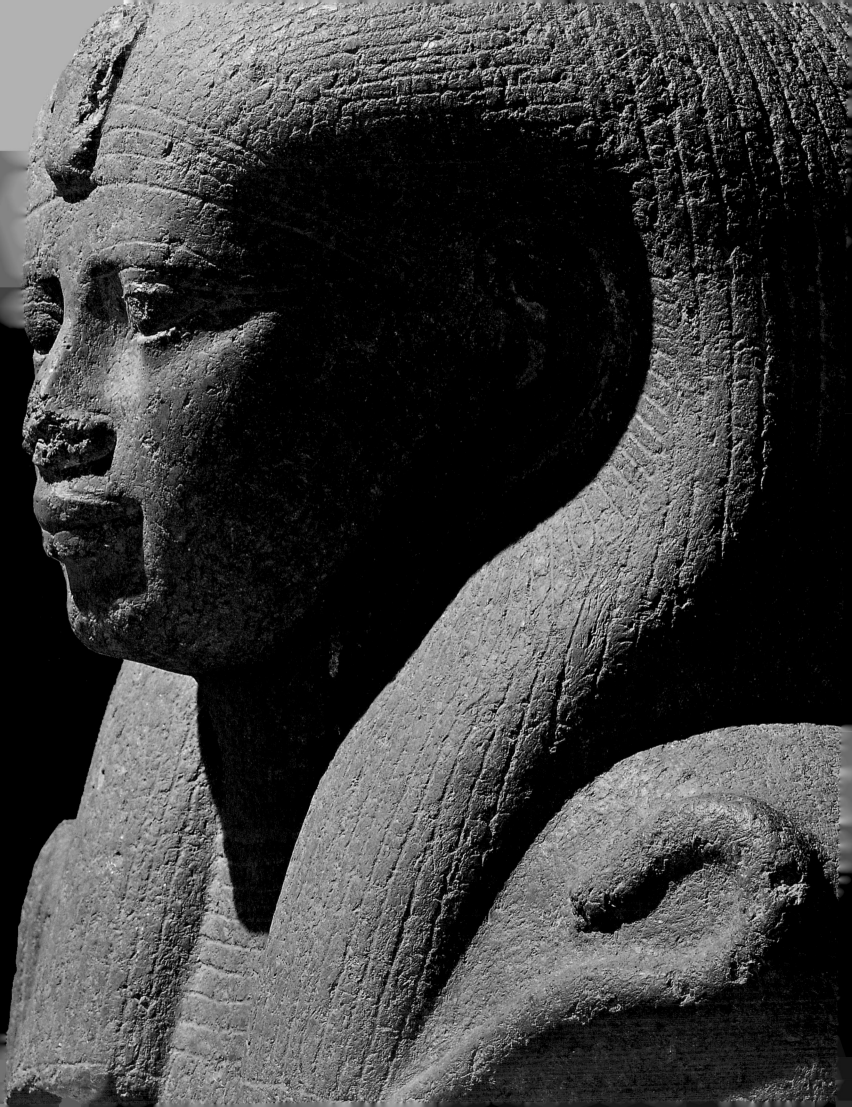

The separation of a tomb from its mortuary structure is consistent with royal burial customs during the New Kingdom and earlier; but it would have been anomalous in the Third Intermediate and Late Periods, when kings and members of their family were typically buried in small funerary chapels, within a temple precinct. The best known burials of this kind are at Tanis; but there are numerous other known or presumed examples, including Shepenwepet II's predecessor as God's Wife, the Kushite Amenirdas I, at Medinet Habu, and Psamtik I and his successors at Sais.

Nitocris's Medinet Habu chapel appears similar in type to these examples; but the huge pit in which the sarcophagus was found is not unlike those of the Twenty-sixth and Twenty-seventh Dynasties nonroyal shaft tombs at Sakkara and Abusir. If Nitocris—and Ankhnesneferibre—were indeed buried at Deir el-Medina, it is possible that this location was chosen because of its proximity to the temple of Isis. **Edna R. Russmann**

1. See Salima Ikram and Aidan Dodson, *The Mummy in Ancient Egypt* (London, 1998), 268–69.

2. Bertha Porter and Rosalind Moss, *Topographical Bibliography of Ancient Egyptian Hieroglyphic Texts, Reliefs, and Paintings.* Vol. 2, *Theban Temples,* 1929 (2d ed., rev. Oxford, 1964, 1972), 478–80.

3. Porter and Moss, *Topographical Bibliography.* Vol. 1, *The Theban Necropolis,* 1927, part 2, *Royal Tombs and Smaller Cemeteries,* 686 (tomb 2005).

4. The former view has been expressed by Bernard Bruyère, and the latter by Ikram and Dodson, *Mummy in Ancient Egypt,* 269.

5. Porter and Moss, *Theban Necropolis,* 685–86 (tomb 2003).

101 Pair of *wedjat* eyes

Late Twelfth Dynasty, c. 1800 BCE; Egyptian blue, calcite, and bronze. Height 13 cm (5⅛ in); width 28 cm (11 in); depth 1 cm (³/₈ in). Provenance unknown. The Egyptian Museum, Cairo JE 90194

• These two eyes probably come from the side of a rectangular coffin, into which they were once inlaid. Coffins with inlaid eyes of this kind are typical of the later Twelfth Dynasty, particularly the reigns of its last three pharaohs (Amenemhat III, Amenemhat IV, and Sobekneferu, 1831–1773 BCE).

The eyes and eyebrows are human in form, but the markings below them come from the face of a falcon. Together they symbolize the eyes of the god Horus, the Egyptian principle of kingship, who was usually depicted as a falcon. Horus was thought to operate both in the sun, the dominant force of nature in ancient Egypt, and through the person of the Egyptian king. According to ancient Egyptian mythology, Horus once fought a cosmic battle with Seth, the principle of chaos, during which Seth tore out one of his eyes. After Horus defeated Seth, the eye was restored. The Egyptians referred to this renewed organ as *wedjat,* meaning "the sound one," and saw in it a metaphor for the ultimate triumph of good over evil.

Eyes were depicted on the exterior front of Middle Kingdom coffins, opposite the head of the mummy, which usually lay on its side within the coffin. In the burial chamber, this side of the coffin normally faced east, allowing the deceased symbolically to view the new life engendered each day by the rising of the sun. Like the sun, the deceased's spirit was believed to travel through the netherworld at night before being reborn at dawn. By depicting the coffin's eyes in *wedjat* form, the Egyptians hoped to incorporate the power of this new life into the coffin itself, making it possible for the deceased's spirit not only to view but also to participate in the phenomenon of daily rebirth. The eyes thus served both as a window onto the world of the living and, more important, as a portal through which the spirit could enter that world every day. **James Allen**

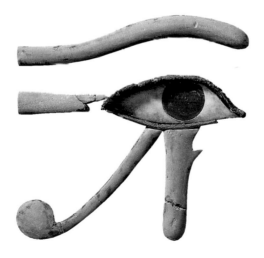
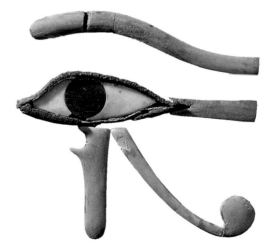

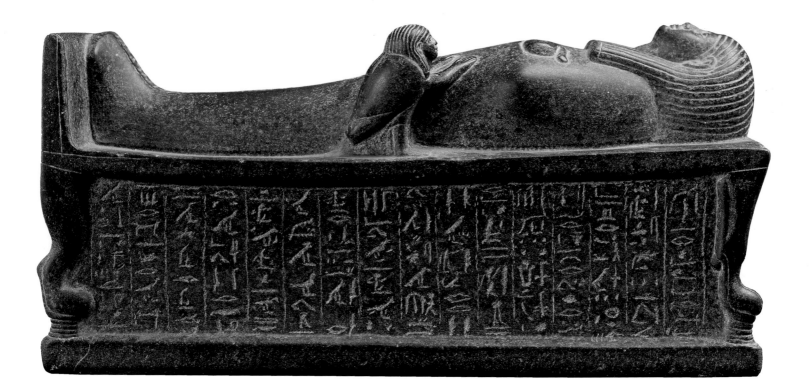

102 Mummy on bier

Reigns of Thutmose IV – Amenhotep III,
c. 1400 – 1352 BCE; granodiorite. Height 11.5 cm
(4½ in); width 24 cm (9⁷⁄₁₆ in); depth 8.5 cm
(3³⁄₈ in). The Egyptian Museum, Cairo JE 7752/
CG 48483

• Among the most important aspects of the search
for immortality was the survival of the spirit and
its communication with the mummy. One aspect
of the soul, called the *ba,* was represented from
the Eighteenth Dynasty as a human-headed bird.
The *ba* allowed the deceased to maintain contact
with the sunlit world, which was essential to the
ancient Egyptians. During the day, the *ba* left the
subterranean burial chamber, flew up the burial
shaft, and entered the offering chamber of the
tomb through the false door, and from there into
the daylight. Tomb paintings and papyri show the
ba enjoying the sun and partaking of cool water.
As the sun set, the *ba* returned to the body and
rested upon it during the night, reuniting the
mummy with its soul.

This funerary statuette shows the *ba* of
the royal herald, Re, resting its human arms pro-
tectively upon the mummy, which is shown upon
a lion-legged funerary bed. The area under the
bed is inscribed with a corrupt version of Book
of the Dead Spell 89, calling upon the gods to
protect the *ba* as it returns to the mummy.

The statuette was found within a model
sarcophagus, which is richly covered with texts
and images of protective gods. The right and
left sides are divided into three panels, each deco-
rated with a deity. Of the six deities, four are
the Sons of Horus who guarded the viscera of
the deceased. Anubis, the god of embalming,
is shown twice. The head and foot show the god-
desses Isis and Nephthys, the sisters of Osiris,
who traditionally mourn the deceased.

The inscriptions on the sarcophagus call
upon the gods to provide food, protection, and a
good burial in the afterlife. However, a significant
portion of the text is devoted to Re's many titles
and the specific mention of his name, for the
preservation of the individual's name was of criti-
cal importance for immortality. The combination
of his name and bureaucratic titles served to
immortalize the individual and to show how he
fit into the fabric of society. These texts relate
that Re had a distinguished career in the time
of Thutmose IV and Amenhotep III. Among his
titles were Overseer of the Treasure House, the
First of the Royal Heralds, the God's Father, the

Overseer of Works in Upper and Lower Egypt,
and Royal Scribe. His perseverance in his duties is
reflected in his claim to be "the eyes of the king,"
and "ears of Horus." He was buried in Theban
tomb 201.

Other similar artifacts indicate that this
statuette was a variant form of a *shabti.* A small
statue of a mummy on a bed with a *ba* at its side
(Cairo CG 48574)[1] is inscribed with the *shabti*
spell (Spell 6 from the Book of the Dead). A wood
effigy from the tomb of Tutankhamun (Cairo
60720)[2] which, like the figure of Re, was paired
with a wood sarcophagus and shows the *ba* on
the chest, was equipped with miniature tools
that are characteristic of those supplied for *shabti*
figures.[3] A third statue, in Turin (no. 2805),[4] shows
a mummy on a bed with the *ba* on his chest.
Small *shabti* figurines, incised with Book of the
Dead Spell 6, stand at the head and foot of that
statuette. **Emily Teeter**

1. J.D. Ray. *The Archive of Hor* (London 1976); Dieter Kessler,
Die heiligen Tiere und der König (Wiesbaden, 1989).

2. Percy E. Newberry, *Funerary Statuettes and Model Sarcophagi.*
Catalogue général des antiquités égyptiennes du Musée du Caire
(Cairo, 1930), 404 – 5, pl. 28.

3. I.E.S. Edwards. *Treasures of Tutankhamun* (New York, 1976),
150 – 51.

4. On the Tutankhamun statue, the mummy of the king is also
protected by a falcon, an expression of the king's royalty.

5. W. Seipel, *Ägypten: 4000 Jahre Jenseitsglaube* (Linz, 1989),
no. 199.

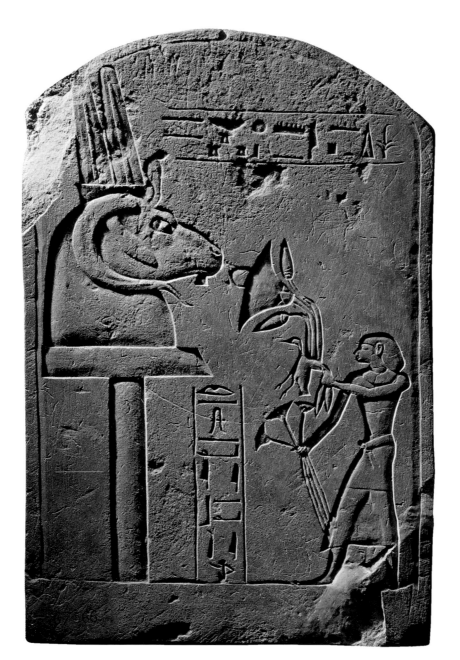

103 Stele of Amun-Re

Eighteenth Dynasty, c. 1550–1400 BCE; limestone.
Height 50 cm (19 11/16 in); width 33.5 cm (13 3/16 in);
depth 5 cm (1 15/16 in). Provenance unknown.
The Egyptian Museum, Cairo JE 67566

• This stele is an example of the personal piety
expressed in ancient Egypt particularly during
the New Kingdom and later. Here on a mid-
Eighteenth Dynasty monument dedicated by a
private person is represented a direct relationship
between the offerer and the great national god
Amun-Re. Guglielmi has discussed the personal
connection expressed by images of Amun as
ram receiving worship from pious offerers.[1] The
dedicant, Benaty, is shown not before a statue
of Amun-Re, to which he would almost certainly
not have had access, but before an emblem
of that god, such as would have been carried in
temple processions. Amun was often embodied
in the image of a ram, as was the sun god, and
here we see the ram with the tall plumes usually
seen on images of Amun-Re in a human form.
The ram horns when worn by the king associate
him both to Re and to Amun, and this is true
for the image of Amun as ram as well. Benaty
proffers a great lotus bouquet and a goose. The
goose was sacred to Amun and here may well be
an intentional allusion. The dedication at the top
of the stele simply reads: "A gift which the king
gives [to] Amun-Re, lord of the thrones of the Two
Lands." This indicates that this is indeed Amun
of Karnak temple and may suggest that this stele
derived from the Theban area. **Betsy M. Bryan**

1. Waltraud Guglielmi and Johanna Dittmar, "Anrufungen der persönlichen Frömmigkeit auf Gans- und Widder-Darstellungen des Amun" in *Gegengabe. Festschrift für Emma Brunner-Traut*, (Tübingen, 1992), 119–142.

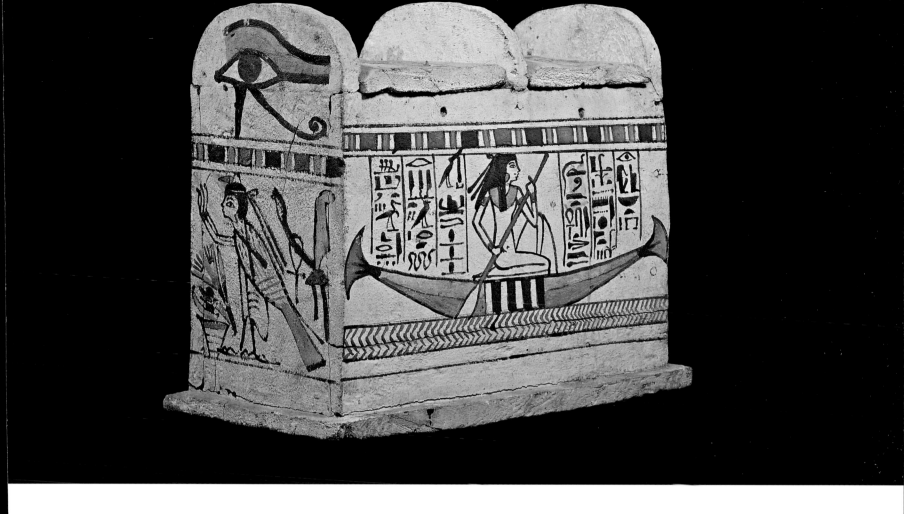

104 *Ushebti* box of Djed-Maat-iuesankh

Twenty-first to Twenty-second Dynasties, 1069–715 BCE; painted wood. Height 39 cm (15³⁄₈ in); width 48 cm (18⁷⁄₈ in); depth 27 cm (10⁵⁄₈ in).
The Egyptian Museum, Cairo TR 4-12-24-4

• This lady's *ushebti* box would have contained the full complement of funerary figures required for burial in the Third Intermediate Period. Probably small glazed faience *ushebtis*, numbering 401, were deposited in the box, where they were believed to lie sleeping until invoked to work by the names and spells inscribed on them. In the Twenty-first Dynasty it was common to inscribe the figures only with the name and titles of the deceased, but this was sufficient to identify the *ushebtis* when work was ordered in the afterlife.

The box is designed with the barrel-vaulted roof associated with the Lower Egyptian Shrine. Examples as shown in cats. 38 and 63, both at least three hundred years older, are more archaic in form, being decorated with false door or niched temple facades, suggesting more specifically the origin of the architectural form. Here the exterior surface has been given over to scenes similar to those on papyrus or tomb walls. The box itself is made of a number of pieces of wood that have been pegged together and plastered over to hide any differences in materials. The lids, hardly vaulted at all, have pegs as knobs, and similar pegs had been placed on the sides so that the lids could be tied down for sealing.

On one side of the box the god Anubis is shown lying in a wakeful pose (p. 208, top). His tail does not hang down but is up as if he were ready to spring. The god holds the crook and flail of rulership, the emblems associated with Osiris particularly. Anubis thus protects the deceased who becomes an Osiris and her funerary equipment as well. The opposite side of the box shows the deceased kneeling in a papyrus boat, as she

rows herself across the sky (p. 208, bottom). The inscription runs as follows, from right to left: "The Osiris, the mistress of the house, the singer of Amun-Re, king of the gods, Djed Maat-iuesankh, vindicated. Ferrying in peace to the Field of Reeds, that excellent bas may be received." The lady is shown wearing a long linen garment that spreads out around her one upraised knee. She wears a red fillet on her head, similar to those worn by participants in funerary rituals. On the short side of the box we see the left eye of the sun god, here indicating the moon, or evening solar orb. Djed-Maat-iuesankh rows away from the evening toward the morning and the right eye of the sun. Beneath the left eye, on the right, is the hieroglyph for the west, reaching out to extend life to the deceased. The *ba* of Djed-Maat-iuesankh stands over food offerings in the gesture of adoration, presumably toward the sun god. The *ba* hopes through the journey into the west and across the waters to be reunited with its corpse and ultimately rejuvenated to live with other *bas*. **Betsy M. Bryan**

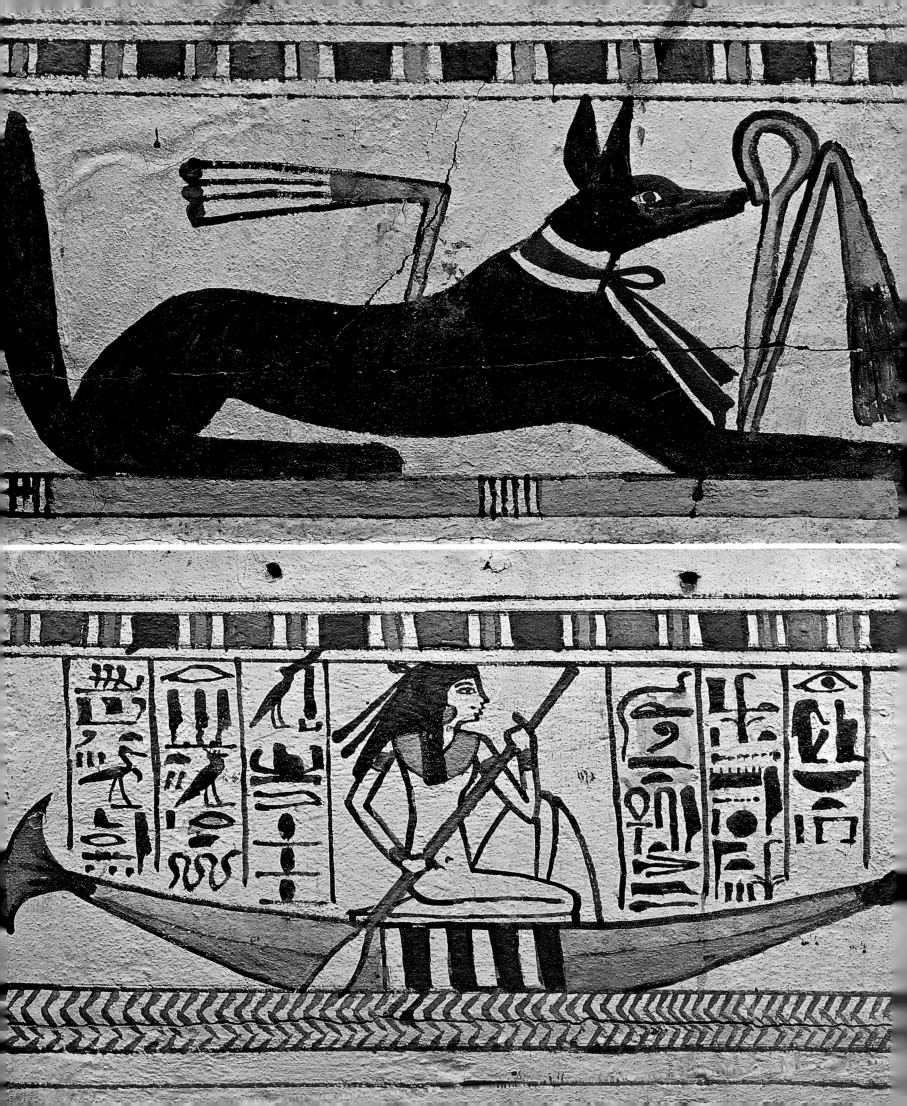

105 Statue of Paakhref

Twenty-sixth Dynasty, 664–525 BCE; graywacke.
Height 48 cm (18⁷⁄₈ in); width 22 cm (8¹¹⁄₁₆ in);
depth 32 cm (12⁵⁄₈ in). Karnak cachette (K. 364).
The Egyptian Museum, Cairo JE 37171/CG 48642

• This squatting statue represents Paakhref, son of Harsiese, the overseer of cargo boats of the Lord of the Two Lands. This type of statue is also known as a "block" or "cubic" statue. Squatting statues appear from at least the beginning of the Middle Kingdom (2055–1650 BCE), as an addition to the repertoire of standing and seated private statues. These squatting statues represent an individual sitting on the ground, as here, or on a low cushion, with the legs bent up against the body, so that the knees are approximately at the same level as the shoulders. The cubic block of these statues shows more stiffness and allows inscriptions and representations to be carved more easily on its surface. These squatting statues were only made to represent private individuals, and at the first were only situated in tombs. Later they became a temple statue, as the pose represents a position of dignity. This statue type, starting as a funerary and commemorative offering, served well as an ex-voto, as the owner could put himself before the god and thus share in the offering.

In the Late Period (664–332 BCE), with the development of private statuary, squatting statues were preferred to other types. As with most statues of this period, the statue of Paakhref came from Karnak. The face of Paakhref is long and thin; it is well connected to the body by the typical double wig, leaving half of the ears uncovered, with a short beard protruding from the chin. His features are characteristically Saite: the mouth displays a faint smile, he has long almond eyes with short cosmetic lines under plastically

rounded eyebrows, very wide cheeks, and a thin nose. The front of the enveloping garment of the statue is dominated by a large head of Hathor in bold raised relief. The feet are free of the bottom of the garment, revealing widely spread toes with well-defined nails. His disembodied hands lie on the upper surface of the cube. Adjacent to and toward the shoulders are cartouches of Psamsetik I (664–610 BCE). The back pillar bears two columns of well-drawn inscription enclosed in framing lines. The inscription's continuation down onto the statue's base is an unusual feature. The base has a rounded front and is encircled by a horizontal band of signs on its sides. **Mamdouh El-Damaty**

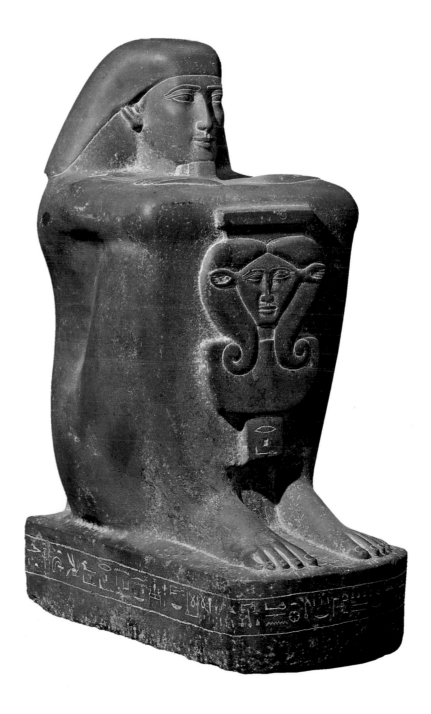

106 Scarab

Ptolemaic era, 332–30 BCE; glass, gold. Height 2.5 cm (1 in); width 11 cm (4 5/16 in); 7 cm (2 3/4 in). The Egyptian Museum, Cairo TR 15-1-25-44

• The scarab beetle is an insect seen to drag a dung ball from which often its offspring may appear to arise. As a coprophagous beetle, the scarab both consumes dung and sometimes lays its eggs within it, such that the dung ball does indeed give birth to new scarabs. This glass scarab is a depiction of the beetle in movement rather than at rest, the form more often seen on Egyptian scarab amulets.

The dung beetle (*kheper* in Egyptian) was associated with its homonym deity Khepri, the rising sun. From prehistoric times scarabs and other beetles were venerated and regarded as magical and sacred. The click beetle, for example, was sacred to the goddess Neith from the First to the Fourth Dynasties (c. 3000–2498 BCE), and perhaps later as well. Many early burials contained jars with dried beetles in different sizes. With the domination of the sun god in the Old Kingdom, the scarab beetle supplanted the click in significance, and after that time the scarab emerged as one of the potent symbols of resurrection and solar worship. Because of its dung ball larvae, the scarab was an image of self creation.

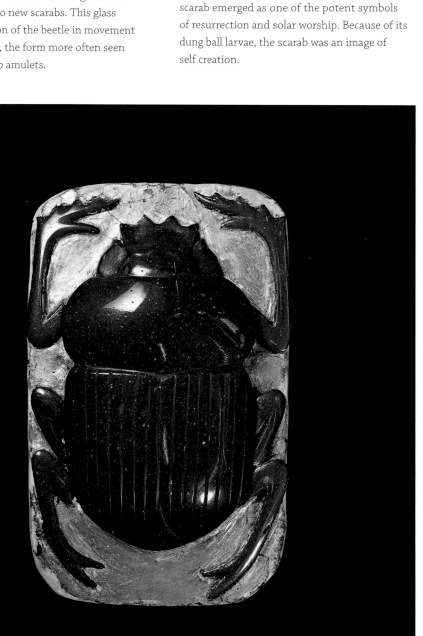

Scarabs were made for a variety of purposes — funerary, memorial, and even administrative. In the funerary context there were heart scarabs inscribed with Chapter 30 of the Book of the Dead that addressed the heart directly. The spell directs the heart not to speak against the deceased in the judgment hall before Osiris. Scarabs could also be inscribed with royal names and divine ones as well. These probably provided the scarab's owner with the amuletic power of those divinities, and in the case of ruling kings, allowed the carrier of such a scarab to be recognized (empowered) as a servant of the pharaoh. Similar to these scarabs were administrative seals carrying the name and titles of administrator, particularly in the Middle Kingdom (2055–1650 BCE). So-called historical scarabs carried texts that commemorated events, such as the slaughter of 102 lions by Amenhotep III or his marriage to the Mittani ruler Shuttarna's daughter Gilukhipa.

As amulets scarabs were made of numerous materials, including stones, both common ones and precious, including lapis lazuli and jade, as well as faience. Glazed steatite was a favored material for scarabs, since it had a bright finish similar to faience, but it was more durable. The form and size of this beetle suggest that it was not a simple amulet, to be worn on a string or carried as a talisman. Rather, it may be a funerary object, one that perhaps even once was part of a larger group of objects or composition. Nonetheless, its meaning is the same as all scarabs — it indicates the regenerative dawning of the sun on the eastern horizon and promises thereby regeneration for all. The scarab beetle, backing its way into the morning as it pulls the sun disk with it, may be seen at the end of the Twelfth Hour of the Amduat. It looks just like this beetle.

In the latest periods of Egyptian pharaonic history, when this scarab was fashioned, the beetle was still identified with the sun and seen as a symbol of the light that ringed the world continuously. In the astronomical setting the beetle appeared in the newly introduced zodiac in the place of Cancer the Crab. This was a reference to its appearance at the summer and winter solstices (the beginning and midyear solar births). The scarab thus typified self-reproducing power in nature. **Ibrahim El-Nawawy**

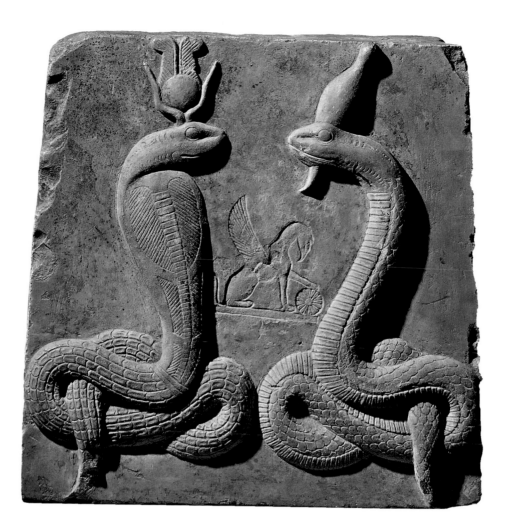

107 Relief with two snake deities and griffin

Roman Period, 30 BCE – CE 395; limestone.
Height 31.5 cm (12 3/8 in); width 29.5 cm (11 5/8 in);
depth 15 cm (5 7/8 in). The Egyptian Museum,
Cairo CG 27528

• This limestone relief shows two coiled snakes
in high relief, with a more lightly incised griffin
between them. The cobra on the left wears a
crown consisting of cow's horns, a sun disk, and
double plumes. Such a headdress is closely associ-
ated with both Isis and Hathor. The snake on the
right is bearded and is adorned with the White
Crown of Upper Egypt. There is a short, unfortu-
nately illegible demotic inscription on the top
of the relief.[1] Campbell Cowen Edgar, who
first published the piece, noted traces of black
paint on the head of the bearded serpent as
well as red paint on the sun disk and tail of the
other serpent.

The griffin is in shallow sunk relief.
Under one of its paws is a wheel in the shape of
a rosette. The griffin was a popular figure in the
Roman Period. It was equated with Nemesis (the
goddess of vengeance) and often shown with
a wheel, a symbol of fate (the Wheel of Fortune).
The bearded cobra on the right has been identi-
fied as Agathodaimon, or Fate, also important in
the Late Ptolemaic and Roman Periods. This
personification of fate was widely worshiped by
Greeks and Egyptians, and the deity probably
has characteristics drawn from both native and
Hellenistic religious traditions. The snake with
the Isis crown is most likely the goddess of Har-
vest, Renenutet, who was the female counterpart
to Agathodaimon.[2] Such female deities as Rene-
nutet were closely identified with Isis in the
Roman Period.

Snakes and snake symbolism play an
important role in Egyptian mythology. This
imagery is frequently used for deities associated
with the earth and fertility, but guardian beings
and other kinds of gods also appear as snakes.
Snakes and serpents populate the underworld
regions according to the Amduat and other
underworld books. In the desert the sun barque
itself assumes the guise of a snake, so that it
can navigate in the sand more easily.[3] Naturally,
the snake form not only possesses a positive
protective nature, but can also appear in a threat-
ening aspect. The archenemy of the sun god
in the underworld, Apophis, for example, has the
shape of a snake or serpent. **Richard Jasnow**

1. Wilhelm Spiegelberg, *Die Demotischen Inschriften I: Die
Demotischen Denkmäler 30601–3116* (Cairo, 1904), 77. Catalogue
général des antiquités égyptiennes du Musée du Caire.

2. Jan Quaegebeur, *Le dieu égyptien Shaï dans la religion et
l'onomastique* (Louvain, 1975), 173.

3. Erik Hornung, *The Ancient Egyptian Books of the Afterlife*
(Ithaca, New York, 1999), 36.

Facing the Gods: Selected Guide

Terence DuQuesne

On the walls of Thutmose III's tomb no fewer than 741 gods and goddesses are depicted, all of whom interact with the king when he comes to life again in the Beyond.

The task of comprehending such a refined and complex system of religion is not easy at this distance in time and metaphysical belief. Part of the problem is in classifying the inhabitants of the other world in some appropriate way. Not all the deities shown or referred to in the Egyptian Books of the Netherworld and other texts are of equal consequence. Relatively few are major figures, such as the sun god Re and Hathor, Lady of the Sky. Some are not full-fledged goddesses and gods with their own personalities but are instead just manifest functions. Among these are the pair of gods Hu and Sia, who respectively symbolize "magical utterance and divine understanding." Certain others represent the divine aspects of natural phenomena, such as the divisions of time: hence there are twenty-four goddesses of the hours. Many more, perhaps better described as spirits or demons although still called *netjeru* (gods) in Egyptian, have ancillary and other subordinate functions, such as the Spirits of the West, who are shown as black jackals and whose tasks include towing the barque of the nocturnal sun.

All these entities, separate as they may seem, nevertheless work as an ensemble. Every aspect of Egyptian funerary art is planned — nothing is arbitrary or without symbolic meaning. Even the colors in which the tomb walls are painted, while allowing sometimes for artistic idiosyncrasy, conform to principles or canons that are self-consistent and never completely arbitrary. If the face of Osiris is shown as black, that signifies, among other things, that the god is symbolizing the fertility of the earth and the numinous magic of night.

The owner of the tomb, royal or otherwise, would expect to be familiar with the principal divinities, so as to engage with them, and if necessary propitiate them, in the other world. He would see the images of the major divinities painted on the walls of his tomb as a sort of aide-mémoire to guide him on his travels as a justified soul.

Amun

Amun, see cat. 103

Name: The name means "The Hidden One."

Appearance: Amun is most commonly shown in entirely human form. Often he is standing or sitting on a throne and wearing a flat-topped crown with two tall plumes. In his aspect as "bull of his mother," he takes a form identical to that of the god Min and is represented as an ithyphallic, mummiform deity. Amun can also assume the appearance of a ram, his particular sacred animal.

Divine associations: The syncretism of Amun and Re became important in the later New Kingdom, when Amun-Re, creator and sun god, was seen as the preeminent divine entity, and his popularity for a time eclipsed that of other major deities. Since both Amun and Min are deities of generation and natural increase, they are closely associated. The warrior-god Montu was known as a manifestation of Amun. A Theban triad consisted of Amun; his wife Mut; and their offspring Khonsu, the moon god. All three had temples at Karnak.

Origin and cult: It is possible, but not certain, that Amun's original cult center was Thebes, where he was worshiped as the major local god from the Middle Kingdom onward. The enormous temple complex of Karnak was then the principal home of his worship, although the nearby Luxor temple was also dedicated to him by the New Kingdom. He may have been native to Hermopolis in Middle Egypt.

Character: Amun is a god whose attributes are so extensive that he seems to lack the personality of other deities. His role as creator is emphasized in many hymns. Regarded as having been self-generated, he is a fertility god who impregnates his mother, the Celestial Cow, to ensure the fecundity of animals and plants. He was closely involved with kingship, and many pharaohs regarded themselves as one of his incarnations and included the god's name in their own. Amun was therefore also seen as the divine consort of Egyptian queens. Queen Hatshepsut presented herself as an offspring of the god during a visit to her mother. His virile strength made

him an appropriate deity for ensuring military victory for the pharaoh. Amun was invoked for healing from the bites of dangerous animals and other illnesses. During the New Kingdom he was a personal-savior god of ordinary working people, as numerous devotional stelae testify.

Myth: Religious texts relating to the city of Hermopolis speak of Amun and his shadowy consort Amaunet as creators of the pantheon of the eight primeval deities.

Assmann, Jan. *Re und Amun*. Fribourg, 1983.

———. *Egyptian Solar Religion in the New Kingdom: Re, Amun, and the Crisis of Polytheism*. Trans. Anthony Alcock. London/ New York, 1995.

Barta, Winifred. *Untersuchungen zum Götterkreis der Neunheit*. Munich, 1973.

Otto, Eberhard. *Osiris und Amun*. Munich, 1966.

———. *Egyptian Art and the Cults of Osiris and Amon*. Trans. Kate Bosse Griffiths. London, 1968.

Sethe, Kurt. *Amun und die acht Urgötter von Hermopolis*. Leipzig, 1929.

Zandee, Jan. *Der grosse Amonhymnus des Papyrus Leiden I 344, verso*. 3 vols. Leiden, 1992.

Anubis

Anubis, see cat. 104

Name: Of uncertain meaning, the name may be an onomatopoeic word for young jackal or puppy.

Appearance: Anubis is most often seen as either a jackal-headed god in human form or a seated black jackal.

Divine associations: He is given as the son of Re or of Osiris. Among the goddesses regarded as being his mother are Isis, Sakhmet, and the cow-goddess Hesat.

Origin and cult: It is likely, but not certain, that the original jackal deity of the sacred city of Abydos, Khentyamentiu, was the prototype of Anubis. On the other hand, he may originally have been venerated in the Cynopolitan province of Middle Egypt, whose local deity, the goddess Anupet, was his original manifestation or his consort. As a complement to his fellow jackal deity, Wepwawet of Asyut in Middle Egypt, Anubis

was the patron deity of the necropolis of that town. He was also closely connected with the Memphite region.

Character: The best-known function of Anubis is that of embalmer. He is frequently depicted with his jackal's head as he tends the mummy on its bed. Anubis is also associated with the judgment of the dead at the Tribunal of Osiris, where he tests the accuracy of the balance. His role in reviving the deceased and guiding him through the netherworld is important and attested early. Anubis is an archetypal deity of initiation and was probably involved in the circumcision of the divine king. In later times he was often invoked for healing and especially in love-magic. In the Amduat, Anubis is the only deity to have access to the subterranean cavern of Sokar, through which the sun god passes at midnight.

Myth: Anubis is recorded as having assisted Isis in the quest for and regeneration of the scattered limbs of Osiris after the latter's dismemberment by the god Seth. Later myths report how the goddess Hesat squirts her milk on the cow skin that is the emblem of Anubis to separate the bones and the soft organs prior to rebirth of the deceased. Another mythical story relates how Anubis' mother, Isis-Sakhmet, taking the form of a snake or a scorpion, bites or stings her son, who is then told to lick the wound to heal it.

DuQuesne, Terence. *Jackal at the Shaman's Gate*. Thame Oxon, U.K., 1991.

———. *Black and Gold God: Colour Symbolism of the God Anubis*. London, 1996.

Grenier, Jean-Claude. *Anubis alexandrin et romain*. Leiden, 1977.

Geb

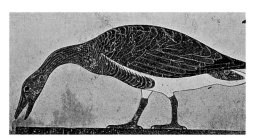

Geb: Detail, painting of a goose from the tomb of Iter at Meidum, Fourth Dynasty, c. 2600 BCE. The Egyptian Museum, Cairo

Name: The meaning is uncertain, but the word is possibly onomatopoeic, from the sound made by a goose: the Cackler.

Appearance: Geb is usually seen in entirely human form. Often he is shown supine below the sky goddess Nut. His color is green. The sacred animal of Geb is the goose, and he is sometimes depicted in that form.

Divine associations: Relationships between Geb and the other chthonic deities such as Sokar and Tatjenen are hard to unravel, but Geb is primeval. References to him in the Books of the Netherworld are elliptical. In the Book of Earth the corpse of Geb seems to be complementary to that of Osiris, with both personifying the fallow earth.

Origin and cult: Geb's association with the ritual hoeing of the earth in Heliopolis may suggest an early cult association in that city. Geb's origin is entirely obscure, but he was believed to have been the earliest earthly king.

Character: Geb represents the power and fecundity of the earth. Funerary offerings were made to him. Minerals, food plants, and natural phenomena such as earthquakes were considered to be his gifts. As the ancestral member of the Divine Ennead (the nine great gods of Heliopolis, the family of the sun god), together with the sky goddess, he had the highest judicial power.

Myth: When Horus and Seth, sometimes explained as nephew and uncles and sometimes as brothers, engaged in conflict over which of them was to rule over Egypt, it was Geb as president of the divine tribunal who eventually ordered that Horus would prevail. A late myth records how, during a time of turbulence, Geb wrested the kingship of the gods from his father Shu.

Bedier, Shafia. *Die Rolle des Gottes Geb in den agyptischen Tempelinschriften der griechisch-römischen Zeit*. Hildesheim, 1995.

Hathor

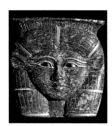

Hathor, see cat. 32

Name: The name means something like "Dwelling of Horus," probably expressing a symbolism similar to that of the *shekhinah*, or earthly habitation of the divinity, in Jewish mysticism.

Appearance: One of Hathor's most consistent manifestations is that of a cow. But she is also often shown as a human figure with the head of a cow, or as an entirely human deity with a headdress of cow's horns and a sun disk.

215

Glossary

akh The form that the soul took to inhabit the underworld after the *ba* and *ka* were successfully united.

Akhmenu A temple built by Thutmose III within the temple complex at Karnak.

Amarna Period/Amarna Era A period during the late Eighteenth Dynasty centered around the reign of Amenhotep IV, also known as Akhenaten.

Amduat A text describing the sun's twelve-hour passage through the night into the netherworld.

annals Records from the reign of Thutmose III inscribed on the walls of Karnak Temple.

Apis bull A carefully chosen cult animal identified with the *ba* of the god Ptah. When the bull died, it was mummified and entombed at Sakkara.

atef crown A tall crown flanked by plumes at either side and worn by kings and Osiris.

ba The part of the soul that could move between the physical body and the area outside the tomb, including the underworld. It is often depicted as a bird with a human head and arms.

barque of the sun In Egyptian mythology the sun was believed to move through the sky by day and the underworld by night by means of a barque, or sacred boat.

benben stone An obelisk-like stone topped by a pyramidion that was symbolic of the primeval mound of creation in Heliopolis.

Book of Caverns A Nineteenth Dynasty text in which the netherworld is divided into six parts. On its journey through the netherworld the sun must pass over caves or pits in each section.

Book of the Celestial Cow A text from the late Eighteenth Dynasty describing an attempt of the sun god to destroy all of mankind.

Book of the Dead/Book of Going Forth by Day A collection of spells from the Second Intermediate Period and later, some of which are continuations of Coffin Text spells. These texts were placed within burials to aid passage to the next world after death.

Book of the Earth A royal text from the Twentieth Dynasty concerning the voyage of the sun through the netherworld.

Book of Gates A late Eighteenth Dynasty text referring to the necessary passage through various gates that divide each of the twelve hours of the night.

canopic chests Chests or boxes designed to contain the four canopic jars.

canopic jars Vessels specially designed to contain the mummified viscera including the lungs, stomach, intestines and liver. The jars came in sets of four, and each of the Four Sons of Horus were assigned the duty of protecting the contents of one of the vessels.

cataract A dangerous area of rapids along the Nile River. There are six cataracts south of Aswan.

chthonic deities Deities deriving from the earth.

Coffin Texts A group of spells to assist the deceased's journey to the next world, some of which were derived from the Pyramid Texts. They were inscribed on coffins during the Middle Kingdom.

Colossi of Memnon A pair of colossal statues of Amenhotep III erected by that same pharaoh as part of his vast mortuary temple on the west bank at Thebes. One of the statues—the true Colossus of Memnon—made a whistling sound when the wind passed through it and ancient Greek travelers equated it with the Homeric figure of Memnon.

crook and flail Both part of the royal regalia. The pharaoh was often depicted holding these items crossed over his chest. The crook was a curved scepter and the flail may represent a fly whisk. These symbols were also associated with the god Osiris.

Deir el-Bahari A site on the western bank of the Nile at Thebes where Mentuhotep, Hatshepsut, and Thutmosis III built terraced funerary temples in a large bay in the cliffs.

Deir el-Medina A walled village on the west bank of the Nile at Thebes that housed the workmen who built and decorated the royal tombs in the Valley of the Kings and some tombs of courtiers in the Theban necropolis.

Destruction of Mankind A myth in which the sun god, tired of people's evil doings, sends his daughter, an avenging goddess, to destroy all of humankind. In the end the sun god relents, and the goddess is tricked into stopping her rampage. See Book of the Celestial Cow.

devourer of the dead Known as Ammit, this composite creature has the head of a crocodile, the forelegs of a lion, and the back legs of a hippopotamus. She sits at the scales of the Judgment of Osiris, waiting to eat the heart of the deceased if it is found to be unjust.

djed pillar The symbol of stability depicting a pillar of woven plants. It came to be associated with the backbone of Osiris, god of the underworld.

Ennead A group of nine deities. The Heliopolitan creation myth revolves around the Ennead of Heliopolis, which includes Atum, Shu, Tefnut, Geb, Nut, Osiris, Isis, Seth, and Nephthys.

Eye of Re/Solar Eye The wandering eye of the god Re; often associated with the goddesses Hathor, Sakhmet, and Wadjet.

faience A material made of crushed quartz, lime, plant ash, or natron used to make a variety of objects including amulets and vessels. It is pressed into a mold, covered in glaze, and fired to form a vitreous-like material.

feather of Maat During the Judgment of Osiris the heart of the deceased was weighed on a scale against the feather of Maat, the symbol of truth and justice. If the heart was light the deceased was allowed to pass, but if it was heavy it was eaten by the devourer and the deceased ceased to exist.

Festival of the Valley/Beautiful Festival of the Valley A Theban festival in which the cult statues of Amun, Mut, and Khonsu were brought in procession from Karnak Temple to the funerary temples on the west bank. Deir el-Bahari was a favored destination.

Four Sons of Horus Four deities associated with the embalmed internal organs of the deceased. These gods include the human Imsety, the jackal Duamutef, the baboon Hapy, and the falcon Kebehsenuef.

funerary temple A structure built for the maintenance of the funerary cult of a deceased king. They functioned before and after the death of a ruler.

Giza A necropolis just outside modern Cairo. The site includes several cemeteries, the Great Pyramids, and the Great Sphinx.

God's Wife of Amun A priestess who played the consort of the god Amun in temple rituals. In the early Eighteenth Dynasty the position was associated with the royal house, and the holder of the title appointed her own successor.

Great Sphinx at Giza A colossal statue of a human-headed lion. The pharaoh represented may be Khafre of the Fourth Dynasty. During the New Kingdom the Great Sphinx was identified with the god Horemakhet.

hieroglyphic writing system Pictographs used to write the ancient Egyptian language. Three types of signs were used: phonograms, logograms, and determinatives.

Hyksos A group from Syria-Palestine who migrated into Egypt during the later Middle Kingdom. They settled in the Nile Delta and by the Second Intermediate Period controlled the northern half of Egypt. The Fifteenth Dynasty is often referred to as the Hyksos Dynasty.

inundation An annual event in which the Nile would flood its banks every June through September, starting at Aswan and moving northward to the area around Cairo. The layer of silt deposited by the flooding made the soil exceptionally fertile.

Intermediate Period A designation made by modern historians for periods of Egyptian history during which there was no strong, central, unified Egyptian government.

Judgment of Osiris/Tribunal of Osiris The heart of the deceased would be weighed upon a scale against the feather of the goddess Maat, the personification of truth and justice.

ka Part of the Egyptian concept of the soul. The *ka* came into being at the moment of birth and formed a type of double for a person. After death the *ka* continued to live on and needed to be sustained with offerings. The *ka* would eventually join with the *ba* to form the *akh*.

Karnak Temple A huge temple complex located in modern Luxor and dedicated to the Theban triad of deities: Amun, Mut, and Khonsu. The temple complex was modified and expanded from the Middle Kingdom onward into the Greco-Roman Period.

Kush Also known as Upper Nubia; including in modern geographical terms northern Sudan and the southern border of Egypt. At various points in their history the ancient Egyptians controlled this area and relied heavily upon it as a source of gold. During the Twenty-fifth Dynasty, rulers from Kush took over the throne of Egypt.

lapis lazuli A dark blue stone with inclusions of gold or pyrite. It was prized by the Egyptians for use in amuletic jewelry and had to be imported over great distances from northern Afghanistan.

Litany of Re An Eighteenth Dynasty text found in royal tombs that describes the seventy-five names of the sun god Re. This text also elaborates on the role of the king and his connection to the deities.

Lower Egypt Ancient Egypt was divided into Upper and Lower Egypt. Located in the North, Lower Egypt extended from the Nile Delta to just south of Memphis. It was designated "Lower" because the Nile River flows northward.

Luxor Modern geographical name for the ancient city of Thebes.

Luxor Temple Founded in Thebes during the reign of Amenhotep III. It was dedicated to the cult of Amun and modified by successive pharaohs down to and including Alexander the Great. It was connected to Karnak Temple by a processional road.

mastaba A term derived from an Arabic word meaning bench. It denotes a type of tomb with a rectangular brick or stone superstructure with sloping walls surmounting a burial chamber and storage area. This type of tomb was used for royal and non-royal burials.

Medinet Habu A temple complex built on the western bank of the Nile at Thebes. It was founded during the Eighteenth Dynasty, but the mortuary temple of Ramesses III dominates the site.

mehen serpent A great serpent who protected the sun god Re.

Memphis The capital of the first Lower Egyptian nome. Memphis was an important administrative center during most of the pharaonic period.

Memphite Theology A creation myth centered around the god Ptah of Memphis. Ptah creates by conceiving an idea within his heart and then speaking it aloud. He first created the god Atum and the deities of the Ennead.

mummification A process developed in ancient Egypt to preserve the remains of the deceased. The body was chemically cleansed and desiccated. It was then packed, perfumed, and wrapped in linen. Often the viscera were removed and embalmed separately.

225

natron A naturally occurring desiccant composed of sodium carbonate and sodium bicarbonate. It could be found on the banks of the Wadi Natrun and at a few other sites in Egypt. It was a principal ingredient in the mummification process and in some temple rituals of purification.

necropolis "City of the dead," a term for a burial ground.

negative confession Also known as the "declaration of innocence." The deceased would recite his negative confessions before Osiris and the forty-two gods of the judgment. It illustrated the innocence of the deceased and his right to pass through. For example: "I have not lied, I have not stolen, [etc.]."

nome One of the forty-two provinces or districts into which ancient Egypt was divided. There were twenty-two nomes in Upper Egypt and twenty in Lower Egypt. Forty-two was a sacred number.

Nun The primeval waters of chaos. The primeval mound of creation arose from the Nun. The depths of the netherworld were also associated with the Nun.

obelisk A tall, tapering four-sided monument topped by a pyramidion.

ogdoad A group of eight deities. There were four frog gods and four snake goddesses who represent the pre-creation chaotic elements of water, hiddenness, infinity, and darkness.

Opening of the Mouth ritual Performed upon the mummy and the statues of the deceased before they were placed into the tomb. By a series of anointments, actions, and repetition of spells, the senses of the deceased were restored so that he could breathe, eat, and move through the netherworld.

Opet festival An annual festival in which the statue of the god Amun was carried in procession from Karnak Temple to Luxor Temple.

Punt An area in eastern Africa to which Egypt sent trading expeditions. The exact location of Punt is unknown. The famous expedition sent to Punt by Hatshepsut is illustrated on the walls of her temple at Deir el-Bahari.

Pyramid Texts A group of some eight hundred funerary spells inscribed on the walls of the burial chambers of the pyramids beginning at the end of the Fifth Dynasty. The texts were designed to protect the deceased king and aid his journey into the sky.

Qurn The pyramidal shaped mountain that rises up behind the royal and non-royal necropoli on the western bank of the Nile at Thebes.

Red Crown The crown of Lower Egypt. It was often combined with the White Crown to symbolize the power of the pharaoh over both Upper and Lower Egypt.

rishi **coffin** A type of coffin decorated with a feather pattern. The feathers were symbolic of the protective wings of several winged deities.

Saite Period c. 664–332 BCE. The Saite Period is a name for the Twenty-sixth Dynasty. The kings of this dynasty ruled from the site of Sais in the Nile Delta.

Sakkara Located near modern Cairo; the necropolis for the city of Memphis. The site was in use from the First Dynasty through the post-Roman Christian period.

sarcophagus An outer container for a coffin; used to give the physical remains of the deceased an additional layer of protection.

scarab beetle Symbolic of the god Khepri and the rising sun. The scarab beetle became a powerful symbol of resurrection.

Sea People A migratory population of groups from Asia Minor and the Mediterranean. Ramesses III illustrated his repulsion of the Sea Peoples from Egypt's border on the walls of his temple at Medinet Habu.

Sed festival A ceremony of the renewal of kingship. It was normally celebrated for the first time during a king's thirtieth regnal year, although some kings appear to have celebrated their festivals much earlier in their reigns.

Serapeum The burial place of the Apis bulls at Sakkara.

shabti/shawabti/ushebti Funerary statuette that was often mummiform. The *shabti* was intended to stand in for the deceased in the afterlife to perform any necessary manual tasks, such as planting fields and clearing irrigation ditches.

sphinx Most often a combination of the body of a lion with the head of a human. Kings desired to combine their own images with that of the lion in order to absorb the power of the animal. The sphinx was also associated with the sun god.

stele A flat, round-topped monument.

Thebes Ancient name for the modern city of Luxor.

triad A group of three gods, generally a family grouping of a god, his consort, and their child. Each site in ancient Egypt had its own local triad.

Upper Egypt Ancient Egypt was divided into Upper and Lower Egypt. Located in the South, Upper Egypt extended from just south of Memphis to Aswan. It was designated "Upper" because the Nile River flows northward.

uraeus A symbol of kingship. It is the figure of a rearing cobra, representing the cobra goddess Wadjet. The uraeus was often added to the brow of the king as part of his headdress.

ushebti See *shabti*.

Valley of the Kings The necropolis of the New Kingdom kings located on the west bank of the Nile at Thebes. The necropolis is composed of an eastern and a western valley containing a total of sixty-two numbered tombs.

wedjat **eye** The eye of the god Horus. Horus lost his eye in a fight with Seth, but the goddess Hathor was able to restore it. The eye of Horus thus became a powerful symbol of healing and protection.

West Considered the realm of the dead.

White Crown The crown of Upper Egypt. It was often combined with the Red Crown to symbolize the power of the pharaoh over both Upper and Lower Egypt.

Abbreviations for Frequently Cited References

Catalogue général:
Catalogue général des antiquités égyptiennes du Musée du Caire. Cairo, 1906–25, 1930, 2000.

Lexikon der Ägyptologie:
Lexikon der Ägyptologie. 7 vols. Ed. Wolfgang Helck and Wolfhart Westendorf. Wiesbaden, 1972–92.

Oxford Encyclopedia:
The Oxford Encyclopedia of Ancient Egypt. 3 vols. Oxford, 2001. Ed. Donald B. Redford.

Thutmose III and the Glory of

the New Kingdom

Baines, John. "Classicism and Modernism in the New Kingdom." In Antonio Loprieno, ed., *Ancient Egyptian Literature: History and Forms.* Leiden/New York, 1996.

Bryan, Betsy M. "The Eighteenth Dynasty before the Amarna Period (c. 1550–1352 BC)." In Ian Shaw, ed., *The Oxford History of Ancient Egypt.* Oxford/New York, 2000.

Gardiner, A. H. *Egypt of the Pharaoh.* Oxford, 1961.

James, T. G. H. *Pharaoh's People: Scenes from Life in Imperial Egypt.* Oxford, 1985

Martin, G. T. "Memphis: The Status of a Residence City in the Eighteenth Dynasty." In Miroslav Bárta and Jaromír Krejcí, eds., *Abusir and Saqqara in the Year 2000.* Praha, Czech Republic, 2000.

Lichtheim, Miriam, comp. *Ancient Egyptian Literature: A Book of Readings.* Vol. 2, *The New Kingdom.* Berkeley, 1976.

Parkinson, R. B., ed. and trans. *Voices from Ancient Egypt: An Anthology of Middle Kingdom Writings.* London, 1991.

Radwan, Ali. "Thutmosis III als Gott." In Heike Guksch and Daniel Polz, *Stationen: Beiträge zur Kulturgeschichte Ägyptens: Rainer Stadelmann Gewidmet.* Mainz, 1998.

Romer, John. *Ancient Lives: Daily Life in Egypt of the Pharaohs.* New York, 1984.

Valbelle, Dominique. *Histoire de l'Etat pharaonique.* Paris, 1998.

Vanderleyen, C. *L'Egypte et la Vallée du Nil, Tome 2.* Paris, 1995.

van Dijk, Jacobus. "The Amarna Period and the Later New Kingdom (c. 1352–1069 BC)." In Ian Shaw, ed., *The Oxford History of Ancient Egypt.* Oxford/New York, 2000.

Vernus, Pascal, and Jean Yoyotte. *Dictionnaire des pharaons.* Paris, 1996.

Exploring the Beyond

Introduction

Allen, Thomas George. *The Book of the Dead or Going Forth by Day: Ideas of the Ancient Egyptians Concerning the Hereafter as Expressed in Their Own Terms.* Ed. Elizabeth B. Hauser. Studies in Ancient Oriental Civilization, no. 37. Chicago, 1974.

Assmann, Jan. *Tod und Jenseits im alten Ägypten.* Munich, 2001.

Faulkner, Raymond O., ed. and trans. *The Ancient Egyptian Coffin Texts.* 3 vols. Warminster, England, 1973–87. Reprint, 1994

Faulkner, Raymond O., Ogden Goelet Jr., and Carol Andrews, ed. and trans. *The Ancient Egyptian Book of the Dead.* San Francisco, 1994.

———. *The Ancient Egyptian Pyramid Texts.* 2 vols. Oxford, 1969. Reprint, Warminster, England, 1985.

Hodel-Hoenes, Sigrid. *Life and Death in Ancient Egypt: Scenes from Private Tombs in New Kingdom Thebes.* Trans. David Warburton. Ithaca, New York, 2000.

Hornung, Erik. *The Ancient Egyptian Books of the Afterlife.* Ithaca, New York, 1999.

———. *Die Nachtfahrt der Sonne: Eine altägyptische Beschreibung des Jenseits.* Zurich/Munich, 1991.

———. *Die Unterweltsbücher der Ägypter.* Zurich/Munich, 1992.

Piankoff, Alexandre. *The Tomb of Ramesses VI,* vol. 1. Ed. Nina Rambova. Bollingen Series XL. New York, 1954.

Taylor, John. *Death and the Afterlife in Ancient Egypt.* Chicago, 2001.

Zandee, Jan. "Book of Gates." In *Liber Amicorum: Studies in Honour of Professor Dr. C. J. Bleeker.* Leiden, 1969.

227

The Tomb of a Pharaoh

Fornari, Annamaria, and Mario Tosi. *Nella sede della verità: Deir el Medina e l'ipogeo di Thutmosi III*. Milan, 1987.

Hornung, Erik. *The Valley of the Kings: Horizon of Eternity*. Trans. David Warburton. New York, 1990.

———. *The Tomb of Pharaoh Seti I/Das Grab Seti' I*. Zurich/Munich, 1991.

Lehner, Mark. *The Complete Pyramids: Solving the Ancient Mysteries*. London, 1997.

Reeves, Carl Nicholas, and Richard H. Wilkinson. *The Complete Valley of the Kings: Tombs and Treasures of Egypt's Greatest Pharaohs*. London, 1996.

Romer, John. "The Tomb of Tuthmosis III." *Mitteilungen des Deutschen Archäologischen Instituts, Abteilung Kairo* 31 (1975): 315–51.

Schneider, Thomas. In Hanna Jenni, ed., *Das Grab Ramses' X. (KV 18)*. Basel, 2000. Aegyptiaca Helvetica, 16.

Weeks, Kent R. *Atlas of the Valley of the Kings*. Cairo, 2000.

Weeks, Kent R., ed. *Valley of the Kings: The Tombs and the Funerary Temples of Thebes West*. Vercelli, Italy, 2001.

The Amduat

Hornung, Erik. *Das Amduat: Die Schrift des Verborgenen Raumes*. 3 vols. Wiesbaden, 1963–67, with a complementary edition of all versions of the New Kingdom in idem, *Texte zum Amduat*, 3 vols. with continuous pagination. Geneva, 1987–94. Aegyptiaca Helvetica, 13–15.

Sadek, Abdel-Aziz Fahmy. *Contribution à l'étude de l'Amdouat*. Fribourg, 1985.

Litany of Re

Hornung, Erik. *Das Buch der Anbetung des Re im Westen*. 2 vols. Geneva, 1975–76. Aegyptiaca Helvetica, 2 and 3.

Piankoff, Alexandre. *The Litany of Re*, vol. 4. Bollingen Series XL. New York, 1964.

Quirke, Stephen. *The Cult of Ra: Sun-Worship in Ancient Egypt*. London, 2001.

Art for the Afterlife

Andrews, Carol. *Egyptian Mummies*. Cambridge, Mass., 1984.

Assmann, Jan. "Death and Initiation in Ancient Egypt." In William K. Simpson, ed., *Religion and Philosophy in Ancient Egypt*. New Haven, 1989.

Aubert, Jacques-F., and Liliane Aubert. *Statuettes égyptiennes: chaouabtis ouchebtis*. Paris, 1974.

Brock, Edwin. "Sarkophag" (pp. 471–85) in *Lexikon der Ägyptologie*, vol. 5. 1984.

Bryan, Betsy M. "The Eighteenth Dynasty before the Amarna Period (c. 1550–1352 BC)." In Ian Shaw, ed., *The Oxford History of Ancient Egypt*. Oxford/New York, 2000.

David, Ann Rosalie. "Mummification" (pp. 439–44) in *Oxford Encyclopedia*, vol. 2.

De Cenival, Jean-Louis. *Le Livre pour Sortir le Jour: Le Livre des Morts des anciens Egyptiens*. Paris, 1992.

Freed, Rita E., Yvonne J. Markowitz, and Sue H. D'Auria, eds. *Pharaohs of the Sun Akhenaten, Nefertiti, Tutankhamen*. Boston, 1999.

Faulkner, Raymond O., Ogden Goelet Jr., and Carol Andrews, ed. and trans. *The Ancient Egyptian Book of the Dead*. San Francisco, 1994.

Gitton, Michel, and Jean Leclant. "Gottesgemahlin" (pp. 792–812) in *Lexikon der Ägyptologie*, vol. 2. 1977.

Hornung, Erik. *The Valley of the Kings: Horizon of Eternity*. Trans. David Warburton. New York, 1990.

Houlihan, Patrick F. *The Animal World of the Pharaohs*. London, 1996.

Janssen, Jac. J. *Commodity Prices from the Ramessid Period*. Leiden, 1975.

Kozloff, Arielle P., and Betsy M. Bryan. *Egypt's Dazzling Sun: Amenhotep III and His World*. Cleveland, 1992.

Laboury, Dimitri. *Le statuaire de Thoutmosis III: Essai d'interprétation d'un portrait royal dans son contexte historique*. Liège, 1998.

Lacovara, Peter, and Betsy Teasley Trope. *The Realm of Osiris Mummies, Coffins, and Ancient Egyptian Funerary Art in the Michael C. Carlos Museum*. Atlanta, 2001.

Lichtheim, Miriam. *Ancient Egyptian Literature: A Book of Readings*, vols. 1 and 2. Berkeley, 1975, 1976.

Lindblad, Ingegerd. *Royal Sculpture of the Early Eighteenth Dynasty in Egypt*. Stockholm, 1984.

Niwinski, Andrzej. *Studies on the Illustrated Theban Funerary Papyri of the Eleventh and Tenth Centuries B.C.* Göttingen, 1989.

Niwinski, Andrzej, and Günther Lapp. "Coffins, Sarcophagi, and Cartonnages" (pp. 279–87) in *Oxford Encyclopedia*, vol. 1.

Porter, Bertha, and Rosalind Moss. *Topographical Bibliography of Ancient Egyptian Hieroglyphic Texts, Reliefs, and Paintings*. Vol. 1, *The Theban Necropolis*, 1927. Part 1, *Private Tombs*. Part 2, *Royal Tombs and Smaller Cemeteries*. Vol. 2, *Theban Temples*, 1929. 2d ed., rev. Oxford, 1964, 1972.

Reeves, Carl Nicholas, and Richard H. Wilkinson. *The Complete Valley of the Kings: Tombs and Treasures of Egypt's Greatest Pharaohs*. London, 1996.

Robins, Gay. *The Art of Ancient Egypt*. Cambridge, Mass., 1997.

Romano, James. "Observations on Early Eighteenth Dynasty Royal Sculpture." *Journal of the American Research Center in Egypt* 13 (1976): 97–111.

Russmann, Edna R. *Egyptian Sculpture: Cairo and Luxor*. Austin, 1989.

Saleh, Mohamed, and Hourig Sourouzian. *The Egyptian Museum, Cairo: Official Catalogue*. Cairo/Mainz, 1987.

Sandison, A. T. "Balsamierung" (pp. 610–14) in *Lexikon der Ägyptologie*, vol. 1. 1975.

Shaw, Ian, ed. *The Oxford History of Ancient Egypt*. Oxford/New York, 2000.

Simpson, William K., ed. *Religion and Philosophy in Ancient Egypt*. New Haven, 1989.

Spanel, Donald B. "Funerary Figurines" (pp. 567–70) in *Oxford Encyclopedia*, vol. 1.

Stierlin, Henri, and Christine Ziegler. *Tanis: Trésors des Pharaons*. Preface by Jean Leclant. Fribourg/Paris, 1987.

Taylor, John. "The Third Intermediate Period (1069–664 BC)." In Ian Shaw, ed., *The Oxford History of Ancient Egypt*. Oxford/New York, 2000.

van Voss, Matthieu Heerma. "Sarg" (pp. 430–68) in *Lexikon der Ägyptologie*, vol. 5. 1984.

Wildung, Dietrich, and Sylvia Schoske. *Nofret, die Schöne: Die Frau im Alten Ägypten*. Mainz, 1984.

Catalogue

The King and Society in the New Kingdom (cats. 1–16)

Altenmüller, Brigitte. "Harsaphes" (pp. 1015–18) in *Lexikon der Ägyptologie,* vol. 2. 1977.

Baines, John, and Jaromír Malék. *Atlas of Ancient Egypt.* Oxford, 1980.

Berman, Lawrence M. "Amenhotep III and his Times." In Arielle P. Kozloff and Betsy M. Bryan. *Egypt's Dazzling Sun: Amenhotep III and His World.* Cleveland, 1992.

Dabrowski, Leszek Teodozy. "A Famous Temple Re-examined: Queen Hatshepsut's Temple at Deir El Bahari — And a Hitherto Unknown Temple." *Illustrated London News* 245, no. 6529 (September 19, 1964): 413–15.

Borchardt, Ludwig. *Statuen und Statuetten von Königen und Privatleuten,* vols. 2 and 3. 1911–36. Catalogue général.

Dorman, Peter. "Senenmut" (pp. 265–66) in *Oxford Encyclopedia,* vol. 3.

———. *The Monuments of Senenmut: Problems in Historical Methodology.* London/New York, 1988.

Graham, Geoffrey. "Tanis" (pp. 348–50) in *Oxford Encyclopedia,* vol. 3.

Hope, Colin A. *Gold of the Pharaohs: An Exhibition Provided by the Egyptian Antiquities Organisation.* Melbourne/Sydney, 1989.

Laboury, Dimitri. *Le statuaire de Thoutmosis III: Essai d'interprétation d'un portrait royal dans son contexte historique.* Liège, 1998.

Legrain, Georges. *Statues et statuettes de rois et de particuliers,* vol. 1. 1906. Catalogue général.

Lipinska, Jadwiga. *The Temple of Tuthmosis III.* Vol. 2, *Architecture.* Deir el-Bahari. Warsaw, 1977.

Michalowski, Kazimierz. "Dans la Vallée de Rois les Polonais à Deir-el-Baheri." *Archeologia,* no. 9 (March–April 1966): 66–73.

Museum of Fine Arts. *Mummies and Magic: The Funerary Arts of Ancient Egypt.* Boston, 1988.

Petrie, W. M. Flinders. *Sedment,* vol. 2. London, 1924.

Porter, Bertha, and Rosalind Moss. *Topographical Bibliography of Ancient Egyptian Hieroglyphic Texts, Reliefs, and Paintings.* Vol. 1, *The Theban Necropolis,* 1927. Part 2, *Royal Tombs and Smaller Cemeteries.* Vol. 2, *Theban Temples,* 1929. 2d ed., rev. Oxford, 1964, 1972.

Quirke, Stephen. *Ancient Egyptian Religion.* New York, 1992.

Robins, Gay. *Egyptian Painting and Relief.* Aylesbury, U.K., 1986.

———. *The Art of Ancient Egypt.* Cambridge, Mass., 1997.

Russmann, Edna R. *Egyptian Sculpture: Cairo and Luxor.* Austin, 1989.

Saleh, Mohamed, and Hourig Sourouzian. *The Egyptian Museum, Cairo: Official Catalogue.* Cairo/Mainz, 1987.

Sethe, Kurt. *Urkunden der 18. Dynastie.* Berlin, 1988.

Simpson, William Kelly. "Senenmut" (pp. 849–51) in *Lexikon der Agyptologie,* vol. 4. 1982.

Smith, William Stevenson. *The Art and Architecture of Ancient Egypt.* Rev. and ed. by William Kelly Simpson. New Haven, 1998.

Sourouzian, Hourig. "Standing Royal Colossi of the Middle Kingdom Reused by Ramesses II." *Mitteilungen des Deutschen Archäologischen Instituts, Abteilung Kairo* 44 (1988): 229–54.

Spanel, Donald B. "Herakleopolis" (pp. 91–93) in *Oxford Encyclopedia,* vol. 2.

Terrace, Edward L.B., and Henry George Fischer. *Treasures of Egyptian Art from the Cairo Museum.* London, 1970.

Tiradritti, Francesco, ed. *The Treasures of the Egyptian Museum.* Cairo, 1999.

Vandier, Jacques. *Manuel d'archéologie égyptienne.* Vol. 3, *Les grandes époques.* Paris, 1958. Reprint, 1981.

van Dijk, Jacobus. "The New Kingdom Necropolis of Memphis: Historial and Iconographical Studies" (Ph.D. diss., Groningen, 1993).

Van Siclen, Charles C. "Obelisk" (pp. 561–64) in *Oxford Encyclopedia,* vol. 2.

The Royal Tomb (cats. 17–51)

Aldred, Cyril. *Jewels of the Pharaohs.* New York, 1971.

Altenmüller, Hartmut. "Djed-Pfeiler" (pp. 1000–1105) in *Lexikon der Ägyptologie,* vol. 1. 1975.

Altenmüller, Hartwig. "Papyrusdickicht und Wüste: Überlegungen zu zwei Statuenensembles des Tutanchamun." *Mitteilungen des Deutschen Archäologischen Instituts, Abteilung Kairo* 47 (1991): 11–19.

Andrews, Carol. *Amulets of Ancient Egypt.* London/Austin, 1994.

———. *Ancient Egyptian Jewelry.* New York, 1991.

Assmann, Jan. *Egyptian Solar Religion in the New Kingdom: Re, Amun, and the Crisis of Polytheism.* Trans. Anthony Alcock. London/New York, 1995.

Galeries nationales du Grand Palais. *Tanis: L'or des pharaons.* Paris, 1987.

Barsanti, Alexandre. "Tombeua de Zannehibou: Rapport sur la decouverte." *Annales du Service des Antiquités de l'Égypte* 1 (1900): 262–71.

Bissing, F. W. von. *Ein Thebanischer Grabfund aus dem Anfang des Neuen Reiches.* Berlin, 1900.

Capart, Jean. *L'Art égyptien,* vol. 4. Les Arts mineurs. Brussels, 1947.

Bleeker, Claas Jouco. *Hathor and Thoth.* Leiden, 1973.

Bresciani, Edda. "Eléménts de rituel et d'offrande dans le texte démotique de l'Oeil du Soleil." In Jan Quaegebeur, ed., *Ritual and Sacrifice in the Ancient Near East.* Proceedings of the International Conference Organized by the Katholieke Universiteit Leuven, April 17–20, 1991. Louvain, 1993.

Careddu, Giorgio. "L'art musical dans l'Egypte ancienne." *Chronique d'Egypte* (1991): 39–59.

Daressy, Georges. *Fouilles de la Vallée des Rois.* Cairo, 1902.

———. *Statues des divinités,* vols. 1 and 2. 1905–06. Catalogue général.

Dasen, Véronique. *Dwarfs in Ancient Egypt and Greece.* Oxford, 1993.

Daumas, François. "Les objets sacrées de la déesse Hathor à Dendara." *Revue d'Egyptologie* 22 (1970): 63–78.

Davis, Theodore M., et al. *The Tomb of Iouiya and Touiyou.* London, 1907.

Derchain, Philippe. "Anchzeichen" (pp. 268–69) in *Lexikon der Ägyptologie,* vol. 1. 1975.

Doxey, Denise M. "Sobek" (pp. 300–301) in *Oxford Encyclopedia,* vol. 3.

Eaton-Krauss, Marianne. "The Coffins of Queen Ahhotep, Consort of Seqeni-en-Re and Mother of Ahmose." *Cahiers d'Egypte* 65 (1990): 195–205.

Farag, Nagib, and Zaky Iskander. *The Discovery of Neferuptah.* Cairo, 1971.

Gosline, Sheldon Lee. "The *mnjt* as an Object of Divine Assimilation." *Discussions in Egyptology* 30 (1994): 37–46.

Goyon, Georges. *La découverte des trésors de Tanis: Aventures archéologiques en Egypte.* Preface by Jean Leclant. [Paris?], 1987.

Griffiths, J. Gwyn. "Isis" (pp. 188–91) in *Oxford Encyclopedia,* vol. 2.

Guglielmi, Waltraud. *Die Göttin Mr.t: Entstehung und Verehrung einer Personifikation.* Leiden/New York, 1991.

Hickmann, Hans. *Dieux et déesses de la musique.* Cairo, 1954.

Hope, Colin A. *Gold of the Pharaohs: An Exhibition Provided by the Egyptian Antiquities Organisation.* Melbourne/Sydney, 1989.

Hornung, Erik. *The Valley of the Kings: Horizon of Eternity.* Trans. David Warburton. New York, 1990.

Houlihan, Patrick F. *The Animal World of the Pharaohs.* London, 1996.

———. "Felines" (pp. 513–16) in *Oxford Encyclopedia,* vol. 2.

Jéquier, Gustave. *Considérations sur les religions égyptiennes.* Neuchâtel, 1946.

Kákosy, László. *Zauberei im alten Ägypten.* Leipzig, 1989.

Koemoth, Pierre. *Osiris et les arbres: Contribution à l'étude des arbres sacrés de l'Egypte ancienne.* Liège, 1994.

Bedford, Donald B. "Thutmose III" (pp. 540–48) in *Lexikon der Ägyptologie,* vol. 6. 1986.

Lise, Giorgio. *Egyptian Amulets.* Milan, 1988.

Malaise, Michel. "Bes" (pp. 179–80) in *Oxford Encyclopedia,* vol. 1.

Markowitz, Yvonne J., and Peter Lacovara. "Gold" (pp. 34–38) in *Oxford Encyclopedia,* vol. 2.

Martin, Karl. "Uräus" (pp. 864–68) in *Lexikon der Ägyptologie,* vol. 6. 1986.

Maspero, Gaston. *Guide du visiteur au Musée du Caire.* 4th ed. Cairo, 1915.

Montet, Pierre. "La Nécropole des Rois Tanites." *Kemi* 9 (1942): 1–96.

———. *La nécropole royale de Tanis.* Paris, 1947– . Vol. 2, *Les contructions et le tombeau de Psousennès à Tanis.* Paris, 1951.

Mysliwiec, Karol. *The Twilight of Ancient Egypt: First Millennium B.C.E.* Trans. David Lorton. Ithaca, New York, 2000.

Müller, Hans Wolfgang, and Eberhard Thiem. *Gold of the Pharaohs.* Trans. Pierre Imhoff and Dafydd Roberts. Ithaca, New York, 1999.

Morgan, Jacques Jean Marie de. *Fouilles à Dahchour en 1894–1895.* 2 vols. Vienna, 1895–1903.

Müller-Winkler, Claudia. *Die ägyptischen Objekt-Amulette: mit Publikation der Sammlung des Biblischen Instituts der Universität Freiburg, Schweiz, ehemals Sammlung Fouad S. Matouk,* vol. 1. Orbis biblicus et orientalis: Senes Archaeologica. Fribourg/Göttingen, 1987.

Münster, Maria. *Untersuchungen zur Göttin Isis.* Berlin, 1968.

Naguib, Saphinaz-Amal. *Le clergé féminin d'Amon Thébain à la 21e dynastie.* Louvain, 1990.

Petrie, W. M. Flinders. *Amulets.* London, 1914.

Pinch, Geraldine. *Votive Offerings to Hathor.* Oxford, 1993.

Poole, F. "Tanis, Royal Tombs" (pp. 757–59). In *Encyclopedia of the Archaeology of Ancient Egypt.* London/New York, 1999.

Porter, Bertha, and Rosalind Moss. *Topographical Bibliography of Ancient Egyptian Hieroglyphic Texts, Reliefs, and Paintings.* Vol. 1, *The Theban Necropolis,* 1927. Part 2, *Royal Tombs and Smaller Cemeteries.* 2d ed., rev. Oxford, 1964, 1972.

Quibell, James Edward. *The Tomb of Yuyaa and Thuiu.* 1908. Catalogue général.

Reeves, Carl Nicholas, and Richard H. Wilkinson, *The Complete Valley of the Kings: Tombs and Treasures of Egypt's Greatest Pharaohs.* London, 1996.

Reisner, George Andrew. *Canopics.* Revised, annotated, and completed by Mohamad Hassan Abd-ul-Rahman. 1967. Catalogue général.

Reynders, Marleen. "Sšš.t and Shm: Names and Types of the Egyptian Sistrum." In *Egyptian Religion, The Last Thousand Years: Studies in Memory of Jan Quaegebeur,* vol. 2. Louvain, 1998.

Roberts, Alison. *Hathor Rising: The Power of the Goddess in Ancient Egypt.* Totnes, U.K., 1995; Rochester, Vermont, 1997.

Roth, Ann Macy. "The Ahhotep Coffins: The Archaeology of an Egyptological Reconstruction." In Emily Teeter and John A. Larson, eds., *Gold of Praise: Studies on Ancient Egypt in Honor of Edward F. Wente.* Chicago, 1999.

Roulin, Gilles. "Les tobes royales de Tanis: analyse du programme décoratif." In Philippe Brissaud and Christiane Zivie-Coche, eds. *Tanis: Travaux récents sur le tell Sân el-Hagar, Mission française des fouilles de Tanis, 1987–1997.* Paris, 1998.

Saleh, Mohamed, and Hourig Sourouzian. *The Egyptian Museum, Cairo: Official Catalogue.* Cairo/Mainz, 1987.

Schneider, Hans D. *Shabtis: An Introduction to the History of Ancient Egyptian Funerary Statuettes with a Catalogue of the Collection of Shabtis in the National Museum of Antiquities at Leiden,* 3 vols. Leiden, 1977.

Shaw, Ian, and Paul Nicholson. *British Museum Dictionary of Ancient Egypt,* London, 1995.

Spanel, Donald B. "Two Unusual Eighteenth-Dynasty Shabtis in the Brooklyn Museum." *Bulletin of the Egyptological Seminar* 10 (1989/90): 145–67.

Speleers, Louis. *Les figurines funéraires égyptiennes.* Brussels, 1923.

Stierlin, Henri. *The Gold of the Pharaohs.* Trans. P. Snowden. Paris, 1997.

Stierlin, Henri, and Christine Ziegler. *Tanis: Trésors des Pharaons.* Preface by Jean Leclant. Fribourg/Paris, 1987.

Tiradritti, Francesco, ed. *The Treasures of the Egyptian Museum.* Cairo, 1999.

Tobin, Vincent Arieh. "Amun and Amun-re" (pp. 82–84) in *Oxford Encyclopedia,* vol. 1.

van Dijk, Jacobus. "Ptah" (pp. 74–76) in *Oxford Encyclopedia,* vol. 3.

Vernier, Émile Séraphin. *Bijoux et orfèvreries.* 3 vols. 1907–27. Catalogue général.

Vilímková, Milada. *Egyptian Jewellery.* Prague/Feltham, New York, 1969.

230

Vischak, Deborah. "Hathor" (pp. 82–85) in *Oxford Encyclopedia,* vol. 2.

Wildung, Dietrich, and Sylvia Schoske. *Nofret, die Schöne: Die Frau im Alten Ägypten.* Mainz, 1984.

Wilkinson, Alix. *Ancient Egyptian Jewellery.* London, 1971.

Wilkinson, Richard H. *Symbol and Magic in Egyptian Art.* New York, 1994.

Winlock, Herbert. "The Tombs of Kings of the Seventeenth Dynasty at Thebes." *Journal of Egyptian Archaeology* 10 (1924): 217–77.

Ziegler, Christiane. "Sistrum" (pp. 959–63) in *Lexikon der Ägyptologie,* vol. 5. 1984.

The Tomb of a Noble (cats. 52–75)

Al-Misri, Mathaf. *Le Musée Egyptien,* vol. 3. Cairo, 1890–1915.

Anderson, Robert. "Music and Dance in Pharaonic Egypt." In Jack M. Sasson, ed., *Civilizations of the Ancient Near East,* vol. 4. Peabody, Mass., 2000.

Andrews, Carol. *Amulets of Ancient Egypt.* London/Austin, 1994.

———. *Ancient Egyptian Jewelry.* New York, 1991.

———. *Egyptian Mummies.* Cambridge, Mass., 1984.

Aufrère, Sydney. *L'Univers Minéral dans la Pensée Égyptienne.* Cairo, 1991.

Barsanti, Alexandre. "Le Tombeau de Hikaoumsaf Rapport sur la découverte." *Annales du Service des Antiquités de l'Égypte* 5 (1904–05): 69–83.

Bénédite, Georges. *Objets de toilette,* vol. 1. Cairo, 1911.

Bietinski, Piotr, and Piotr Taracha. "Board Games in the Eastern Mediterranean: Some Aspects of Cultural Interrelations." In *Studia Aegaea et Balcanica in Honorem L. Press.* Warsaw, 1992.

British Museum. *A Handbook to the Egyptian Mummies and Coffins Exhibited in the British Museum.* Department of Egyptian and Assyrian Antiquities. London, 1938.

Brunner-Traut, Emma. *Die Alten Ägypter: Verborgenes Leben unter Pharaonen.* Stuttgart, 1974.

Bruyère, Bernard. *Mert Seger à Deir el Bahari.* Cairo, 1930.

———. *La tombe no 1 de Sen-nedjem à Deir el Médineh.* Cairo, 1959.

Daressy, Georges. *Cercueils des cachettes royales.* Cairo, 1909.

———. *Statues des divinités,* vols. 1 and 2. 1905–06. Catalogue général.

Davies, Norman de Garis. *The Tomb of Puyemrê at Thebes.* 2 vols. New York, 1922–23.

Decker, Wolfgang, and Michael Herb. *Bildatlas zum Sport im alten Ägypten,* vol. 1. Leiden, 1994.

Dodson, Aidan. *The Canopic Equipment of the Kings of Egypt.* London, 1994.

———. "Canopic Jars and Chests" (pp. 231–35) in *Oxford Encyclopedia,* vol. 1.

DuQuesne, Terence. *Anubis and the Spirits of the West.* Thame Oxon, U.K., 1990.

Fischer, Henry George. *Ancient Egyptian Representations of Turtles.* New York, 1968.

———. "Kopfstütze" (pp. 686–93) in *Lexikon der Ägyptologie,* vol. 3. 1981.

Freed, Rita E. *Ramesses the Great.* Memphis, Tennessee, 1988.

Friedman, Florence Dunn. "*Shabti* of Lady Sati." In Florence Dunn Friedman, ed., *Gifts of the Nile: Ancient Egyptian Faience.* Providence, 1998.

Galeries Nationales du Grand Palais. *Ramses Le Grand.* Paris, 1976.

Hayes, William Christopher. *The Scepter of Egypt,* vol. 2. New York, 1990.

Hermann, Alfred. *Die Stelen der thebanischen Felsgräber der 18. Dynastie.* Glückstadt, 1940.

Hickmann, Ellen. "Klapper" (pp. 447–49) in *Lexikon der Ägyptologie,* vol. 3. 1981.

Hickmann, Hans. *Instruments de Musique,* 1949. Catalogue général.

Hill, Marsha. "Das Grab Sethos' I." In Erik Hornung, *The Tomb of the Pharaoh Seti I/Das Grab Seti' I.* Zurich/Munich, 1991.

Hornung, Erik. *The Valley of the Kings: Horizon of Eternity.* Trans. David Warburton. New York, 1990.

Houlihan, Patrick F. "Frogs" (p. 563) in *Oxford Encyclopedia,* vol. 1.

Kákosy, Lászlo. "Frosch" (pp. 334–36) in *Lexikon der Ägyptologie,* vol. 2. 1977.

Kampp, Friederike. *Die thebanische Nekropole: Zum Wandel des Grabgedankens von der XVIII. bis zur XX. Dynastie.* Mainz, 1996.

Kendall, Timothy. *Passing through the Netherworld.* Belmont, Mass., 1978.

Kendall, Timothy, et al. "Les jeux de table dans l'antiquité" (pp. 122–65). In *Jouer dans l'antiquité. Musée d'Archéologie Méditerranéenne – Centre de la Vielle Charité, 22 novembre 1991–16 février 1992.* Marseille, 1992.

Killen, Geoffrey. "Ancient Egyptian Carpentry: Its Tools and Techniques." In Georgina Hermann, ed., *The Furniture of Western Asia, Ancient and Traditional.* Papers of the Conference held at the Institute of Archaeology, University College London, June 28–30, 1993. Mainz, 1996.

———. *Ancient Egyptian Furniture.* Vol. 2, *Boxes, Chests and Footstools.* London, 1994.

———. *Egyptian Woodworking and Furniture.* London, 1994.

Kozloff, Arielle P., and Betsy M. Bryan. *Egypt's Dazzling Sun: Amenhotep III and His World.* Cleveland, 1992.

Lawergren, Bo. "Music" (pp. 450–54) in *Oxford Encyclopedia,* vol. 2.

Lilyquist, Christine, and Robert H. Brill. *Studies in Early Egyptian Glass.* New York, 1993.

Maspero, Gaston. *Les momies royals de Déir el-Baharî.* Paris, 1889.

Milde, H. *The Vignettes in the Book of the Dead of Neferrenpet.* Leiden, 1991.

Museum of Fine Arts. *Egypt's Golden Age: The Art of Living in the New Kingdom, 1558–1085 B.C.* Boston, 1982.

———. *Mummies and Magic: The Funerary Arts of Ancient Egypt.* Boston, 1988.

Niwinski, Andrzej. *Studies on the Illustrated Theban Funerary Papyri of the Eleventh and Tenth Centuries B.C.* Fribourg/Göttingen, 1989.

———. *Twenty-first Dynasty Coffins from Thebes: Chronological and Typological Studies.* Mainz, 1988.

Niwinski, Andrzej, and Günther Lapp. "Coffins, Sarcophagi, and Cartonnages" (pp. 279–87) in *Oxford Encyclopedia,* vol. 1.

Otto, Eberhard. *Egyptian Art and the Cults of Osiris and Amon.* Trans. Kate Bosse Griffiths. London, 1968.

Pieper, Max. *Das ägyptische Brettspiel.* Leipzig, 1931.

231

Porter, Bertha, and Rosalind Moss. *Topographical Bibliography of Ancient Egyptian Hieroglyphic Texts, Reliefs, and Paintings.* Vol. 1, *The Theban Necropolis*, 1927. Part 1, *Private Tombs.* Part 2, *Royal Tombs and Smaller Cemeteries.* Vol. 2, *Theban Temples*, 1929. Vol. 3, *Memphis*, 1931. Part 1, *Abû Rawâsh to Dahshûr.* 2d ed., rev. Oxford, 1964, 1972.

Pusch, Edgar Bruno. *Das Senet-Brettspiel im alten Ägypten.* Munich/Berlin, 1979.

Ranke, Hermann. *Die ägyptischen Personennamen.* Glückstadt, 1935.

Redford, Donald B. "Offerings" (pp. 564–69) in *Oxford Encyclopedia,* vol. 2.

Reisner, George Andrew. *Canopics.* Revised, annotated, and completed by Mohammad Hassan Abd-ul-Rahman. 1967. Catalogue général.

Robins, Gay. *The Art of Ancient Egypt.* Cambridge, Mass., 1997.

Saleh, Mohamed. *Das Totenbuch, Text und Vignetten.* Mainz, 1984.

Saleh, Mohamed, and Hourig Sourouzian. *The Egyptian Museum, Cairo: Official Catalogue.* Cairo/Mainz, 1987.

Schlick-Nolte, Birgit. *Die Glasgefässe im alten Ägypten.* Berlin, 1968.

———. "Glass" (pp. 30–34) in *Oxford Encyclopedia,* vol. 2.

Schneider, Hans D. *Shabtis: An Introduction to the History of Ancient Egyptian Funerary Statuettes with a Catalogue of the Collection of Shabtis in the National Museum of Antiquities at Leiden,* vol. 1. Leiden, 1977.

Scott III, Gerry D. *Temple, Tomb and Dwelling: Egyptian Antiquities from the Harer Family Trust Collection.* San Bernardino, 1992.

Spencer, A. Jeffrey. *Death in Ancient Egypt.* New York/Harmondsworth, U.K., 1982.

Taylor, John. *Egyptian Coffins.* Vol. 11 of *Shire Egyptology.* Aylesbury, U.K., 1989.

Terrace, Edward L.B., and Henry G. Fischer. *Treasures of Egyptian Art from the Cairo Museum.* London, 1970.

Tiradritti, Francesco, ed. *The Treasures of the Egyptian Museum.* Cairo, 1999.

Toda, Eduardo. "Découverte et L`inventaire du Tombeau de Sen-nezen." *Annales du Service des Antiquités de l'Égypte* 20 (1920): 145–58.

Vandier, Jacques. *Manuel d'archéologie égyptienne,* vol. 4. Paris, 1964.

Vernier, Émile Séraphin. *Bijoux et orfèvreries.* 3 vols. 1907–27. Catalogue général.

Wenig, Steffen. *The Woman in Egyptian Art.* Trans. Barbara Fischer. New York, [1969].

Wildung, Dietrich, and Sylvia Schoske. *Nofret, die Schöne: Die Frau im Alten Ägypten.* Mainz, 1984.

Realm of the Gods and the Amduat (cats. 76–107)

Altenmüller, Brigitte. "Anubis" (pp. 327–33) in *Lexikon der Ägyptologie,* vol. 1. 1975.

American Research Center in Egypt. *The Luxor Museum of Ancient Egyptian Art Catalogue.* Cairo, 1978.

Andrews, Carol. *Amulets of Ancient Egypt.* London/Austin, 1994.

Arslan, Ermanno A., et al. *Iside: Il mito, il mistero, la magia.* Milan, 1997.

Assmann, Jan. *Maât, l'Égypte pharaonique et l'idée de justice sociale.* Paris, 1989.

Aubert, Jacques-F., and Liliane Aubert. *Statuettes égyptiennes: chaouabtis, ouchebtis.* Paris, 1974.

Bakry, Hassan S.K. "The Discovery of a Temple of Sobk in Upper Egypt." *Mitteilungen des Deutschen Archäologischen Instituts, Abteilung Kairo* 27 (1971): 131–46.

Barocas, C. "Les statues 'réalistes' et l'arrivée des Perses dans l'égypte saïte." In *Gururajamanjarik: Studi in onore di Giuseppe Tucci.* Naples, 1974.

Benson, Margaret, and Janet Gourlay. *The Temple of Mut in Asher.* London, 1899.

Bianchi, Robert. *Cleopatra's Egypt: Age of the Ptolemies.* Brooklyn, 1988.

Bonhême, Marie-Ange, and Annie Forgeau Pharaon. *Les secrets du pouvoir.* Paris, 1988.

Bothmer, Bernard V., comp. *Egyptian Sculpture of the Late Period, 700 B.C. to A.D. 100.* Contributions by Herman de Meulenaere and Hans Wolfgang Müller. Ed. Elizabeth Riefstahl. New York, 1960.

Bouriant, Urban. *Petits monuments et petits texts.* Vol. 7 of *Recueil de travaux, rélatifs à la philologie et à l´archéologie égyptiennes et assyriennes.* Paris, 1886.

Brunner-Traut, Emma. "Crocodile" (pp. 320–21) in *Oxford Encyclopedia,* vol. 1.

Bryan, Betsy M. "The Statue Program for the Mortuary Temple of Amenhotep III." In Stephen Quirke, ed., *The Temple in Ancient Egypt: New Discoveries and Recent Research.* London, 1997.

Bury, J.B., S.A. Cook, and F.E. Adcock, eds. *The Cambridge Ancient History.* Vol. 1, *Egypt and Babylonia to 1580 B.C.* Cambridge, 1927.

Cook, Stanley A. "The Gods of the Twilight: Man's Early Efforts towards an Embodiment of His Spiritual Needs in a Personal Religion." In John Alexander Hammerton, ed. *The Universal History of the World,* vol. 1. London, 1927.

Daressy, Georges. *Statues des divinités,* vols. 1 and 2. 1905–06. Catalogue général.

Doxey, Denise M. "Sobek" (pp. 300–301) in *Oxford Encyclopedia,* vol. 3.

———. "Thoth" (pp. 398–400) in *Oxford Encyclopedia,* vol. 3.

DuQuesne, Terence. *Black and Gold God: Colour Symbolism of the God Anubis.* London, 1996.

Edgar, Campbell Cowan. *Greek Sculpture.* Osnabrück, 1974; reprint of 1903 ed. Catalogue général.

Eggebrecht, Eva. "Greif" (pp. 895–96) in *Lexikon der Ägyptologie,* vol. 2. 1977.

Ferrari, Daniela. *Gli amuleti dell'antico Egitto.* Imola, 1996.

Graefe, Erhart. "Upuaut" (pp. 862–64) in *Lexikon der Ägyptologie,* vol. 6. 1986.

Harris, James Renel. *Egyptian Art.* London, 1966.

Helck, Wolfgang, and Eberhard Otto. "Pavian" (pp. 915–20) in *Lexikon der Ägyptologie,* vol. 4. 1982.

Holmberg, Maj Sandman. *The God Ptah.* Lund, 1946.

Holm-Rasmussen, Torben. "On the Statue Cult of Nectanebos II." *Acta Orientalia* (Copenhagen) 40 (1979): 21–25.

Hornung, Erik. "Komposite Gottheiten in der ägyptischen Ikonographie." In Christoph Uehlinger, ed., *Images as Media: Sources for the Cultural History of the Near East and the Eastern Mediterranean, First Millennium B.C.E.* Fribourg, 2000.

Hüttner, Maria. *Mumienamulette im Totenbrauchtum der Spätzeit.* Vienna, 1995.

Ikram, Salima, and Aidan Dodson. *The Mummy in Ancient Egypt.* London, 1998.

Johnson, Janet H. "The Demotic Chronicle as a Statement of a Theory of Kingship." *Journal of the Society for the Study of Egyptian Antiquities* 13 (1983): 61–72.

Josephson, Jack A., and Mamdouh Mohamed Eldamaty. *Statues of the Twenty-fifth and Twenty-sixth Dynasties*. 2000. Catalogue général.

Kákosy, László. "Atum" (pp. 550–52) in *Lexikon der Ägyptologie*, vol. 1. 1975.

Kessler, Dieter. *Die heiligen Tiere und der König*. Wiesbaden, 1989.

Killen, Geoffrey. *Ancient Egyptian Furniture*. Vol. 2, *Boxes, Chests and Footstools*. London, 1994.

Kozloff, Arielle P., and Betsy M. Bryan. *Egypt's Dazzling Sun: Amenhotep III and His World*. Cleveland, 1992.

Leclant, Jean. *Les pharaons*, vol. 3. Paris, 1979.

Legrain, Georges. "La statuette de Hor fils de Djet Thot Efankh." *Annales du Service des Antiquités de l'Égypte* 16 (1916): 145–48.

Málek, Jaromír. *The Cat in Ancient Egypt*. London, 1993.

Mariette, Auguste. *Monuments divers recueillis en Égypte et en Nubie*. Paris, 1872.

———. *Notice des principaux monuments exposés dans les galeries provisoires du musée d'Antiquités Egyptiennes*. Alexandria, 1864.

Meeks, Dimitri. "Hededet" (pp. 1076–78) in *Lexikon der Ägyptologie*, vol. 2. 1977.

Müller-Winkler, Claudia. *Die ägyptischen Objekt-Amulette. mit Publikation der Sammlung des Biblischen Instituts der Universität Freiburg, Schweiz, ehemals Sammlung Fouad S. Matouk*, vol. 1. Orbis biblicus et orientalis: Senes Archaeologica. Fribourg/Göttingen, 1987.

Myer, Isaac. *Scarabs: The history, manufacture and religious symbolism of the scarabaeus in ancient Egypt, Phoenicia, Sardinia, Etruria, etc.; also remarks on the learning, philosophy, arts, ethics, psychology, ideas as to the immortality of the soul, etc. of the ancient Egyptians, Phoenicians, etc.* London, 1894.

Mysliwiec, Karol. *Studien zum Gott Atum*, vol. 1. Hildesheim, 1978.

———. "Zwei Pyramidia der XIX. Dynastie aus Memphis." *Studien zur Altägyptischen Kulturkunde* 6 (1978): 145–55.

Moret, Alexandre. *Rois et dieux d'Égypte*. Paris, 1911.

Newberry, Percy E. *Funerary Statuettes and Model Sarcophagi*, 1930. Catalogue général.

Niwinski, Andrzej. "Untersuchungen zur ägyptischen religiösen Ikonographie der 21. Dynastie/ Mummy in the Coffin as the Central Element of Iconographic Reflection of the Theology of the Twenty-first Dynasty in Thebes." *Göttingen Miszellen* 109 (1989): 53–66.

Pernigotti, Sergio. "Una statua di Pakhraf (Cairo JE 37171)." *Rivista degli Studi Orientali* 44 (1969): 259–71.

———. "Due sacerdoti egiziani di Epoca Tarda." *Studi classici e orientali* 21 (1972): 305–6.

Petrie, W. M. Flinders. *Scarabs and Cylinders with Names: Illustrated by the Egyptian Collection in University College, London*. London, 1917.

Picard-Schmitter, M-Th. "Une tapisserie hellénistique d'Antinoé." *Fondation Eugène Piot: Monuments et Mémoires* 52 (1961): 50–51.

Piehl, Karl Fredrick. "Varia." *Zeitschrift für Ägyptische Sprache und Altertumskunde*. 1888.

Pijoán, José. *History of Art*, vol. 1. Trans. Ralph L. Roys. New York, 1927.

Pirelli, Rosanna. "Statue of Isis from the Tomb of Psamtek." In Francesco Tiradritti, ed., *The Treasures of the Egyptian Museum*. Cairo, 1999.

Porter, Bertha, and Rosalind Moss. *Topographical Bibliography of Ancient Egyptian Hieroglyphic Texts, Reliefs, and Paintings*. Vol. 1, *The Theban Necropolis*, 1927. Part 1, *Private Tombs*. Part 2, *Royal Tombs and Smaller Cemeteries*. Vol. 2, *Theban Temples*, 1929. Vol. 3, *Memphis*, 1931. Part 1, *Abû Rawâsh to Dahshûr*. 2d ed., rev. Oxford, 1964, 1972.

Quaegebeur, Jan. "Divinities égyptiennes sur des animaux dangereux." In *L'Animal, l'homme, le dieu dans le Proche-Orient ancien*. Louvain, 1984.

———. "De L'Origine égyptienne du Griffon Némésis." In François Jouan, ed., *Visages du destin dans les mythologies: Mélanges Jacqueline Duchemin, Actes du Colloque de Chantilly 1er–2 mai 1980*. Paris, 1983.

Rammant-Peeters, Agnès. *Les pyramidions égyptiens du Nouvel Empire*. Louvain, 1983.

Ray, J. D. *The Archive of Hor*. London, 1976.

Redford, Donald B. "Monkeys and Baboons" (pp. 428–32) in *Oxford Encyclopedia*, vol. 2.

———. "Thoth" (pp. 398–400) in *Oxford Encyclopedia*, vol. 3.

———. "Felines" (pp. 513–16) in *Oxford Encyclopedia*, vol. 1.

Ritner, Robert K. *The Mechanics of Ancient Egyptian Magical Practice*. Chicago, 1993.

Roeder, Günther. *Ägyptische Bronzefiguren*. Berlin, 1956.

———. *Die ägyptische Götterwelt*. Zurich/ Stuttgart, 1959.

Russmann, Edna R. *Egyptian Sculpture: Cairo and Luxor*. Austin, 1989.

———. *Le dieu égyptien Shaï dans la religion et onomastique*. Orientalia Lovaniensia Analecta 2. Louvain, 1975.

Saleh, Mohamed, and Hourig Sourouzian. *The Egyptian Museum, Cairo: Official Catalogue*. Cairo/Mainz, 1987.

Schmidt, Valdemar. *Sarkofager, Mumiekister, og Mumiehylstre i det Gamle Aegypten: Typologisk Atlas*. Copenhagen. 1919.

Seeber, Christine. *Untersuchungen zur Darstellung des Totengerichts im alten Ägypten*. Munich/Berlin, 1976.

Shaw, Ian, and Paul Nicholson. *British Museum Dictionary of Ancient Egypt*. London, 1995.

Spalinger, Anthony John. "The Concept of the Monarchy during the Saite Epoch—An Essay of Synthesis." *Orientalia* 47 (1978): 12–36.

Taylor, John. *Death and the Afterlife in Ancient Egypt*. Chicago, 2001.

Teeter, Emily. "Maat" (pp. 319–21) in *Oxford Encyclopedia*, vol. 2.

Trapani, Marcella. "Statue of Isis." In Alessandro Bongioanni and Maria Sole Croce, eds. *The Illustrated Guide to the Egyptian Museum in Cairo*. Cairo, 2001.

van Dijk, Jacobus. "Ptah" (pp. 74–76) in *Oxford Encyclopedia*, vol. 3.

von Känel, Frédérique. "Scorpions" (pp. 186–87) in *Oxford Encyclopedia*, vol. 3.

Ward, John. *The Sacred Beetle: A Popular Treatise on Egyptian Scarabs in Art and History*. London, 1902.

Zabkar, Louis V. *A Study of the Ba Concept in Ancient Egyptian Texts*. Chicago, 1968.

Index